The European Avant-Garde
1900–1940

CULTURAL HISTORY OF LITERATURE SERIES

Andrew J. Webber, *The European Avant-Garde*
Tim Whitmarsh, *Ancient Greek Literature*

The European Avant-Garde
1900–1940

ANDREW J. WEBBER

polity

First published in 2004 by Polity Press Ltd.

Polity Press
65 Bridge Street
Cambridge CB2 1UR, UK

Polity Press
350 Main Street
Malden, MA 02148, USA

A catalogue record for this book is available from the British Library.

Library of Congress Cataloging-in-Publication Data
Webber, Andrew.
 The European Avant-Garde 1900–1940 / Andrew J. Webber.
 p. cm. – (Cultural History of Literature Series)
 Includes index.
 ISBN 0-7456-2704-8 (hb : alk. paper) – ISBN 0-7456-2705-6
 (pb : alk. paper)
 1. Avant-Garde (Aesthetics)–Europe–History–20th century.
 2. Arts, European. I. Title. II. Series.
 NX542.W43 2004
 709′.04′1–dc22
 2003022059

Typeset in 10.5 on 12 pt Sabon
by Graphicraft Limited, Hong Kong
Printed and bound in Great Britain by MPG Books, Bodmin, Cornwall

For further information on Polity, visit our website: www.polity.co.uk

The book was completed in loving memory of my father,
John Robert Webber.

Contents

List of Plates viii

Preface ix

1 Introduction: The Historical Avant-Garde and
 Cultural History 1

2 Manifestations: The Public Sphere 17

3 Writing the City: Urban Technology and Poetic
 Technique 61

4 Modes of Performance: Film-Theatre 103

5 Case Histories: Narratives of the Avant-Garde 167

6 Conclusion: Allegories of the Avant-Garde 214

Epilogue: After the Avant-Garde? 219

Notes 223

Index 246

List of Plates

1 Paul Klee, *Angelus Novus* (1920) 6

2 Carlo Carrà, *Manifestazione Interventista* (1914) 25

3 Marcel Duchamp, *LHOOQ* (1919) 49

4 Hannah Höch, *Da-Dandy* (1919) 51

5 René Magritte, *Le Viol* (1934) 56

6 Federico García Lorca, *Self-Portrait of the Poet in
 New York* (1929–32) 100

7 The woman with the pince-nez on the Odessa Steps
 in *Battleship Potemkin* (1925) 128

8 Epic film-theatre: the agitprop group 'Das rote
 Sprachrohr' ('The red megaphone') performs in
 Kuhle Wampe (1932) 135

9 The self-reflexive cine-eye in *Man with a Movie
 Camera* (1929) 152

10 The fountain in the Tuileries gardens, from
 André Breton, *Nadja* (1928) 211

11 Guillaume Apollinaire, 'La Colombe poignardée
 et le jet d'eau' (1914) 217

Preface

The roots of my interest in the European avant-garde go back to a course in the Cambridge Faculty of Modern and Medieval Languages, itself conceived as an avant-garde challenge to the scholarly and pedagogical regime that held sway there, and in many places besides, in the early 1980s. The seminars for the course, enlivened by the likes of Elizabeth Wright and Toril Moi, had something of the unaccountable character of avant-garde happenings. Its comparative, intermedial, and theoretically informed approach provided perhaps the most inspiring experience of my undergraduate study, and the enthusiasm stayed with me when I came in later years to teach the course and the module that emerged from it in the Cambridge M.Phil. in European Literature. The arguments and the material that I have assembled in this book owe much to the exchanges with students and teachers that were enabled by that now defunct course, and indeed by the courses in comparative film studies and representations of the body that have replaced it in the Cambridge syllabus and still sustain many of its interests.

The completion of the book was made possible by a Research Leave Award from the Arts and Humanities Research Board. For this, as for the support of the Cambridge German Department and Churchill College, I am very grateful. I also wish to thank my referees for the project, Martin Swales and John White, and my editor at Polity, Andrea Drugan, who has steered the book through with good humour, energy and expertise. There are reflections in my arguments here of the discussions that I have had with a fine group of Ph.D. students over the last few years, and I would like to record my thanks to them for the stimulation that their diverse projects have given

me. And thank you too to my family and friends for support of every kind.

The translations given in the book are mine unless otherwise indicated. An earlier version of the reading of Trakl's 'Abendland' in chapter 3 appeared in *Landmarks in German Poetry*, ed. Peter Hutchinson (Berne: Lang, 2000) and of the reading of *Kuhle Wampe* in chapter 4 in *From Classical Shades to Vickers Victorious: Shifting Perspectives in British German Studies*, ed. Steve Giles and Peter Graves (Berne: Lang, 1999).

1

Introduction: The Historical Avant-Garde and Cultural History

The aim of this book is to explore the classic, so-called historical manifestation of the avant-garde in the radical experimentation of European cultures in the first four decades of the twentieth century. The approach is comparative, focusing on material from the six main language areas of European avant-garde activity – English, German, French, Spanish, Russian and Italian. While the core interest of the project is literary, it will also incorporate discussion of other media, more especially visual art and film, in particular where these are in dialogue with textual experimentation. The various chapters will deal with the formal challenges of avant-garde art against the context of publicity and technology, the metropolis, radical politics, psychoanalysis and gender. The avant-garde's mobilizations and distortions of the body will provide a leitmotif for the investigation. If the avant-garde proposes a new intervention or incorporation of art into life, then the body can be seen as the privileged site of its impact, sociopolitical, psychosexual and technological.[1]

The early decades of the twentieth century saw an unparalleled set of challenges to conventions of understanding in the domains of biological and physical science, politics, philosophy, technology and psychology. The interventions of a range of radical nineteenth-century thinkers, from Darwin to Marx, Bakunin and Nietzsche, came to exert a profound influence on and beyond their respective fields. And new theorists like Einstein in the field of science, Trotsky and Gramsci in the field of politics, Bergson and Wittgenstein in the field of philosophy, Saussure and Jakobson in the field of linguistic theory, and Freud in the field of psychology, propounded their own versions of the relativity of things in contestation of accepted world pictures.

Above all, the new discourses of relativism implied a breaking down
of absolute categories, a rethinking of relatedness and difference.
The, in many ways trenchantly different, projects of these and other
pioneering thinkers could also be seen to be related, not as part of a
monolithic world-view, but through a principle that relativizes the
claims of any established system. Following the Nietzschean principle
of the revaluation of all values, the challenge to established modes of
thinking and behaving is absolute, incorporating *all* values, but it is
also differential, implying the impossibility of a solid state of valu-
ation. Thus, while Bergsonian theories of time as duration seem to run
counter to Einstein's differential theories of relativity, there is in fact
a significant degree of correlation in the two positions.[2] Similarly,
theorists like Darwin, Marx, Bakunin and Freud may seek to estab-
lish a grand narrative of things, each according to the logic of his
own system, but their ideas on the subject and society inevitably
provoke, question and differentiate each other, opening up the blind
spots that each would see in the other's view. Bakunin challenges the
centralism of Marx's revolutionary orthodoxy with a more federalist
view of social change.[3] And Freud, in what he calls his 'revaluation
of all psychic values',[4] pitches social Darwinist notions of the
survivalist struggle against what he sees as the inflationary ideology
of total community in Marxist doctrine, locating his own view of
human development and interaction in a dialectical combat between
these positions.

The ferment of contending versions of the revaluation of conven-
tional values created a powerful, often contradictory sense of cultural
expectation, a readiness for new ideas and new forms. Culture in
the broadest, social sense placed new expectations on culture in the
aesthetic sense. A principal element in the influence of Nietzsche on
cultural thinking was his insistence upon the aesthetic as the primary
category of philosophical justification, one that could subsume and
organize the ethical and logical concerns of social order. If, following
Nietzsche's famous dictum, the world could be justified only as an
'aesthetic phenomenon', then the aesthetic field is given a new pre-
eminence here, but only in so far as it engages with the world, revalu-
ates it, and makes it significant. Nietzsche's anti-theology creates
the possibility for a new cult of aesthetically ordained culture, where
aesthetic meaning is always defined according to his own philosoph-
ical presuppositions. In the systems of Marx and Freud, the death of
God creates room for other authorities, political or psychical, and
both at once have recourse to the aesthetic as a legitimating category
and challenge conventional idealizations of its workings. In each of

these, albeit antagonistic thinkers, aesthetic culture is a key testing ground for the claims of their projects. Art is a superstructure upon which the substructure, whether ethical, political or psychical, is dependent for its representation. The art of early twentieth-century Europe at once seizes the possibility of taking the place of a God declared dead, draws inspiration from radical cultural thinkers who revaluate its cultural function, and contests the new limitations that those thinkers seek to impose upon that function.

If the early part of the century was culturally energized by innovative theories, it was also profoundly transformed in matters of social practice. The metropolitan centres of Europe attained a new scope and vigour, with the great cities of the nineteenth century – pre-eminently London and Paris – coming to be rivalled by new centres of industrial, political and cultural activity like Berlin, Vienna, Moscow, Milan and Madrid. On the industrial level, this was what Walter Benjamin famously calls the Age of Technical Reproducibility, a time when the Industrial Revolution had pervaded and reshaped most parts of Europe, and a time of new media technologies providing networks for the massive diffusion of information. On a political level, new or renewed versions of nationalism and Imperialism contended with visions of Internationalism, and these violently antithetical political movements swept the streets and fields of Europe. Technological reproducibility galvanized not least the armaments industry and new industrial forms of warfare. The Marxist idea of a proletarian revolution became a reality, but capitalism reasserted its regime and ran riot, with currency in its turn becoming subject to an inflationary machinery of reproduction. And on a cultural level, there was an unprecedented wave of new forms of aesthetic production and reproduction, a migration of artists and passage of artistic ideas between the countries of Europe, and between Europe and the rest of the world. The superstructure of aesthetic production was co-opted and thrown into question in often brutal and contradictory ways. Artists entered into the cities, the factories, the battlefields and the revolutionary struggles, asserting a new possibility for art to adopt a vanguard position in social and political developments, but they also took up positions of resistance to those developments. The ranks of the politically engaged avant-gardists were rivalled by those of the more aesthetically interested Modernists, and not infrequently individuals and groups found themselves on both sides of this divide. A cultural history of the European avant-garde will have to take the measure, however schematically, of these contradictions and ambiguities.

This is not a Cultural History of the Avant-Garde

The title of this section is a playful performance of a key avant-garde statement, the legend 'Ceci n'est pas une pipe' ('This is not a pipe'), written in school blackboard style on Magritte's textbook painting of a pipe, *Le Trahison des images* ('The Treason of Images' (1929)). The painting, constructed in emblematic form, with fixed and framed image and identifying *subscriptio*, raises fundamental questions about representation and reproduction. It is an emblem that challenges the very basis of emblematic meaning. Borrowed for the introductory motto for this cultural history of the avant-garde, it indicates that it will both be a cultural history (just as Magritte's image of a pipe evidently is a pipe), and will not be (just as Magritte's image of a pipe is evidently also not a pipe).

The title of this project incorporates multiple tensions that it will seek to exploit productively. If the concept of the avant-garde can be situated, then it is as a force that positions itself always on a mobile, leading edge. It is figured in radical opposition, therefore, to any stabilized sense of culture or of history. Its fundamental strategy is to scandalize culture and to keep history under radical review. In this sense, contradiction inheres in the very concept of a 'cultural history' of the avant-garde. To propose an avant-garde is to occupy a position that must be provisional, prone to be overtaken as soon as it is marked out. Its rationale is one of dialectical sublation of what is in place, a lifting or suspension of the canonical authority of tradition. This principle seems bound to extend to its own positions as soon as these are established in their turn as part of an aesthetic tradition; that is, the sublation carries the dialectical shadow meaning of the German term *Aufhebung*, preserving tradition on a different level as well as suspending it.

The avant-garde names itself after a military force that adopts a forward position in the war against the established lines of culture. It derives, in the first place, from the move in the first half of the nineteenth century towards a more engaged role for post-Romantic art. Renato Poggioli traces its coinage back to the writings of the Fourierist Gabriel-Désiré Laverdant, who sees art as adopting an initiatory function for culture at large: 'Art, the expression of society, manifests, in its highest soaring, the most advanced social tendencies, it is the forerunner and the revealer. Therefore, to know whether art worthily fulfils its proper mission as initiator, whether the artist is truly of the avant-garde, one must know where Humanity is going.'[5] For Laverdant, the campaign of cultural initiation lies in a form of revelation

that lays bare 'all the brutalities, all the filth, that are at the base of our society'. That is, in 1845, the avant-garde and its rhetoric of transcendence were in the service of social realism, while for the 'historical' avant-garde of the first decades of the twentieth century, realism was part of the encrusted old order that had to be attacked. Laverdant's vanguard is destined to become the rearguard for new initiators; in spite of their often zealous claims to the contrary, even the most far-sighted avant-gardists can never fully know 'where Humanity is going'.

The heroic rhetoric of the historical avant-garde could not extend to anticipating its own incorporation into the museological hall of fame, or indeed its revision by the new avant-gardes of the second half of the twentieth century. The cultural battle sustained by successive avant-gardes is a curiously self-reflexive one. The avant-garde is at the leading edge, taking cultural practices forward into new territory, but always by battling with that which it leads. The war being waged here has to be pictured as divided between two fronts. Culture is established both behind and in front of the artistic vanguard. To its rear is culture as tradition, and in front is new culture waiting to become traditional. Thus, culture is always ready to accommodate the aggression of the avant-garde, to canonize its works of resistance, and the avant-garde is preoccupied in spite of itself with the history that it would seek to outstrip.

The Angel of Cultural History

> There is a picture by Klee called Angelus Novus. An angel is depicted on it, who looks as though he were in the process of distancing himself from something, whilst staring at it. His eyes are wide open, his mouth gaping, and his wings spread. The angel of history must look like that. He has his countenance turned towards the past. Where a chain of events appear before *us, he* sees a single catastrophe ceaselessly piling debris upon debris and hurling it before his feet. He would gladly tarry, awaken the dead and reassemble what has been smashed. But a storm is blowing from paradise, which has become caught in his wings and is so strong that the angel can no longer close them. This storm drives him irresistibly into the future, to which he turns his back, while the pile of debris before him grows towards the heavens. That which we call progress is *this* storm.[6]

Like the angel of history, as postulated by Walter Benjamin after Klee's picture *Angelus Novus* (1920) (see plate 1), the avant-garde directs its gaze at what lies behind as it moves forward with its back

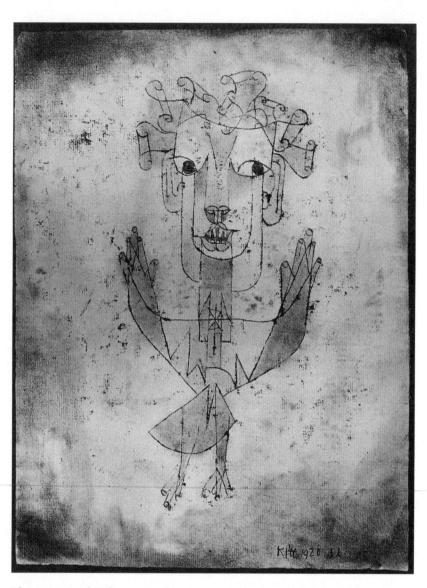

Plate 1 Paul Klee, *Angelus Novus* (1920). Collection, The Israel Museum, Jerusalem. © DACS 2004. Photograph by David Harris.

to the future. Its futurism is always disposed dialectically, set in a sort of reverse gear. Indeed Benjamin's adoption of Klee's image nicely encapsulates that double movement: an icon of modern aesthetic form comes to be read here as archetypically historical in its disposition. Benjamin, the cultural critic, historicizes the avant-garde image. He makes the modern mythical image of the new angel into an image of the dialectically viewed progression of history.

Benjamin's reading of the picture is clearly a creatively inductive one. The openness that he stresses in the representation of the angel's eyes and mouth and the unclosable wings is also indicative of an openness of signification. If it can be seen as a figure of annunciation, then the content of its message – whether joyful, melancholic, shocking or terrible – remains open. As is characteristic of many of Klee's emblematic cartoon figures from the early 1920s, the angel is represented in an emphatically static, more or less symmetrically placed, linear fashion, its barely coloured-in body tending towards the same lack of substance as the open space around it. It is without depth of field, without foreground or background perspectives, fixed in time and space. Benjamin reads the image against the grain of this fixture, energizing and extending it. He projects the angel's reverse motion into the virtual background of the image (as the space of the future), and the space between the gazes of the angel and the viewer into its virtual foreground. For the viewer this space, properly the space of the past in Benjamin's analysis, is protensive ('before *us*'), switched into a futural perspective, a successive chain of events with a forward momentum. For the angel it is a conflation of forward space ('before its feet') and the retrospective, always already past. Rather than being articulated as a chain, it is continuous and so defying any ordering differentiation. In so far as it lies before his gaze, this is to construe the catastrophe of the past as both before and behind, in a sort of future perfect tense, incorporating what will have been into this nihilistic perspective on history. The wind of historical 'progress' blows him remorselessly back into the future, projecting an ever more catastrophic heap into the virtual reality of the picture's foreground. It is perhaps worth noting a feature that Benjamin's reading overlooks: the angel's gaze is actually awry, directed obliquely rather than straight on to the conjectural debris before his feet and the viewer before that. The sort of historical analysis that it suggests is therefore one that should adopt a strategic squint in order to see the truth of what lies before it.

Klee's angel, as worked by Benjamin, corresponds to the allegory in his definition, as an image removed from its normal framework,

fitted with a textual gloss or *subscriptio*, and made to carry a special, emblematic significance. For Peter Bürger, this allegorical model (derived by Benjamin from the aesthetic conventions of the Baroque) is transferable, *mutatis mutandis*, on to the avant-garde aesthetics of montage, say in the photomontage works of John Heartfield.[7] While Klee's picture is not as such in the mode of montage, it works by mounting a strategically removed image, the old, iconic image of the angel, into a new spatial frame. Benjamin supplies the more developed montage aspect of that framing by reading the fragments of history into its virtual space. If we follow this model, then the new angel functions something like its avatars in Baroque allegory, as analysed by Benjamin in his study *Ursprung des deutschen Trauerspiels* ('Origin of German Tragic Drama'), embodying a melancholic view of the passage of things.[8] The forward propulsion of the avant-garde montage is also fixed by a melancholy sense of being overtaken by history.

Like Klee's angel, the avant-garde has a more complex relationship to history than its rhetoric of historical renewal might seem to suggest. There is no straightforward story of organic development to be told here, no coherent cultural campaign. The avant-garde moves back and forth, in fits and starts, through the sectarian engagements of its various -isms, and, even as history proceeds at an accelerated pace, and the avant-garde seeks to set that pace, the melancholic fixture of the emblematic angel is a recurrent feature right from the beginning. As we will see, this sense of historical impediment and alienation is even in evidence in Futurism, the movement that seems most unconditionally and dynamically to embrace the new technologies of the twentieth century, not least in the machinery of war. It is perhaps most explicitly present in Expressionism, which becomes polarized between the heady celebration of ideas of socio-political renewal and the profound melancholy of the alienated city-dweller and the shell-shocked war veteran. The avant-garde of the early twentieth century is at once protean in its reactions to, and attempts to lead, the course of history, and yet constantly reverting to certain fixed forms that can be subsumed under the figure of historical melancholia.

Theories and Histories of the Avant-Garde

To assume that we can call a period of avant-garde activity *the* avant-garde is to affirm a particular act of cultural reification of avant-garde energy. It is to lift the cultural experimentation of the early

twentieth century out of the mobility of a history that always has new avant-gardes, to define it as the mythical instance or archetype of that disruptive, counter-cultural phenomenon, and thereby to give it a select cultural status. Such a move might appear to mimic the special status given to the 'historical' avant-garde by Peter Bürger in his immensely influential *Theorie der Avantgarde* (1974), and thereby to assume a negative, epigonal view of what Bürger calls neo-avant-garde tendencies in postmodern culture. In fact, the legitimacy of this view has been persuasively challenged; as we will see in the epilogue, the work of Hal Foster and others provides a necessary corrective to it.[9] While any substantial discussion of the avant-gardes of the second half of the twentieth century, or indeed those that pre-date 1900, cannot be accommodated in this study, it will work in its own way, from within its designated historical parameters, against the idealizing of the 'historical' avant-garde.

This 'cultural history' of the avant-garde should be understood as a strategic rewriting of the theoretical mode of understanding that has had almost axiomatic authority since the publication of Bürger's book. The tension within the avant-garde between doctrinal theory and actual praxis transfers to that between a *post hoc* theorization of it and the historical variety that has to be accounted for by the theory. Part of what will be argued here is that there is no singular theory that can encompass the avant-garde, but that it is best understood through a negotiation of a plurality of, sometimes contradictory, *theories*.

One way to understand the avant-garde is as a continuous dialogue of accommodations and contradictions between theoretical statement and aesthetic practice. Theory is applied both a priori, especially in the form of the manifesto, and a posteriori, in the form of patterning memoirs, histories and mythologies. The manifesto, as a document of intent, is, like the avant-garde itself, radically futural in its rhetorical disposition. Yet it must also work genealogically; it is made to give account of the past and the model of previous strategic disruptions in order to establish its own break with orthodoxy. In the course of the avant-garde years, the manifesto becomes an established genre, and each new one inevitably relates as much intertextually to the generic conventions of its predecessors as to its own forward-looking agenda. It becomes an artefact of cultural history. The manifesto, in other words, manifests as much as anything else the impossible desire for anti-historical singularity of different avant-garde movements or groupings, their desire to show that they are *the* avant-garde rather than part of a modular and in many ways heterogeneous arrangement of historical motions.

In keeping with this double bind, this study will negotiate between theory (political, philosophical, psychological) and historical specificities. In the style of Benjamin's reading of the *Angelus Novus*, it will work between the allegorical figure that is taken to embody a theory of history and the gaze of that figure that has to encompass so much that is different from its own shape. Specifically, in this variation on Benjamin's reading, the allegorical angel trains its gaze on the pile of cultural historical shards left by the strategic fragmentations of the avant-garde. It conforms, that is, to Benjamin's analysis of the material process of history as an abiding negotiation between the resistant fragment and the accommodating allegory.[10] This analysis sees the allegory itself as a fragment, but one that is invested with a special relation to historical processes, reflecting upon the broader picture. The present study will privilege such allegorical constructs in its account, seeing them as exemplary of the tension between patterning and variety in the avant-garde. These constructs will include key works in all media, as well as the manifesto as a prototype that is intended to establish a pattern for the variety of work that first provokes and then follows upon it.

If the manifesto establishes a theoretical gesture in the culture of the avant-garde, it also has a bearing on the method of its subsequent reception, creating a rationale for theorization to prevail over empiricism. Largely as a result of Bürger's *Theorie der Avantgarde*, the avant-garde has both been conceived as peculiarly predisposed to theory in its historical operations and been given a privileged status of incorporation into the cultural theory of the twentieth century. Bürger's book sums up and extends a development that was inaugurated by the formative significance of the debate over the avant-garde for the German tradition of Critical Theory. Its key argument is that at the base of the heterogeneous manifestations of the avant-garde is a theoretical determination to reintegrate art as institution into the praxis of life.

While Bürger takes some care in his account of cultural history to respect the elements of 'countermovement' that undermine any neat epistemic definition, his mode of reading in the Marxist tradition has a telling blind spot in relation to a key countermovement to the ideological drive of that tradition: psychoanalysis. While Bürger's model of avant-garde praxis as anti-autonomous is focused on its opposition to the politically withdrawn art of late nineteenth-century Aestheticism, psychoanalysis represents an alternative focus for the debate over autonomy. The failure of this theory of the avant-garde to take any notice of psychoanalysis reveals that it is lodged in

the orthodox tradition that sees Marxist ideological critique and psychoanalysis as at base inimical. This is a view that would brand psychoanalytic theory as mythologizing, anti-historical, individualizing, and so dangerously autonomous in its relation to political imperatives. There is, however, another theoretical tradition, which has approached the orthodox opposition in a more open, dialectical fashion. The work of Fredric Jameson or, in a different mode, Slavoj Žižek has shown the potential for incorporating psychoanalytic modelling into the methodology of ideological critiques of culture. Given that this dialectically complicated disposition between Marx and Freud is already determinant in the work of the avant-garde (especially in Surrealism) and in the analysis of that work by early Critical Theory, not least as practised by Benjamin, it would seem necessary to reappraise its possibilities. This follows the cue of Raymond Williams in his analysis of Modernism, which was always alert to the disjunctive effects of the 'attempt to combine Marxist and Freudian motifs – so characteristic of the avant-garde in this period'.[11]

What is proposed in the current study is a theory of the avant-garde that acknowledges the relative autonomy that is implied by the psychoanalytic element in its disposition. This is the aesthetic, but not aestheticist, autonomy that is represented in the techniques of automatic production in writing and visual art and in the construction of new, psychoanalytically informed mythologies. It is, in other words, the sort of autonomy that is embodied in a figure like the protagonist of Breton's *Nadja* (1928), a form of radical subjectivity motivated by psychic drives, which is, however, co-produced by and co-produces the political radicalism of the avant-garde. An adequate theory of the avant-garde must take account of the integral role of the subject and of the unconscious in the reintegration of art into the praxis of life, as well as recognizing that the model of *Nadja* reveals the profoundly problematic character of making the unconscious practicable for life in that way.

If Benjamin, through the model of Klee's angel, figures historical progression as retrospectively fixed, or fixated, then this is because his view of cultural development is one informed by what Jameson has called 'the political unconscious'. Benjamin's project provides a model of cultural historiography that attends above all to the material produced by history or the material through which history is produced. His methodology is one of analytic observation of the architectures, the places and passages of historical behaviour, and of the objects of material culture that were placed in or moved through those spaces. This materialist cultural history is, however, guided by

a principle of rooting through the vestiges of material culture to find traces of the unconscious of history. His mode of analysis is thus informed by the model of Freud's reading of everyday life, of dreams, speech and other forms of behaviour, in order to understand why certain objects are privileged over others, why they are, in Freudian terms, subject to cathexis, to special investments of libidinal interest, and to selective acts of repression.

Material culture is a culture of objects, but one that can be read as carrying the traces of the historical subjects that produce and organize it. The photograph or film in Benjamin's 'Work of Art' essay appears to represent an objective imprint of such material scenes as streets, stations and domestic interiors, but it in fact registers an 'optical unconscious',[12] a subliminal sense of organization that accords with that of subjective behaviour and its psychic fixture. Film is seen to work explosively, to break the object world down into spatio-temporal fragments and thereby to reveal the 'unconsciously' worked spaces between them. In this sense it acts as a model apparatus for the avant-garde, its fragmentations driven by an analytic desire to expose effaced structures. But it also suggests a historiographic model for the analysis of the avant-garde, one that resists the homogenization of the big picture but, rather, fragments its object in order properly to understand its motivating structures. This is a model that, like the avant-garde, incorporates as a strategic first move what Benjamin calls the 'destructive character'.[13] It rejects the museological fetishization of cultural objects, acts of conservation that make things 'untouchable', but seeks a more dialectical mode of cultural transmission, which takes hold of situations or relations between things and breaks them down (or sees them 'destructively' in their broken state) in order to show how they work and to make room for others to supersede them. This form of destruction is partly responsible for the catastrophic pile of debris upon which Benjamin's angel's gaze is fixed, but it is a form of destruction that redirects that gaze away from the fixating fragments and on to the path 'which runs through them'.[14] The 'destructive character' is in itself nihilistic, but it shows the way and prepares the ground for other, more productive characters to work on.

This study of the relations that sustain the avant-garde and that the avant-garde sustains with mainstream culture will require something of the destructive character of cultural transmission. It will have to break down the structures of bad consciousness that characterize so much of avant-garde operations, in order to lay bare the 'unconscious' that drives those operations. If it works under the aegis

of Benjamin's latter-day angel, then it is in so far as the angel's back-ward focus sees that that history proceeds at the expense of its sub-jects, and that symptomatic traces of traumatic exclusion are to be found, and should be seen, amongst the material shards of cultural history. As Susan Buck-Morss has it, the focus of Benjamin's angel upon the 'destruction of material nature as it *has actually taken place*' works dialectically against 'the futurist myth of historical progress (which can only be sustained by forgetting what has happened)'.[15] By analogy, it can provide a check to the element of unbridled futurism which features in so much of the rhetoric and aesthetic praxis of the avant-garde, not least in the Futurism writ large of Marinetti and his followers in Italy and elsewhere. Not for nothing does Benjamin cite part of Marinetti's manifesto on the Ethiopian war in his 'Work of Art' essay as an example of the totalitarian clarity of art in the manifest service of Fascism.[16] He sees that the dialectician has a duty to co-opt and rework that rhetoric, to draw out its historical contradictions.

The method of this study, then, will follow the Benjaminian spirit of avant-garde analysis, turning the shock-tactical effect of the avant-garde back upon its objects and situations, in order to surprise out of it identities, characteristics and relationships that have been neglected or suppressed. In Benjamin's methodology, the destructive character of violent fragmentation is sublated by the 'constructive principle' of materialistic historiography. The totalized flow of history is broken, a particular monadic object immobilized, and a structural insight into history is reconstructed from it by the historian: 'He perceives it [the structure] in order to break a particular epoch out of the homo-genous course of history; thus he breaks a particular life out of the epoch, a particular work out of the life's work. The yield of his procedure consists in the fact that the life's work is conserved and sublated [*aufgehoben*] *within* the work, the epoch *within* the life's work, and *within* the epoch the whole course of history.'[17] History – here, the history of the historical avant-garde – is thus proposed as retrievable in the analysis of certain objects, but retrievable always in a way that is dialectically self-sublating, suspending as much as preserving the object in its historical relation.

Allegory and Case History

This study, then, will adopt the dialectical negotiation between Marxist and Freudian brands of materialism as a model for the theoretical

handling of a history of the avant-garde. A prime example of how an at once politically and psychoanalytically attuned version of cultural history can work is provided by Benjamin's principal object of scrutiny, the dominant avant-garde movement of Surrealism. Surrealism is a particularly telling form of avant-garde, not least because of a fundamental ambivalence in its relation to materialist models of historical understanding. Surrealism embraces a Marxist ideology that demands an orthodox approach to history as a product of the material interaction of collective interests; but it also embraces the more personalized ideology of psychoanalysis with its prioritizing of the case history over history writ large. Even as the Surrealists attempt to objectify the subjective through forms of materialist registration of the psyche – automatic writing or 'hasard objectif' ('objective chance') – the intrinsic immateriality of the unconscious remains a haunting presence, a ghost in their machine.

What the split affinity of Surrealism also shows, however, is that the supplementation of a Marxist-style critique of ideology by psychoanalytic attention to the cultural unconscious is only a first step in the dialectical analysis of the avant-garde. The reading of *Nadja*, a sort of history of Surrealism as constructed by its self-styled founding father, in the final chapter of this study will show up the tensions in this model. On the one hand, *Nadja* represents a version of the Freudian case history, and as such it is burdened by the theoretical limitations of the psychoanalytic methodology. If psychoanalysis can provide a productively resistant supplement to a Marxist reading of history, it, in its turn, requires strategic supplementation. In particular, the case of *Nadja* will show that an isolation of the object case as cultural historical paradigm in Benjamin's sense will only work if it incorporates a critique of gender politics that has to be adopted from outside the theoretical apparatus of psychoanalysis. The necessity of a feminist supplement in the theoretical handling of this 'case history' exposes a blind spot on the level of gender that is common to Surrealist avant-garde praxis and to psychoanalytic theory, and is a key constituent in their special relationship.

On the other hand, this is a text that seeks to describe a mythological embodiment of the Surrealist idea, a guiding spirit for the 'modern mythology' that the Surrealists espouse. Nadja, as a subject who resists the socialized regime of time and place, failing to meet appointments, thus also represents a wilful, mythical failure to engage with the material march of history. She corresponds, in other words, to the aspect of Benjamin's theory of history that might seem most inimical to the notion of the avant-garde, its tendency towards a

metaphysical or messianic model. Equally, and paradoxically, she embodies the sort of mystique that Benjamin sought to critique in his study of Surrealism, whilst valorizing its more politicized tendencies. The metaphysical aspects that complicate Benjamin's political theory of history from within can thus be understood as a reflection of the paradoxical disposition of his object of study. In the transcendental aspect of the angel figure we can recognize a feature not only of the painter Klee, but also of much other avant-garde production. Specifically, Nadja, as the protagonist of Surrealism, is also its visionary spirit or angel, but, like Benjamin's *Angelus Novus*, an angel with her gaze fixed upon the material damage of history. In these two senses, Nadja can be understood, like the Klee picture in Benjamin's reading, as an emblematic, guiding figure for a cultural history of the avant-garde. This is a figure that embodies intense contradictions between the idealist and the materialist, between the collective and the personal: one who seems to be able to resist the demands of the everyday, but is then brutally bound back into them; an embodiment of the collective idea of a movement who disappears into the personal world of her psyche, a place of case history where that movement cannot, or will not, follow. She carries the projections of avant-garde revolution, but also exposes its inevitable shortcomings, its failure to suspend the difference between the real and the imagined, the historical and the theoretical.

As a paradigm figure, Nadja thus exemplifies the potential for telling the cultural history of the avant-garde as a sort of 'case' history. In a study of such broad comparative scope as the present one, ranging across European culture in its diverse media over four tightly packed decades of artistic innovation, the treatment of historical specificities must be limited. Rather than assembling an overall calendar or map of historical developments, the study will take its guidance from the twin figures of Benjamin's angel and Breton's Nadja, the allegory and the case history. This involves sorting through the fragments for the figures, encounters and configurations that can serve as paradigms for the overall picture, and that therefore carry a significance that is theoretical as well as historical. As the case of Nadja shows, these paradigmatic instances are designed to show the constitutional contradictions of avant-garde praxis as much as its guiding principles. In order to achieve this, they have to be submitted to close, critical reading, both individually and in cross-reference, as they are set in relief through the methods of montage. And this reading has to be directed askance at the works in question, adopting the critical squint of Benjamin's angel.

The chapters that follow address, in turn, the principal forms of activity of the avant-garde, whilst also taking account of the subversion of conventional boundaries between forms, the intermedial and cross-generic experimentation that is one of its defining features. The second chapter, 'Manifestations: The Public Sphere', addresses the public demand that the avant-garde makes in its various forms of manifestation, from the manifesto to the exhibition, the happening, and the demonstration. This introduces a key aspect of the argument: that the avant-garde is a fundamentally performative phenomenon, defining itself through its enactments, be these pictorial, typographical or theatrical. The performativity of the avant-garde is, however, seen to be deeply ambivalent in its disposition, fixated upon problematic forms of exhibitionism. The third chapter, 'Writing the City: Urban Technology and Poetic Technique', discusses the, in many ways, troubled performance of poetic writing under the avant-garde in the shape of four epic poems of the city. The chapter considers how this poetry constructs forms of creative simultaneity between past and present times, absent and present places and figures, yet also adopts a more melancholic or abject view of the non-simultaneity of experience in the modern metropolis. In the fourth chapter, 'Modes of Performance: Film-Theatre', a prime example of avant-garde intermediality is given in the assessment of the interdependence of, and resistances between, the two key performance media of theatre and film. The tensions between the three-way demands of politics, the psyche and experimental form provide the principal focus for the framing argument and for the close reading of three canonical avant-garde films and of the lapses and accidents in their respective systems. The final chapter, 'Case Histories: Narratives of the Avant-Garde', considers the contested status of narrative under the avant-garde. It uses two particular narrative genres inherited from the nineteenth century – detective story and case history – to consider the potential and the limitations of avant-garde experimentation in narrative form, with close readings of an exemplary case of each. In this chapter, as throughout, the construction of gender and sexuality provides a central focus for the consideration of the ambivalence that is inherent in the performative project of the avant-garde.

2

Manifestations: The Public Sphere

The Manifest and the Latent

Bürger's axiom that the avant-garde is defined above all by its integration of art into life implies a move from an aestheticist form of private pleasure to an active entry into and engagement with the public sphere. Art finds new ways of coming out on to the street. Architecture and design are thus integrated on an unprecedented scale into the intermedial experimentation of the avant-garde: from the Bauhaus in Germany to Russian Cubo-Futurism and Constructivism, sculpture and stage design become templates for designs on the urban environment. The avant-garde has a message of renewal, and its medium (for which read its intermedial constructions) becomes its message, performing the core idea of active innovation. New forms of technologized urban living provide new mass modes of communication, and the avant-garde co-opts these in order to achieve its impact. Photography, film, telecommunications and the print media become models for visual and literary art and for the merging of the two in new forms of montage text and typographical image. The advertising pillar and the street kiosk serve as emblematic structures of this intervention in the public sphere. In the Cubo-Futurist oil and collage by Kasimir Malevich, *Dama u afishnogo stolba* ('Woman Beside an Advertisement Pillar' (1914)), the body is constructed into the new media through the physical act of reading text and image on the street. And in Herbert Bayer's Bauhaus *Zeitungskiosk* ('Newspaper Kiosk' (1924)), the kiosk becomes a multi-media construction (with newspaper cuttings, neon lighting and painted planes in the manner of De Stijl), serving to make all aspects of modern life manifest to the

'man on the street'. The man in question is represented here as a cut-out figure in old-fashioned bourgeois garb, suspended next to the kiosk with his back turned to it, an ironic image of the denial of the new used as a device to provide human scale. The merging of the body with the pillar in the first image and the turning of the back of the unreconstructed bourgeois on the kiosk in the second indicate the potential of, and the resistance to, the new forms of art as advertisement.

It is this act of making manifest that is perhaps the defining gesture of the avant-garde, and its defining form is that of the manifesto, designed like the advertisement pillar and the kiosk to be seen, heard and read in public, and to incorporate radical reader-listeners and repel the conservative. In the historical avant-garde, the theoretical statement of intent achieves a status and a dynamic such as it never had before or has had since. The history of the avant-garde is often told through the inaugurating moments (frequently plural or serial) of the various movements, which are marked by their theoretical principles being publicly broadcast or going to press as manifestos. The avant-gardists may not have been more theoretically inclined on the whole than any other groups in cultural history, but they pinned the idea of radical theory to their mast, by using it as their most high-profile and media-efficient means of entry into the public sphere.

The manifesto is derived, of course, from the political sphere, here appropriated for a politicized idea of the avant-garde as radical faction. It is a textual act of public showing, a making manifest of a challenge to historical conventions, and as such it tends towards the mode of spectacle. The terms 'manifesto' and 'manifestation' are rooted in the idea of the hand (Latin *manus*), always suggesting a form of deictic display that is both handled by the showing subject and made palpable to the viewing subject. In the context of the avant-garde, this material aspect, the gesture of showing as handing over, is all-important as a framework for a more material understanding of the function of art. A key part of the gesture is that the material offering should be manifest in the theoretical statement, implying that the manifesto is to be read as already going some way towards fulfilling its promise. The manifesto, in other words, demands to be read as a cultural object of communication. It is materially committed to a project of change, at once exemplifying in its own right a new mode of production and acting performatively, in the sense that speech act theory gives to that term, bringing about the state of affairs that it describes. The manifesto acts in this performative sense as a gesture of investiture, a dynamic act of address that calls the

reader/spectator into an avant-garde form of reception, conceived as a process of reciprocal activity. It is an opening interpellation, to cover all that follows, of the politicized recipient who has been handed and shown the manifesto. The manifesto thus has a tendency to transcend the idea of the individual work as an integral object, setting it within a structure of organized showing. Hence the legitimacy of Bürger's strategy to relativize the artwork as part of a process: 'Instead of speaking of the avant-gardiste work, we will speak of avant-gardiste manifestation.'[1] When invitations were issued for the 1917 *première* of Apollinaire's play *Les Mamelles de Tirésias* ('The Breasts of Tiresias'), it was advertised as a 'MANIFESTATION SIC', and this merging of the work of art as hitherto understood with manifesto and demonstration is all-important for the aspirations of the avant-garde at large.

The manifesto is programmatic in the sense that it pre-programmes techniques of reading, above all converting reading as an act of private, contemplative reception, as steady and regularized as the lines on the page, into an active form of viewing that is demonstrative and public – a form, that is, of textual spectacle. Thus the 'text' of the manifesto is rarely discursive, tending instead towards the notational and imitating the formats of the mass media, of newspaper headlines, telegraphic messages and placards (in Italian, *manifesto* also means poster). It adopts forms of typographical experiment that disorient and reorganize the conventional act of reading. It is writ large in its format, and designed to make manifest articles of faith and a strategic programme of work. But the manifest form, precisely in so far as it is notational, is also indexical, gesturing towards a latent level of meaning that has yet to be made fully manifest. It is, in other words, a type of blueprint, an outline design for what is to come.

While the manifesto, anything but cryptic in its model form, is designed to point directly at the latent potential of the movement in question, indeed, to initiate what it headlines, it may also be read in a less straightforward fashion. At its limit, this implies that the manifesto can be considered to be the dream text of the avant-garde. This is to shift the avant-garde genre of the manifesto out of its putative political framework into a more subversive psychoanalytic one. According to the model of Freud's *The Interpretation of Dreams*, the manifest level of the dream, or its content, encodes the latent level, or its thoughts. As prescribed by Freud, the dream is a wishful production, but its true wishes are generally disguised by the formal distortion of its appearance. To adopt this model would be to imply a reading of the manifesto text against its programmatic grain, in order

to establish what it really desires, and this is what is proposed in what follows.

Futurism

The inaugural case of the avant-garde manifesto is generally held to be the famous publication of Marinetti's 'Manifesto of Futurism' in *Le Figaro* in 1909, which, together with the first showing of Picasso's *Demoiselles d'Avignon*, has also established itself as the original public act for the European avant-garde at large. This document, inserted into the public sphere through the most conventional of media vehicles, at once sets out a specific agenda for the radical experimentation of Italian Futurism and signals a general principle of futurism for the avant-garde as a whole.[2] The manifesto form is, in other words, designed to be futuristic in its disposition and rhetoric, a form of news that is tomorrow's, categorically in advance of the events that the newspaper routinely reports (the manifesto ironically shares the front page with a report on the investiture of an academician).

This 'arche-manifesto' is a curious hybrid, however. Its proclamation of revolutionary new practices to come is set within a framing narrative that is retrospective, indeed nostalgic in mood. While Marinetti figures himself and his writing cohorts in proper avant-garde style as 'proud beacons or forward sentries against an army of hostile stars',[3] their electric vitality is surrounded by more passéist trappings: mosque lamps and oriental rugs. Marinetti's new form of aesthetic Imperialism, driven by what John J. White has called the 'colonizing intent' of the Futurists,[4] is also dressed in the stuff of the old empires. The attempts at machine-driven forward momentum in the narrative are recurrently pulled back into more atavistic territory inhabited by spectres, sickness and prayers. In particular, it transports the writer back to 'the maternal ditch' and the colonial breast of his Sudanese wet nurse.[5] This primal attachment to maternal figures casts a distinctly Oedipal light on the demonstrative misogyny of the phallocentrically inclined manifesto. The manifestly futural programme is mediated by a sort of dream-text in the psychoanalytic style, laden with a sense of the past that can be said to function as its latent meaning. It tends to displace the futuristic claims of Marinetti's manifesto into a sort of future perfect, describing what, in due course, will have been. On the one hand, this is designed to lend the manifesto a lived sense of authority and to show the sort of texts that are programmatically intended; on the other, it performs the sort of

contortion that Benjamin describes in the fixation of Klee's angel, twisting the perspective into reverse. While Marinetti's narrative proclaims the demise of mythology and mysticism, it also looks to their new birth, and specifically the 'first flight of Angels'.[6] But these avatars of the *Angelus Novus* are virtual, only about to be seen. The styling of the prospective origin of the new age as a positive act of energetic recycling is threatened by a more empty form of circularity. While the narrator's racing car hurls aside the watch-dogs of the old bourgeois order, flattening and curling them like collars, the figurative collars curl back in the shape of the car going into a spin like 'a dog trying to bite its tail'.[7] The emblematic vehicle thus describes the sorts of curves and spirals that are anathema to the rectilinear aesthetic thrust of the Futurist programme.[8]

The narrator recovers his thrusting shark-car from the 'maternal ditch', and launches the manifesto proper with it; but the rebirth remains ambivalent in its representation. When the racing car is re-cycled as the martial vehicle of the 'new beauty' in the fourth propo-sition of the manifesto, the impeded motorization of the framework narrative is latently at work. Standing on 'the last promontory of the centuries', the narrator asks, 'Why should we look back?', and thereby invokes the inevitable backward look on to history,[9] just as the war-like hymn to the racing car can only be achieved by comparison with the Classical image of war in the *Victory of Samothrace*. The mani-festo is inevitably drawn to look back at the works in the museums it excoriates, returning in spite of itself to 'leave a floral tribute beneath the *Gioconda*'.[10] The 'young and strong *Futurists*' who want no part in the past have to place strategic parts of it in their manifesto state-ment. If they advocate flooding the museums and burning the librar-ies, it seems that the iconoclasts would salvage some works in spite of themselves. While they profess themselves ready to go the same way in their turn, when the next incendiary generation supersedes them, it is in the image of the dog, a displaced form of the same old-order dogs that they ran over in the opening narrative, that the next generation is represented. Like the dog that digs up the bones in the first section of Eliot's *The Waste Land*, this one marks the recycling of the morbidity that ran through the rebirthing narrative that preceded the manifesto.

The cult of Futuristic youth, sweeping all before it with its innovatory violence, has a compulsive death-drive as its counterpart, constructing fantasies of the death of the author. The logic of the text is recursive rather than protensive, circling back once more at its end, and so making a mockery of its futural propulsion, as the Futurists

hurl defiance once more at the stars that compulsively draw them back from their electric trajectory. The return of a repressed attachment to history, which is the latent content of the framing narrative, must be registered only to be denied in the radical ambivalence of the confessional mode of the text's penultimate section, which finishes with a violent block to the 'analytic' voice that might expose the latency: 'Our fine deceitful intelligence tells us that we are the revival and extension of our ancestors – Perhaps! . . . If only it were so! – But who cares? We don't want to understand! . . . Woe to anyone who says those infamous words to us again!'[11]

The founding manifesto of Futurism establishes a hybridity of purpose and style that will characterize much Futurist writing and visual art: a combination of technophilia and primal landscape, anti-grammatical anarchism and formal convention, raw compression and self-indulgent dilation, populism and elitism. The compulsive return to past scenes and motifs within the manifesto's structure is repeated in the resumptive patterns of the series of Futurist manifestos that follows it. In the 'Manifesto dei pittori futuristi' ('Manifesto of the Futurist Painters') of 1910, the dynamic of future intent is overwhelmed by an obsessive invocation of the past that the painters would do away with. If Italy is 'a land of the dead, a vast Pompeii, white with sepulchres',[12] then it seems that the new breed of Italian artists who seek to proclaim its rebirth are as morbidly attached to the spectral past as is the protagonist of Jensen's *Gradiva* in Freud's reading of that text. The national archaeology corresponds to the individual case histories of the protagonists of Futurism, a sense of the irremediable Oedipal burden of the Classical academic tradition. As with Marinetti, the painters' attack on academic and museological traditions is tempered by an attachment to old masters, as they rebel not against the works of Rembrandt, Goya and Rodin, but against the critical discourse of aesthetic good taste that they, paradoxically, accuse of a paradoxical iconoclasm in its sanitization of past works. In spite of the closing call to bury the dead and sweep the threshold of the future free of mummies, here, too, the spirits of the dead remain unexorcized. The dynamic thrust of the Futurist rallying cry to make room 'for youth, for violence, for daring!' is held up by the sense of a threshold that is still mummified.[13]

While the Futurists' manifest intention is to follow the impulsion of the force-line (as propounded in the catalogue for their Paris exhibition at the Galerie Bernheim-Jeune in 1912), in their photodynamic interpretations of both human and inanimate figures, their rhetoric of movement in the simultaneous image is shadowed by a latent

sense of the 'grave melancholy' that characterizes the conventional styling of the still human form.[14] The impossibility of the project of '*physical transcendentalism*',[15] of representing movement into the future in a still image, strikes the dynamic intentions of the Futurist picture or sculpture with an inevitable sense of fixture at the threshold to the movement in question. The photodynamic image is like the mummified figure frozen in the desperate move to escape Pompeii, or like the melancholic pinning of the *Angelus Novus*, where the supposed figure of impulsion into the future is held up with its gaze fixed on the past. Where the Futurist painter seeks to represent the dynamic forces imputed to the material world, as in Boccioni's *Materia* ('Matter') of 1912, the force field of fractured pictorial planes is organized around a monumentally static human figure, embodying the matter in question. The picture bears the conventional iconographic hallmarks of the academic tradition of allegorical portraiture, and the frozen face, fixed gaze and clasped hands of the allegorical figure lend a melancholic aspect to what might be expected to be a celebration of material energy.

In his readings of Futurist text-image experimentation, John J. White employs a semiotic analysis based on the terms developed by Peirce, suggesting that the various forms of pictographic representation combine iconic and symbolic levels of meaning.[16] He points out that Kaja Silverman aligns these two semiotic modes with the 'thing-presentation' and 'word-presentation' of Freudian theory. In pictographs the two modes tend to be coterminous, as in the rebus structures of Freud's *The Interpretation of Dreams*, while in the more conventional disposition of pictorial work and linguistic title, they are juxtaposed. White brackets out of his analysis here the third mode in Peirce's triadic system, the indexical. While the iconic is a representation based on the image of the thing (White suggests that the force-lines of Futurism are an extension of the iconic in this sense), and the symbolic is one based on the arbitrary sign attached to the thing, the indexical is a semiotic element that is, as White states, resultative (smoke for fire) or symptomatic. If the indexical level of signification is indeed at work in the Futurist aesthetic, then it is as a subversive factor. While Futurism devotes its violent energies to the achievement of results (implying an incorporation of future impact into its representations of present conditions), what emerges is symptomatic in a more problematic sense. The aesthetic of the machine man is indicative of the yearning of flesh-and-blood humanity for a more dynamic state of matter, but the disavowed melancholic attachment to old pictures and primal scenes (the *Gioconda* and the wet nurse's

breast) is part of a more symptomatic mode of indexical semiotics in the psychoanalytic sense: signs that the manifest word- and thing-presentations are disturbed by a latent level of contradictory organization, one driven by unconscious desires. The futurity of the movement is, in other words, tied back into the past, into the faculty of memory, which, as Severini in his manifesto of 1913, 'L'analogie plastiche del dinamismo' ('The Plastic Analogies of Dynamism') avers, is the 'sole *raison d'être* of an artistic creation'.[17]

In his reading of Carrà's *Manifestazione Interventista* ('Interventionist Demonstration'), also known as *Festa Patriottica* (1914), (see plate 2), White discusses the radical uncertainties that are produced by the 'free-word picture' that styles itself in the most direct of future-focused language.[18] Here the 'free' use of word images opens up a flexibility of interpretation that confounds any straightforward political function for the work. White traces the debate over whether the intervention in question is a past event recorded retrospectively or a clarion call for a future manifestation – that is, whether the image is one of memory or one of anticipation and initiation. The 'free words' in this collage are, of course, not free. They are textual fragments of past works, a network of back-references that scholars have duly tracked down, provoking a variety of interpretations. On the symbolic level, the collage incorporates the language of Futurist radicalism and the Italian flags, caught in what appears to be a sema-phore position. On the iconic level, it has been read as signifying the irradiation of an electric sun or the spinning propeller of the Futurist aircraft. If it is indeed to be read as the latter, then it nicely encapsulates the impossibility of a cut-and-paste aesthetics of dynamism: when the propeller spins at speed, it comes to be perceived as a still circle, so that the vision of propulsion becomes fixed in line with the static representational possibilities of the collage. White questions whether the 'TOT' in the upper right section of the picture is to be read as dead in German, as some commentators have suggested. If it is, how-ever, then it seems to function as a block to the circulating 'vivas' of the collage. It emblematically introduces death into the drive of futurist vitalism; death to the Austrians in their own tongue, perhaps, or death as an inevitable element in the clamour for war, but also death in and of the picture itself, its inevitable rigor mortis in relation to what it would render manifest. This would be to suggest that the 'Manifestazione' – the pictorial manifestation of the political voices of the mass manifestation – is struck by the same latent melancholy as the manifesto; whether retrospective or prospective, it can only represent its intervention as fixture, never as futuristically propelled happening.

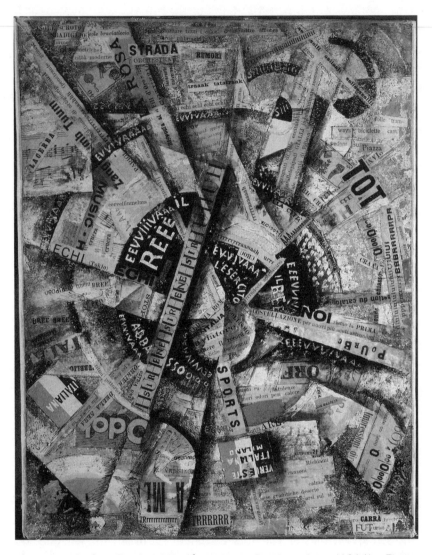

Plate 2 Carlo Carrà, *Manifestazione Interventista* (1914). Peggy Guggenheim Collection, Venice. © DACS 2004. Photograph © 2002 The Gianni Mattioli Collection.

The manifesto proper, and its secondary incorporation into the interventionist 'manifestations' of the works of Futurism, thus obliquely shows that the 'wireless imagination' or 'imagination without strings' of the Futurists does indeed have strings attached.

It is perhaps not surprising that the love of the new expressed in Marinetti's 1913 pamphlet, 'Distruzione della sintassi – Immaginazione senza fili – Parole in libertà' ('Destruction of Syntax – Imagination without Strings – Words in Freedom'), has 'dread' of the old as its counterpart.[19] It is the dread of the *revenant*; it feels its object creeping up on it and must resort to apotropaic forms of rhetoric to ward it off. Marinetti goes on to acknowledge the contradiction that the founding manifesto sought to deny, that the vitalism of the new aesthetic is dialectically bound up with intensified morbidity: 'Since poetry is in truth only a superior, more concentrated and intense life than what we live from day to day, like the latter it is composed of hyper-alive elements and moribund elements.'[20] That is to say, the eroticized drive for life is also a death-drive, and the rhetoric of liberty from the mortification of the past a compensation for its inevitable return.

Anti-Futurisms

If the Futurist manifestos develop a degree of awareness of what was always, from the beginning, latent in their rhetorical organization, they also prompt reaction from the manifestos of other movements. The manifesto, as public proclamation of the movement's dogma, provokes responses of solidarity, rivalry or mockery. Marinetti's arch-manifesto creates a template form for what follows, one that, however, in avant-garde spirit, must be superseded in the new forms that it provokes. The battle with the old order is soon diverted into a battle between versions of the new. Thus, the proclaimed singularity of Futurism breaks down in the contest between Italian Futurism and Russian Cubo-Futurism. Marinetti meets his putative kindred spirits in Russia as an evangelizing exporter of his Imperialistic new order, but finds only ' "pseudo-futurists" who live in *plusquamperfectum* rather than in *futurum*',[21] while Kruchenykh and Khlebnikov lambast the self-styled master warriors of Italian Futurism for wielding the false weapons of the manifesto without the true metal of art.[22]

The new rhetoric of machinism is quick to seize up, like the putative propeller of Carrà's *Manifestazione*. As the Futurists put their machinist aesthetic at the service of military intervention, the mass carnage of the First World War created a picture of death with no room for nationalistic vitalization. Manifestos written by other avant-garde groups in the course of, or after, the war treat the clarion call of Futurism with varying degrees of derision, and the manifesto genre

at large with a new sobriety or irony of tone. The sense of what 'will have been', of the inevitable overhauling of events and actions, present and future, is more openly built into the rhetorical structure of the genre. Thus Amy Lowell, on behalf of the Imagists, adopts a more circumspect, ironically inflected language of passion when she proclaims the transitory character of the Futurist cult object, and so of a brand of avant-garde aesthetics that does not have the vision or the invention to remain at the cutting edge: 'We believe passionately in the artistic value of modern life, but we wish to point out that there is nothing so uninspiring or so old-fashioned as an aeroplane of the year 1911.'[23] When Flint acknowledges that 'Imagism' is not a 'movement', he recognizes both the looseness of the affiliations between members of the putative group, who cannot be marshalled into concerted motion, and its resistance in its works to the cult of mobility.[24]

Pound's well-known poem 'In a Station of the Metro' is characteristic of this resistance. The poet's vision is turned away from the technological framework of the modern urban experience and on to an imagistic metaphor for the passing 'apparition' of the crowding faces (petals fallen but stuck to a tree), appealing to a timeless, iconic quality.[25] His concern here is with the *station* as a holding-place on the transport network. In his negative version of a manifesto in the style of a training manual for aspirant poets, 'A Few Don'ts By An Imagiste', Pound counters the Futurists' machine-driven rhetoric of liberty through the material mastering of space and time with a more metaphysical claim to 'freedom from time limits and space limits' in the 'intellectual and emotional complex' of the poetically fixed moment of the image.[26]

When Pound the Imagist gravitates to the group of poets and visual artists around Wyndham Lewis and coins the term 'Vorticism' for them, he maintains something of the poetic fixity of his earlier affiliation. The vortex is conceived as what Pound calls 'the point of maximum energy',[27] but this point is one of latent rather than manifest dynamics: Pound's poetry or Wyndham Lewis's technographic compositions represent the more or less still centre of the abundant energies of modern existence. To cite the title of one of Lewis's pictures, Vorticism mounts a 'Slow Attack', rather than an ostentatiously high-speed one. The Vorticists thus create a hybrid between the static plane and line designs of Cubism, the extrovert personal appeals of Expressionism, and the technological dynamics of Futurism. The Vorticist manifestos, published in 1914 in the first number of *BLAST*, a 'Review of the Great English Vortex' edited by Lewis, seek to establish originality of purpose and praxis for an

Anglo-Saxon avant-garde in the wake of those pioneering Continental formations. They stand under the shadow, in particular, of the production line that began with the publication of Marinetti's foundational manifesto of Futurism. Marinetti, who stood by at the birth of Vorticism, is a constant ambivalent presence in the two numbers of *BLAST*, his 'Automobilism' held up as a false fixing of machinery in a sort of fetishistic cult. When Lewis lambasts him, under the heading 'The Melodrama of Modernity', for hammering away 'in the blatant mechanism of his Manifestos, at his idée fixe of Modernity',[28] he registers a threat that also hangs over his own anti-Futurist version of Futurism. Vorticism seeks to outmanoeuvre this danger of becoming fixed in the workings of the machine age and playing a part in its melodrama. The second number of *BLAST*, published in 1915 after the advent of the war and the death in the trenches of the leading Vorticist artist, Henri Gaudier-Brzeska, observes that the mass destruction of the machinery of war leaves no space for the 'booming and banging' of Marinetti's literary artillery, and finds a 'Passèist [sic] Pathos' in the thought.[29]

BLAST thus has a highly developed sense of the ironies of the avant-garde, but it is caught up in ironic counterblasts of its own. The manifestos are organized around an apparently apodictic binary logic, listing with outspoken typography the people, the institutions and the characteristics that it would respectively BLAST and BLESS.[30] Inevitably, however, the scheme breaks down into a more dialectically complicated picture; the English and the French become confused, and the blest are found on the side of the blasted. The second manifesto recognizes this procedure of starting from 'opposite statements' in a 'violent structure of adolescent clearness between two extremes', only to 'discharge ourselves on both sides'.[31] Thus the rhetoric of muscular masculinity is subverted by the internalization of gender difference in the description of the English climate as a

DISMAL SYMBOL, SET round our bodies,
 of effeminate lout within.[32]

And English humour is at once blasted in the figure of the fixed grin as 'Death's Head symbol of Anti-Life' and blessed as an 'hysterical WALL built round the EGO'.[33] On either side of the divide it seems to stand as an emblem of the dilemma of these manifestos cast between programmatic earnest and ironic mockery. The humour of Vorticism is haunted by a twin structure of blessing and blasting, by hysteria as symptomatic of the need to immure its individual

character from outside influence and by morbidity as represented by the grin of the skull, a *memento mori* for its will to life.

BLAST protests its originality, its presence and its vitality at every turn, but it is also turned back towards a more morbid sense of the hold of the past, necessary, as Lewis argues, 'to sponge up and absorb our melancholy'.[34] Not for nothing do both numbers of the journal incorporate death notices, for Frederick Spencer Gore and for Gaudier-Brzeska. Futurism may be, according to Pound, one of the 'CORPSES of VORTICES' and Marinetti himself 'a corpse',[35] but the Vorticist organ is also, as it were, cast in the death mask of Futurism. If Marinetti is indeed, as Lewis recognizes, 'irrepressible',[36] then he also defies repression in the project of Vorticism, coming back upon it as a *revenant* figure.

When Pound proclaims that 'The vorticist relies not upon similarity or analogy, not upon likeness or mimcry [sic]',[37] he seeks to deny the strain of mimicry, not least the miming of Futurism, which runs throughout the journal. The misspelling of 'mimicry' may be seen as symptomatic of the performance of Vorticism. A performative statement of avant-garde activism such as *BLAST*, enacting the new poetics and iconography of Vorticism, cannot afford to make mistakes, and yet amongst the first things encountered by the reader of the first number of *BLAST* is a sheet of errata, corrections to the vortex. The first of these relates to Lewis's play *Enemy of the Stars*, where 'MINES' in 'CHARACTERS TAKING UP THEIR PLACES AT OPENING OF SHAFT LEADING DOWN TO MINES QUARTERS' is to be replaced by 'MIMES'.[38] The correction appears to be symptomatic in substituting figures of mimicry for sites of industrial work, acting for action.

This shift from the 'real' world of work to the world of theatre raises more extensive questions about the political import of the Vorticist manifesto and other programmatic works. One of the things that Vorticism does indeed mimic, at least in part, in Futurism is its readiness to embrace forms of proto-Fascist cultural politics. The manifestos propose ruthless aesthetic individualism, drawing upon and controlling the unconscious energies of the popular herd, and Pound's contributions to the journal invoke the vocabulary of eugenics and anti-Semitism. While not all Vorticists or all of Vorticism can be called proto-Fascist, any more than all Futurists or all of Futurism, Lewis and Pound, for all their anti-Futurist rhetoric certainly share this aspect of what Lewis calls 'Marinetteism'.[39] Whether this is to be understood as a language of performance, of theatrical manifestation, rather than one making claims on political reality, must

remain something of a moot point.[40] What is clear is that this wing of avant-garde acting and action is as susceptible to the ideology of the Right as that of the Surrealists and others is to the ideology of the Left.

DADAism

While Futurism, Imagism and Vorticism manifest their overt intentions in their names, DADA is designed to confound such conventions. Perhaps more than any other of the avant-garde movements, DADA cultivates mobility and resistance rather than absorption in a group identity and location. In the course of the ten years or so of its existence, it migrates from Zurich to Paris, with factions moving via Berlin and New York. Its members congregate and collaborate noisily, but they also resist any real sense of communal purpose, and are prone to go their own separate ways. In Breton's famous formulation from his 'Géographie Dada' manifesto, DADA is neither a school of art like Cubism nor a political movement like Futurism, but 'a state of mind',[41] a 'state' though that resists hypostasis, keeping on the move geographically and historically. Any attempt to establish a coherent aesthetic code or programme and so pin down that state of mind is anathema to DADA. Under the slogan 'Art is shit', it revels in the anarchic pleasures of events and impulses in flux, defying acts of aesthetic legislation. The successive manifestos that were performed at DADA demonstrations and evenings are thus designed to be model acts of performance, theatrical speech acts, rather than legislative texts.

As set out by Tristan Tzara in his 'manifeste de monsieur antipyrine' ('Monsieur Antipyrine's Manifesto') of 1916,[42] DADA manifests itself as denunciation, a denunciation not least of a bourgeois order that has been driven by its pursuit of industrial capitalism into its own spectacular self-annihilation in the war. DADA denounces both the orthodox cultural order and the dogma of other avant-garde movements, not least the false satisfactions of the Futurist motor car. But the denunciation is also self-reflexively turned on its own postures. It rejects the essentialist claims of the Futurist manifestos by proclaiming its own mortality and setting itself against the future, and yet its claim that it is 'definitely against the future' runs on from the declaration that it is 'against and for unity',[43] suggesting that the second negation may also be paired with an affirmation. Any unified position has to be liable to splitting in this fashion. DADA sees the dogma in its anti-dogmatism, and, while it cries freedom like the

Futurists, it insists that that freedom is false. And if it counters the warlike nationalism of the Futurists with an internationalist spirit, it is one that revels in its desecration of all nations: 'DADA remains within the European framework of weaknesses, it's still shit, but we want henceforth to shit in various colours so as to adorn the zoo of art with all the flags of all the consulates.'[44] The founding gesture is at once of self-assertion in proper manifesto style and of self-negation, denying that it is materially different from culture at large and yet exposing that material for the shit they see it as and recycling it for the production of a new (anti-)aesthetic spectacle. DADA produces itself and takes itself away, resists its utilization, in the selfsame gesture.

Tzara's 'manifeste dada' of 1918 mocks the 'bacteriological' attempts of critics to invest the name of the movement with dictionary meanings, especially those revolving around primitivism or infantilism.[45] DADA takes its name from the page that presented itself when Tzara, Arp and Huelsenbeck opened a dictionary at random, on a random day in 1916. They take the dictionary as a model form of classificatory order and use it in a way that contravenes all the rules. This is a cultural bacterium that defies classification, continuously mutating into new strains. DADA is neither a piece of Futurist onomatopoeia nor a dictionary entry (its preferred, upper-case typography underlines its status as a non-word in dictionary terms). It is meant to be throw-away in its significance, a 'mark of abstraction' from conventional systems of meaning.[46] This resistance to categories includes its own insertion into the system of the manifesto. DADA is against manifestos and so writes one, and it wears this contradiction perversely on its sleeve. It takes the manual gesture of showing that is integral to the manifesto genre and points it up self-reflexively by incorporating a stylized pointing hand on the page, a deictic device also used in various other DADAist image-texts. This is a form of *manifestation* that denies itself, a cipher of the bodily performance that is so fundamental to DADA that is introduced into the textual frame in order to show that: 'DADA DOES NOT MEAN ANYTHING'.[47]

The 1918 manifesto thus operates as an anti-manifesto, exposing and mocking the conventions of the form as such, and in particular the double standards of the 'cubist and futurist academies'.[48] The Futurists are depicted as representing material objects, say a photodynamic cup, as 'embellished by a few force-lines',[49] rather than as genuinely electrifying. The primal dynamics of matter are exposed as the classificatory stuff of a style manual. DADA counters this

neo-academicism by seeking to keep itself continuously under review. Matter is represented here in the recurrent language of scatology, as waste and passage, shit, piss, vomit and spit, in forms that are inimical to fixture in established categories of form, subverting social and aesthetic conventions of continence. The DADAist manifesto thus takes its cue from one of the inaugural provocations of the avant-garde, the word 'merdre' that opens Alfred Jarry's play *Ubu roi* ('King Ubu' (1896)) as a performative call to a theatre of indiscriminate shitting and that prompted a riot at its *première*. In the 1918 manifesto, language as aesthetic medium is incorporated into this excremental condition, challenging readers to see whether they can do anything with it, whether they can find any sort of recipe or blueprint in the excretions of the anti-manifesto.

Two sorts of reading are challenged in particular: the dialectical and the psychoanalytic. DADA seeks pre-emptively to foreclose the sorts of recuperation of systematic meaning that these forms of interpretation might yet be able to impose upon it. It wants to establish contradictions so categorical that dialectics cannot negotiate and so classify them: 'The way people have of looking hurriedly at things from the other point of view, so as to impose their opinions indirectly, is called dialectic, in other words, heads I win and tails you lose, all staged with a show of method.'[50] And it defies psychoanalysis to do what no other interpretative system would stoop to – that is, even to incorporate all the bodily waste that DADA displays into a classificatory order, to make its scatological cult of disgust mean something. It presents itself as the unclassifiable cultural disease and pre-empts any diagnosis by what it brands as a disease pretending to be a cure: 'Psychoanalysis is a dangerous disease, it deadens man's anti-real inclinations and systematizes the bourgeoisie.'[51] In its very name, DADA, a crude repetition designed to be meaningless, it presents a block to dialectical methods, and not least to the dialectics of psychoanalysis, as embraced by Breton and Aragon under the entry for 'Dialectics' in their *Dictionnaire abrégé du surréalisme* ('Abridged Dictionary of Surrealism' (1938)).[52]

What, however, if we extend the logic of acute ambivalence, of being for and against, to this issue? As the 1918 manifesto avers, 'The contradiction and unity of opposed poles at the same time may be true.'[53] Even if the manifesto explicitly excludes psychoanalysis from its reckoning, we may ask the question whether DADA may incorporate something of that opposed force in spite of itself. Perhaps this movement, which appears to be so manifestly frank in what it says, is also attended by a latent counter-position. If, contrary to its

declared intentions and in line with the imputations of its early com-
mentators, DADA does really mean something, then its significance
might indeed be found in the nursery figures those commentators
identify, as mockingly cited by Tzara: 'The word for a cube, and a
mother, in a certain region of Italy: DADA. A hobby-horse, a chil-
dren's nurse, a double affirmative in Russian and Rumanian: DADA.'[54]
The double affirmative is, as it were, the counterpart to the double
negation of dialectics and psychoanalysis in the manifesto. It runs
counter to the anti-dogmatic 'for and against' element in the rhetoric
of DADA, and so seems ready to flip over into its own contradiction.
This is the form of strategic non-sense to which Tzara brazenly lays
claim in the 1918 manifesto: 'as for continual contradiction, and
affirmation too, I am neither for nor against, and I won't explain
myself because I detest good sense.'[55] According to this resistance to
any Manichaean system of meaning, to be for and against is also to
be neither for nor against; to affirm is also to contradict, and vice versa.

In spite of Tzara's disclaimer, it seems worthwhile, then, to look
for some psychoanalytic sense in the manifesto, in case it may be
affirmed after all. In particular, the dada that is a mother or nurse
figure can be understood as rooting DADA in maternal terrain in a
way similar to Marinetti's manifesto fantasy. Here, the hobby-horse
would be the toy that works by a rhythmic to-and-fro, a figure of
repetition in infantile play. Which is to say that DADA can be under-
stood as a variation on the game of 'fort-da', which Freud formu-
lated in his *Beyond the Pleasure Principle* (1920). For Freud, the
child, deprived of his mother, plays a game with a toy as substitute
object, casting a cotton-reel to and fro in order to gain a measure of
control over loss and accompanying this by primal sounds approxim-
ating to *fort* ('gone') and *da* ('there'). While the Freudian 'fort-da'
represents the imbrication of erotic and death-drives, 'DADA' (whether
conceived as mother, nurse or toy) is a linguistic structure that re-
affirms its own identity and the identity of that which it represents,
asserting and reasserting presence. For psychoanalysis, this affirmat-
ive self-duplication makes a false claim; it is the stuff of infantile
fantasies of omnipotence, fantasies that have to be broken down into
the more dialectical rhythms of the 'fort-da', which Freud, indeed,
construes as the rules of the game for artistic creation as well as
child's play. A psychoanalytic reading of DADA would also want
to ask whether the double affirmative actually glosses over an
ambivalent attachment to the absent or negative term, and whether
psychoanalysis, itself represented as negated and rejected in the
manifesto, is in fact a disavowed, latent presence in its construction.

This hypothesis would in its turn be linked to the omission in the list of meanings attributed to 'dada', and in a sense the most obvious, the call for the father.[56] What more ambivalently invested father figure could there be for DADA than the father of psychoanalysis who has an answer for every provocation? It may be an integral part of the painful 'interweaving of contraries and of all contradictions' that underpins the Liberty proclaimed at the end of the manifesto, thus recalling the confession from the 'manifeste de monsieur antipyrine', that 'we cry liberty but are not free'.[57] To which proposition the unwilling analysand might well say 'Nonsense', or shout 'DADA', an act of echolalia that may be an affirmation, a child's needy cry, or a denial.[58]

Surrealism

If psychoanalytic potential may be projected to be a disavowed part of the contradictory structure of DADA, it is more evidently part of the double life of the movement that derives its initial energies from DADA in its Parisian phase: Surrealism. Surrealism resists the more positivistic, demystifying side of the Freudian project, but it also recognizes the productive power that psychoanalysis puts at the disposal of art. If Tzara and Breton, the self-appointed spokesmen of DADA and Surrealism, could not agree on the Freudian question, then this is symptomatic of the more general difference that led to the establishment of the latter and the demise of the former. While Tzara satirically describes the Cubist and Futurist styles of representing a cup, implying that the DADA cup, which we might for instance imagine as a ready-made in the Duchamp style, would be free from any such formulaic treatment, the Surrealist version would never content itself with the installation of a found cup as anti-aesthetic object. It aims at more transformative types of provocation with mundane materials. It subjects objects like cups to dreamlike distortions (Dalí) or clads them in fur and so invests the everyday object with the subjectively motivated power of the fetish (as in Meret Oppenheim's famous *Déjeuner en fourrure* ('Breakfast in Fur' (1936)). Where DADA resists consumption, Surrealism transforms it in order to play with its pleasures and unpleasures; the cup in furs, which resists being used for drinking, may afford other, more subliminal and more ambivalent forms of satisfaction.

The Surrealists look beyond the technophilia of the Futurists and the material anarchy of DADA for the correlation of the objective

world, old and new, with the subjective impulses of the psyche. As the essay 'Limites non-frontières du surréalisme' ('Limits but not Frontiers of Surrealism'), which appeared in the *Nouvelle Revue française* in February 1937, proclaims: 'Above all we expressly oppose the view that it is possible to create a work of art or even, properly considered, any useful work by expressing only the *manifest content* of an age. On the contrary, Surrealism proposes to express its *latent content*.'[59] It celebrates the resources of dream and psychopathology, and rails against the forces of order that bracket these out of the cultural domain. The two *Manifestes du surréalisme* (1924 and 1930) set out this programme, and they restore to both the manifesto form and the idea of a meaningful -ism the seriousness of intent that DADA as the anti-movement propagating anti-manifestos had sought to scotch. In the context of Surrealism and its cult of dream-life, the 'manifeste' more or less inevitably resonates with the psychoanalytic language of dream content, and therefore asks to be read as, in the Freudian sense, overdetermined in its meaning. A latent level of meaning would seem to have to be taken as read here, and with it an aesthetics of what Freud calls 'distortion', a displacement and condensation of psychic elements and energies. The question, then, is how is this psychoanalytically informed aesthetic innovation embodied in the Surrealists' contributions to the genre of the manifesto?

The Surrealist manifestos would seem to have little in common with earlier examples of the genre. The aesthetics of the poster or the cabaret, producing immediate and compressed graphic impact, are largely replaced in the manifesto of 1924 by a form of discursive essayism. The emphatic gesture of showing is rendered into the more conventional style of the text to be read. Thus, the watchword proclamations, like *'pratiquer* la poésie' ('*practice* poetry'), which have been compiled *post hoc* into a virtual manifesto of the movement, are couched in a textual order that is largely neither practical (in the sense of actively demonstrative) nor poetic (demonstrative or performative of its own principles). For the most part, the manifesto is theoretical and prosaic. While Tzara presents DADA as a neologism that wants no place in the aesthetic dictionary, Breton's techniques are more accommodating. When he declares his psychoanalytically inspired credo of the lifting of conventional antinomies: 'I believe in the future resolution of these two states, dream and reality, which are seemingly so contradictory, into a kind of absolute reality, a surreality,' he tellingly gestures towards the rules of the cultural lexicon by adding 'if one may so speak'.[60] The rhetorical twist is telling in its nod to normative usage; where DADA would simply speak new words

without compunction, Surrealism qualifies its assault on the language of the academy. DADA's non-entry for the cultural dictionary is superseded here by a more pragmatic, but thereby manifestly contradictory approach. Surrealism's manifesto definition is produced in a form that is ready for the dictionary:

> SURREALISM, n. Psychic automatism in a pure state, by which one proposes to express, whether verbally, by means of the written word, or in any other manner, the real functioning of thought. Dictated by thought, in the absence of any control exercised by reason, outside any aesthetic or moral preoccupation.[61]

Here, the manifest form could hardly be more orthodox, more controlled or reasonable. The impersonal 'one' of the entry is clearly not operating automatically; nor is it possible to envisage it in any form other than the 'written word'. The only thing that the subject of the entry reveals about itself is, indirectly, its gender. In French, the entry is categorized as 'n.m.', masculine noun, so that under the cover of dictionary conventions the movement, as it were incidentally, marks itself out as the male order it manifestly is.

Along with its dictionary entry, Surrealism secures for itself an encyclopaedic one. The ambiguous relationship of the earlier avant-garde movements to the cultural past has already been noted: the Futurists lay flowers, in spite of themselves, before the *Gioconda*, even as they call for the smashing of museums, while DADA, as we shall see, adds iconoclastic graffiti to da Vinci's high cultural portrait as ready-made (in Duchamp's *LHOOQ*). Surrealism adopts a more conventional attitude to its place in cultural history, rejecting certain past practices and embracing others, so that it establishes its position in an aesthetic genealogy. The Realist novel is denounced as incorrigibly empiricist,[62] whereas the avatars of Surrealism are derived from the fantastic tradition, from Romantic fairy-tales and Gothic narratives in the style of Lewis's *The Monk* (not for nothing does the manifesto assemble this new avant-garde in a half-ruined castle) to the dream and fantasy texts of Nerval and Lautréamont. The flexibility of the cult of fantasy even allows Breton to claim the ancestry of Dante and Shakespeare along with a list of more or less canonical authors who are at once appropriated as Surrealist in some aspect or other, yet are not comprehensively enough so to present a threat to the status of the Surrealists proper as radical innovators.

The dialectical character of this invention of its tradition, wanting at once to have and yet not to have a continuous ancestry, is replicated

in the structure of the first manifesto. The essayistic continuity of the text is in due course broken by a series of disjunctive implants that bring it closer to the strategies of impact that inform the 'anti-tradition' of the avant-garde manifesto. The diction and organization of the manifesto are thus divided between what the Futurists would call a passéist mode and one more in keeping with the new-found conventions of the genre. Both the first and the second manifestos of Surrealism appear fraught with concerns about legitimacy, with anxieties of originality and influence. While the first is largely devoted to establishing a group cause and extending it, albeit not without qualification, to a variety of antecedent practitioners, the second expends much of its energy in revoking the membership of Surrealists living and dead, actual and co-opted, from Artaud to Edgar Allan Poe. Artaud is excommunicated as a dishonoured opportunist, and Poe relegated to the side of the forces of law and order, spat on as a 'policeman' who can have no part in the transgressive ethos of the movement. Even here, though, the strategy is confused. Having proclaimed no 'need of ancestors', Breton proceeds to recuperate at least one, privileged ancestor in the shape of Lautréamont, proof that exceptions to the historical rule are still possible. By identifying with the 'unattackable' Lautréamont,[63] Breton gives himself cover from assaults on his integrity. The anxiety of historical illegitimacy seems to prevail over the anxiety of influence.

If the manifestos, rather than being unequivocal policy statements or publicity documents, are indeed structured by such competing anxieties, then Freud represents a particular instance of the sort of 'ambivalence' that Breton recognizes in his sober preface to the 1946 edition of the second manifesto.[64] On the one hand, the first manifesto is openly beholden to Freud's example and pervaded by the psychoanalytic vocabulary of the unconscious. On the other, it registers a resistance to a discourse that DADA rejected as positivistic and corrective, a discourse that at once serves to lend legitimacy to Surrealist experimentation and questions the originality of its achievements. This double bind can only lead to an acutely ambivalent relationship. In the first manifesto, the negative side of the bind finds its expression only, as it were, in latent form. When Breton mounts his assault on the taxonomic aesthetics of Realism, he does so in language that assimilates psychoanalysis into the accusation: the Realists are driven by a 'desire for analysis' that is seen as pathological: 'the incurable mania of transforming the unknown into the known, the classifiable'.[65] DADA's blatant diagnosis of psychoanalysis as the real disease is thus rehearsed more obliquely here.

If Breton is, as he says, put off from entering the room that Dostoevsky describes in the passage cited from *Crime and Punishment* as an example of the 'analytic' style of Realist discourse, then it seems that this refusal to enter might extend to the consulting room of the psychoanalyst. He wants to enjoy the liberation of creative imagination that the Freudian project offers him without allowing it to be rendered into realistic 'commonplaces' ('lieux communs') by analytic demystification. The idea of the threshold as a place of transition but also of resistance is a leitmotif of the manifestos. In the second manifesto, Breton talks of the threshold to the mystery space of Surrealism being armed with a malediction after the example of the inner place of the alchemist's work and the apotropaic signs at the start of 'alchemical' works by Rimbaud and Lautréamont. The occultation of the Surrealist work place is designed to repel the uninitiated: 'It is absolutely essential to keep the public from *entering* if one wishes to avoid confusion. I must add that the public must be kept in exasperation at the gate by a system of challenges and provocations.'[66] This applies as much to the physical laboratory of the Surrealist movement, the Bureau of Surrealist Research, as to the metaphorical place of the Surrealist artwork.

The threshold is thus a focus for the ambivalence that motivates the manifesto. On the one hand, it is designed as a document of access to new places; on the other hand, it is rebarbative to the profane, would-be neophyte. Not for nothing does the second manifesto begin with a series of images of apparent exclusion, followed by two challenges to kill: one an apparent recommendation, quoted from *Nadja,* that psychiatric patients should kill their doctor, and the other a claim that the simplest Surrealist act would be to go down into the street and shoot at random. The non-committed reader might indeed turn away at this threshold, notwithstanding the subsequent qualification of these statements. Just as the manifestos operate a continuous exchange of admissions of new members and ejections of old, it seems that Surrealism as propounded here by Breton is anxious not to give ready admission to its place of mystery, or to enter into places that might expose the alchemical magic, or the occultist 'manifestations',[67] as manifestly commonplace.[68] The irony is that the control of the threshold is cast in the sort of language that is anathema to Surrealism, the language of accounting and policing, crime and punishment, which runs throughout the second manifesto. Breton adopts the voice of the law, in order to have the renegade ex-Surrealists taken out of circulation: 'To the extent that it is within my means, I judge that I am not authorized to let cowards, simulators, opportunists,

false witnesses, and informers run around loose.'[69] Breton, who abhors the established discourses of religion, capital, psychiatry and the law, plays the authority figures of those institutions by turns, earning the ironic title of 'le pape' (a Pope who excommunicates heretic followers), acting as accountant in his review of the financial dealings of group members, doctor in his diagnosis of their psychopathologies, and as self-appointed head of the movement's judiciary, presiding over its kangaroo courts. The manifesto is constantly preoccupied with the demarcation of the proper place of Surrealism. The threshold becomes a focus for the two-way traffic of accusations of fraud, embezzlement and double standards, for inclusions and exclusions, escapes and incarcerations.

The trope of the threshold to a different place can be said, then, to work in two directions. On the one hand, it works inwards from the special place of Surrealism to what Freud calls the 'other scene' of the unconscious and Breton the 'unusual place' of the dream and the 'hidden places' of the forbidden zone within.[70] The potential scenes of these inner 'manifestations' include the alchemical laboratory and the spiritualist chamber, but the most telling place of access is the psychoanalyst's consulting room. This is a site of subjective production, of manifestation, through free association, but one that is also subject to forms of control. The ambivalence of this inner threshold is registered by Breton's citation of another form of boundary between private and public space as a model Surrealist image: that of a man cut in half by a horizontal window pane. The image is designed to represent the spontaneous potency of the Surrealist method, yet its presentation is marked by a curious lack of spontaneity. In a footnote, Breton relates the sort of potential that this image might have had if he were a visual artist. The footnote appears here, as throughout these manifestos, as a form of textual supplement that manifestos should not need, a form of subtext, providing second thoughts. Here it seems to compensate for the failure of Breton the writer to make this model work in writing. Though he claims that it impressed itself upon him in an unalterable form, the wording of the ostensibly compelling phrase eludes him. This hypnagogic vision is supposed to function as an example of 'surreality', a link between the fecundity of the dream image and waking life, opening up to the mind 'the limitless expanses where its desires are made manifest'.[71] In fact, what is manifest here is the limitation imposed upon the Surrealist method, whereby the window, far from opening upon an expanse of manifest desire, is figured as a device of entrapment, and one that the conscious mind cannot properly access after the event.

Breton glosses the image as a creative distortion of the normative idea of a man leaning out of a window; when the man straightens up and moves, he takes the window with him. But the movement of the man, which we may read as an exemplary imaginative form for the movement of Surrealism, is more revealing in its French version, 'déplacement', where it can be read as an enactment of Freud's principle of displacement as a key function of distortion in the working of dreams (a literal displacement of the human figure into the plane of the window in order to lean 'out of it'). Surrealism seems to be caught here between the notion of movement in its mundane sense and the more elusive motions of the unconscious. The failure to make the model image work as a figure of displacement in the Freudian sense exposes a latent anxiety in the manifesto as to the possibility of tapping the latent power of the unconscious as figured by Freud.

On the other hand, the threshold also works outwards, into the political sphere. The man caught in an attitude of looking out of the window, even when he moves away from it, is a telling image for a movement making claims for political engagement.[72] Breton claims that Marxism is the sole 'movement' ('démarche') with which Surrealism will align itself,[73] but the Surrealists are on the whole supportive observers of that movement, rather than its agents on the march. It indicates something of the ambivalence of the Surrealists' relationship to public space, and thus to the idea of the integration of their art into life. The threshold to the street is regulated by the group's affiliation to Marxism that is fostered increasingly closely in the years between the two manifestos. The second manifesto, which culminates in a declaration of faith in Marxist revolution through the renaming of the group's journal as *Le Surréalisme au service de la Révolution*, is fraught with difficulties in the relationships between revolutionary political realities and the operations of the Surrealists as the aesthetic wing of the movement. As he acknowledges in a footnote, Breton's call for random shooting in the street is also a transgression of the official guide-lines of revolutionary discipline, not the authorized form of entry into the battleground of the streets.

Both these forms of threshold represent at once boundaries leading into desired territories and places of surveillance and threat to the unorthodox activities of the Surrealists. Above all, the surveillance reveals precisely that the movement is sustaining a double life, aiming to access both inner and outer spaces, both the occult, alchemical or psychoanalytic 'manifestation' and the 'manifestation', or demonstration, on the street. Breton singles out both Marxism and psychoanalysis as *the* place for Surrealism to be, and thereby marks its

impossible double bind. Marxism is the sole legitimate 'movement', and psychoanalysis the sole critical practice with 'a really solid basis'.[74] Though he uses Freud's increasing concern with the super-ego in his later theory as licence for his own turn towards more social political concerns, it is clear that the Freudian threshold faces another way. Whereas Freudian concerns point towards double meanings, towards forms of latency, revolutionary Marxism and its ideology of historical materialism demand a straightforward form of manifestation: 'there is no way of playing with these words'.[75] The archetypal counter-model to Freud's *The Interpretation of Dreams* is Marx's own *Communist Manifesto*. Orthodox, manifesto-based Marxism demands singular allegiance, as evidenced by a scene recalled by Breton: ' "If you're a Marxist," Michel Marty bawled at one of us at about that same time, "you have no need to be a Surrealist," '[76] to which Breton's response is that the label of Surrealists is like relativists for the followers of Einstein and psychoanalysts for those of Freud, thereby revealing that he, and his own followers, incorporate both psycho-analysis and relativism, as much as Marxism, in their hybrid identity. If an ideological emplacement at once in psychoanalysis and Marxism is unworkable, it is not surprising that Breton resorts to the utopian language of the non-place, to a profound relativism of location: 'Surrealist confidence cannot be well or ill placed for the simple reason that it is not placed.'[77]

The preface to the second manifesto acknowledges a problem that has general significance for manifestos of the avant-garde. It has something of the retrospective aspect of the *Angelus Novus*. Its tone is melancholic and apologetic, setting a frame of historical relativism around the absolutist claims of the manifesto itself. Where the reader might expect unmitigated vigour, Breton acknowledges 'traces of nervosity'.[78] The gravitation from the first to the second manifesto is evidence of an attempt to 'maintain a platform mobile enough to cope with the changing aspects of the problems of life and at the same time stable enough to attest to the non-rupture of a certain number of mutual – and public – commitments undertaken at the time of our youth'.[79] The platform at once embodies a fixed raft of essentialist tenets and a more flexible construct, subject to the fluctuations of historical contingency. One of the inserts in the first manifesto, under the heading 'to make speeches', indicates the inherent rhetorical excess of the manifesto 'speech': 'He will promise so much that any promises he keeps will cause consternation.'[80] This suggests that the consternation caused by the post-manifesto works of the avant-garde artist will be deeply ambivalent, at once a form of

wonderment at the realization of even a small part of the extravagant programme and an equally profound sense of disillusionment at the manifest double standards.

Exhibitionism

The importance of the manifesto is indicative of the more general principle of exhibitionism, the drive for impact through public performance and display that is incorporated in the diverse -isms of the avant-garde. Thus the manifesto in its printed form represents a kind of textual production that is in the first instance meant for exhibition as poster and for the performative spectacle of public recital. Poster and performance art are constitutive of the sort of actionist challenge that the avant-garde mounts on conventions of aesthetic exhibition, on what can be shown and how. They are aimed at bringing the street and its theatre into the space of art, and art as performance on to the street. The integration of art into the praxis of life sees the privileged space of museums and galleries as a particular site of resistance, and exhibitionism primarily signifies showing the iconoclastic breaking of the physical and ideological boundaries and inner organization of that space. For the gallery-going public and the media, the assaults on conventions of showing were registered at once as sensational must-see events and as preposterous affronts to accepted standards of aesthetic decorum and value. The pioneering avant-garde exhibitions were represented as pornographic (especially in the case of the Surrealists), seditious (especially in the case of Berlin DADA) or monstrous (in almost every case). Thus, 0–10: The Last Futurist Exhibition of Pictures, held in Petrograd in 1915, caused a mixture of outrage and perplexity with its radical abstractions, taking art to the degree zero. One of Malevich's emblematic Suprematist works, a painting of a black rectangle entitled *Chetyreugolnik* ('Rectangle' (1915)), was hung in the top corner of one of the rooms in the position reserved for the icon in Russian homes, an uncompromising assault on cults of aesthetic ornamentation. The First International Dada Fair, held at the Galerie Otto Burchard in Berlin in 1920, was dubbed 'The Great Monster Dada Show' in the press. Its display of political slogans, sociopathic paintings, satirical photomontages and installations was gathered under the hanging figure of the *Preussischer Erzengel* ('Prussian Archangel') by Heartfield and Schlichter: an effigy with a pig's head in a Prussian army uniform providing a grotesque counter-version of the angel of history, hovering over

representations of the fractured structures and bodies that were produced under the historical aegis of Prussian militarism. And when the International Exhibition of Modern Art was held at the Armory in New York in 1913, the Cubist room, hung with such works as Duchamp's *Nude Descending a Staircase*, became known as the 'Chamber of Horrors'. The paradox of this form of exhibition of the modern nude was that its simultaneous, geometric projection through the visual space of the painting at once denied the conventional exhibition value of the nude and created a new kind of exhibitionist attraction in what was perceived as a monstrosity.[81]

Part of what the discourse of avant-garde monstrosity registers is the spectacular act of showing ('monster' being derived from *monstrare*, the Latin for 'to show'), an aggressive intervention in the controlled space of public viewing, whether in the manifesto or the exhibition. And both of these forms are linked by a form of showing that is fundamentally performative, where the programmatic text or the work of visual art is an act of theatre that is designed to pronounce a new mode of activity into being. The strategic act of public declamation in *Le Figaro* that marked the foundation of Futurism inaugurates a reciprocal series of manifesto publications and of public performances that often incorporated the declaiming of manifestos. As Futurist artwork recorded manifestations in cabaret and on the street (such as Cangiullo's *Milano-Dimostrazione* ('Milan Demonstration') (1915)), it also provided an installation framework for such manifestations. The Futurists sought to integrate the various art-forms into a synthetic performance art and to integrate this, in its turn, as event into the key sites of the public sphere. Political action and artistic creation were thus to be rendered radically simultaneous, to occupy the same temporal and spatial frames, rather than the one following from the other. The declamation of the manifesto, as centre-piece of a Futurist *serata*, or performance event, was designed to manifest that principle of political action as simultaneous with artistic production. Its place could be the street, the theatre, a café or a gallery, and in each case the performance synthesized visual art and sound, the printed and spoken word, material objects and the body in multi-media assaults on the conventional expectations of the audience.

Thus *Piedigrotta* by Cangiullo was performed as a synoptic pantomime at the Sprovieri Gallery in Rome in March and April 1914, with interpenetrating levels or planes of performance. It featured the author at the piano and others on a variety of noise instruments, Marinetti and Balla declaiming the 'parole in libertà' text, a backcloth

painted by Balla and the works of other of the group's leading painters like Carrà, Severini and Boccioni, all bathed in red light, and a company of Futurists dressed as dwarves in paper hats. The *Piedigrotta* was based on the Neapolitan street festival of the same name, and was designed to replicate the convergence of urban energies in the popular spectacle: 'The performance began with a procession, a brief reflection of the many processions that roam through the city from various points to join up at one meeting-point.'[82] The gallery thus took on the function of the synoptic site for the manifestation. And a key part of the synoptic principle was to involve the audience in the production of the manifestation, to activate its own exhibitionistic tendencies.[83] On the model of the urban festival, the performance released the hectic dynamism of the carnivalesque, but also freed it from its socially ordained time and place, making the street reproducible in the gallery and at a time of the performers' own choosing.

The exhibitionistic performance aesthetic of Futurism is informed by what Russian theatre and film director and cultural theorist Sergei Eisenstein came to call the 'montage of attractions', a style of representation that is focused on aggressive moments that magnetize the spectator. In both cases, the 'attraction' is derived from the acts of popular theatre (circus or variety) and involves a wrenching of performance art out of the conventional framework, in both social and aesthetic terms, of high cultural theatre. The attraction is an autonomous element in a montage of other elements: compressed, activating and rupturing time-honoured notions of narrative continuity in the realist theatre. In the terms developed by Tom Gunning in his analysis of early avant-garde cinema, what makes the fairground or vaudeville aesthetic attractive to the avant-garde is its tendency towards 'exhibitionist confrontation rather than diegetic absorption',[84] a form of exhibitionism that he sees as breaking up the voyeuristic satisfaction of the narrative mode. For the Futurists, variety theatre offered an anti-traditional tradition that they could adopt as self-made Prometheans. As Marinetti puts it in his manifesto 'Teatro di Varietà' ('The Variety Theatre') of 1913: 'The Variety Theatre, born as we are from electricity, is lucky in having no tradition, no masters, no dogma, and it is fed by swift actuality.'[85] It is dynamic, erotic and spectacular, and makes the spectator collaborate in the spectacle, rather than remaining 'static like a stupid voyeur'.[86] It strips hallowed master-works of their immortal status and presents them as 'mere *attractions*'. It removes all traces of psychologizing, which for Marinetti is academic, bibliophiliac and museological, and opposes

to it a form of instinctual 'body-madness' or *fisicofollia*,[87] to be trans-
mitted from performers to audience.

How this exhibitionist aesthetic might work in practice can be
gauged from examples of the 'sintesi', the pieces of synthetic theatre
that the Futurists produced as 'attractions' in their version of
the variety theatre. In Cangiullo's *Il donnaiuolo e le 4 stagioni* ('The
Lady-Killer and the Four Seasons'),[88] the four 'seasons' of the pro-
tagonist's erotic life are represented as a synchronic spectacle by
four female figures – a schoolgirl, a bather, a widow and a bride –
who enter and adopt poses or activities (reading or swimming). While
their eyes are hidden or averted, the lady-killer fixes the audience
with a sweeping and precise gaze, and proclaims the single word
'Voilà!'. The erotic charge of the synthesis is created by the female
bodies, exhibited synoptically by the protagonist as showman, but
the potential voyeurism of the audience is challenged by the aggres-
sion of the impresario's gaze, which focalizes the performance as an
attraction in Marinetti's sense. A similar logic is at work in Boccioni's
La Garçonnière ('Bachelor Apartment'), which parodies the conven-
tions of seduction in the realist theatre.[89] The stage is decorated in
an anti-Futurist style, but with a newly acquired painting on an easel
that may or may not be the latest work by one of the Futurists. He
uses it as an exhibit, to lure his female guest, kissing her as she
scrutinizes it. She resists his advances until he asks her to leave, when
she casts off her fur coat to reveal 'black silk panties with her bosom,
shoulders, and arms nude'. As she becomes the exhibit, she requires
that the exhibited painting should be turned away; the fetishized
body of the latter-day Venus in Furs can only serve its exhibitionistic
purpose if the artwork is not to be seen. But the turning away of the
exhibited work also performs as a curtain, marking the end of the
theatrical exhibition for the audience.

In Boccioni's *Il corpo che sale* ('The Body that Ascends'),[90] the
body in question, which flies up outside the windows of an apart-
ment block, causing consternation amongst the tenants, creates an
exhibitionistic spectacle that the onlookers cannot properly see. It
transpires that the 'long and hairy' body was that of a man sucked up
to the fifth floor by the gaze of his female lover. What might have
seemed to be a Futurist hero in ascendancy turns out to be a lover
avoiding a zealous concierge. The synthesis shows only a confused
picture of its exhibitionistic object, and can only describe the fantasy
of the erotic power of the female gaze. The audience is as fascinated
and frustrated by the spectacle as the men on-stage. In each case, the
'sintesi' mount provocative forms of attraction but also block them

or cut them short (the curtain at the end of Cangiullo's *Il donnaiuolo* falls down the page, with the letters printed vertically in imitation of the visual cut). They construct exhibitionist fantasies but deny their extrapolation into conventional narratives of desire, and hence mount an assault on the voyeuristic or spectacular pleasures that they seem ready to promote. The attractions are designed to work in series, each creating energy but never releasing it.

The dismantling of conventional theatre in synthetic, variety mode is an example of the iconoclastic drive to revolutionize the showing of art. As we have already seen, however, this iconoclasm is not absolute; it varies in form and includes certain accommodations of convention. The treatment of the *Gioconda* as an archetypal high-cultural icon is characteristic of the range of possibilities. On the one hand, Marinetti secures a safe space for the exhibition of this icon, so that the Futurists can make occasional votive offerings before it, on the other, in a more DADAist gesture, he includes 'GIOCONDA PURGATIVE WATERS' in his bravura outburst of logorrhoea at the end of the 'Variety Theatre' manifesto.[91] The high-cultural icon is thus grotesquely appropriated by the discourse of advertising, harnessed to a form of production that is excremental and incontinent.

DADA's treatment of the *Mona Lisa*, in the 'rectified ready-made' *LHOOQ* (1919), is no less provocative, as it sets about retouching, or re-touching, the iconic image. DADA mounted itself as a spectacle of celebrity, nudity and sexual exhibitionism. As Robert Short relates, Paris DADA drew audiences to its happenings with a telling series of promises: 'The technique now was to arouse expectations with tantalizing publicity – the Dadas would shave their heads bald, Charlie Chaplin would appear in person, Dada would reveal its sex – and then to disappoint these hopes with insults and nonsense.'[92] In the spectacle of *LHOOQ* Duchamp combines these principles, taking the most celebrated of artworks, but showing it only as a defiled reproduction and turning it into a piece of shameless exhibitionism. The letters of the new title translate phonetically into 'elle a chaud au cul' ('she's got a hot arse'), making manifest the putative latent randiness of the enigmatic smile of the *Mona Lisa*. Male DADA may not directly 'reveal its sex' here, but it does show it through the mediation of the sex of the other sex. At the same time, this image of patent male heterosexual titillation is strangely queered. That is, the 'sex', or gender and sexual identity, that is shown here is a distinctly ambivalent one.

How, then, does this act of exhibitionism work? The pencilled moustache and beard on the cheap print are a scandal at once to the sort of idealization of gender that the painting represents and to

the idealization of the work of art as a finely crafted reproduction. The legend 'LHOOQ' is a typically playful gesture, which apes more meaningful encryptions in the texts applied to paintings. This strategic re-exhibition is aimed at blatantly showing the lack of art, in any sort of conventional terms, in the DADA work. At the same time, it converts what is exhibited in the painting from an enigmatic mystery of femininity into a lascivious show of erotic pleasure. That is, it is an act of exhibitionism in both the general, social and the sexual sense. The female body remains decorously covered, but in the trick of the caption is also made to show what is hidden beneath the clothes and in the part of the figure not included in the picture. The vandalism breaks the picture out of its frame and makes it exhibit a body on heat, a form of spectacle that is not admissible according to the conventions of art exhibition. Indeed, the addition of the hair around the lips renders the enigmatic smile of that part of the body that is sanctioned for naked viewing into a displaced image of the 'hot arse' that is taboo for high art. This can be understood as the projection of the male artist on to the female figure, exhibiting the sort of erotic arousal in the male viewer that is the secret of da Vinci's painting. The DADAist shows an image of himself, as well as his genital fantasy of the feminine, in the stylized form of moustache and beard, so that the act of exhibitionism is a double one.[93] The masculinization of the female icon is a reminder of the meaning of DADA that is not included in Tzara's dictionary list, its status as patriarchal interpellation, putting a male stamp upon the object of the male gaze. The bearding of the *Gioconda* thus manifests two types of latency, one being feminine sexuality and the other the patriarchal authority that would seek at once to control and to enjoy it. At the same time, its transgendering makes a potentially queer performance of the image, informed perhaps by Freud's outing of Leonardo's sublimated homosexuality in his essay of 1910, *Leonardo Da Vinci and a Memory of his Childhood*. The image thus also reveals a latent threat to the homosocial economy that trades on images of femininity like the *Mona Lisa*.

While Duchamp's image is an exceptional one, it is in certain ways characteristic of avant-garde 'exhibitionism'. It mounts an assault on high art, on its conventions of styling and framing. It explodes the boundaries of the art object; nothing is too high or too low to be incorporated and combined in the new art. It announces total reproducibility of even the most special of images, so that Duchamp's reproduction for the gallery is in its turn reproduced as the cover design for Picabia's magazine *391*. Nicely enough, this second-order reproduction removes the facial hair and so restores the image to its

original, unrectified appearance. The versions of the image that are 'shaved' in this way (see plate 3) represent the scandal of an appropriation of the original that hides the marks of its iconoclastic fakery. While art has always been reproduced, this form of reproduction denies any difference in authority between original and reproduction, between the gallery and the magazine as modes of display. It introduces into the hallowed ground of the gallery a more naked view of the desires that motivate artist and spectator in their interaction through the work of art. It is at once a sort of lure, drawing the spectator into a naughty, new relationship to a revered image, and an act of aggression. The 'showing of the arse' is like the apotropaic images discussed by Freud, or adolescent 'mooning', aimed to repel as much as to display, to establish control over the visual field by transgressing the regime of taboo that governs it. The *Mona Lisa* is made to break out of her enigmatic silence and invite the art-loving bourgeoisie to kiss her in an avant-garde position.

Another version of this invitation is produced by an equally notorious piece of DADAist provocation, Duchamp's rectified ready-made *Fontaine* ('Fountain' (1917)). The inverted urinal is designed to scandalize the museological culture inherited from the nineteenth century by asking the art-lover to contemplate as artwork an object only fit to be pissed upon. The piece is exhibitionist not just in showing an object that is meant to be hidden, but in implying that its proper use for the spectator would involve a reciprocal form of public exhibition of organs and a function that is not intended for the public eye. The ready-made, whether a high-art reproduction or a low-life functional object, is perhaps the most extreme form of the rupture of the aura that Benjamin describes in his 'Work of Art' essay. Aura is understood here as a cover that encloses the cult object. It produces the paradox of a close form of contemplation that none the less holds the artwork at a distance. The spectator is allowed up close in order to contemplate the remote site of the work's origin, the place of its metaphysical presence (say, the place where the smile of the *Mona Lisa* originated). To contemplate her image is to enjoy the illusion of being the object of her contemplation, to be close to her remote smile. The breaking of the aura is taken as a mark of the reproducibility of object and perception. Not for nothing does Benjamin cite the *Mona Lisa* as an exemplary case of the reproducible artwork;[94] it is a work that is taken to have a particular auratic appeal, and that is subject to hyperbolic reproduction and thus desacralization precisely by virtue of that appeal.[95] In the case of the *Fontaine*, Duchamp represents this shattering of the auratic space around the object by

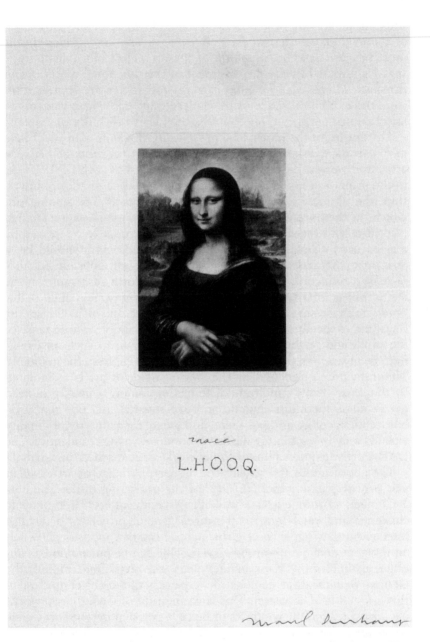

Plate 3 Marcel Duchamp, *LHOOQ* (1919). Museum Boijmans Van Beuningen, Rotterdam. © Succession Marcel Duchamp/ADAGP, Paris and DACS, London 2004.

substituting the art object by a functional object of the most anti-aesthetic kind, one that works only when its user gets up close in the most physical sense. The taking of the art object out of its auratic space is imitated by the displacement of the functional object out of the space where it can function (say, the toilets that are separated off from the exhibition space of the gallery) into one where it seems to lay claim to, but inevitably shatters, the idea of the aura of display.

The graffiti of the moustache in *LHOOQ* finds its equivalent here in a parodic version of the mark of the auratic contract between artist and viewer, the signature. The painting of 'R. MUTT 1917' on to the urinal is a fake reproduction of the historical mark of authorship, the ultimate avant-gardist counter-signature. The signing off, which, in the auratic tradition, totalized the artwork as an original identified with the special talent of its originator, is here replaced by a signature in a place where the manufacturer's mark should be, a guarantee, that is, less of originality than of the self-replicating quality of mass production. It is the signature of a form of assault on the iconic object of ritual display that Benjamin describes thus in his photography essay: 'The peeling of the object out of its cover, the smashing of the aura, is the signature of a perception, whose sense of the similitude of things in the world has grown to such an extent that, by means of reproduction, it can also derive it from the unique.'[96] The individual object that is the auratic work of art is assimilated by the sense of the similitude of things, becoming a mass-produced object made for indiscriminate and excremental use, one that anybody could acquire and put there, and where the painterly originality extends only to a signature dashed off under an assumed identity. The DADA artist exposes himself in his work as unabashed 'piss-artist'.

The act of importuning with the archetypal image of art as silent and private pleasure in *LHOOQ*, or the proffering of the urinal as art object, is then extreme and idiosyncratic in its exhibitionistic challenge and yet relates to the more general principles of DADA interventions. What is present throughout is a new mode of showing, an insistent demand upon the viewer. This can be understood as another reading of the 'dada' name, where the phatic repetition of the German *da* indicates a demonstrative placing of the object up close in the viewer's field of vision. This is the gesture of Georg Grosz sticking his posters on the windows of Berlin cafés, making the social gaze see political art in its everyday environment. And it is there too in a type of DADA work that might act as a corrective to Duchamp's blatant co-option of the female image, as represented by Hannah Höch's *Da-Dandy* collage and photomontage of 1919 (see plate 4).

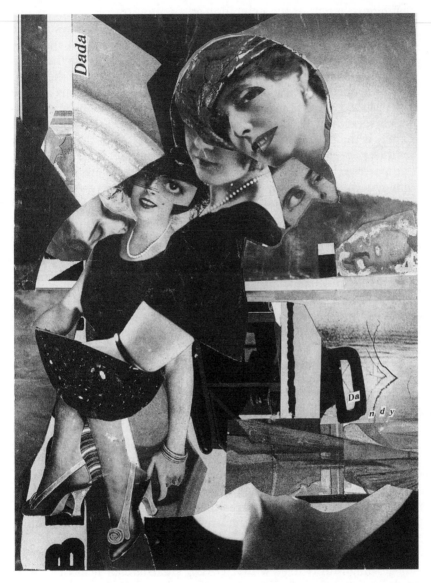

Plate 4 Hannah Höch, *Da-Dandy* (1919). Private Collection. © DACS 2004.

While so much of the exhibitionistic demonstrating of the avant-garde, especially in its DADAist and Surrealist forms, relies on the virile performance of masculinity, or of female objects for the male gaze, Höch's work presents a counter-performance. To use the terms developed by Judith Butler in her extension of speech act theory to the cultural construction of gender and sexuality,[97] DADA is at base a hyperbolic exercise in masculine performativity. The primal patriarchal speech act of 'Dada', the first pronouncing of the name of the father, is the performative signature of much of what the movement produces, even where it appears to be mounting a carnivalesque, anti-partriarchal challenge to institutions and traditions. Höch takes that speech act and converts it into an alternative type of performativity, opening up the sort of stage for at least provisional reformulations of gender performance that Butler sees in forms of drag artistry. Höch cuts and pastes images of women taken from magazines and arranges them in an open environment. She strategically misappropriates the figure of the dandy, as defined by Barbey-d'Aurevilly and Baudelaire, the generically male self-styling aesthete who at once makes an elegant spectacle of himself and, as *flâneur*, takes in the spectacle of modern, urban spaces. The two-way spectacle is transformed here into a collage that both replicates and reorganizes it. The Da-dandy here may be a composite of the female figures represented in the image, where the superimposition of fashion photographs suggests a form of masquerading for public appearance. These images of women might be understood as the visual objects of the dandy as *flâneur* in the age of DADA, the collation of real women and shop-window mannequins that he might behold when walking through 1919 Berlin, their provocative gazes and stockinged legs. Alternatively, the gaze of these figures, trained on the viewer, may be understood as a counteractive strategy to Duchamp's, appropriating the male gaze of the dandy for a feminized Da-dandy. Like *LHOOQ*, *Da-Dandy* challenges the gallery as the privileged site of the artwork with the 'art' of the street, graffiti, make-up and fashion, and it subjects the cult of the original work to the ready-made and reproducible aesthetics of the magazine and the shop-window. Both images might also suggest that DADA's patriarchal field of view is perhaps less secure than it may want itself to be. They allow themselves to be read as objectifications of the female body for the pleasure of the male gaze; but equally, with their transgendering strategies, they serve to disrupt that model. These are forms of exhibitionism that employ masquerade to unsettle the security of received ideas of erotic viewing.

An image like *LHOOQ*, the anti-icon adopted as a media image for DADA, points up both the breaks and the continuities between that most blatant form of avant-garde exhibitionism and the somewhat more tempered exhibition practices of the Surrealists. The breach between the two groups was indeed brought to a head by the rampant exhibitionism of the Paris DADAists. On the infamous occasion of the DADA happening that staged the mock trial of the writer Barrès, Breton, who played the role of judge, turned on the witness Tzara and ruled his fooling behaviour in contempt of court. That is, he tried to impose order upon the anarchy of DADA's exhibitionistic cabaret. As Maurice Nadeau has suggested, Surrealism and DADA were in a historical relationship of double bind; the one 'needed the other in order to be born, but needed just as much to abandon the other in order to live'.[98] It is in the ambiguous nature of this Oedipal relationship between Surrealism and its anti-social 'dada', its 'père Ubu', that the old adversary should be readmitted to the depleted ranks of Breton's followers in the early Thirties. In the second Surrealist manifesto, he acknowledges that the affront he and his circle felt at the insulting exhibitionism of the DADAists' 'Coeur à Barbe' resignation spectacle in July 1923 was in the nature of an event aimed at causing confusion (and thus, by implication, in the volatile nature of exhibitionism as a mode of performance). Confused as to whether they were on the side of the performers or the audience, the insulters or the insulted, they declared a schism that was supposed to create clarity in this matter. Characteristically, this was a spectacle that turned, as much as anything, on the desire of each of the two sides to have agency in the split, and thus priority over the other.

Where DADA celebrates incontinent provocation in the act of showing, Surrealism is more inclined to exercise control over the display. Breton's rhetoric of the occult place of Surrealism is contrasted with what he sees as the false public openness of DADA.[99] Yet those exhibitionistic impulses that helped to bring Surrealism into being retain a hold over the movement. As Breton adopts the role of arbiter in what turns into the trial of DADA, so he struggles with the more unruly impulses inherent in the new movement of Surrealism. These are submitted to forms of control, following the Freudian principle of sublimation that Breton embraces in the second manifesto. In his Freudian mantle, Breton adopts the agency of the super-ego, legislating over his and his group's more anarchic desires. One of the recipes he provides for Surrealist activity is a prescription for exhibitionism, but one that subjects itself to censorship. Under 'How to catch the

eye of a woman on the street', the manifesto offers only an extended ellipsis.[100] What is unwritten here is an act of public exhibitionism by the male Surrealist in order to capture the female gaze. While this naked self-display incurs a mock form of official censorship, making itself into an open secret, the manifesto is less inhibited in its co-option of the female body as an object of exhibition. The fantasy of the men of Surrealism gathered for a creative colloquium in the Gothic castle cannot do without the supplement of women as visual objects – 'and gorgeous women too, I might add'[101] – and this need is replicated in the female figure hanging from the ceiling of the Bureau of Surrealist Research. As *LHOOQ* relays the viewer's gaze from the face to more hidden parts, so the catching of the woman's eye on the street encodes the more general entrapment of her body for the male gaze. The look moves from the eye to the legs in the Surrealist sentence quoted from Max Morise: 'The colour of a woman's stockings is not necessarily in the image of her eyes.'[102] What the gaze really seeks is the stocking as fetish of feminine sexuality, and this cannot simply be read from the eyes of the objectified woman. As in *Da-Dandy*, the stocking-clad leg as object of desire is foregrounded, but it cannot be connected to the eyes that also form part of the picture and that have a look of their own, thus resisting objectifying control. This is a scenario that we will encounter once again in the discussion of Breton's *Nadja* in the final chapter.

The movement towards intimacy, from the eye to the stocking, is completed in the undressing of the female body in a fantasy of mass hysteria. Aragon and Breton celebrate the phenomenon of hysteria in the March 1928 number of *La Révolution surréaliste*, which marks the fiftieth anniversary of Charcot's 'discovery' of it. Charcot's clinical revelation of hysteria is dubbed the great poetic achievement of the late nineteenth century, partly as an antecedent of the Freudian project, but more especially because it brings to light the 'young female hysterics' that Breton and Aragon adore above all else. A reference in the second manifesto confirms that this is what hysteria really means to them. As in Charcot's 'theatre' at the Salpêtrière, hysteria is constructed here as the public exhibition of the female body for the male gaze, but with the hysterics released from the clinic to be seen in the outside world by the Surrealist visionaries: 'So glory be to hysteria, Aragon and I have said, and to its cortège of young, naked women sliding along the rooftops.'[103] What it fails to register is the inability of the male seers to see *as* these hysterics, to really participate in the exhibition that they envision, as will be seen in the case history of *Nadja*.

A prime example of the exhibitionistic aesthetics of Surrealism, and one readily comparable in its iconography and assertion of reproducibility to Duchamp's *LHOOQ*, is Magritte's *Le Viol* ('The Rape' (1934)) (see plate 5). Both works fit the category of the monstrous, as categorized by Elza Adamowicz in her analysis of Surrealist collage techniques.[104] They are both forms of bearded lady, and so monstrous in the etymological sense of the word, freakish hybrid attractions intended for show. Like *LHOOQ*, the 'original' painting of *Le Viol* is replicated in various forms. Just as Duchamp's picture was distributed as an anti-iconic image of the manifestation of DADA (appearing above Picabia's 'Manifeste DADA' on the cover of *391*), so Magritte's was reproduced as a drawing on the cover of Breton's 1934 brochure *Qu'est-ce que le surréalisme?* It appears that this figure, shaped like a latter-day Sphinx, could either embody an archetypal answer to that question or be particularly well suited to pose the enigma. While the original is painted with virtuoso skill, it comes to be reproduced for this rhetorical purpose as a quick cartoon. It seems, then, that, like *LHOOQ*, it is primarily an idea, a visual trick or pun, and that even though Magritte does the elaborate artwork of the original painting for himself, this is ultimately redundant. When *Le Viol* was included in the 'Minotaure' exhibition in Brussels in 1934, it was subject to a form of censorship, kept in a special place beyond the public gaze, along with other such provocative images as Dalí's *Le Grand Masturbateur* ('The Great Masturbator' (1929)). As Dawn Ades puts it, the work 'was hung in a private room at the back and shown only to initiates'.[105] As an act of exhibitionism concealed within and behind the exhibition, it seems that it was taken to show both the innermost secret, the mystery or monstrance of Surrealism, and its monstrous, hard-core image.

Le Viol is typical of Magritte's work in questioning the representability and reproducibility of meaning. As in the famous example, cited at the start of this study, of the much-reproduced image *Le Trahison des images*, featuring the legend 'This is not a pipe' under a copybook picture of a pipe, Magritte paints with an alluring form of photo-realism, but adopts anti-realist, or Surrealist, techniques to break the seductive illusion that he mounts. As Foucault has argued in his essay *Ceci n'est pas une pipe*, Magritte's images work through the tension between different levels of signification, between text and image, sign and picture.[106] Magritte challenges the realist illusion by suggesting, as in *La Clé des songes* ('The Key of Dreams' (1930)), that an image can bear an unconscious meaning quite contrary to its routine one, that it can, in the terms set out by

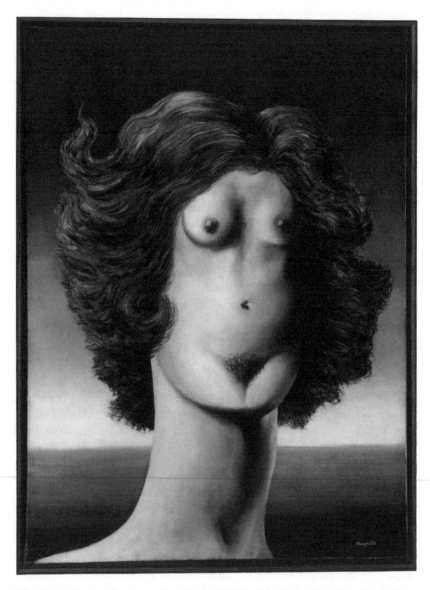

Plate 5 René Magritte, *Le Viol* (1934). The Menil Collection, Houston. © ADAGP, Paris and DACS, London 2004.

Freud in *The Interpretation of Dreams*, signify through a form of semiotic relation (*Zeichenbeziehung*), rather than pictorial value (*Bilderwert*).[107] In *La Clé des songes*, as in *Le Trahison des images*, objects are framed and painted with alluring perfection but made treacherous by carrying linguistic labels that are contrary to their appearance. By the same token, a tension is created between the pictorial appearance and the title of *Le Viol*, suggesting a meaning on the level of semiotic relations. The viewer is asked to consider how an albeit naked female figure can represent an act of violation when she is so monumentally static, isolated in empty space with no trace of the rapist. At the same time, the painting's answer to 'Qu'est-ce que le surréalisme?' may well be as contradictory as the pipe's relation to 'Ceci n'est pas une pipe'. The image exhibits itself as an icon, presented with the same iconographic precision and simplicity as the *Gioconda*; yet it also scandalizes iconic traditions, suggesting that there can be no neat question-and-answer format in the definition or exhibition of Surrealism.

Like *LHOOQ*, *Le Viol* combines a blatant, exhibitionistic visual scandal with more ambiguous sexual political resonances. The image is characteristic of Magritte's work, in playing on the relationship between exhibiting and exhibitionism, especially by mounting framed reproductions of fetishistically presented versions of bodies or body parts. They are mounted as versions of the pornographic spectacle, clinically reproduced images of sex and violence. Jack Spector has discussed the Freudian references that the picture displays, suggesting that its title relates to a complex web of word-play, incorporating violin, violet and the name of the young woman, Violette Nozières, who became a *cause célèbre* for the Surrealists when she murdered her parents, supposedly having been abused by her father.[108] The word-play extends to a network of variations on the theme of sexual violence in and around the book produced by a group of Surrealists in 1933, *Violette Nozières*. For Spector, Magritte's image incorporates not least the expression 'jouer au violon' ('playing the fiddle'), meaning to masturbate, the German form of which is cited by Freud in *Totem and Taboo*. According to this logic, the picture and its title can be interpreted like one of Freud's dreams, as a radically overdetermined manifestation of unconscious desires, expressing in more encoded form what is explicit in the title, at least, of Dalí's *Great Masturbator*. At the same time, it might well be understood as a fantasy construction, specifically a masturbatory fantasy, a kind of secondary elaboration of the sort of dream image that Freud discusses in *The Interpretation of Dreams*, whereby 'The genitals can

also be represented in dreams by other parts of the body [. . .] the female genital orifice by the mouth'.[109] The merging of mouth and genitals, face and torso, is an archetypal form of dreamwork distortion, where representation is governed by principles of condensation and displacement. Lacan has aligned the processes of condensation and displacement with metaphor and metonymy respectively, and Magritte's image follows both kinds of figurative logic in its troping of face into body. The sexing of the facial image is both a metaphorical substitution (the face is rendered as the erotogenic body through a logic of visual similarity) and a metonymic combination (the body is displaced on to the face that is contiguous with it). What is standardly hidden from view (clothed or below the frame in the portrait) is thus revealed, and with it the erotic potential of the face that, in life and art, is so brazenly exhibited for all to see.[110]

On one level, *Le Viol* can undoubtedly be understood as a typical act of Surrealist phallocentrism. The female face is exposed as an act of naked exhibitionism that inspires the phallic pleasures of the beholding gaze (axiomatically male for the purposes of the exhibition of Surrealist fantasy). Indeed, the exhibit can be said to include the showing of the male sex that it serves, as the mounting of the body/face on an elongated neck gives it a priapic form. The phallic violence of the title thus enters into the picture and penetrates the body on show on a more iconic level. The female figure is not given agency in this exhibition; the nipples she has in place of eyes are blind, and the genital mouth shows no sign of opening. As is so often the case in the images of women propagated by the men of Surrealism, this exhibitionist is dismembered, blinded and gagged. At the same time, the silencing of the icon suggests a crisis in the purpose she is supposed to serve by answering the question 'What is Surrealism?' Neither is the male gaze granted open satisfaction here. The protuberant eyes may be unseeing, but they have a way of fixing the viewer with their blind stare, thereby daunting the gaze. Like the closed mouth, they seem to challenge and resist the fantasy of visual violence that might be done to them. In this, they could be said to function in the way that Freud describes for the shocking revelation of the genitals as an apotropaic challenge, working like the evil eye to fend off the menace in the gaze of the other.[111] As the figure blindly looks at you looking at it, it has a mirroring effect that also suggests a blinding of voyeuristic pleasure. As Elizabeth Wright argues in her reading of the image, the viewer 'is caught out by his own looking; his eyes see themselves seeing themselves'.[112] If this is a latter-day Sphinx, then part of what it might thus impart is the blinding that links Oedipus

to the fate of the voyeurs of myth. Following a Freudian logic, this means that the image is less the phallus than a fetishistic substitute for it, and so represents the trauma of castration that is at the base of all fetishistic pleasures. Indeed, the exaggerated cavity at the base of the throat, forming an apparent supplementary orifice, perhaps suggests just that. The wig that frames the body-face stands for the idea of an artificial prosthesis fashioned as a cover for what has been cut or lost, yet drawing attention to the loss by its excessive styling. The cutting and pasting of the female body in an act of phallic exhibitionism is thus also a cutting of the phallus. Magritte's exhibit both draws viewing pleasure and exposes and so, in every sense, frames it.

A similar process can be seen at work in his *Les Liaisons dangereuses* ('Dangerous Liaisons' (1936)). The picture produces a complex relay of body images and looks and an interplay of two- and three-dimensional illusions. It breaks the exhibitionistic promise of the full-frontal female nude by having her hold a mirror in front of her torso, but the mirror also reflects a somewhat more revealing oblique view of the same body, as though she was also standing, in a different pose, in front of the mirror. This frame within the frame, projecting an image within an image, is a characteristic use of the *mise-en-abyme* structure on Magritte's part. The viewer, presented with a pictorial mirror, is at once put into the position of the frustrated voyeur and of the half-hidden exhibited body that offers no gaze, 'as if she did not want to be seen and to see that she is seen', as Foucault argues in his reading of the work.[113] He goes on to note that the lure of the reflections in the picture is also upset by the fact that the figure's left hand is not reproduced in the shadow that she projects on the wall behind her. It is the same representational structure as can be observed in *La Représentation* ('Representation' (1937)), where a nude image of the belly and thighs of a woman is set in a frame shaped around the body image. Magritte photographs the original canvas being held in front of the naked legs of Irène Hamoir, and thereby suggests that the representation is nothing but a cover for the real thing, which is always concealed tantalizingly behind and beyond it. The image was intended for a one-man show in the Galerie Gradiva,[114] which never came about in the event. As in *Le Viol*, the exhibitionistic picture is haunted by a sense of lack in what it exhibits and reflects that lack to the viewer.

The Surrealists were great enthusiasts for the sort of masterpieces of the past that they saw as sharing their anti-realist vision of life and art, subjecting their representations to psychic transformation. Two such images, achieving forms of metamorphosis, or what Dalí called

psychic anamorphism, are Dürer's engraving *Melancholie* ('Melan-
cholia' (1514)) and Holbein's double portrait *The Ambassadors*
(1533). Both images employ allegorical techniques to represent the
melancholic underlay of worldly vanities. Dürer's angel of melancholy,
surrounded by the fragments of human ideas, arts and architectures,
is an emblematic forerunner of Klee's *Angelus Novus*.[115] In *The
Ambassadors*, the display of masculine power is subjected to the
blind gaze of the skull as *memento mori*, and it thus connects with
the Surrealists' project in ways that they appear to overlook. Just as
Holbein's picture incorporates, through the trick of anamorphosis,
an image of the skulls that are concealed in the posed and costumed
bodies on show,[116] so *Le Viol* can be said to include in its blind
stare the melancholic gaze of death. In this sense, *Le Viol* can be
understood as an allegory in Benjamin's sense, an image cut out of
the normal view of things and marked by a melancholic sense of
the subjection of all powers and energies, not least virile power, to
transience. It foresees, that is, another act of transformation of face
and torso through the splicing of an image of the skull on to the
naked female body in Magritte's later picture, *The Spoiler* (1935),
which also appeared as an emblematic manifestation of the move-
ment on the cover of one of its journals.[117] If Lacan is right in reading
The Ambassadors as an exhibition of phallic power subject to the
death's head as a mark of castration,[118] then a similar logic can be seen
to apply to the exhibitionistic spectacle of the Surrealists. Indeed,
it is the sort of dialectical logic that draws Lacan to participate in the
manifestation of the Surrealist project by publishing in the journal
Le Minotaure. Magritte's images embody just the contradictory
combination of imaginary appeal (what Lacan calls 'the lure') and
daunting symbolic threat that informs the Lacanian theory of the
dialectic of eye and gaze. That is, what is exhibited here is a trap for
the viewer, an apparent image of his eye's gratification, which, how-
ever, exercises the power of the gaze, at once erotic and deathly,
which is always beyond the viewing subject. Violation is a two-way
street in the exhibitionistic fantasy works of Surrealism. And their
exhibitionism is only one of the more scandalous forms of a structure
that is at work across the various manifestations of the avant-garde.
As we have seen, what is made so provocatively manifest is always
also both a cover and a vehicle, however involuntary, for more
ambivalent provocations on the level of latency.

3

Writing the City: Urban Technology and Poetic Technique

Simultaneism

A part of the lure and of the challenge to viewing that is exerted by the Surrealist works of such as Magritte is a technical one. His techniques of multiple perspectives, of false frames and mirrors, and of hyper-real reproduction are strategically aimed at challenging conventional notions of painterly workmanship and displacing painting into the paradigm of the photographic reproduction. The hallowed art of painting is made here to adapt its virtuoso possibilities to its own self-exposure as technique, and thus as subject to the Age of Technical Reproducibility. When Magritte, in his *La Durée poignardée* ('Stabbed Duration' (1939)), has a train caught emerging from a hearth, he emblematically represents the invasion of technology into the domestic framework of the artist and the anachronistic, pre-industrial expectations of the viewer, as marked by the old-fashioned technology of the clock on the mantlepiece. In a complex visual pun, the fire-driven train is displaced by a perverse metonymic logic into the fireplace, and the clock marks an arrival that can never be timetabled. The painting can only freeze-frame its representation of the technology of time-travel, along with the workings of the clock; but it thereby exposes the resistance of the painterly medium to technologies of movement and change. Magritte's canvas with its rigidly simultaneous representation of inner and outer dimensions thus conducts an ironic debate with the more excited versions of simultaneity that we encountered in the Futurist project.

The experience of time as radical acceleration and of space as foreshortened to the point of virtual simultaneity fuels a cult of

simultaneous representation in the art of the avant-garde. But the modes of simultaneity are fundamentally divergent. Where the Cubist dismantles the conventional view of a stationary object by opening up perspectives that could only be experienced as a succession over time, the Futurist applies a multi-dimensional aesthetic to the representation of dynamic objects. The first defamiliarizes the time-honoured method and perspective of still life, portrait and genre picture by shifting the focal point, but none the less retains the effect of fixture proper to those genres; the second seeks to incorporate the effect of movement as force into the image. In a painting like Duchamp's *Nu descendant un escalier* (1912), these divergent models are combined; the successive stages of the moving figure are represented in the style of Muybridge's serial photography, while the figure itself is rendered in the terms of Cubism's new aesthetics, where the analytic, abstracting methods of still life and portraiture converge. The picture scandalizes the academic tradition of the nude, analysing the naked body for its mechanics of movement in a sort of abstract anatomy, and thus disrupting the aesthetic and erotic study of the human form. Duchamp integrates a technological view of movement (on the model of Muybridge's chronographic camera) into his painterly perspective and into the representation of a figure moving from floor to floor in a pre-technical mode (rather than by a lift that would move for the figure). His conflation of Cubist and Futurist styles shows that the technological apparatus of photography can work only to a limited extent as a model for the semi-abstracted representation of the workings of the body in the painterly image.

What the Duchamp and the Magritte images have in common is a problematic relation to the project of simultaneity. Both bring technology into domestic space and reproduce forms of technical reproducibility in their projection of movement into a spatial frame. Magritte's freeze-frame and Duchamp's serial frames both represent the limitations of the technical reproducibility of movement through space and over time in the mode of painting. Their espousal of photographic paradigms exposes the limitations that also attach to technical enhancements; the nude descending the staircase and the train entering the living-room are only properly reproducible through the technology of motion pictures, and the appeal to still photography, even in its serial forms, remains lodged in the aesthetics of the singular rather than the simultaneous scene.

The cult of simultaneity in avant-garde aesthetics thus appears to be marked by the problem of fixture. If simultaneity is perhaps the key battle-cry of the avant-garde, signalling its rationale of

cutting-edge mobility, then its subjection to hold-up seems to represent a fundamental threat to the whole idea of the avant-garde as movement. The urban interior is a privileged scene for this ambivalent tension between technological mobility and conventional fixture. The transportation and informational systems of the city impinge upon it, but are also relatively excluded by its domestic framing. The fixed irruption of Magritte's miniaturized train into the living-room is a counter-image to its proper dimension in the urban context: full-size, on track and in, or bound for, a station. This free-wheeling but transfixed machine stands in an ironic relationship to those forms of technology that find their place in the domestic scene and are also devoted to overcoming the bounds of space and time: the telephone, the radio, the typewriter, the camera or the phonograph. These are machines that enable the reproducibility of communication, social and aesthetic, and thereby at once open up new possibilities for artistic interaction, but also represent a threat to its conventional methods.

If photography presents an ambivalent new model for painting, a stimulation and a threat, then mass communication of sound and writing has the same mixture of implications for literature. As Magritte's *La Durée poignardée* reproduces the studied aesthetic observation and privacy of an old master interior, only to scandalize it with an unscheduled technological intervention, so the experimental literature of the early twentieth century introduces the disruptive effects of new technologies of the recording and reproduction of the voice. Nowhere is the urban, technological challenge more keenly felt than in the domain of poetry. Until the Paris poems of Baudelaire, poetic convention had demanded a retraction from the urban scene as a place of the undifferentiated masses rather than of the privileged subjective experience associated with the poetic mode. Poetry, like painting, had a particular attachment to the idea of creativity as an individual act, to an uninterrupted privacy of space away from the urban crowd – the poet's study or the painter's studio – and thereby to the principle of aesthetic autonomy. Poetry relied perhaps more heavily than any other art-form on the idea of originality, and so for poetry the culture of the urban masses in the Age of Technical Reproducibility represents a particularly acute form of challenge, not to say threat. The ideas of transportation, transformation and communication associated with the inspirational individual's wings of song are revolutionized by their mass-produced, technological equivalents. The experiences of translocation and dislocation associated with a new age of travel within and between cities re-energize but also traumatize poetic form and diction. The dialectics of mobility and

fixture that characterize Duchamp's nude and Magritte's train, the body reproduced as a machine and the machine entering the space of bodies, are transferred to the internal and external scenes of avant-garde poetry. At its extreme, the new poetry realizes an instrumentalization of this most autonomous medium, making poetry into a machine of political intervention. This is the poem as instrument of war in the hands of Marinetti. But the broader picture is characterized by a particularly acute dialogue between the demands of the new and traditional objects and methods, between the icono-clastic animus of the avant-garde and the more recuperative strat-egies of Modernism.

The image of fixture can be located between two models. On the one hand, there is the idea of duration, the holding of experience in time that is theorized by Bergson; on the other, there is a more traumatic view of momentary impact, as theorized by Benjamin in the experience of shock. Both hold up the run of things, the one in a more idealized sense than the other. Bergson's theory of duration tends to support the projects for a recuperation of time associated with the master-works of Modernism (especially Proust's *A la Recherche du temps perdu*), while Benjamin's focus on shock effects tends towards more avant-garde strategies. In fact, both thinkers work more dialectically than this. That is, Bergson's duration is more properly a theory of the relative difference inherent in identity over time, rather than one of selfsameness or the possibility of total self-recollection against the ravages of time. And Benjamin's notion of shock is tactical, a necessary form of traumatic breaking of conven-tional routines, an act or experience of secession that prepares for a more aesthetically and politically adequate encounter with the conditions of modernity; hence his inclination and ability to read the more attenuated forms of breakage with past practices in Proust, as well as the more properly avant-garde character of Brecht or the Surrealists.

The poems to be considered in this section can be located in the dialectical space between duration and shock, and so between the more inward, recuperative strategies of Modernism and the more outward, aggressive strategies of the avant-garde. They are all city poems work-ing on an epic scale. Their assumption is that poetry and the city are inimical, yet that the poet must adopt, however difficult, a relation-ship to urban culture. The titles of the poems in question mark the contours of the difficulty. Federico García Lorca's cycle *Poeta en Nueva York* ('Poet in New York') derives its initial energy from what,

by conventional standards, is an oxymoron: the poet has no place in the definitive metropolis of the early twentieth century. As much as New York serves as a beacon of urban modernity for the avant-garde, it also represents perhaps the most monumental challenge to its medial and generic resources, threatening to lure the artist's acts of avant-garde reconnaissance into disorientation.

This sense of strategic misplacement also resonates in different forms in Guillaume Apollinaire's *Zone* ('Urban Zone'), Georg Trakl's 'Abendland' ('Occident/Evening-land'), and T. S. Eliot's *The Waste Land*. The Western city, as putative epitome of advanced, technological civilization is paradigmatically located in a place of passage (a zone), a place of emptiness and cultural rejection (a wasteland), and a place of decline and incipient darkness (an evening-land). Each of the titles asserts a programme of dialectical tension between familiar grounding, a durable sense of located identity, and an alien or dislocated condition. The familiar place of the occidental poet is transformed by passage into strange, new locations. As indicated by the model name New York, the new place of the poet rests on an impossible combination of new and old. In this place the exemplary poetic topos of dawn (in the poem 'La aurora' from *Poeta en Nueva York*) has thus been displaced into an alienated new time-space. The poems are in locations that at first appear to have a stable carto-graphical identity (New York, an urban wasteland; the Occident, an urban zone), yet open up into a more transitory space of meaning on closer inspection. New York is a place of migratory and fugitive experience, one that moves between the native and the foreign, the archaic and the hyper-modern. The wasteland is in fact a waste land, not reducible to the confined space set apart for wastage, but by virtue of the separation of the place and its epithet, opened up in its meaning, potentially total in its extension. 'Abendland' is not simply readable as Occident (the lands to the West, where the sun sets) but, after Heidegger, as the 'Land des Abends',[1] irreversibly placed, by a metonymic logic, in the crepuscular, temporal site of evening. It is a falsely fixed orientation, marking indeed an absence of the Orient, the antipode upon which it relies for its sense of place. And *Zone*, referring at face value to the locatable space of an urban hinterland on the metropolitan map of Paris, asks, like 'Abendland', also to be understood as a time-zone, a place where time has a dialectical set-ting, at once fixed and transitional. In each case, then, ostensibly durable identities (the poet, the city, the West) are subjected to the shock of strategic displacement. In an age where the established cat-egories of time and space are being remapped according to theories of

relativity, New York, Paris, London and Berlin, the cities of avant-garde poetry, are capital sites for the cultural negotiation of the new networks of strange relationship and relative estrangement.

In their spatio-temporal co-ordinates, their treatment of objects, and their enactment of intersubjective relations, the four texts to be read here are divided between the threat – or exhilaration – of disorder and the quest for new forms of poetic order. In her reading of Eliot's *The Waste Land*, Maud Ellmann suggests that the poem is haunted by the sort of failure of definition that is understood by the term 'abjection'. She aligns the representation of bodily waste, odours and leakages, and of the permeable boundary between life and death, with the citational structures of the text, its parasitic incorporation of other texts and its internal 'echolalias'.[2] In *The Waste Land*, the threats to categories of cultural, corporeal and linguistic distinction are subjected to the sort of ritual structure that is designed to give definition to the abject, in the shape of a synthetic mythology of sacrificial regeneration. However, this system for the functional disposal of cultural and bodily waste is always set to be abjected in its turn by the sheer incontinence of the text. Abjection, according to this analysis, is a thing of visceral disgust, but it also offers potential for liberation from established constraints. The idea of the iconoclastic sacrifice of the past for its own sake, the unredemptive letting of blood and the smearing of excrement that characterizes the most extreme practices of the DADAist wing of the avant-garde, is one of the impulses that run through the poems to be considered here, albeit under constant pressure for ritual control. The attempts at constructing new mythologies for the urban age expose an ultimately irresolvable tension between abjection and redemptive order, waste and fertility.

Apollinaire: *Zone*

Apollinaire's *Zone*, written in 1912, is one of the works that, like Picasso's *Demoiselles d'Avignon* or Marinetti's Futurist manifesto, is taken to be a foundational statement of the avant-garde. Apollinaire was in many ways the self-styled master of ceremonies of the early avant-garde, a publicist as much as an activist, and not least the reviewer and propagator of the pioneering experimental images and texts of both Cubism and Futurism. His appeal for new forms of poetic expression takes its cue from the productions of the machine age, from new modes of transport, communication and scientific

investigation. As propounded in his lecture, delivered in 1917, on 'L'Esprit nouveau et les poètes' ('The New Spirit and the Poets'), the new technologies promote possibilities at once for the virtually boundless, telescopic synthesis of experience, for the poetry of the urban crowd and internationalism, and for analytic attention to the microscopic details of everyday life. The aeroplane is the model for new possibilities of poetic flight; the telephone and telegraph the models for a new simultaneity of spatial experience; newspapers the model for the collection of diverse events and sites into a single prospectus; radiography the model for new techniques of introspection, akin to the analytic anatomies of Cubism. The poet is conceived as a new-age alchemist and prophet, an inventor and technologist set to adapt the motive powers of the phonograph and the cinema to the traditional stasis of the poetic world: 'The poets wish to tame prophecy [. . .] They wish one day to machine poetry ['machiner la poésie'] as the world has been machined.'[3] Above all, the poet is placed in the mobile state of the vanguard, a technologically enhanced agent of reconnaissance and forward positioning in new territories, especially those to be discovered in urban and industrial zones.

The original title of *Zone* was *Cri*, and it has something of the character of a battle-cry publication, an impassioned challenge from the vanguard both to his own previous poetic praxis and to the genre of poetry at large. It is the latest of Apollinaire's poems to be included in the collection *Alcools* of 1913, but it is set at its start in the style of a poetic manifesto. It is a provocation in its form and content, an announcement of aesthetic intent that looks beyond the often comparatively conventional and elegiac cocktail of the *Alcools* collection to the more radical *Calligrammes*, which would be written over the next three years. The 'zone' in question suggests an approach to the more focal points of the metropolis through the indeterminate suburban fringe around the city wall, and thus, on an allegorical level, a tentative negotiation of the new poetic city-space. But the poem is in fact anything but a peripheral transition. The 'zone' of the title is a strategic misplacement, a cover for precipitate entry into the epicentre of the city, thus setting off a complex sequence of disorientations.

The poem, which is designed as a clarion call for innovation, opens the collection with an ironic assertion of an ending: 'A la fin tu es las de ce monde ancien' ('In the end you are weary of this old world' (1)).[4] In the style of Eliot's 'East Coker', Apollinaire finds his end in his beginning. The teleological model of passage from beginnings to ends that is proper to the quest model of epic poetry is here

suspended in favour of a more mobile and openly adventurous form of progression. The much-vaunted abandoning of the conventions of punctuation is a technical aid to this less regulated form of exploration. The lines of the poem and the images, people and objects within them are compiled according to a principle of montage, subjecting the reader to unexpected encounters. What is suggested is a virtual simultaneity of experience, whereby the successive verses are felt to be proximate in their significance, yet uncertain in their relation. The opening line invokes both time and place as categories of contradiction, as simultaneous oppositions that are mutually interdependent: it calls an end at its beginning, and identifies not the modern world of the urban zone but 'ce monde ancien' as the present place of the poem. Throughout the poem, the pattern introduced here of a dialectical negotiation between duration (the dogged durability of the old world) and the shock of change (the misplacement of the world of antiquity into a modern urban zone) will operate in a sequence of variations, recyclings and novelties, and this on all levels of form and content.

One such level is that of personal identity, where a durable sense of self is subjected to a series of modalities, both shocking and more nuanced. Thus the split in the temporal and spatial zones of the poem is reflected in the self-interpellation of the poetic subject in the second person; this is a poem that will adopt a complex system of voices and personae to accommodate its explorations of new terrains. It moves in the second line to the very emblematic landmark of the modern city, the Eiffel tower, and switches its address to the apostrophic 'Bergère ô tour Eiffel' (2). The monumental epitome of the communication age is ironically miniaturized and dressed in the prettifying clothes of the Arcadian shepherdess, a cliché from the pastoral tradition, mocking the incorrigible attachment of the poetic voice to the generic conventions of the 'monde ancien'. The technological communications tower becomes a shepherdess calling her flock, and that flock not the mobile throng of people and vehicles that circulate at her feet, but, by a metonymic slip, the bridges that sustain their flow. By a similar process of slippage, the address of the second person in the third line could be read either as a reprise of the poet's durable ennui or as a merging of his resistance to a Classically ordered world with that of the tower that he has just misappropriated in a mock-Classical allegory. The confusion of address between poetic subject and poetic object is then carried over into the ironic provocation of addressing Christianity in the personal 'tu' form as the single thing that has achieved the paradoxical status of *remaining*

new (7). First, the putative only abidingly new thing can be vouch-
safed only by means of a comparison with another such thing, and
a plural thing at that – aircraft hangars. Secondly, the 'tu' form
assigned to Christianity resonates still in the 'toi' of line 9, who is
ashamed of entering a church, and whom logic would have us read
as the poet. The tantalizing possibility remains that the apostrophic
intimacy with the Christian faith, undermined by the poet's con-
fessional shame, has exposed Christianity itself as ripe for a confes-
sion it cannot undertake and subject to displacement from its place in
the cityscape. In both the Eiffel tower and Christianity, an object is
addressed as a fixed point of reference for the poet's explorations,
but both are potentially implicated as unreliable constructs, put in
question by the divagations of the itinerant subject who calls upon
them for a durable sense of location. The pronoun 'tu', and the things
to which it is attached, are not reliably self-identical.

If the errant poetic subject can find no shelter, no place for a
confessional voice, in the church, the street leading through the 'zone'
offers a conduit for a powerful synaesthetic clamour to bear his city
poem along: the poetry of the street posters and prospectuses that
the latter-day *flâneur* claims to read, but that sing out loudly, either
in response to, or in spite of, his reading; the clarion call of the sun
on the street; the marking of time by the passage of the commuters,
the rabid barking of the bell, and the siren; the strident cries of
signs. While the street seen that morning is introduced in the past
tense, it leads by association into a street from the subject's childhood,
announced as present both spatially and temporally by the phatic,
even performative, 'Voilà la jeune rue' ('Here is the young street'
(25)). The poet cannot remember the name of the modern street from
that morning, but it serves to recall a street from another time and
place and the name of 'le plus ancien', the oldest, of his childhood
friends, which he does remember. This in turn gives him access to the
sanctuary of the church from which he had felt excluded and a litany
of assertions of metaphysical presence, of resurrection and duration,
each introduced by the phatic 'C'est'. The culmination of these is
Christ as a record-breaking aeroplane *avant la lettre*, and the school-
child's vision of him condensed in the remarkable 'Pupille Christ de
l'œil' ('pupil Christ of the eye' (42)), which reads as a punning crys-
tallization ('pupille cristallin') of Christ in the pupil of the eye of the
pupil. The metamorphic vision leads in its turn to the metamorphosis
of the twentieth century into a bird and then the first aeroplane,
ascendant after the model of Christ, and attended in its elevation by
the great levitators of the Old Testament and Classical mythology

and by birds both real and fantastic. Only in the final arrivals does the vision of universal ascent appear troubled: the phoenix born out of its own burning breaks for an instant the duration of the vision, veiling it in ash; and the sirens transformed into birds may have left their perilous straits, but their seductive song still seems dangerous for the epic vision of heroic progress.

In the event, the transcendental vision is rudely broken. The siren calls were perhaps merely a prelude to the return to the alarms of their more mundane, technological equivalents. The 'Maintenant' ('Now' (71)) that cuts the machine-age version of mythical elevation brings a more sober form of presence to bear, with a return to a more errant and destitute mock version of the Homeric quest. If the vision worked through the co-option of mythological beasts and narratives, the return to the present is marked by an empty counterpart to that process as the earlier images are recycled in a meaningless form of mechanical poetry. The metaphor of the flocks of bridges is repeated by a process of metonymic transfer, as mediated by the endless circulation of the Parisian traffic down streets and over bridges. The buses are now flocking by the subject's side: a mockery of the birds that flocked around the twentieth-century aeroplane. And the shame that kept the subject out of the church is invoked once more, attached here to the olden-times fantasy of entering a monastery. The subject in search of a secure place to enter can only make a mockery of himself and his attempts at origination of new meaning, undertaking empty resurrections of past acts and images. The scene is conceived as a picture hanging in a museum, and it prompts a gallery of such images, of the subject seeing himself, seeing others and objects, and being seen. The poem invokes a sequence of past places as present; and as the poet sees himself in these images, so he also sees himself as possessed by the image that sustains him. As he was watched by the windows in his first invocation of a church that might give him a place to be, so now the window of St Vitus in Prague watches him in his own image as a sort of *Doppelgänger*. The identification with a crazed Lazarus offers at best a questionable promise of resurrection. The autoscopic subject is split by the system of surveillance into the separate grammatical persons of 'je' and 'tu', and can find no steady community with his friends in the first person plural. The images lead him kaleidoscopically from place to place, from happiness to fear and madness, proceeding and reversing, one minute itinerant, the next 'under arrest'.

The image sequences of the poem represent a dialectical state of duration in transience; the subject is transfixed by past times that are,

however, defined as lost: 'j'ai perdu mon temps' (118). The passage
of objects and scenes is always set to be overcome by abjection,
flooded by the fluids of water, blood, tears, milk and alcohol. Blood
and tears (correlated through the resonance of 'sang' in 'sangloter'
(119)) are strung uncertainly between wastage and suffering (the
incontinent menstruation of the refugee women – 'les femmes sont
ensanglantées' ('the women are bloodied' (81)) – and the promise of
redemption (the inundation of the blood of the Sacré-Cœur). And
milk, too, gives a degree of sustenance to the children of the displaced
immigrants, but is also delivered mechanically by the milkmen, mark-
ing the return of the morning for the errant subject. The subject
drinks not the morning milk of childhood but the fiercely dialectical
substance of alcohol: 'Et tu bois cet alcool brûlant comme ta vie / Ta
vie que tu bois comme une eau-de-vie' ('And you drink this alcohol
burning like your life / Your life that you drink like the water of life'
(148–9)). The alcohol follows the model of the self-burning but self-
engendering phoenix; it is cast in a chiastic structure that embraces
the dialectical forces of consuming or being consumed. Alcohol is the
allegorical substance of this poetry, designed to resolve the other fluids
that circulate in it. It operates with all the dialectical complexity of
'Aufhebung' in its different senses. It is at once destructive, preservat-
ive and transformative. It is ready to sublate past forms of experience:
to burn, transform and revivify. At the same time, the transportations
that it affords are unreliable. Alcohol may be construed as essence,
but it is consumed in a variety of more derivative forms. The powerful
chiasmus is also broken down by a more circular logic, by the return
of 'vie' in 'eau-de-vie'; this is either a resolution of the allegory into
the essence of life or the resolution of that fantasy of life as essence
into an empty form of punning repetition. The alcohol that might
embody the transubstantial blood of Christ is, on the model of
the fetishes that the poet has around his bed, a derivative substance
sustaining an uncertain cult of life, a drink in a bar to help him
sleep.
 The chiasmus arguably represents less an emblem of poised resolu-
tion than the epitome of the structures of switching and reversal that
run through the poem and question the ability of the errant poet in
a post-theological city to construct a meaningful quest narrative. The
poet, who, like the un-dead, walks the streets of the urban zone at
night and retreats to his bed at dawn, remains unredeemed at the end
of his quest. In the abrupt, paratactic effect of the final line, 'Soleil
cou coupé' ('Sun cut neck' (155)), sunrise, as birth and incipient
elevation, is figured instead in the mythological terms of sunset (the

sacrifice that must be sustained in order to lead to the putative
rebirth of dawn). The conventional cycle is as drastically reduced as
the grammar of the line. The poem, which started with a declaration
of ending, here ends with a beginning collapsed into its own closure.
The punning that had operated as a potential production of new
meaning and relation in the poem (finding crystal in the eye of Christ,
'argent' ('money'/'silver') in 'Argentine' (125), and 'vie' in 'eau-de-
vie') is now catastrophically undercut by the more brutal paronomasia
of the 'cou coupé', which seems set to flood the world with unredeem-
ing blood. The end is a shocking, suicidal cut to the forms of, albeit
provisional, duration that had been ventured in the body of the poem.
The project for the machining of a new urban poetry is thus trun-
cated here, at its beginning, by an image redolent of the prototypical
public killing-machine of Paris, the guillotine. Having figured the city
throughout in the form of more or less distressed bodies, the poem
takes the capital as head at its end and decapitates that trope. The
revolutionary possibilities of this programmatic poem of the avant-
garde are traversed by a trenchant ambivalence.

Trakl: 'Abendland'

Georg Trakl is taken to be a poet of private, deeply hermetic, land-
scape poetry rather than one of the expressly urban poets of German
Expressionism. While Expressionism found its base in city culture,
and especially in Berlin, Trakl pursued the backward-looking role of
the *poète maudit*, styling himself as the leprous or benighted prophet,
displaced from the habitations and conventions of the masses. While
other poets, like Heym or Lichtenstein, more easily attributable to
the concerted movement of Expressionism, treated the big city as
their prime object, entering into it energetically as a paradoxical site
of poetic exhilaration and abjection, Trakl largely views it from afar.
Where his poems do turn to urban scenes, it is almost exclusively
the provincial and time-locked town of Salzburg. Yet it is Trakl who
arguably offers the most productive basis for comparison with the
epic forms and the thematics of quest and displacement in the other
city poems treated here. Like Apollinaire, and in a similarly messianic
style, Trakl identifies the possibility of a poetry of urban machinery;
but here the redemptive possibilities of the city are more difficult to
find. The city is figured as a place of madness, alienation, abortion,
disease and prostitution in Trakl's poem 'An die Verstummten' ('To
the Silenced' (1913)); but the final lines suggest the work of a sort of

underground cell of avant-garde activists engaged in the construction of a redemptive head out of hard metals.[5] That the work on this machine-age golem has to be conducted bleeding, in darkness and silence, away from the magnetic lights of the city, indicates the profound self-estrangement involved in this form of underground resistance to the perceived pathology of metropolitan culture.

The ambivalence already identified in *Zone* is no less profoundly at work in 'Abendland', the poem in the epic style that Trakl wrote in 1914 on the occasion of a brief stay in Berlin. As we have seen, the poem's title collocates the dimensions of time and space. It establishes a kind of time-zone, taking a neutral category of spatial organization 'Land' and territorializing it as belonging to the evening. If this deconstructive play with the title-word seems somewhat fanciful, we shall see that the resonances of the title in fact prefigure the fundamental structure of the text as a whole. A negotiation between the dimensions of time and space runs right through the poem and defines the reading of it. Time and space are invoked here at once on a personal and on a collective level. The land of evening is a personalized or case-historical space and time for Trakl's poetic persona, but also a political historical place and time, Europe on the eve of the First World War. While the poem operates on both contemporary and primordial levels, it is also, in formal terms, a hybrid work, adopting at once a rhetorical voice with archaic resonance and a semantic and syntactic audacity that locates Trakl at the cutting edge of avant-garde poetic experimentation.

The scholarly tradition that sees Trakl's poetry as purely personal and profoundly hermetic would deny any historicity in this work. But Heidegger contradicts this view of Trakl's 'innermost lack of history'; for him, while the poetry eschews any kind of historiographical narrative, it is imbued with a deep sense of the history of humankind.[6] In fact, there is much that would seem to make 'Abendland' a poem of its age, correlating with that age's view of its history. Part of the poem's claim to a representative character has to do with the subsequent career of the word 'Abendland'. As Trakl was writing the successive versions of his poem in 1914, so Oswald Spengler was sketching the work that, in the post-war world, would irretrievably associate 'Abendland' with the mode of declension. As 'Untergang' is another watchword of Trakl's poetry, it might seem tempting to correlate the two models of decline. Through the historical lens of the First World War and the textual lens of Spengler's *Der Untergang des Abendlandes* ('Decline of the Occident' (1922)), Trakl's poem seems to assume a prophetic, apocalyptic character.

On one level, Trakl's poem seems like an epic premonition of the end of civilization as his age has known it. The stony latter-day cities of the plain appear to prefigure the stone cities of Spengler's treatise, petrifaction as the terminal phase in his biomorphic model of cultural development.[7] But this would imply an opposition between the urban and the natural that caricatures their relationship in Trakl's writing. The poetic persona of Trakl's text is as estranged from the natural landscape as from the stone age of the city; indeed, petrifaction is a condition that afflicts life in the poetry in natural and domestic scenes as much as in urban. Cultural pessimism may have historical resonance in Trakl's work, but it is an adjunct to a more metaphysical sense of melancholia at the decline and fall of the human condition, one that obtains as much in the archaic alternative realities of his poetry as in its representation of urban modernity.

While there is undoubtedly an elegiac tenor in Trakl, as in much of the poetry of his time, this is constantly transformed by the radically forward-looking character of his poetic diction. 'Abendland' takes to the limit many of the defining features of the Modernist aesthetic: its formal experimentation, its concern with inwardness and the liminal states of human consciousness, its challenge to the assumptions of a unitary voice and perspective in the order of mimesis. It is these characteristics that lead us to read 'Abendland' alongside Apollinaire's *Zone* and, in particular, *The Waste Land*. While Eliot's text has a more epic scale, more self-consciously varied tonality, and more multivocal organization, it shares certain of the distinctive features of 'Abendland'. The first of these is, of course, its title, whereby the land of human culture has been colonized by its waste and shadow parts, its no man's land. Eliot's poetic landscape is more polemically one of cultural ruins and relics than is Trakl's, but the two poems are characterized by a strikingly similar attempt to construct new poetic meaning out of the evacuated space of poetic convention. 'The nymphs are departed' (179) for both poets;[8] as Trakl has it in his poem 'Psalm' (1912): 'Die Nymphen haben die goldenen Wälder verlassen' ('The nymphs have left the golden woods').[9]

In both cases, the evacuation is a sign of violation, sexual and poetological, and their respective texts struggle with attempts to redeem the violence. If the departed nymphs have emptied the lyrical landmark of the Classical and Romantic woods of their mythical life, then they are replaced by another mythopoeic presence. Trakl's hyacinth grove and Eliot's hyacinth garden are, on the one hand, sites of mythological sacrifice, the place where the beautiful youth Hyacinth has been slain, but they are also sites of restoration, where

the blue flower of poetic meaning may be cultivated. Both 'Abendland' and *The Waste Land* are thus caught between a profound historical atrophy, as witnessed by Trakl's bare trees and Eliot's 'withered stumps of time' (104), and a quest for regeneration out of their land-scapes of stone, shadow and waste. The 'withered stumps of time' may yet function as a type of landmark, giving some form, however wasted or effaced, of historical guidance. As we shall see, one of Eliot's voices makes what seems like a programmatic poetological statement: 'I can connect / Nothing with nothing.' (301–2). Where the cultural landscape offers up only shards, the poet's latter-day quest for the grail has to be radically modified, but not necessarily negated. The despair of being able to make no connection can equally be read as the assertion of a new mode of production, connecting forms of nothing, fragments against ruin. As idiosyncratic and ulti-mately incommensurable as the poetic identities of Eliot and Trakl may be, they share in this fundamental paradox of establishing con-nections between what has been emptied or extinguished.[10] It is not for nothing that both poets adopt as a persona the mythical figure of the blind seer Tiresias, one who may conjure new visions out of what has been effaced.

If the encounter with Eliot appears at face value somewhat unlikely, German Expressionism seems to provide a more obvious frame of reference. Expressionism is a profoundly reactive phenomenon; it challenges aesthetic conventions of externality, whether in the mode of Realism or that of Impressionism. While Impressionism relies on such contingent effects of outward appearance as the play of light and shade, Expressionism insists upon the projection of subjectivity into the objective world. Its iconic image is Edvard Munch's *Scream* (1893), the human subject at its centre, visually distorted by an extreme act of self-expression, and its disfigurement forced outwards as though through visual sound-waves into the contorted lines of the surrounding landscape. The shock waves from Munch's picture can be traced throughout the iconography of German Expressionist art, visual, musical and textual.

In the context of poetry, the aesthetics of the shock wave imply a radical challenge to conventions of form, according to such watchwords as *Ballung* ('concentration') and the *Simultangedicht* ('simultaneous poem'). *Ballung* signifies a compaction of poetic energy without regard to formal regulation, the *Simultangedicht* an affiliation to the cult of simultaneity. The aim is to transform the fundamentally linear medium of the poetic text into the spatial coin-cidence of the image. A key part of this move from the diachronic to

the synchronic is the *Reihungsstil*, whereby the poem is presented as a montage of paratactic lines, without the conventional cohesion of syntax or narrative development.

These principles of poetic intensification can all be applied to Trakl's poetry. In his early works, they appear in a form that is also recognizable in, say, the poetry of Georg Heym, fitted ironically into such conventional shapes as the sonnet. In the later poetry, however, Trakl again becomes less a standard example than a paradigm, as he takes the principles of simultaneity and compaction of meaning to a different level, whilst adopting the more apposite and enigmatic shape of free verse. If Expressionism styled itself as a visionary movement,[11] seeing beyond the photographic surface of the human condition, then Trakl is the arch-seer, and his poetry combines radical compaction with a more mystical sense of dispersal and dissociation.

The double challenge to conventional boundaries is not least a function of ontological crisis. If Expressionist poetics seek a communication of naked subjectivity, then their violent challenge to convention effects a traumatic estrangement of the subject as conventionally understood. The lyrical 'I' of Expressionism is a reconstitution, in other words, of the radically alienated and hallucinatory subject of Rimbaud, of his notorious dictum 'Je est un autre' ('I is an other'). And nowhere is this poetic alterity more acute than in Trakl, the latter-day *poète maudit* who imitated Rimbaud's alchemical experimentation with words. Indeed, part of this condition could be said to be his otherness to, and isolation from, the other poets characterized as Expressionist, as he makes a world of his own out of the altered state of poetic expression.

Trakl's closest interaction with another Expressionist poet is marked at once by affinity and alterity. He met Lasker-Schüler when he was in Berlin, at the time of the initial composition of 'Abendland'. Berlin was, in many senses, the centre of Expressionism, the base for collective activities, and the object of many of its most distinctive poems. Trakl, the self-styled Kaspar Hauser, is a stranger to this metropolitan centre, destined to experience it not as a place of community, but as another place of exile. It is apt, then, that he should establish there a poetic dialogue with a figure in other kinds of exile, one who constantly performed as other through her persona of Jussuf, Prince of Thebes. Lasker-Schüler, a woman amongst the men of the Expressionist movement, a Jew in an era of ascendant anti-Semitism, thus performs a role of double self-alteration: an Orientalist fantasy of manhood. The traces of the encounter between these exiles are enigmatic and open to contradictory interpretation, but they do serve

to project the paradox of a common ground for the condition of alienation. This common ground is a shadowy, virtual one. It is offered up as a communication from one to the other in the enigmatic terrain of 'Abendland'. This 'gift' establishes evening as a type of metastatic ground for poetic negotiation. As such, it is offered back in the form of Lasker-Schüler's counter-dedication in the poem 'Georg Trakl', which registers the shadowy enigma of Trakl's poetry and person by a reciprocal spatialization of her own evening: 'Sein Schatten weilte unbegreiflich / Auf dem Abend meines Zimmers' ('His shadow dwelt beyond comprehension / On the evening of my room.').[12] Thus dedication and counter-dedication sustain the paradoxical grounding of the title of Trakl's poem and lead us into the uncertain ground of 'Abendland' itself.

As has already been suggested, the most authentic way of proceeding with this poem is to follow the logic of its allegorical construction: the journey through the Occident as evening-land. If we envisage the readerly journey as an actual, physical one, then the difficult profile of the spiritual travel that is figured here emerges. The model of the journey of life, a journey through different seasons and terrains, is, of course, a topos, a commonplace of literary creation. But here, the commonplace, far from being a site of community of understanding, is transmuted into a more shifting, complex and tenuous topography, a place into which it is far from easy to follow the poet or his personae. If we expect a journey to have a teleological form – to lead, that is, along a progressive line from a beginning to an end – then 'Abendland' confounds that form.

Part of the challenge to linear development is effected by the work of the poem's tropes. While the use of metonymy establishes a certain sense of spatial relation, it frequently merges with the effects of metaphor that introduce alternative spaces into the poem. This is marked immediately by the opening figure of the poem: 'Mond, als träte ein Totes / aus blauer Höhle' ('Moon, as if a dead thing stepped / from a blue cave' (1–2)).[13] The metaphorical birth of the poem, its projection into narrative life, is figured as the stepping out of a dead thing. Something emerges into the poetic space, steps out in animal or anthropomorphic shape, yet is also a kind of still birth for the poem. The thing itself, which emerges with extraordinary presence in syntactic and pictorial isolation, is one that tracks through Trakl's writing: a mythically resonant figure, conceived as between states of being, androgynous (hence its neuter form here), and un-dead, ghostly and vampiric. As elsewhere in Trakl's poetry, the moon emerges as a thing of vision, like an eye from its socket: it illuminates, it creates

vision, but its gaze seems blind. In its living-dead ambivalence, it also inaugurates the poem as a generic hybrid, sustaining a dialogue and a sense of passage between the hymnic singing of presence and the elegiac lament at what is lost. And the image of the moon's still birth combines an archetypal scene of cosmic mourning with the personal trauma of Trakl's sister's abortion.

If the opening steps are, in some sense, abortive, they nevertheless provoke a sequence of images; or, rather, a simultaneity of images, as the 'Und' of the third line indicates a layered rather than a chronological syntax. The poem here works through a logic of metonymy; the moon emerges from the matrix of the blue sky, cast metaphorically as a cave, but the cave is also a metonymic part of the landscape that the moon illuminates, one that leads on to the contiguous 'cliff path', which in turn leads to other parts of the lunar landscape. This linearity, however, is cut across by spatial simultaneity, the metaphorical connections that tend to fuse the different parts of the landscape. The images repeat structures within a picture registered as synchronic. The falling of the blossoms, imitating the falling of the moonlight, is in turn imitated by the falling of tears by the 'Abendweiher' ('evening-pool' (6)).

The 'Krankes' ('sick thing' (5)) is a perplexing figure – like the moon, neuter and impersonal, and cast in an attitude of mourning. It perplexes, partly, by backtracking: a poem that begins with death seems only able to graduate backwards into sickness unto death. Hence, the regression into the past tense to describe another journey, a journey, as it were, on the dark side of the moon (the canoe being associated elsewhere with the crescent moon floating in the sky). The lovers have passed over into death on a black moon, and the sick thing apparently mourns their passage, though their relationship is one of contiguity rather than explicit causality. The 'Abendweiher' is here implicitly what it is explicitly elsewhere, a mirror element. On one level it performs the function of mirroring the title in this section: the evening-pool as a metonym for the 'Abendland' as a whole. It also acts as a specular crux for this portion of text, enabling the closing lines of passage into death, the motion stressed by the ungrammatical construction of 'hinüberstarben' ('overdied' (8)), to reflect, with an extraordinary sense of simultaneity, the mortified movement of the opening line.

The second part of the first section compounds the simultaneity of effects. It does so by a characteristic alternation, through the mediation of 'Oder' ('Or' (9)), a rhetorical twist that Trakl derives from Hölderlin. This new picture presents either a view of a new

scene as an alternative (through a logic of metonymy) or an altern-
ative view of the same scene (through a logic of metaphor). It offers
another kind of movement; the stepping 't' sounds of 'träte ein Totes'
('stepped a dead thing' (1)) are taken up here in 'läuten die Schritte'
('the footsteps ring out' (9)), but transmuted into a ringing sonority.
This is the signature of Elis, a figure who appears recurrently in the
late poetry, a mythical personification of the living death evoked in
the first part. The synaesthetic movement of Elis, in colour and sound,
represents a sort of lament, a model form of death song. It is thus
that the sound disappears almost simultaneously with its appearance.
In the hyacinth grove, the figure of Elis, associated with tales of
mummification,[14] incorporates the mythical fate of Hyacinth, a blue
flower sprung from premature death.[15] Thus, even after the sounds of
Elis have rung away, the poem, in an elegiac gesture, holds on to his
form: 'O des Knaben Gestalt' ('Oh, the boy's shape' (13)); the apo-
strophic 'O des' resonates with the 'Oder es' that introduced this part
of the poem. The boy's form is composed in the style of a Petrarchan
oxymoron: made of crystallized liquid and insubstantial shadows, a
non-body that can assert its shape only in a poetic sense. The lament-
ing 'Krankes' of the first part wept by the 'Abendweiher', and Elis as
a figure of possible redemption is constructed here in retrospect from
the tears and shadows of that scene.

The section ends on an ambiguous note. On the one hand, this is a
body that is 'immerkühl' ('ever-cool' (17)), not amenable to any form
of electrification into new life; on the other hand, this 'immerkühl'
initiates a sequence of assonance that moves into the promise of new
growth in spring. By a characteristic metonymic move, underwritten
by the internal rhyme of 'grünenden' ('greening') and 'Hügel' ('hill'
(18)), the landscape of 'Abendland' itself is transformed by the
greening of that which grows on it. Like 'Den hyazinthenen' ('The
hyacinthine' (11)) before it, the posterior and separate location of the
epithet 'Die immerkühle' at once gives its object more duration, and
serves as a basis for a turning-point in the narrative. In the first
instance, the turn is towards the elusive, in the second it is towards
a more living presence.

If the first section is in spring, the second is in summer. The
seasonal progression creates a diachronic time-scale for the poem,
one that is in counterpoint with the synchronic insistence, the simul-
taneity, of the time-zone of evening. The second section begins by
reviving the pastoral landscape of the first. It establishes community
between the two seasonal pictures, the greening and the green,
but also between the unidentified voice of the poem and others or

another. This 'we' may embrace Else Lasker-Schüler through an encoded communication, or it may, as earlier versions of the poem suggest, interpellate Trakl's brother-poets, Hölderlin and Novalis, into a shared landscape. At any rate, Trakl's poetic voice proposes something that, for all of these other fellow-travellers, is as elusive an idea as for himself, 'Heimat'. The loss of any stable sense of homeland, physical or metaphysical, and the poetic construction of alternative places to be, are an abiding feature of the writings of all four poets. Here, though, Trakl ventures a home-space in which the poets of different times and places might move and sing together. The second section revives mournful memories of the first, re-creating the sacrifice of Elis in the figure of the dying crystal wave, and reproducing the tears of lament that formed the figure. But it also hesitantly moves forward, and so edges the reader 'mit zögernden Schritten' ('with halting steps' (25)) into a more positive negotiation of 'Abendland'. This trekking is guided by a landmark that represents the suffering that sustains the song: 'along the thorny hedge' (26). Through the power of this chorus of poets' voices, the time-zone of evening is incorporated here into the season of peace and achieved growth: 'Abendland' is commuted into the zone of 'Abendsommer' ('evening-summer' (27)) that encloses the wandering singers.

The double temporal enclosure is, however, despite its slow and careful pace, always already a lost space. The vineyard, another landmark that appears to act as a sort of distant compass to the progress of the poem, projects a dying light. And as the steps of Elis rang out and away in the same poetic moment, so the singers are placed by the radical simultaneity of 'nun' beyond evening-light into the shadowy, cool, mournful condition that Elis prefigured. The substance of the homeland and its errant singers is rendered insubstantial. As shadows in the shadowy womb of the night, their presence is merely the absence of light. While the final couplet appears to recapitulate the quiet optimism of the 'So leise' ('So quiet' (20)) that opened the second section, it in fact projects back further to the very beginning of the poem. The cool womb of the night bears only dead things. It gives the relief of closure for a traumatic existence, as white lunar light extinguishes the bloody purple of the dying sun. But the 'so leise' here also implies the muting of the song that was born out of the pain of the journey through the 'Abendsommer', guided by the penitential landmark of the hedge of thorns.

The community of poets and of the poetic subject with his landscape that is slowly produced and quickly lost in the second section, seems irremediably past in the apocalyptic vision of the final section.

The tentative incorporation of the landscape into organic growth, the 'grünenden Hügel' of the spring and summer, is superseded here by the petrifaction of winter. The autumnal season that gave solace in the wine and song of Trakl's early poetry is thus cut out of a truncated annual cycle. The very shape of the section on the page is pictographic, a reduced form that can represent the bare material outline first of mounting (the cities at the beginning) and then of falling (the stars at the end). The quiescent 'So leise' of the second section gives way here to monumental apostrophe. The poet invokes the latter-day cities of the plain, cities like the Berlin in which the poem was conceived. Yet the poem's first direct act of speech is coupled with a radical silencing of the subject within the poem. The 'So leise' idiom is supplanted by a polarization of vocal possibilities between thundering exclamation and mutism. The community of singers walking together in a shared 'Heimat' ('homeland' (21)) are replaced by the speechless, lone, vagrant figure of the 'Heimatlose' ('homeless one' (38)). 'Heimatlos' ('homeless') and 'sprachlos' ('speechless' (37)) mark an identity doubly subject to loss of faculties that might sustain identity. His silent isolation is pitted against the recurrent, overpowering pluralism of the apostrophic invocations in the section.

While the figure still appears to have a sense of direction, what he follows are the insubstantial wind and trees now bare on the denuded rock of the no longer greening hill. He follows these grim landmarks through a form of metonymy that is characteristic of Trakl, with the dark brow mediating the movement of the body. The first version of the poem exchanged 'Sterne' for 'Stirne',[16] stars for brows, and, through their near homophony, these two are always in some sense configured in Trakl's writing. The casting of the moon as a bodily shape at the start of the poem is part of a more general metamorphic principle whereby the sun, moon and stars are invoked as constellations in the poet's private cosmic mythology. Encoded in the metonym of the dark brow is the 'Schläfe' ('temples' (16)) of Elis's cosmic form in the first section, which in turn correlates with the tearful 'Schlaf' ('sleep' (24)) of the second section. This 'dunkle[r] Stirne' ('dark brow' (39)) indicates a sort of astral body, one that is under the oneiric sway of a dark star.

The second apostrophe invokes monumental streams; the liquid imagery of the first two sections, which was more particular, controlled and even constructive of the body of Elis, is here opened out in a more cataclysmic form. The landscape is cast in a sort of generalized, apocalyptic anxiety. Where we had the neologisms 'Abendweiher'

and 'Abendsommer' as signatures of the land of the title in the first two sections, here we have a more standard construct, 'Abendröte' ('sunset'/'evening-redness' (43)). It is configured, however, in a distinctly non-standard fashion as the subject of an extraordinary neologistic verb, 'ängsten' (42), echoing the transitive verb 'ängstigen' ('to make anxious'), but working here in an intransitive structure. The 'evening-redness' seems at once to be subject to fear, and to subject the unnamed, probably universal, other to it. It is the sort of contortion of poetic grammar that figures in the angst-ridden poetry of August Stramm. By suspending the conventional shaping of relations between subject and object, it emulates the confusion of the two in Munch's *Scream*, and as such represents a limit form of Expressionism.

The third apostrophe, once again monumental and plural, is to the dying peoples, incorporating, albeit in an impersonal form, a highly uncharacteristic interpellation of the reader. The poet adopts a version of the hieratic persona familiar from Hölderlin, mediating prophetically between the heavens and humankind. The apocalyptic fear of the 'Abendröte' is thus transmitted to the peoples by the prophet in the wilderness of the 'Abendland'. The streams of the second apostrophe are singularized once more, caught in the massive metonym of the 'Bleiche Woge' ('Pale wave' (46)) that is composed only to be smashed. Specifically, it shatters against another figure, both metonymic and metaphorical. The logic of the spatialization of time that has informed the poem from its title onwards is terminated in the metaphorical complex of a wave of last light smashing on the shore of the night. The night as a terminal space of time is rendered through its border; 'Abendland' is stranded and breaks up, as it were, on the 'Strande der Nacht' ('shore of night' (47)). And the 'fallende Sterne' ('falling stars' (48)) that embody the effects of the shattering blow resonate with the 'Stirne' of the figure that has led us to that vision. Cosmic shattering incorporates the breaking up of the human form and its spirit as represented in the subtextual metonym of the brow. The ending of the poem thus reproduces the dark scene of many of Trakl's later texts, the schizoid condition of 'Umnachtung' ('benightedness').

'Abendland' is, then, a deeply ambivalent city poem of the avant-garde. It is a poem that, like many others of its time, not least in Expressionism, takes an evasive approach to the city, viewing it from afar.[17] Yet its anti-urban topography is profoundly conditioned by the experience of simultaneous dislocation, of temporal and spatial condensation and displacement, that characterizes urban modernity. And the poetic voice that it adopts to negotiate that topography is at

once strangely sonorous, ventriloquizing the lyrical style of past masters, and powerfully disjunctive: a voice of melancholic elegy but also of the avant-garde.

Eliot: *The Waste Land*

Like *Zone* and 'Abendland', Eliot's *The Waste Land* is a poem dedicated to the pursuit of a form of meaning that seems irredeemably lost. The latter-day quest for the grail, for a vessel capable of holding transcendental substance, is one that is from the outset stymied, and yet the poem seeks to find a means of moving towards it. While Trakl invokes the voices of poets from the past, and Apollinaire has been called a 'brocanteur' of poetic styles,[18] Eliot employs a more pervasive and self-conscious form of citation of other writers. The appropriation of voices from the past is undoubtedly driven by a fundamental cultural conservatism, by dismay at the degradation of individual traditions in the age of mass culture; but the techniques employed by Eliot in the display of the loss of high culture are, paradoxically enough, avant-gardist in their disposition. That is, the arch-poet of high Modernism is forced to work against his own principles in exposing the need for a radical treatment of the conditions of modernity. In the terms set out in his programmatic essay, 'Tradition and the Individual Talent' (1919), a more aristocratic form of the avant-garde manifesto, Eliot embraces simultaneity less as a cult of technological immediacy, than as a sense of community with traditions, and hence of relative duration.[19] But the traditional is not a guarantee for organic autonomy on the part of the modern writer, nor simply an object of nostalgia; rather, it is 'what makes a writer most acutely conscious of his place in time, of his own contemporaneity'.[20] If Eliot recognizes that 'No poet, no artist of any art, has his complete meaning alone',[21] then this can be read not merely as a passéist appeal to the authority of past masters but as a denial of the possibility of any form of autonomous meaning. The time-honoured songs of the community of poets have to share dialogical space with the clamour of less privileged cultural voices here. In Eliot's poetic practice, meaning emerges as a dialectically complicated quantity, relative but always also broken in its relatedness, never 'complete' and 'alone'. It follows, in other words, the aesthetic method of montage.

In Eliot's poetry, montage has a twofold effect. On the one hand, it has to do with an assumption of other shapes, other voices, which

are identified as organic. In the terms of 'Portrait of a Lady', this is the metamorphic method, embracing change as a pre-condition for poetic expression:

> And I must borrow every changing shape
> To find expression . . . dance, dance
> Like a dancing bear,
> Cry like a parrot, chatter like an ape.[22]

The changes wrought here are less the metamorphoses of Classical mythology, whereby change of shape is a prelude to a sort of memorial fixture in a species of flower or animal, than a change into the process of changing. The adoption of the voices of other writers is subject to this principle of borrowing, and hence always liable to be reducible to the anti-poetic performances of imitative animals. This, in its turn, attaches the world of organic metamorphoses to the world of technical reproducibility: the borrowing of voice and shape that is afforded by auditory and visual recording. There is always in Eliot's borrowing this double movement: the mythological and the technological: the dancing bear and the mechanical instrument that dictates its motions. This is the pattern established by Eliot's critique of the *tour de force* of avant-garde musical composition, Stravinsky's *Le Sacré du printemps* ('The Rite of Spring' (1913)), which he heard performed in 1921, during the period of composition of *The Waste Land*. The stamping sequence, which overturns the melodic conventions of music for ballet, is one of the key performative moments of the avant-garde, co-opting an archaic, ritual performance of vernal energy to enact the driving potential of modernity. Eliot sees the piece as transforming 'the rhythm of the steppes' into the machine-driven noises of modern life. Art demands, he argues, 'interpenetration and metamorphosis',[23] and this implies not least the metamorphosis of myths of penetration and transformation into the terms of the machine age: a quasi-Vorticist interpenetration of timeless forms of human experience and the contemporaneity of city-based life in the machine age.[24]

Eliot, in other words, undertakes his own form of Apollinaire's programme following the motto of 'machiner la poésie', but at the same time keeps a desperate grip on more traditional ideas of authorship. The poet's 'recording' of the songs of others is always a threat to the idea of personal integrity, to the possession of his own shape and voice. As he has it in 'Portrait of a Lady':

I keep my countenance,
I remain self-possessed
Except when a street-piano, mechanical and tired
Reiterates some worn-out common song
With the smell of hyacinths across the garden
Recalling things that other people have desired.
Are these ideas right or wrong?[25]

The mechanical songs and the metamorphic flowers of myth prompt an automatic recall of the lost desires of others, the desires that are also embodied by the hyacinth in Trakl's poetry, and recalled again by Eliot in the first section of *The Waste Land*. His poetry is caught in this way between the self-possession of individual talent and possession by others, by the other of others' desires, as reproduced by myth and technology. Whether the ideas, the shapes and the voices which he thus borrows, or is borrowed by, are right or wrong remains an open question in both aesthetic and ideological terms.

Like *Zone* and 'Abendland', *The Waste Land* is a poem that reformulates the teleological model of the quest narrative, where linear movement through time leads the subject through a continuous topographical space. In his review of Joyce's *Ulysses*, Eliot formulates the new imperative of returning to myth as an alternative method to narrative for shaping the 'immense panorama of futility and anarchy which is contemporary history'.[26] But, as John Bowen has argued, the method is more properly allegorical, in the way that Benjamin defines that term: the myths of *The Waste Land* are never organically integrated, they are always dialectically related through breaks and interruptions, and the shaping they afford is accordingly irregular.[27] Under the influence of this dialectically complicated, mythical method, the poem takes a shifting generic form: the form of a drama in five 'acts', mixing Tragedy and Burlesque, as much as that of a narrative poem. It is a drama where the *mise-en-scène* is fractured but recursive, and the often ill-defined, protean dramatis personae come and go, sustain monologues and dialogues, without the framework of a conventional plot structure. In the manner of the sort of 'poèmes conversations' developed by Apollinaire, the poetic line follows exchanges between voices that are often disembodied and uncertain in their conversational relations. The transformation of traditional body–voice relations, through a metamorphic borrowing of shapes and a polyphonic speaking in tongues, is introduced in the first 'scene'. With the changing of corporeal and linguistic identity comes a radical changeability of temporal and spatial zones. The poem looks at

once backwards and forwards in time and place, 'mixing / Memory and desire' (2–3), invoking death and growth, creating climatic and cultural surprise, establishing relative durations and types of community ('and talked for an hour' (11)), only to break these up. As in 'Abendland', the spatial mapping of time, with summer 'coming over the Starnbergersee' (8) and the subject going 'south in the winter' (18), creates a narrative framework not of narratorial regulation and orientation, but of unexpected passages and migrations.

If the first scene is composed out of memories and desires, this merely defers the entry into the real territory of the waste land in the second, a place of drought and broken images, where shadow holds only false promise of relief. The fear of this emptiness projects into it a snatch of song from *Tristan und Isolde*, so reinvoking the world of the first stanza. It is followed by a first-person voice that may be identical with that of Marie and is identified here with the epithet 'the hyacinth girl' (36), followed by an apparent rejoinder from her interlocutor. The waste land is filled with flowers from the hyacinth garden, and the hyacinth girl appears full and wet, but this image is constructed only to be broken. The sacrificial side of the Hyacinth myth seems to haunt the fertile promise of new life here, as the first-person voice is silenced and his vision blinded. The full, wet sea is exposed as '*Oed' und leer*'(42), in another line from *Tristan und Isolde*, an oceanic waste land.

In the third scene, the poem moves from the epic world of Wagnerian opera into a more arch type of theatrical mode. Madame Sosostris, the clairvoyant, is a sort of mock mask for the poet-director. She lays out her tarot cards as if plotting the drama to come, envisioning the encounters and dangers of the quest. Before she breaks off from her visionary voice into a more familiar form of address, she previews the 'crowds of people, walking round in a ring' (56) who will feature as the largely mute chorus of the drama, representing its tendency towards circularity of development. And in the final scene of 'The Burial of the Dead', this crowd, drawn from Baudelaire's Paris and Dante's *Inferno*, duly appears, flowing across the river through the sectioned visual space between the fog and the bridge, the un-dead of the 'Unreal City'. The mechanical motions of the urban crowd are regulated by the chimes of Saint Mary Woolnoth, with its 'dead sound on the final stroke' (68). London is the 'timekept City' (*Choruses from 'The Rock'*),[28] but the time kept here is also marked by the sort of loss that characterized Apollinaire's *Zone* ('j'ai perdu mon temps'). Its repetitions are struck by mortification, just as the 'final stroke of nine' fails to follow the preceding rhyming couplet by

chiming with 'the hours'. The dead sound marks the presence of the buried and unburied dead in the city, of corpses that may bloom after the manner of Hyacinth, be blighted by an untimely frost, or be dug up by dogs. In the cultural waste land, the poetic persona speculates on the duration of death, whether it will hold over time, give way to new life, or be suddenly shocked out of its resting-place. In his Baudelairean interpellation of the reader as hypocritical brother and double, he demands that he should adopt his place in the drama of memory and desire in the un-dead city.

Having called the reader into witnessing the burial rites of the first act, Eliot sets up 'A Game of Chess' in the second, a game both within the world of the poetry and of intellectual challenge between poet and reader. The game of combat, based on courtly culture and feudal power, is transferred here to a conversational piece between a mock king and queen in a modern, urban setting. The 'queen' is introduced in a pastiche from Shakespeare's *Antony and Cleopatra*, an overwrought poetic confection which performs the excessive profusion that it describes.[29] The simulation of the Shakespearean speech is ironically undermined in the *mise-en-abyme* effects of doubling, reflection and synthesis. The excesses of the verse do not produce refreshment for the drought that racks the waste land, but an inundation in the style of *Zone* and 'Abendland', drowning the 'sense', in both bodily and epistemological senses of the word. The powerful beauty of Cleopatra is reduced here to a mechanical reproduction and prepares for the inadequacy of the latter-day neurotic 'queen' for her role in the game. The king, on the other hand, is introduced through the myth of Philomel, as reproduced in a picture above the mantle, giving the illusion of a window. The picture features one of the 'changes', the mythical metamorphoses, which structure the poem, but which offer transformation only at the price of violence. Philomel is raped by the king and, in the shape of a nightingale, 'Filled all the desert with inviolable voice' (101). The myth seems to promise a sort of transformed voice that could fill the emptiness of the waste land, but this is a voice subject to its new embodiment, and so to the pursuit of a violating world. To the 'dirty ears' of the world the ineffable song of the nightingale is transliterated as 'Jug Jug' (103), a crude container for the essence of the voice and a degraded, mass-produced version of the grail as transcendental vessel. The mythical picture, far from offering sustenance in the desert, is one amongst a series of wasted figures, 'withered stumps of time' (104), offering neither fruit nor orientation.

Here the poem reverts to the mode of poetic conversation, the neurotic queen figure in desperate quest of engagement with her counterpart, the presumed king. He takes up the first-person base voice of the poem, offering only images of waste and repetition in response to the desperate questioning. His 'Nothing again nothing' (120) reprises the vision of his earlier incarnation in the first act, 'I knew nothing' (40), a declaration that hovers between a lack of knowledge and a knowledge of some mystical state beyond things. Here it is turned more clearly towards an empty repetition of negative meaning. Similarly, his next rejoinder, 'I remember / Those are pearls that were his eyes' (125), recalls the parodied forecast of Madame Sosostris. A memory of things past is activated in the poem, but the remembered thing is a sort of prosthetic 'nothing', the absent presence of eyes. The pearls are an opaque version of the crystalline eyes of Christ in *Zone*, fit to see nothing; for the poetic subject, as for his tarot card, the condition of absence of knowledge is embodied by an organic absence: 'Is there nothing in your head?' (126). The 'nothing' in question here turns out to be a 'Shakespeherian Rag' (128), the low cultural pastiche of high cultural quotations that opens and closes this act. Like the pearls in place of eyes, these are forms of literary gem that fetishistically attract the reader's eye, but are not necessarily suited for seeing. High-cultural fragments are adopted as prosthetic supplements for the representation of modern culture, aiming to shore up its degraded and violated body, supplements that are further supplemented by the notes attached to the poem.[30] These may be 'pearls' of wisdom, alluring like the cosmetic pastiche of *Antony and Cleopatra*, or they may be akin to the less attractive falsity of the dentures that repeat the prosthetic theme in the final scene of this act.

This scene is another form of 'poème conversation', reminiscent of Apollinaire's 'Lundi Rue Christine' ('Monday Rue Christine'), as a montage of voices overheard in a bar. It is a style of poetry that challenges conventions of authorship, suggesting that the author may merely be a reporter rather than the organizing genius of the game. The game of chess turns to the more overtly mundane moves of the social pawns, its most expendable pieces, their interplay threatened at intervals by the voice of the 'timekept City', the bar-keeper as time-keeper: 'HURRY UP PLEASE ITS TIME'. The poem moves here into a mode that seems radically anti-poetic, a recording of common speech, marked by the invariable repetition of parts of the verb 'to say'. The mini-drama pitches a report of past conversations against the claims of the present, imitating the attachment to the past in the previous scenes. The dialogue is an act of recall, but thus also a denial of

presence and origination: like the themes of ageing, cosmetics and abortion that run through it, it speaks of the same fears as the scene before. The 'antique mantel' (97) and Lil's 'antique' (156) looks both refer to an ironic recycling of the structures and stories of antiquity. Eliot's practice here is finely poised between that of the aesthetic Modernist, representing the drama of the common people overheard in a pub as the nadir of cultural abasement, and a strategy that is more properly avant-garde. The formulation of the lines as verse, with refrains, repetitions and modulations, and the resonance of the poem's grand themes in the life and speech of its lowliest characters, suggests a levelling of the chess-board hierarchy. The pub-goers, too, are given a voice in the 'Shakespeherian Rag' at the end of the act. Indeed, there is a possibility of reading this scene, against the grain, through a Brechtian form of avant-gardist strategy. The scene turns present, first-person enactment into past, third-person narrative ('she said') in a way that approaches Brecht's programme for a historiciza-tion of drama. Brecht famously had his actors add 'said . . .' to their lines in rehearsal to achieve an effect of epic defamiliarization, and hence of politically critical distance, in their performance of first-person roles.[31] Eliot's turning of a present drama towards retrospect-ive narrative may not be driven by the same sort of radical political agenda as Brecht's, but it certainly troubles the apparent conservative elitism of his project.

The third act returns to the Thames, but finds the protective structure of its tent broken. Like Apollinaire's sirens, the nymphs of Trakl's 'Psalm' and Lorca's 'El rey de Harlem' ('The King of Harlem'), the mythological spirits of the river no longer inhabit it, even in the embodiment of city girls: 'The nymphs are departed' (179). Even the 'testimony' of their trysts – empty receptacles and cigarette ends – is no longer borne (or born) by the waste disposal system of the river. The poetic voice can only implore the river to flow on while he still sings. He moves from the emptied river to the dull canal to fish, and the sometime chess-board king reveals himself now as a Fisher King, adopting lines from Shakespeare's *Tempest* to vouchsafe his relation to other, albeit wrecked and dead, kings. The sounds of the traffic are synthesized into more snatches from songs he has known, ventriloquizing the voices of Marvell, Day and the children's chorus from Verlaine's 'Parsifal'. This, in its turn, introduces a reprise of the voice of the metamorphosed Philomel from the previous act, whose 'Jug Jug' is now accompanied by the mocking, idiotic sound of 'Twit twit twit' (203). And the intratextual memory of the forcing of Philomel leads the poetic subject into the sordid sexual encounters of

the city. First he 'suffers' the homosexual advances of Mr Eugenides, then, in the transsexual shape of the seer Tiresias, he foretells and foresuffers the banal act of sex between the typist and the clerk. Sex is transmitted here by the metonymic means of the taxi into the mechanical motions of the throbbing 'human engine' (216). As in Trakl's 'Abendland', the time of evening is transmuted into place: 'the violet hour, the evening hour that strives / Homeward' (220–1). But home is a site of mechanically repetitive sacrifice in the city. The 'violet hour' resonates with the violent deflorations of mythical figures metamorphosed into violets and other flowers. Violation is changed here into 'indifference' (242): the indifference of the typist to her lover and the indifference embodied in the synthetic figure of Tiresias, whereby the apparently changing characters of each sex in the drama of the Waste Land merge towards a single, indifferent one.[32] Tiresias, the human engine, is thus linked up to the post-coital machinery switched on by the indifferent typist; in a gesture befitting a woman who works machines: 'She smooths her hair with automatic hand, / And puts a record on the gramophone' (255–6).[33]

The gramophone reintroduces a medley of musical styles around and about the river, culminating in the pseudo-Wagnerian songs of the Thames-daughters, songs of the vehicles, both grand and mundane, manual and mechanical, borne on the river and bearing a variety of cargos: oil, a queen, the peal of bells and sexual intercourse. The third daughter, washed down to Margate Sands, takes up once more the voices of the second act. Like Tiresias, she moves between genders; she is both the queen, after the style of Elizabeth and Cleopatra, and the king, who could only say and recall versions of nothing. Her people expect 'Nothing', and this is what she offers: 'I can connect / Nothing with nothing' (301–2). This is either the voice of despair at the unrelatedness and indifference of things or an assertion of a sort of poetic ability to take the various 'nothings', the 'broken fingernails' (303), of culture and achieve at least a form of connection between them.[34] The 'la la' (304) that barely echoes the Wagnerian chorus of her sisters reduces these dialectically uncertain possibilities to their most basic: it approaches the negative condition of a fragment of song where the singer does not know the words, but it also asserts the positive basis of song in rhythm and repetition. In other words, it embodies the contrary possibilities of indifference, enabling the poetic voice to string together at the end of this act the repetitive and radically reduced fragments of two ecstatic voices from the Eastern and Western traditions: the Buddha's Fire Sermon embracing Augustine's *Confessions*. It remains painfully unclear whether

this Petrarchan embrace of opposite cultural traditions achieves a degree of connection or an incineration of identities into the indifference of ash and the terminal decline of both Orient and Occident.

The following act seems designed to quench the burning thirst of the end of the previous one, but it does so only in the form of 'Death by Water' and the drowning of the Phoenician sailor foreseen by Madame Sosostris. The regenerative possibilities offered by metamorphosis are here transformed into the degenerative effects of a 'sea-change'.[35] The pearls that were his eyes turn out to foresee the bones that were his body. The brief act takes up a single scene, and one without song, indeed without any other than a narrative voice. It is in the style of a *memento mori*, exposing the vanity of commerce and journeying. The currants in which his *alter ego*, Mr Eumenides, dealt are here resolved by a brutal pun into the currents of the sea, and the rise and fall of the submarine corpse imitates the profit and loss of the merchant's balance sheet. Once more the body is reduced to its bones, and these provide a form of instrument (like the mandoline of the previous act), but picked here by the sea and producing only whispers.

The sober reduction of 'Death by Water' makes way in the final act for a more epic scale and vocal register. 'What the Thunder said' is reminiscent of the landscape and the prophetic logic of 'Abendland', making difficult progress into the Waste Land in order to survey the decline of urban civilization on a global scale. It adopts and combines the themes of the journey to Emmaus, the quest for the grail, Shackleton's Antarctic expedition, and the decline of Western civilization after the model of Eastern Europe. The thunder that illuminates the passing spring of 'Abendland' speaks at first only of silence and agony; any promise of water, even of spit, is false in this desiccated land. The dry grass sings, but the only sound of water is in a reprise of the unreliable, transliterated bird-song earlier in the poem, here in the water torture of the voice of the hermit-thrush. It is a landscape of illusion and mirage, of companions seen but not known, and one of maternal lament for the sons lost amongst the anonymous hooded hordes that swarm over the plains.[36]

The violet hour that was used to question the redemption of violence in the third act is here transmuted into the violet air in which the cities of the plains, West and East, explode and reform, but in a cycle out of control. The 'violet light' (379) is also the scene for the rehearsal of the whispering bones of Phlebas, here transferred to the 'whisper music' (378) fiddled on a woman's hair. The bats with their 'baby faces' (379) offer only a Gothic nightmare of regeneration. The 'reminiscent bells, that kept the hours' (383) are no longer capable

of regulating a world turned upside down (bats crawling down a wall in an upturned tower might seem to be crawling upwards). The architecture is emptied, though the wells and cisterns sustain song; the chapel is a charnel house, but from its roof a cock sings and, in contrast to the hermit-thrush, seems able to prompt the arrival of water. This is also the prelude to the promise of more substantial rain, as the journey through the perils of the Waste Land leads to a voice from the thunder that is given the transcendental authority of a mantra. The DA DA DA of the thunder has the potential to resolve into the nonsense of 'la la' or 'twit twit', or indeed to remind the reader of the strategic nonsense of DADA,[37] but here it seems to work for the recuperation of meaning.

At the end, the poetic voice returns in the persona of the Fisher King, considering the possibility of setting his own part of the waste land in order, if not the plains that stretch behind him. The multi-lingual snatches of song, drawn from popular and high culture, that follow this reiterate key themes of the poem: the collapse of the structures of the city, refinement through ordeals (here of fire), the swallow as metamorphic singer of inviolable voice, and the dispossession of property and a proper sense of place in the world. Their relation is one of dialectical complication, dismantled and reformed by the progressions and recessions of the poetic narrative. The collapsing bridge and the falling tower offer some hope of liberation to the imprisoned prince, but also threaten to dispossess him more totally; fire offers the possibility of rejuvenation, in the manner of the phoenix in *Zone*, but it also threatens to destroy less mythically able beasts; the swallow has perhaps survived destruction after the manner of the phoenix, but this 'swallow' may mean 'consume', and so stand for consuming by fire or refer to the impossibility of swallowing when the mouth is desiccated. The fragments that the poetic voice claims to have shored against his ruins may produce a montage that fits the needs of the poet in modern culture ('Why then Ile fit you' (431)), or the disaggregated rantings of a madman ('Hieronymo's mad againe' (431)). With the incantation co-opted from the Upanishads of 'Shantih shantih shantih' (433), and no punctuation to enclose it, the poem arguably ends with no less a sense of ambivalence than *Zone* or 'Abendland'. The notes tell the reader in need of guidance that these words are equivalent to 'The Peace which passeth understanding'.[38] Only words that pass understanding seem suitable for this function, and hence incapable of transmitting their meaning without a supplementary gloss. But to the innocent reader, who speaks it out loud, 'shantih' describes a place of insecure habitation on the

As Eliot drew residual life from the Thames, crossing the flow of the river with the crowd flowing over it, and Apollinaire sought to channel his Rhenish fantasies towards Paris and its bridges, so Lorca looks to the Hudson for a redemptive ablution of New York and its masses. In each case, the river becomes a conduit for a confluence of more or less bitter juices and other fluids (blood, sweat, urine, oil, alcohol) and a mobile site for the assorted disjecta of city life, the bodies and their accoutrements that are washed up there. The river in *Poeta en Nueva York* is at once a source of cleansing energy and cyclical flow, a figure of continuity, within the cityscape and between it and the land on one side and the sea on the other, and subject to blockage and pollution. It can be understood as a leitmotif in an extended poetic structure made up of a montage of broken cycles. The poetry is patterned by the repetition of key figures and substances that stand metonymically for cycles of nature (the moon, crystal, butterflies, milk, etc.); yet these are repeatedly figured as out of kilter, subject to forms of change that go against their natural function. The breaking of natural cycles also extends to their mythical equivalents: the nightingales, hyacinths, nymphs and other figures of metamorphic rebirth out of loss and violence that figure here in an emblematic role similar to that in Apollinaire, Trakl and Eliot.[43] The moon, much as for Trakl, is at once a sacrificial victim ready to be killed for the sun to rise and a more sinister and aggressive figure, accompanied by a retinue of uncertain 'lunar creatures' ('Ciudad sin sueño' ('Sleepless City'));[44] crystal is both a durable substance of transformation into beauty, potentially resonant as in *Zone* with 'Cristo' ('Christ'),[45] and the mundane and breakable glass of the myriad windows of New York. The substitutions that operate in the poetry are always as likely to produce abject, indistinct waste as to effect positive, fertile forms of metamorphosis.

Like *Zone*, the *Poeta en Nueva York* collection opens with a gesture towards ending in 'Vuelta de paseo' ('After a Walk'), a poem that establishes a template for the relationships and procedures of the collection. 'Vuelta' has connotations of turning and returning, but also of the sort of loss of illusions ('estar de vuelta') that characterizes the world-weariness of the poetic subject at the outset of *Zone*. In *Zone*, the reader is referred by the beginning to the end, and there finds a catastrophically cut beginning of a new day. Lorca puts the brutal cut directly into the first line, with the poetic subject 'Asesinado por el cielo' ('Cut down by the sky'),[46] and then has it return at the end to embrace the poem, like the sun at the end of *Zone*. The title suggests that this is the poet as post-*flâneur*, removed from the

Baudelairean tradition of passing through the city as its detached observer and commentator. Returned from his walk, the subject is 'in the city' in the sense of being amongst its most basic objects and subject to its most basic processes. It is an environment that is driven by the desire for change, and the subject finds himself between forms of existence that are moving to transform themselves 'Entre las formas que van hacia la sierpe / y las formas que buscan el cristal' ('Between shapes moving toward the serpent / and crystal-craving shapes'),[47] an intermediate presence between intermediate presences. As he cannot move, his response is to seek to find growth at least in his own shape, to transform himself by letting his hair grow. The three following couplets express forms of community, each starting with a 'with' that appears to associate the poetic subject with a series of things, but the loosely paired things are neither together with each other nor identical in themselves. The 'vuelta' of the title is transferred into a series of reversals in the constitution of these objects. Their only community is in contradiction: the tree is anthropomorphized by having its limbs 'amputated', but the voice that this might grant it to bewail its injury (in the style of the mythical Clorinda) is cut too; the child has a face, but it is the face of an object that is defined as featureless, and one that has to be broken open if it is to produce new life; the little animals display this danger with their cracked skulls, broken containers; the water is personified too (like the river elsewhere), but its rags keep the feet of the potentially life-giving element dry; the deaf-and-dumb things have no means of communication and are too tired to communicate anyhow; and the butterfly that might embody a new form of life is drowned in the ink-well, even as the poet writes it into shape out of ink. In this company of things, conjoined only in their non-self-identity, the poetic subject is only fit to encounter himself in the final couplet as a face unlike the blank and invariable face of an egg, and however like it in its (non-)relation to the different things with which it is found: 'different each day'.

If the subject is 'distinto de cada día',[48] then this renders his identity indistinct over time. The poetry stages a dialectical interplay between the ideal of similitude, embodied, for instance, in the Apollonian figure of Walt Whitman, the man who is selfsame and desires the same thing as himself, and dissimulation, which takes its most outspoken form in the masquerade of the camp gay men that the poet encounters in New York. Whitman is a measure in terms both of poetic form and of Adamic manhood, while the 'maricas' serve as representative of falsity and urban corruption. If homosexuality is no longer the same as itself, no longer equal to the example of Whitman,

then neither are the sorts of belief systems that are associated with the primal figures of Apollo and Adam. The poetic subject is made to embrace differences that are as impossible in their contradictions as the 'gay-acting' and 'straight-acting' types of homosexuality. The 'he's one too', which is mimicked hysterically by the poetic voice, encompasses the subject as well as Whitman in putative common identity with the 'maricas'. The natural and the same are always already past here, only available in the elegiac form of the 'Oda a Walt Whitman'.

The figures of birth and metamorphic development in the opening poem are less channels for movement towards a transformed identity than a collection of disjunct masks for the subject. The dissolution of boundaries between self and other may be a process of magical or alchemical sublimation or may collapse into the condition of abjection. The abjection that is figured as leprous crudescence and tainted blood on the figures of Trakl's poetry, in the 'bloodied women' of *Zone*, and in the diverse forms analysed by Ellmann in *The Waste Land*, also functions as an index of the violence and wastage of urban life in Lorca's New York poems. Here, too, there is a quest for a new mythology, for poetic ceremonials that would make sense of the suffering and debasement of the metropolis, but these are constantly haunted by a failure to achieve redeeming order. The poetry is organized around heterodox forms of ceremonial that fail to function as such, circumcisions that defile rather than purify, and the communion host that cannot find an adequate mouth (in the elevation of the sun in 'La aurora'). As with the other poets, transformation is embraced as a sort of latter-day metamorphosis of shape and alchemy of substance, but it also always threatens to dissolve in uncanny fashion the distinctions between life and death, production and waste. Like the 'female smells' analysed by Ellmann as the paradigm for the abject in Eliot and the blood that soaks Apollinaire's refugee women, Lorca's modern mythology centres on the figure of menstruation. The periodic flow that indicates the cycle of fertility and waste becomes deregulated, and is channelled into the river and the sea, less as a rite of fertilization than as a flux of raw sewage.[49]

The river embodies a possibility of passage and migration, as well as the danger of inundation. As Apollinaire imported the ritual objects of alternative cultures as fetishes of his alienation, as Trakl styled himself as a Kaspar Hauser, a foundling and perennial misfit, and as the émigré American Eliot cultivated the role of the poet in exile, so Lorca travels to New York as a displaced person, following the trail of mass immigration in the early twentieth century. He styles himself, or is styled, as a gypsy figure, such as those that populated

his early poetry, and finds community in the great metropolis only with those who are displaced into and from its margins. If all four poets focus their city poetry on the experience of displacement and disconnection, Lorca most expressly attached that experience to the condition of diaspora. In the context of New York, this finds its key object in the lives of Blacks. The barbaric energy that Eliot found transformed from the stamping rhythms of the steppes to factories and the underground in Stravinsky's *Le Sacré du printemps* is here matched by the primitive life force that Lorca celebrates in his cult of negritude, displaced into the archetypal space of technological modernity: 'New York is Senegal with machines'.[50] He perceives this contradiction as a type of monstrosity, by turns fascinating and repulsive. It accounts for a form of poetry that is at once powerfully impulsive, following the primal rhythm of the pulse, and paratactic, matching the antagonisms and interruptions of the machine-driven city. The resulting poetic conjugation is by turns synchronized and contrapuntal, energetic with life force and mortified, as in 'Danza de la muerte' ('Dance of Death'), where 'El ímpetu primitivo baila con el ímpetu mecánico' ('The primitive impetus dances with the mechanical impetus').[51]

The poem 'El rey de Harlem' ('The King of Harlem') is a sort of elegy for the noble savage enslaved in the city. Like *The Waste Land* and Trakl's 'Psalm', the poem situates itself in a post-mythological age, where the nymphs are departed from the forests, but it seeks none the less to reconstruct a mythical possibility, a return to origins that might be effected in a post-urban age to come, when the city is overgrown by a resurgent nature. The fantasy of this restitution to past, natural glory is based on a monarchic myth much like that which figures in *The Waste Land*. The Fisher King here takes the form of the old man whose beard reaches the sea. Like the Fisher King, he is marked by encroaching impotence – as the Fisher King fails in his ability to serve the office of the grail, so the wooden spoon with which the King of Harlem ritually scoops out the eyes of crocodiles is now whole, now broken, now whole again. The King is imprisoned in the suit of a doorman, in a position of exclusion from the site that he guards, and the blood of his people is imprisoned too – it has 'no doors'. They search for the King who might be able to open those doors for them, but for the time being he is posted at a door that debars them. And while that door is, in principle, open to the Whites who inhabit the space behind it, it also stands for their potential exclusion from the space of the Blacks. The only way of reaching this seductive breathing-space (perfumed with hot pineapple)

across the bridges, is by doing violence to the effects and embodiments of White culture. A sacrificial act against 'the blond vendor of firewater' and 'the little Jewish women' in their bubble baths will enable the King to be rejoined with his people and to celebrate their cult in spite of the artificiality of their urban location and its asbestos moon.[52]

The asbestos moon correlates with the 'gold suns' as part of the planetary cycle that has been reduced to another system of worldly production, exchange and waste, where 'las colonias de planetas / rueden por las playas con los objetos abandonados' ('the colonies of planets / can wheel with the litter on the beaches').[53] The 'great central sun' to which the poet directs the Blacks is of a different order, a jungle sun that is heading down the river to the city to preside over the final sacrifice of White culture and the return of the city to nature. Ultimately, however, the sacrificial fantasy of the poem remains a virtual one, a function of masquerade ('*Ay*, Harlem in disguise!'). As the King of Harlem remains hidden by the cover of a doorman's suit, so Harlem is under the terminal threat of 'a mob of headless suits', the suits of Wall Street that will appropriate and dissemble its natural condition. The dance rhythms that are projected in the interpellation of the Blacks are resolved in the end into the more melancholy sound of the murmur that moves through the city and through the 'gran rey desesperado, / cuyas barbas llegan al mar' ('grand, despairing king / whose beard reaches the sea').[54]

While 'King of Harlem' attempts to foresee a return of the city to a natural state, in 'Nueva York (Oficina y denuncia)' ('New York (Office and Denunciation)') Lorca recognizes the overwhelming power of the dystopian regime of the 'headless suits'. The poem shows the paradox of the profuse supplies for the city's appetites – rivers and trains of blood, milk and oil – fed into the arid repetitions of the mechanically driven Moloch. As in *Zone*, there is a confluence of different liquids here, and blood operates as the ambivalent base element of the system of supply and demand. A drop of it is found beneath the mathematical operations of the city's economy, and the drop is always set to grow exponentially and anarchically into a river replete with the life that is sacrificed to that economy. The hydro-dynamic systems designed to supply the city are seen to run on blood 'which sweeps machines over water-falls'. The poet mounts his denunciation against the energy of this system, the riot of empty consumption and destructive construction that will end in 'the last feast of pneumatic drills'. He looks for the half of the urban population that is unredeemed by the orgiastic cycles of slaughter and supply,

finding delicate and apparently obsolete possibilities of communication amongst the urban underclass 'que llevan frágiles palitos / a los huecos donde se oxidan / las antenas de los insectos' ('who carry fragile twigs / to the emptied spaces where / the insect antennae are rusting').[55] The anachronistic residues of more natural forms of interaction – the last twigs, which correspond in their form to the insect antennae subjected to the corruption of their mechanical counterparts – meet in one of the vacant lots of the city, the sort of void ('hueco') in which a potential for meaningful existence might be relocated.

Lorca borrows the question of how to cope with this from *The Waste Land:* '¿Qué voy a hacer, ordenar los paisajes?' ('What shall I do now? Set the landscapes in order?').[56] He relays the intertextual network that Eliot had constructed as a system of communication to lend some redemptive order to the dystopian anti-community of urban modernity, but the words of the Fisher King are proposed only to be rejected here. The quotation is also a corruption, unable to pronounce the possessive pronoun 'my' for the lands to be ordered. While Eliot has his poem end with at least a potential for order and a return to fertility, Lorca adopts the more direct voice of denunciation. Order is irredeemably the language of the office ('oficina') and its financial numbers, rather than that of the office ('oficio') of ritual purification. The self-sacrifice staged by the poetic subject at the end has none of the ritual potential of the ordered sacrifice of the cult of the Fisher King, standing rather as a *mise-en-abyme*, a self-consuming mockery, of the sacrificial act. He offers himself as food for 'cows wrung dry', herbivores that are themselves sacrificial animals, reduced to a more mundane form of sacrifice to the appetites of the city. The refrain of the Hudson getting drunk on oil lends an emptiness to the gesture, the ritual act resolved into a mechanical form of bacchanal.

The acute ambivalence that is at work in *Poeta en Nueva York* is also displayed in the ink-drawing *Self-Portrait of the Poet in New York* (1929–32) (see plate 6). As the poems tend away from the narrative mode towards a form of imagistic montage around the figure of the poetic subject, so the self-portrait, like many of Lorca's illustrations, sets a highly stylized focal portrait in the same space as architectural and other figures. The spatial coincidence suggests a form of meaningful encounter and relationship, but the nature of any such relationship remains obscure. The outline of the vacant mask that represents the face of the subject is involved both with the line marking the edge of a skyscraper and with one of the cartoon

Plate 6 Federico García Lorca, *Self-Portrait of the Poet in New York* (1929–32).

animals in the foreground of the picture. Yet their continuity is uncertain. As the architectural outline meets that of the head, it fails to reach a base, opening out instead into the arena of the animals. It thus forms a foil to the building in the upper right, which is

constructed upon columns, though half of the columns in question are black, and so reminiscent of the contradictory substances from which the leitmotif of columns in the poetry are constructed (blood, mire, numbers, etc.). If the architectonic columns, anachronistic features in the cityscape, form an unreliable foundation for the building they support, the skyscraper on the left, the face of which has columns of letters for windows, breaks off with a line that also interrupts the alphabetical order that works across the rows above. The bottom line here reads 'KKAK', suggesting perhaps that the 'order' of capital has an excremental basis, that the metropolitan utopia is at base a cacatopia.

The line from the head that cuts across the horse splits it into black (the colour of the other animals) and white, the colour of the subject's face and its background. The emblematic horse, which features in a number of the drawings from this period, appears to relate to the poet as a thing of division, or self-estrangement. The 'white' poet with black moon-shapes on his face lassoes the hybrid horse, but only as his other side is grafted into the architectural order, the numbers and offices, of the city, even as he interrupts its lines. The self-portrait has aspects of the African mask that dances the prophetic death of Wall Street in 'Danza de la muerte' (here literally breaking a wall from the street), but its relation to the black figures remains dislocated. The bizarre little black-and-white, humanoid figure floating over the scene, and given a face that might correspond to that of the subject, appears as an emblem of deracination, its roots in the air. If, as Helen Oppenheimer surmises, this is an aerial seed,[57] then it is a grotesquely disembodied one, its face and Mickey Mouse ears growing directly out of the roots and so mimicking the bodiless condition of the subject below. The portrait suggests, then, at once an entanglement of the subject with the built and natural environment, and a certain involvement of those two orders of things through the subject, but such mediation as may be offered here is fragile in the face of fundamental estrangement.

The *Self-Portrait of the Poet in New York* not only serves as a visualization of key elements in the *Poeta en Nueva York* collection, but it can be seen as an allegorical figure representing on a broader level the contradictions of the artist's place in the city. If its stylized, line-drawn aesthetic seems to correspond to the Klee of *Angelus Novus*, then it lends itself to a similar type of Benjaminian reading. The mask-like face of the subject looks back out of the city to the emblematic figures of the natural world, attempting to straddle their differences. The creatures of his bestiary, embodying the possibility of

4

Modes of Performance: Film-Theatre

In the discussion of avant-garde manifestations, it was argued that if the avant-garde relies upon a principle of the intervention of art in society, then we can define this intervention as performative. That is, it aims to achieve its impact in the innovative process of its enactment rather than in the constatation of established truths. This turns all aspects of avant-garde artistic production towards the theatre and, by the same token, releases the theatre from its institutional framework, and thus from a space that tends towards autonomy from the social sphere, and directs it towards a new actionism. If, as argued above, the opening of Jarry's *Ubu roi* can be seen as an inaugural act for the theatre of the avant-garde (theatre in both the institutional and the more extended sense), then its performative power derives from the sense of bodily expulsion in the word *merdre*. The text, as the most hallowed element in traditional dramatic practice, is here radically carnivalized, turned to the body in its most deregulated, excremental mode. While the extreme anti-social provocation of this act is different in kind to most avant-garde enactments, it provides a model for the performative principle at large, for the turning of aesthetic production towards live, bodily production. A key aspect of the avant-garde in all its forms and media is that of incorporated action. As, for instance, in the MERZ Stage envisioned by the DADAist/anti-DADAist performance artist Kurt Schwitters, this implies a transformation of the stage as a fixed space towards a new performative definition. The MERZ Stage that Schwitters, one of the masters of the avant-garde manifesto, demands of the theatres of the world in his manifesto of 1919 is a 'total artwork' of immediate physical experience. He conceives of all parts of the *mise-en-scène* as

intensely animated bodies, and human performance as merely part
of a general incorporated dynamic of stage action: 'Materials for
the stage-set are all solid, fluid, and aerial bodies, such as white wall,
human, wire coops, stream of water, blue distance, cone of light.'[1]

It would be a mistake, however, to see the performative principle
as a guarantee of unfettered aesthetic licence. The performativity of
avant-garde art, rather, has to be understood on the more complex
model advanced by contemporary theorists, not least in the theories
of gender and sexuality developed by Judith Butler. For Butler, fol-
lowing Derrida and others, the performative is a deeply ambivalent
kind of licence. She shows that acts of gender or of sexuality are as
much constrained as they are opened to liberation by the insistence
of performance. Social conventions operate through unremitting
acts of interpellation, performing their authority upon subjects who
are constantly required to reiterate their subject position. The latit-
ude for challenging or resignifying such renewed acts of subjection
is always only relative to the power of the hegemonic model, the
official way of acting. Butler shows this ambivalence to be para-
digmatically at work in the drag act (the sort of performance that
we saw enacted in Hannah Höch's *Da-Dandy*), but it can be extra-
polated for any enactment of cultural dissidence. The performativity
of the avant-garde, its staging of resistance as masquerade, can cer-
tainly be seen in this fashion. While avant-garde praxis defines itself
by enacting its opposition to norms, it is always also liable to be
resubjected to those norms. It sets out to scandalize, but the scandal,
like the excremental revolt of Ubu, will soon be convertible into a
carnival commodity of bourgeois culture. The avant-gardists are con-
stantly outflanked by the hegemonic logic of that culture; indeed,
they inevitably come to internalize and enact forms of its logic
themselves. An abiding dilemma of avant-garde art is how to ensure
the constant mobility of enactment, how to avoid the sclerosis that
threatens when the performative energy of the avant-garde work of
art is bound to the manifesto promise, to the prescriptions of an
aesthetic (or anti-aesthetic) dogma.

This chapter will consider the tensions inherent in avant-garde
performativity through discussion of the two key performance media
of theatre and film. A main aspect of the analysis will be the inter-
medial relationships that the two develop. In his 'Work of Art' essay,
Benjamin adopts film as the vanguard medium, the 'most powerful
agent' of the new age of culture's technical reproducibility,[2] and
the theatre, at least in its conventional form (what he calls the
'Schaubühne', or show-stage), as paradigmatic for the old guard of

cultural practice that opposes it.[3] In practice, however, the medial definitions are dialectically complicated. It is telling that when Benjamin talks of the liquidation of the auratic value system effected by film, he describes it as 'cathartic',[4] suggesting an ironic complicity between the technological mass medium and the most fundamental processes of the Aristotelian theatre in its identificatory, tragic mode. It is indeed the case that film, the new medium of the technological age and engaged in a deliberate challenge to the predominance of the theatre as public art-form, is in fact reliant, even in some of its more avant-garde manifestations, on the time-honoured conventions of the theatre. This is true especially of the intermedial experimentation of Expressionist cinema, incorporating theatre, music and pictorial art. Expressionist film certainly mounted an assault on the already established narrative conventions of early cinema, but it did so in a form that marked its move towards a form of aestheticist autonomy – towards film as a framed, theatrical or pictorial performance. Wiene's *Cabinet des Dr. Caligari* (1919) is perhaps the exemplary case, a film that is studio-shot, of a highly staged character, exploiting the idea of the cabinet as a privileged site of viewing for the display of curiosities, a space of fantasy away from the world. Conversely, the theatre employs the new medium of film to extend the ambit of its performance. In the experimental theatre of Erwin Piscator, for instance, film is designed as a stage vehicle for bringing the world and its politics into the theatre. The interaction between the two media in various forms of film-theatre at once opens up new possibilities for performative experiment, and highlights the susceptibility of experiment to accommodation by more conventional modes of performance.

As we shall see, the dialogue between the two media points up the tension between the psychic and the political that is a constant and acute feature of the avant-garde. Theatrical innovation at the start of the twentieth century follows this psycho-political axis, often in dialectically complicated ways. On the one hand, Freud's insistence on the psyche as a site of drama, with dreams and other psychic representations as scenarios played out on this 'other scene' is matched by a new recourse to the theatre as psychic site. Strindberg's theatre of dreams establishes a new possibility for the performance of the psyche on-stage, one that runs through much of the new drama of the early twentieth century (Kokoschka's *Mörder Hoffnung der Frauen* ('Murderer Hope of Women' (1907–16)), a piece of Theatre of Cruelty *avant la lettre*, being a drastic example).[5] On the other hand, following Marx's famous adage from the *Eighteenth Brumaire* that heroic tragedies of history like the French Revolution are destined to

repeat themselves as farce, theatre and its genres have a special relationship to the political. In the era of the avant-garde, that relationship is redefined as theatre seeks a new mode of operation, a new generic identity that will correspond to – indeed elicit or perform – revolutionary politics. The theatrical experiment of the period is significantly driven by the aesthetic ideology of Marxism. The desire to integrate art into life, and thus to act performatively on the political, is particularly in evidence in the challenge by Brecht and others to the illusionism of conventional theatrical praxis: the move to expose the apparatus of theatre in order to expose, in turn, the illusory structures of the socio-political apparatus. The new illusionism of psychic theatre and the new anti-illusionism of radical political theatre create a powerful double bind, one that comes to hold sway over theatrical experiment throughout the twentieth century.[6] As Raymond Williams shows in his discussion of Strindberg as instigator of Modernist theatre, political revolution and the interior, psychic upheaval of what the playwright calls 'a revolution against myself' combine in contradictory ways.[7]

At the same time, this dialectic is transferred to the new theatrical apparatus of film. When Benjamin suggests that the new medium of film has the potential to expose what he calls the 'optical unconscious',[8] the parapraxes and repressions of the visual field, his discussion remains ambivalently cast between two conflicting possibilities: the model of psychoanalysis (film shows that the optical field is controlled by psychic drives) and a more political one (film reveals what tends to be hidden in the social order). Early film supports both of these possibilities. As the psychoanalytically inspired *Cabinet des Dr. Caligari* shows, the new medium of film co-opts the apparatus of theatre not least in order to explore psychic fantasy, appealing to the idea of a theatre of dreams. The fantasy in question, however, has distinctly political implications. Dr Caligari, the showman-cum-psychiatrist-cum-madman, is also cast as a figure of disciplinary authority. Not for nothing does he inspire an, albeit debatable, model of reading the fantasy films of Expressionism as prescient fantasies of dictatorship.[9] The notorious changes that were made to the framing of the film, whereby the internal narrative, which figures Caligari as crazed, is switched into the crazed fantasy of his patient, are seen above all to serve a political purpose: the containment of the idea, particularly potent in the wake of the First World War, that those in authority might in fact be mad. On a formal level, what the framing of the narrative does is to mark it as a piece of fantasy theatre, the enactment of a deluded psyche that is now safely secured in the

asylum, rather than a trenchant political view of a mad and coercive world. The case of Caligari shows that the accommodation between the psychic and the political in film is a complex and troubled one. And as revolutionary potential is sequestered in *Caligari* under the cover of the containment of psychic disorder, so in the more overtly revolutionary films to be considered here, the fantasy and pathology of the psyche, which have to be repressed in order to sustain the revolutionary cause, recurrently return to haunt their political scenarios. Eisenstein describes *Caligari* and its ilk as the 'barbaric carnival of the destruction of the healthy human infancy of our art';[10] but aspects of Caligarism can be said to return compulsively to haunt his revolutionary cinema, which is certainly not devoid of carnivalesque fantasy.

Film emerges historically from the theatre, specifically from the more popular theatrical forms of vaudeville and fairground performance. In its earliest form it is fundamentally an attraction, a framed spectacle or act of curiosity or monstrosity. As perhaps the most sophisticated early theorist of film, Eisenstein sees this idea of the attraction as a key element of the cinematic avant-garde, which, as we shall see, he understands as constructing a 'montage of attractions'. If the showman Dr Caligari plays out his version of the cinematic spectacle as such an attraction, he also shows that the attraction follows a logic of demonstration, a manual act of exhibition or exhibitionism.[11] Tom Gunning has suggested that in the heyday of the silent cinema, the avant-garde appropriates this act of exhibitionism from the variety theatre to work against the hegemonic model of the narrative film and the 'diegetic absorption' of the spectator.[12] It is perhaps more appropriate to suggest that the attraction itself also has a more reactionary potential, a tendency to fix things in iconic or fetishistic form. The exhibition by Caligari of the hypnotic attraction, Cesare, works in this way: the hand is in the service of optical fixation. The cinematic medium as attraction can all too easily switch from Gunning's paradigm of the circus as an eccentric and interactive spectacle to a more insidious form of hypnosis on the model of *Caligari*. The avant-garde is thus faced with the challenge of turning the hypnotic power of the attraction that is film spectacle to political effect, converting optical fixation into manual action. Benjamin's understanding of film in the 'Work of Art' essay, as a medium that converts the optical paradigm of aesthetic contemplation into a more tactile mode, suggests that it is designed for an active intervention in the operation of things. He sees the medium as according with the model of the surgeon rather than the magician, who conforms to the

ritual model of the painting as unique artwork. Caligari, the doctor-magician operating in a painterly *mise-en-scène*, shows the liability for film to mount forms of attraction that work against Benjamin's model. For Benjamin, film, in the impact of its succession of shots, follows the demonstrative tactility of the DADAists in their drastic-ally avant-garde staging of the attraction.[13] In albeit more measured form, the cinema functions for Benjamin through effects of shock, and has in this a unique potential to achieve political penetration.

Benjamin's account of the new medium is strikingly lacking in discussion of the cinematic avant-garde. There is a, perhaps melan-cholic, recognition here that the revolutionary potential of film, a medium so in thrall to capital, is largely confined in practice to the aesthetic sphere. Such aesthetic experimentation is rarely seen to be harnessed to progressive political interests, and its principal potential rests in indicating an alternative model of artistic form and perform-ance for other media.[14] It is also the case, as we have noted, that film remains closer to its ostensible polar opposite, the cultic model of theatre as 'Schaubühne', than Benjamin's essay might appear to suggest. While the scenarios of the earliest films are limited by their provenance and technology to the effect of the attraction, and the avant-garde experimentation of Eisenstein and others in the 1920s seeks to incorporate this effect as a strategy of political cinema, mainstream film increasingly aspires to a function more in line with conventional theatre. That is, the spectacular act is extrapolated into staged dramas, with developed plots, often derived from plays and constructed through acts and scenes. As a new art, looking for aesthetic status, film thus simulates the theatre in its key forms and genres: tragedy, comedy and, not least, melodrama.

The removal of the living presence of the performing body from the scene of film drama only serves to emphasize its appeal to illusion and to intense spectatorial identification with the dramas on screen. Film-theatre, recreating old models of drama in newly seductive and efficient forms, thus becomes a key battleground for the avant-garde in its attempts to challenge the terms of aesthetic illusionism. One main strand in this challenge to convention is cinema's version of the new psychic theatre, charged with libidinal and aggressive energies. The second is the film version of the new political theatre, which aims to redefine productively the relationship between spectacle and spectator. The third is the development of abstraction, especially in the experiments in 'absolute film' around the Bauhaus in Germany. Here, the cinema disengages itself from the model of human drama and adopts instead a more abstracted compositional method based

on music and non-figurative pictorial art. In the silhouette films of Lotte Reiniger, for instance, the corporeal reference of the film medium is reduced to two-dimensional shadow-play, and in the pioneering cinematic animations of Oskar Fischinger, László Moholy-Nagy, Walther Ruttmann or Hans Richter, even this minimal representation of corporeality is expunged in favour of a play of abstracted forms. The three strands – psychic, political and abstract or formalist – account for a complex and contradictory avant-garde, or set of avant-gardes, in film-theatre.

Film also emerges from theatre in the more straightforward sense that many of those responsible for the early cinematic avant-garde were trained in the theatre. This is true of several of the principal figures to be considered here, not least Eisenstein. At the same time, many of the key theatrical experimenters of the period – Piscator, Brecht, Artaud, Lorca, Meyerhold and Mayakovsky – became involved with film in significant ways. The new medium influenced their theatrical praxis to a substantial extent. The chapter will start with a discussion of some of these innovators, not least their use of film in the theatre, whether in practical or theoretical terms. There will follow an analysis of three avant-garde films that serve to exemplify the tension between psychic, political and formalist theatres: Dudov and Brecht's *Kuhle Wampe oder Wem gehört die Welt?* ('Kuhle Wampe, or, Who Owns the World?' (1932)), Vertov's *Chelovek s Kinoapparatom* ('Man with a Movie Camera' (1929)), and Buñuel and Dalí's *Un Chien andalou* ('An Andalusian Dog' (1929)).

In the experimental theatre of the period there is an abiding tension between activism and formalism. Pioneers in the renewal of the institution of theatre, like Piscator in Berlin and Meyerhold in Moscow, were criticized for the perceived lack of political function in their productions. While both pursued projects for a move away from bourgeois entertainment to revolutionary theatre, both were open to charges of indulgent theatricality. In his theoretical writings on theatre production Piscator repeatedly defends his revolutionary new designs for the theatre, with film and slide projection, and conveyor or rotating stages, against such charges. He insists that the 'revolution of the stages' (revolution might be understood here in both senses) is in the functional service of revolutionary politics.[15] Naturalism in the style of Stanislavski is seen by him not as congenial to proletarian interests, but as a block to revolutionary thinking. At the same time, he criticizes what he sees as the inadequately politicized use of film by Meyerhold and others in the Soviet theatres as merely indicative of

the decay of bourgeois theatrical conventions; and Meyerhold's radical new biomechanical system of bodily movement on-stage is seen by him as an exercise in aestheticism that fails to be harnessed to effective political ends.[16]

The theatre, declared by Schiller to be a 'moral institution', for which Piscator reads one of bourgeois individualism, is now to be converted in both technical and ideological terms into a 'political institution'. Above all, whether in the form of agitprop street theatre that he at first cultivates or in the institutional conversion of such direct action for production on the highly technologized new stages, this means a theatre of and for the collective, driven by the political logic of the Marxist dialectic. For Piscator the contemporary, ostensibly avant-garde avatars of the old 'Kunst-Theater' (art theatre) are the Expressionists with their 'Ich-Kunst', art in the first person deriving from the 'individualistic anarchic need of bourgeois artists',[17] and the DADAists with their formalistic 'harlequinade'.[18] Both are seen as failing to engage with the social imperative of proletarian politics. He proposes a new language of the theatre, one that supersedes the hyperbolic performances of Expressionism and DADA with a more regulated, objectified style. His model for the styling of performance and direction in the theatre, as for the low-key performative language of his own manifesto texts, is the concrete style of one of Lenin's manifestos.[19] Piscator's Marxist-Leninist programme is for a dialectical 'Aufhebung', a sublation of the bourgeois theatre. Thus, he takes a play like *Rasputin*, a drama that casts history as a function of the extraordinary individual, and converts it into a political review of European history between 1914 and 1917. The multi-dimensional segmentation of stage space in the spherical shape of the 'Globus-Bühne' served to project the individualist drama on to a global scale. The technical expansion and diversification of theatrical production in the 'Globus-Bühne', or the design for a 'Totaltheater' that Piscator developed with Walter Gropius,[20] is intended not least to represent a new, activist view of social relations. They were designed to break down the segregations of the feudal model of theatre, to bring the world into the theatre and to integrate the spectator into the social action on-stage.

In the 1927–8 Theater am Nollendorfplatz production of *Rasputin*, as elsewhere, film is a key technical element in the sociological revision of the theatre. Here, Piscator mobilizes different film genres to serve different theatrical functions: the 'Lehrfilm' (teaching film) provides didactic historical information; the 'dramatische Film' provides focal images (like a red flag being carried on a speeding car) to take

the place of stage action; and the 'Kommentar-Film' addresses the spectators as a latter-day form of Greek chorus, eliciting politicized responses from them.[21] In film, Piscator argues, the conventional dramatic dimensions of time and space are sublated,[22] lifted to a new mass-political level. Film as the epic medium of the modern age serves in his analysis to historicize and collectivize the drama of individual destiny.[23] Typically, this means in practice that the film projections extend the stage action, say in a reconstruction of revolutionary scenes,[24] into a fourth dimension that achieves a perspective at once of mass movement and of historical documentation. Film submits the individual human performers of theatre both to a sort of flattening, a relativization of their dimensions, and an extension into the ideological space of history as a revolutionary process.

This implies at once a rejection of old forms of psychological theatre and of the new forms of interiority that emerge in the Freudian age. Piscator is suspicious of Eisenstein's mobilization of the masses in *Bronenosets Potyomkin* ('The Battleship Potemkin' (1925)) as a mere cinematic display of the revolutionary scenes of 1905, akin to a boxing match or a military parade, rather than a critical analysis of power structures and their historical alterability. Eisenstein is seen as playing on the instinctual and behaviourist resources of the cinema, in thrall to Freud and Pavlov rather than following the rigour of Marxist philosophy.[25] Indeed, Piscator suggests that, notwithstanding its potential as an epic, choric element in the production of theatre, film is in itself a medium lacking in true revolutionary potential, inadequate to the demands of socio-political critique that is the proper province of the theatre.

Brecht, who collaborated extensively with Piscator, especially in the 1927–8 season at the Piscator-Bühne, was an enthusiastic proponent of the technologization of the theatre instigated by him, but also keen to emphasize its limitations. For Brecht, writing in 1927, Piscator's experiments with film are seen as marred by the management of the actors, who stand watching the film like spectators or indulge in operatic pathos of delivery that is debunked by the rigorous naivety of the filmic backdrop. What Brecht proposes is a role for film as a 'pure document' of the real, acting as an ethical testing-ground, a conscience for the performance as a whole.[26] While Piscator insists that the technical revolution of the theatre is of a piece with its revolutionary political character, Brecht suggests that Piscator's theatre is 'revolutionary neither in terms of production nor in terms of politics, but only in terms of theatre'.[27] He thus implicitly reserves the prime function for the author-director, who configures the different elements

of the theatrical work in order to achieve a politically effective mode of production. If 'Film makes drama's bed for it',[28] as Brecht claims, then this implies a dialectical relationship between the two elements, with film adopting a function that is at once intimate with drama and separate from it as a framing apparatus.

Film as the bed, or the bed-maker, of drama can serve as a model for Brecht's intervention in the debates between formalism and realism that dominated much of the discussion about artistic production in the avant-garde of the Twenties and Thirties. While his description of film on-stage as a document of photographic reality seems to put Brecht on the side of a straightforward, material realism, he in fact works dialectically to keep the formalist–realist dichotomy from collapsing into a crass opposition between aestheticist autonomy and political engagement. Realism, Brecht argues in his 1938 intervention in the 'Expressionism Debate', is not a formal issue, which is to say that there is no set realist form. The imperative of dealing with real demands can elicit different formal requirements: realism can demand experimental form where this is the most pragmatic means for exposing social causalities. He lampoons a Futurist *Portrait of Lenin*, made up of a cucumber on a cube, all painted red, but equally argues that the old academic, 'realist' style is inadequate to the purpose of representing Lenin's struggle for innovation.[29] The implication is that the new medium of film is particularly attached to the real through its photographic function, but that its realism should not be limited to a mimetic reflection of material conditions, any more than its potential for abstraction should be put at the service of pure formalistic play. As Brecht applauds Piscator's innovatory introduction of a gramophone recording of Lenin's voice in *Rasputin*, not merely as a document of historical realism but as a device of interruption,[30] so film is to be conceived of as an apparatus of theatrical form, of structural configuration and intervention, as well as one of social realism. In its interruptive function, following Brecht's montage principle of the strategic 'separation of all elements' in the spectacle, film can serve as much to unmake as to make the bed of drama, laying it open to critical question. As Benjamin notes, epic theatre follows the model of cinematic montage, proceeding by means of jumps and shocks, separating the scenic components in order to emphasize their impact upon each other.[31]

Precisely, and paradoxically, in its realist function, film has a special potential as what Brecht would come to call, following Shklovsky's notion of *ostrannenia* ('making strange'), the *Verfremdungseffekt*. In a note of 1936 entitled 'The *Verfremdungseffekt* in the Other Arts',

Brecht sees this principle of defamiliarization as operating in some of the key experimental forms of the avant-garde, from Joyce's use of montage effects in *Ulysses* to the more drastic alienations of DADAism and Surrealism. Whether by a dialectical opening up of the internal economy of a given medium or genre or by interrupting that economy in introducing the terms of another medium or genre into it, *Verfremdung* works to challenge habits of perception and judgement. The use of documentary film material in the theatre functions in this fashion: 'The on-stage actions are alienated by juxtaposition with the more general actions on the screen.'[32] As an element in theatrical production, film can serve to render the familiarity of the theatre unfamiliar. It gives an appearance of transparent realism, but only in the form of an immaterial simulacrum, a two-dimensional play of light that can work only in the physical absence of what it represents. Projected into the physical presence of the three-dimensional drama on-stage, its immaterial simulation of the real serves contrastively to project the human presence of theatre into a sense of unreality. Film, as a separating element of the dramatic spectacle, thus has a paradigm function for the Brechtian dramaturgy of ritualized distance. Brecht sees it as a sort of latter-day stage spook or *deus ex machina*; and the 'good deity of the revolution' that emerges from this machinery in order to haunt the stage spectacle is, paradoxically, naked reality.[33] Documentary sequences of real life outside the theatre work dialectically on the proposed realism of the drama; they enact a revolutionary revision of the staged action, showing its inevitable difference from reality. This is how Brecht employed film sequences from documentary or historical films in various productions of his dramas. He had Mother Courage march in front of footage from Eisenstein's *Oktyabr* ('October' (1927)) and Pudovkin's *Konyets Sankt-Peterburga* ('The End of St Petersburg' (1927)), and used sequences from Eisenstein and others in a *deus ex machina* function at the end of his production of *Die Mutter* ('The Mother' (1933)). He also used film in rehearsal, editing sequences filmed from the performance of *Mann ist Mann* ('Man is Man' (1926)) in order to demonstrate the principal *peripeteia* and thus the core structure of the play. Film, the realist medium, thus gives access to the stylized form of the drama, which in turn dialectically shapes its relationship to the real.

If film is used 'only as decoration to create an environment, then it must be artistically formed, that is, simplified'; it is a stage element like any other, subject to design and construction.[34] What is most important for Brecht is that film as used to produce a 'real environment' on-stage should 'not be allowed to destroy once and for all the

pleasure in the dialectic between the three-dimensional and the non-three-dimensional'.[35] It must work dialectically between the dimensions of the real and the formal. Film is, then, in the service of what Roland Barthes sees as the formalist element that is a necessary part of Brecht's 'realist' art: 'What Brechtian dramaturgy postulates is that today at least the responsibility of a dramatic art is not so much to express reality as to signify it. Hence there must be a certain distance between signified and signifier: revolutionary art must admit a certain arbitrary nature of signs, it must acknowledge a certain "formalism".'[36] By appearing to refer directly to the real in a way that drama never can, on-stage film exposes theatre as a system of signs in Barthes' sense. The human body and its language as signifying elements no longer simply embody their meaning, but demonstrate it through distance. Given that the meaning of theatre is not organically given, but constructed, it is also susceptible to alteration.

If Brecht's practice, as indicated by his understanding of film and its uses in the theatre, involves a contradictory negotiation between the political and the formal, then it also incorporates the third term of the avant-garde film-theatre, the psychic. While Brecht in his Marxist period, from the late Twenties onwards, leaves little overt space for the concerns of the psyche in his writings for or on the theatre, his earliest work for the cinema gives a different picture. In the early Twenties he sketched a series of film projects and scenarios, incorporating a wide range of modes from Expressionist fantasy to *colportage*-style adventures. The first project to be realized was his collaboration with the cabaret actor and film-maker Karl Valentin. He shared in the writing of the script for Valentin's silent film *Mysterien eines Frisiersalons* ('Mysteries of a Hairdressing Salon' (1923)), a Grand Guignol scenario of violence and desire, set in a hairdressing salon in the style of Sweeney Todd, and combining Chaplinesque farce with proto-Surrealist fantasy, complete with Freudian elements.

In his later work, such elements are restrained by the political imperative. A scene from *Die Beule* ('The Bruise' (1930)), Brecht's film treatment of *The Threepenny Opera*, features the dream of the chief of police, which develops the images of misery he has witnessed into a vision of irresistible uprising.[37] The transformation from theatre to cinema allows for the depiction of mass movement, and Brecht has the chief of police dream of the revolutionary masses streaming over a bridge into the sleeping city in the epic style of the new Soviet cinema. While in this scenario psychic processes are co-opted by the forces of the Revolution, it would be mistaken to assume that

the mature Brecht utterly dispenses with psychoanalytic possibilities. He more than once cites Freud as an authority in order to give credence to aspects of his theorizing on the function of the theatre. In his essay 'The Modern Theatre is the Epic Theatre' (1930), he quotes a section of *Civilization and its Discontents* where Freud describes art as a palliative drug that humanity could not do without, even as it diverts energies from more active, socially progressive pursuits.[38] Tellingly, this citation of the psychoanalytic class-enemy arises at a point where Brecht must concede that his opera *Mahagonny* retains some of the culinary trappings of the old bourgeois form, even as it seeks to work towards a society that would not need opera. It seems that the need that still exists for opera is of a piece with a need that still exists for the consumption of Freud and his anti-Marxist analysis of culture. Equally, when Brecht revises his early drama *Baal* (1919) as *Lebenslauf des Mannes Baal* ('Biography of the Man Baal' (1926)), which he claims to be the inaugural work of the new epic theatre, there is still much of the original libidinal psychodrama intact.[39] If in *Baal* the psychic element is hyperbolized, running amok in the polymorphous perversity of the title-figure, it remains an unsettling counter-presence in much of Brecht's later writing. As we will see when we turn to *Kuhle Wampe*, the film in which Brecht collaborated, the psychic has a way of emerging subversively out of the political regime of the epic.

Baal can be seen as representing in its most drastic form the element of libidinal and aggressive energy in Brecht's work that corresponds to the conception of the other leading avant-garde theorist of twentieth-century theatre, Antonin Artaud, who is generally seen as his polar opposite. While Artaud, like Brecht, saw conventional theatre as a sterile consumable, matching Brecht's description of the 'culinary' theatre with his 'théâtre digestif',[40] the sort of new theatrical production each proposed was markedly different. While Brecht's appeal to dialectical thinking as critical practice conformed to a Marxist rationale of organized revolutionary activity, Artaud was more akin to the persona that Brecht more or less exorcized in *Baal*, attached to the gratuitous energy of anarchy. As Baal makes a theatre-cum-circus for its own sake of his life and of those around him, both as performer and director (the *metteur-en-scène*, for example, of the scene where a group of farmers gather to sell their cattle to a non-existent buyer), so Artaud's commitment is to the theatre in and of itself, rather than as a political instrument.[41] A dissident figure on the edge of, and eventually expelled from, the Surrealist movement, Artaud resisted subjection to the service of the revolution in the company of

'ces révolutionnaires qui ne revolutionnent rien' ('these revolution-
aries who achieve revolution in nothing').[42]

The title of his influential collection of essays and manifestos on
the theatre, *Le Théâtre et son double* ('The Theatre and its Double'
(1938)), indicates that the theatre is given priority here over the world
as its double (a world that he redefines away from that of social
contingency towards primal energies and relationships). For Artaud,
the theatre is indeed a substantially autonomous domain, a stage for
revolt certainly, but for a form of revolt that is above all interior
rather than tied to the external world, one that gains its potential
precisely by remaining on a virtual level.[43] This is the revolt of the
unconscious compromised by social convention,[44] the theatre made
'to allow our repressions to come alive'.[45] The stage is conceived
of as a projection of psychic space, a place for the repressed to be
rendered physical and enacted. It is, in short, a dream-space – one
that has an appearance of chaos in its erotic, criminal and fantasmatic
performances, but that in fact follows the same precision of function
as dreams.[46]

If Artaud describes this embodiment in the language of manifesta-
tion, then this is resonant not only with esoteric ideas of the incarna-
tion of the spirit, derived especially from his favoured sources of
Balinese dance theatre and alchemy, but also with the idea of the
manifest in Freud's model of dream work: a physical shape in which
the latencies of the psyche are encoded. When he adopts the plague
as an allegory for the upheaval enacted by the Theatre of Cruelty, he
talks of it giving physical expression to 'sleeping images, a latent
disorder'.[47] This idea of latent meaning, of sleeping images (or the
images of dream), is all-important. Thus, while the dominant rhet-
oric of Artaud's programme for a Theatre of Cruelty, not least in his
gruesome descriptions of the plague, is one of often violent physical
immediacy, this is significantly tempered by a more complex under-
standing of representation that, following the psychoanalytic model,
achieves a manifestation of latent truths only through forms of
dissimulation ('The true expression hides what it manifests').[48]

The vocabulary of *Le Théâtre et son double* is saturated with more
or less explicit forms of Freudianism. The virtual revolt is, specific-
ally, a form of sublimation, in Freud's sense, an enactment that does
not expend the energy of action but turns it round and so retains it.[49]
This turning movement indicates that Artaud's engagement with
action is on the level of the trope, conforming to the sorts of rhetorical
turn that operate in the psyche according to Freud's analysis. He is
above all interested in the form of sublimation that is at work through

the tropes, the dissimulating figures, which organize representation in dreams. Dreams are, after all, a form of representation that Freud aligns with the theatre, making unconscious ideas present by dramatizing them.[50] If Freud sees dreams as working through an aesthetic of *Entstellung*, distortion or disfigurement, then the key principles of that aesthetic are condensation and displacement. He points out that *Entstellung* is etymologically understandable as 'removal to another place',[51] and his theory of dream representation is conditioned by such a removed scene, what he famously calls the 'anderer Schauplatz', the other scene or show-place, of the unconscious. Artaud's conception of theatre can be understood as constructing a *mise-en-scène* for this other scene. Not for nothing does his account of it feature the key words of Freudian *Entstellung*: the 'Second Manifesto of the Theatre of Cruelty' begins with a call for a 'condensation extrême des éléments scéniques' ('an extreme condensation of stage elements'),[52] and he defines the anarchy of theatrical poetry as working through 'ces déplacements de signification' ('these displacements of meaning').[53]

The cruelty of Artaud's vision, then, involves a new incarnation of the theatre that is *entstellt*, disfigured and displaced, in relation to the conventional shape and place of psychological drama. It is a theatre of latter-day myth, one ruled by the cult of a cruel Eros that has taken on the sombre costume of Freud's new deity Libido.[54] The Freudian Libido embodies Eros in a tight dialectical clinch with the aggressions of the death-drive, subject to its inexorable, automatic compulsions, as enacted in Balinese dance theatre.[55] As this reference to physical automatism shows, the reshaping of the body of theatre after the model of Libido involves a new role for the body on-stage. If Western psychological drama subordinates the body to the mind, as expressed through the discursive language of the canonical literary text, Artaud seeks to make the body signify in the manner of the condensations and displacements undergone by bodies in dreams. The body works on-stage as an active ideogram, a form of inscription that is embodied and performative, rather than abstractly discursive and constative. Artaud sees his actors as following the style of the Balinese dancers, as 'des hiéroglyphes animés',[56] or the ideographic gestures and attitudes of pantomime, much as Freud understands the semiotic system of dreams as analogous to Chinese ideographic script or Egyptian hieroglyphics.[57] And while Artaud does not, as is sometimes assumed, wish to do away with language altogether, he insists upon its embodied character, that it should speak directly to the unconscious by means of its concrete shape, and that it should have the sort of functional importance that it has in dreams. Which is to

say, following Freud, that words too should obey the corporeal prin-
ciple of *Entstellung*. For Freud dreams do not conform to conven-
tional syntactic regulation but achieve their significance according to
a more disjunctive aesthetic of montage, cutting and pasting frag-
ments of speech, and this too is the basis of Artaud's use of language
on-stage. Equally, Artaud's stage language resists standard semantic
codes, revealing meaning instead through the counter-effects of some-
thing akin to Freud's notion of parapraxis, the lapses of language
and behaviour that arise in hypnagogic states.[58]

The question of a new language for the theatre clearly has implica-
tions for the performance of the aesthetic manifesto in Artaud's
theoretical writings. There is a slippery relationship between the idea of
the manifesto and the key term of 'manifestation'. Artaud's praxis as
a performer of theory is divided between the claims of the idea of the
manifest on the one hand – for which we can read an embodiment of
psychic drives – and the manifesto in its political sense on the other.
If Brecht's political project is troubled by a vestigial attachment to
the psychic, conversely, Artaud's psychic project is unsettled by its
uncomfortable attachment to a political discourse. As he acknow-
ledges in the preface to *Le Théâtre et son double*, any performative
manifestation requires a language, which, however, always acts as a
double bind, traducing that which demands to be made manifest.
The Marxist dialectic is clearly not appropriate to the needs of
Artaud's version of the revolutionary project. The 'alienation' pre-
scribed by Brecht in his derivation of performative *Verfremdung*
from the Marxist analysis of social *Entfremdung* is incommensur-
able with the celebration of mental 'aliénation', or derangement, and
extreme bodily estrangement that Artaud undertakes in his cult of
the plague.

Artaud attempts to co-opt the Marxist conceptual instrument of
the dialectic for his own purposes, suggesting that it can be adapted
to his idea of theatre as a space of dissonance, working through 'the
dialectical unchaining of expression'.[59] However, the oxymoronic
formulation of an anarchically free dialectic exposes the incom-
patability of the discourses he seeks to hybridize. As he recognizes in
a discussion of the style of his manifesto writing, it has a dialectical
deficiency; the force of the conception is not matched by a measured
system of relation and differentiation on the level of argumentation:
'the dialectics of this manifesto are weak'.[60] The manifestation of
Artaud's ideas on the theatre can neither match the physical perform-
ance of the 'manifest', on the one hand, bound as it is to a discursive
form of promulgation, nor conform to the model of the manifesto

in its strict political sense, driven as it is by the anarchic energies of the psyche.

If the manifesto form exposes a crucial tension between theory and praxis, then Artaud's practical writing for, and engagements with, both the theatre and the cinema show that tension from the other side. On the one hand, he prepares theatre scripts that approximate to conventional dramatic form and seeks to inscribe dramatic performances in fixed systems of notation, resisting any possibility of improvisation; on the other, he would perform his own role of *metteur-en-scène* as an inchoate psycho-drama.[61] Psychosomatic excess and precision, mystique and deliberate codification, are in constant tension here.

Artaud's relationship to film is no less contradictory. Like Brecht, Artaud engaged with film both theoretically and practically, writing several screenplays and acting in a range of films, including Pabst's contentious version of Brecht and Weill's *Threepenny Opera*. Like Brecht, too, he was influenced in his ideas on acting style by the stylized gestural codes of the silent cinema, though his conception of these as a heightened psychic body language differed considerably from Brecht's model of the *Gestus* (as we will see below). And while Artaud did not introduce film directly into his own theatrical productions, and would clearly have had little personal use for the political implementation of documentary footage on-stage, he was impressed by Piscator's experimental productions and took responsibility for the film projection used in the 1927 French production of Yvan Goll's *Methusalem*. Christopher Innes has argued that not only acting styles but also the other key elements of Artaudian stagecraft emulate the cinema, with the use of lighting functioning like a camera and the rhythmic syncopation of stage images working like cinematic montage.[62] In *Le Théâtre et son double*, Artaud both adopts film as a paradigm for his theatrical project and criticizes its function. Thus, the Marx brothers are seen as achieving a magical version of Surrealism on screen, celebrating a humorous form of anarchic revolt and showing how the unconscious of the characters in a film like *Animal Crackers* exacts revenge for the repressive coercion of social convention.[63] As the Marx brothers emerge from a vaudevillian form of theatrical tradition, so Artaud sees the cinema as having a potential akin to that of the music-hall or the circus, an affinity with the spectacular exhibitionism of the attraction and at odds with the decline of the theatre into the voyeuristic appeal of psychological drama.[64] However, Artaud goes on to suggest that, in practice, the cinema has lost its potential for immediacy. In what he calls its 'precocious

old-age',[65] the apparatus serves only to separate the spectators from the action and lull them into a state of torpor. Like many an avant-gardist, he looks to the new medium for a radical transformation of aesthetic production on a mass scale, but finds it succumbing to habitual structures of commodification and consumption.

What Artaud proposes in his screenplays and his essays on the cinema is the development of 'des filmes psychiques',[66] films that tap psychic resources and so subvert conventional narrative strategies and superficial psychologization. He calls for a cinema of dream, working according to a logic of association, as driven by 'the *mechanics of a dream*'.[67] His definition of a cinematic 'avant-garde de fond',[68] one working at psychic depth rather than with surface form, rejects experimental technical effects for their own sake. This is not a cinema of brute materialism, nor one of abstraction, but one that uses the material world and what he calls its 'human skin' to access the essential domain of the psyche.[69] Characteristically, Artaud describes this function with a bodily metaphor: film has to represent that which can be recognized by the 'eye of the screen'.[70] As mediated by this organ, the cinema needs to operate with embodied action, to work through sensation on the bodily perception of the spectator. In place of abstract cinema or the sort that is ruled by narrative discourse, Artaud seeks a form based on visual impact, on 'shock to the eye', which draws upon the concrete energy of the visual, 'the very substance of the gaze'.[71] This extreme channelling of the physicality of his project via the artificial eye of the cinema gives some indication of the difficulty that his body-based aesthetics must face when transferred to the disembodied form of film. The shock effects of film are characterized for Artaud as always already lacking in the true poetic impact that is to be found at the stage of the performance *before* the camera. The recording of the image is for Artaud an act of 'inscription', a turning away from the performative poetry of action before the camera into a form of quasi-textual fixture.[72]

Artaud's screenplays show what the conception of physical, visual action and the coupling of the cinematic apparatus to the 'mechanics of the dream' implies. *Les dix-huit Secondes* uses a watch as a workaday mechanism to mark the passage of 18 seconds of 'real time' as a foil for the film's dilation into interior time as enabled by its dream scenario. The protagonist is a psychically disturbed actor, and the erotic and violent fantasies of power played out in his inner film-theatre are thus characterized as performative, as forms of acting out on-stage and on screen. As both the stage and a crystal ball serve as *mise-en-abyme* devices for the film screen,[73] so the protagonist

experiences a dream within a dream: the two forms of self-reflexive mechanism are coextensive. Here, revolution serves only as an adjunct to subjective fantasy, releasing internees like the protagonist from his asylum and into his fantasmatic theatre.

The only screenplay of Artaud's that came to be made into a film, *La Coquille et le clergyman* ('The Shell and the Clergyman' (1927)), shows what practical difficulties attach to making the dream mechanism work filmically. While the idea of a mechanics of dreams suggests a concern with their concrete workings rather than an idealized notion of the oneiric, films based on dreams all too easily dissipate the psychosomatic immediacy that Artaud seeks. Germaine Dulac, who directed the film, converted a scenario that Artaud wanted to hold in a tight dialectical clinch between dream and physical reality into what he saw as idealized dream-play. In protest at what he saw as a failure to achieve the material cruelty of his concept, Artaud and a group of followers disrupted the film's 1928 Paris *première* and were evicted from the showing. As so often in the performance logic of the avant-garde, the primary spectacle has a supplement in the manifestation of protest that is mobilized by its perceived failure to make the programme truly manifest. These supplementary manifestations have a serial logic of their own: as a group of card-carrying Surrealists around Breton disrupted Artaud's production of Strindberg's *Dream Play*, so Artaud, Desnos and others do so for Dulac's film.

Ultimately Artaud's conception of both film and theatre is a contradictory one. He cultivates a combination of hypnosis and shock,[74] of continuity and interruption; and these effects work at once on a mass level and on the level of the individual psyche, maintaining an unresolved tension between political and psychoanalytic interests. The screenplay *La Révolte du boucher* ('The Butcher's Revolt' (1930)) can serve as an example. Characteristically, revolt here is cast between the political, with various groups (butchers, soldiers, seminarists) mobilized in its street scenes, and the personal revolt of the mad protagonist. As it follows the latter's narrative of erotic contest and brutality, the scenario modulates between interior and exterior scenes, the group and the individual, mass perspectives and close-up. The carcass, which returns at different points in the narrative, operates as a figure for individual sacrifice, while the herd serves as a metaphor for mass movement, and the abattoir for violence on a mass scale. The slaughterhouse narrative follows what the screenplay calls the 'movement of dream',[75] a dynamic of displacement and distortion in accordance with the Freudian model of *Entstellung*. It seems

that this dream is in the first place the private property of a madman rather than the anarchic common ground of the mass movements.

Brecht's Baal, circus performer and ringmaster, drew together a group of farmers and their cattle with the promise of a prize sale, the arch individualist creating a mass spectacle for his own pleasure. Artaud's screenplay envisions human herds mobilized in response to the fantasy of a crazed individual. This preoccupation with the dynamic interaction of individual and crowd is a defining feature of avant-garde theatre and film and of the cross-over between the media. The street scene, with its appeal at once to revolutionary politics and to psycho-dramatics, has the function of a leitmotif in this regard. It is the site of individual and mass movement and manifestation and of the potential collision between the two, a site of chance encounter, of incident and accident. If art is to be lifted into life by the avant-garde, then the street rather than the theatre or the studio becomes the place for spectacle in the new age of mass culture. Not for nothing does Brecht adopt the street corner and an everyday accident that has taken place there as model site and material for his new demonstrative form of social theatre.[76]

Sergei Eisenstein, who can be located somewhere between Brecht and Artaud on the psycho-political scale, is perhaps the master of the individual–mass dialectic, and for him too the configurations of human and animal, individual sacrifice and mass slaughter, are of the essence. They provide the fundamental logic of many of the moving pictures or fixed tableau-style scenes that characterize his pictorial style of film-theatre, not least, as we shall see, in its depiction of revolutionary street scenes. Eisenstein's cultivation of a 'montage of attractions' allows for considerable flexibility in his cinematic productions. Like Brecht and Artaud, in their different ways, he embraces the circus and the music-hall as models of production that feature a succession of attractions, an assemblage of 'acts'. The acts are performative in their impact, designed to show and be shown through framed action on-stage or on screen. Eisenstein's mixed training in the circus-style forms of theatrical eccentrism, which emerged in the early years of the Soviet Union,[77] in the stylized physical theatre of Meyerhold's biomechanics, and in Constructivist stage design, combined to produce the basis for the montage aesthetic. The theories of expressive movement and of the *raccourci* (the foreshortening of the emotional or ideological meaning of a scene into a paradigmatic gestural shape), as elaborated for the stage, lent themselves to a style of film making that foregrounds the body as at once energetic force and pictorial form. The body, caught between mobility and

fixture, becomes the template for the organization of filmic space, and cuts between bodies, or body parts, or between bodies and inanimate objects, are a key form of the associative mode of montage that Eisenstein develops. Eisensteinian montage is in this sense always biomechanical, representing physical form as reorganized by the apparatus of film.

Montage functions for Eisenstein in each of the modes already encountered. It is a formalistic principle, one that focuses the attention of the viewer upon the structure of the framed image in a dialectical tension with, rather than subordination to, the teleological line of the narrative. Eisenstein's cinema is powerfully attached to this iconographic effect. At the same time, the dialectical tension between the individual frame or scene and the whole, brought about by the montage process, enables it to function politically. It works demonstratively, isolating snapshots of the social apparatus in order to show their workings in relation to the whole. And finally, as evidenced by Piscator's critique, montage here has a function akin to what we saw in Artaud, following a psychoanalytic understanding of representation as psychically driven, as in the montage aesthetics of dream. It is telling that Eisenstein cites Freud's discussion of portmanteau words, as deployed especially in dreams, as a basis for his idea of montage.[78] The instantaneous connection achieved by montage here follows the Freudian dream model in producing a form of 'condensation' that conforms to the 'laws of economy of psychic energy'.[79] The laws of this psychic economy evidently run counter to the laws of revolutionary politics or of formalist aesthetics. When Eisenstein describes, on the one hand, the psychically determined inability of Tolstoy's Vronsky to focus on the face of his watch and, on the other, the sequence in *October* showing simultaneous images of 'the historic moment of victory' in different time-bands across the world, he draws out the non-simultaneity of simultaneous experience. The experience of time and place varies according to whether it follows individualist, psychic or internationalist, political determinants.[80] If montage works for Eisenstein according to a principle of collision between images and between the image and the viewer, then it also has the potential for bringing formalistic, political and psychic frames of reference into collision.

While the political is dominant in Brecht, and the psychic in Artaud, the three frames of reference are more evenly triangulated in Eisenstein. As Barthes has it, in his comparison of the Brechtian scene of epic theatre and the Eisensteinian shot as tabular forms of representation, what distinguishes the two is that 'in Brecht the tableau is offered to

the spectator for criticism, not for adherence'.[81] That is, notwith-
standing the breaks between the formal, political and psychic modes
of production in Eisenstein, there is a tendency for each of these
cumulatively to draw the viewer into the spectacle. If Barthes dis-
cusses the effect of the cut-out image of montage in terms of the
potential for fetishism, this indicates that while Eisenstein's editorial
technique is ruled by the abrupt cut, that which is cut is at the same
time pasted, stuck into a compositional whole to which the spectator
is made to adhere. On formal, political and psychic levels, the cut-out
is at once an independent attraction and a token of the film's ultimate
integrity: its commitment to a worked-through compositional struc-
ture, to a revolutionary cause, and to the realization of fantasy.

This threefold binding of the montage image can be seen at work,
for instance, in *Staroye I Novoye* ('The General Line' (1929)). At its
most manifest level, the film is in the service of the Revolution. In
the sequence depicting the dream of the figure Martha around a new
cream-separator, this logic is clearly in evidence. The dream repres-
ents the converse of the slaughterhouse imagery discussed earlier,
drawing together a herd of cattle as a metonymic representation of
the collective and yielding milk rather than blood. It figures a super-
abundance of milk, as yielded by the collective work of Martha's
communal farm. The images of the milk, cut up and yet brimming
over in the montage process, stand as a fetish for the process of
collective production. As Jacques Aumont has shown, however, the
milk also functions fetishistically in a psychoanalytic sense, serving as
a metonym for sexual reproduction, and figured in ecstatic, orgasmic
fashion.[82] Equally, the visual play of the fluid provides an oppor-
tunity for a powerfully formalistic treatment, whereby the milk
becomes a fetish that displays the aesthetic management of the filmic
material at large. The cream-separator, as a processing apparatus
working through selection and combination, might also be under-
stood as a self-reflexive representation of the power and allure of the
cinematic machine on all levels. As a primary organic material, milk
stands nicely for Eisenstein's organic view of cinematic work and
its relation to life, and the machine that works it indicates the
biomechanical character of that organicism.

The sequence can be said to represent the dream vision that this
director in the service of the Revolution has of the cinema. As the
herd of cattle is inseminated by the towering bull, it seems that the
dream also relies on the idea of the heroic individual, the corollary of
Lenin as he is iconically isolated above the masses in *October* or, in
turn, of the *auteur* Eisenstein, the charismatic aesthetic authority who

governs the ostensibly collectivist production of his films. Eisenstein's dream of productivity incorporates autonomy as well as communality; as he writes of *Battleship Potemkin*, the work achieves organic wholeness only when it is at one 'with the very breath of the author. Then and then only will occur a genuine organic-ness of a work, which enters the circle of natural and social phenomena as a fellow-member with equal rights, as an independent phenomenon.'[83] Trotsky's critique of Mayakovsky, and via him of Russian Cubo-Futurism at large, might equally well be applied to Eisenstein: his 'revolutionary individualism poured itself enthusiastically into the proletarian Revolution, but did not blend with it. His subconscious feeling for the city, for nature, for the whole world, is not that of a worker, but of a Bohemian.'[84]

The pull between aesthetic autonomy, political responsibility, and psychic investment is in evidence in all of Eisenstein's films of the 1920s. His revolutionary film-theatre is by turns one of formal extravagance with a distinctive authorial signature and a keen sense of its own theatricality, of political demonstration after the model of the epic theatre, and of psychic fantasy and trauma after the model of the Theatre of Cruelty. Eisenstein's first major film *Stachka* ('Strike' (1924)) is in many ways a hybrid: a political fairy-tale, with aspects of music-hall and *commedia dell'arte*, it crosses genres and styles. This piece of 'agit-guignol' is textbook cinema of attractions, exhibiting a menagerie of performing animals and their human counterparts, and exercising a powerful visual impact through the cut and thrust of its montage logic. The blurring of human figures with animals, on the one hand, and with machines and other man-made frameworks, on the other, serves as a biomechanical model for the processes of montage on every level. The film's camera work and *mise-en-scène* combine Expressionist influences with the geometric and machine-based aesthetics of Constructivism. Its manifest programme is a celebration of proletarian revolt and its utopian potential, but it also has an attachment to individual figures, their distinctive physiognomies and fates. The melding of the collective and the individual leads to a mode of paradigmatic characterization or 'typage'. The film's epic political sweep also incorporates elements of Hollywood genre movies (especially slapstick), which give individual form to such model types and are generally seen as in the service of industrial capital, entertainments that collude in shoring up the *status quo*. The film thus remains suspended between a progressive view of political struggle and a fatalistic display of the human (tragi-)comedy. Its historical analysis is divided between a Marxist orthodoxy that

aligns change with revolutionary forces and a more psychoanalytic vision of subjection to trauma. Eisenstein compared film art to a tractor ploughing over the psyche of the audience, and this image nicely embodies the conversion of the exemplary machine of collective production into an apparatus of psychic penetration.[85]

This focus on divided forms of vision is a constant feature of the film. It sustains a continuous self-reflexive commentary on the workings of film, matching the ubiquitous wheels and technical modes of transportation with the turning and travelling of the cinematic apparatus, giving recurrent attention to framing, animation and trick shots. As a film not least about surveillance, it constantly foregrounds and questions the function of the gaze. In the film's closing *tour de force*, cross-cutting the epic street scenes of the brutal putting down of the strike with images from a slaughterhouse, this attachment to complex viewing techniques is in particular evidence. The parallel montage is at once metaphorically and metonymically conditioned, relying on a visual substitutability between the two forms of cutting down and a structural logic of contiguity between two interdependent forms of brutal, exploitative regime. Along with gun-fire (as in *October*), the cutting process of montage is here aligned with the physical cutting on display in the two cross-cut sequences. The film's form thus works performatively on the viewer, enacting a traumatic visual assault that couples the aperture of the camera lens that is exposed to the cutting to that of the eye.

The film concludes with an injunction to the worker-spectators never to forget this episode of revolutionary history. The implication is that collective memory will serve to sustain them in the present and future of the revolutionary project. But the reference to the 'bleeding scars' that are left unforgotten on the 'body of the proletariat' also suggest a more compulsive, psychically damaged form of memory: history as a nightmarish trauma that can be neither forgotten nor adequately remembered. The political message of the film is thus at once heightened and troubled both by the aesthetic design of its elaborate editorial form and by the psychic latency that shadows it. The cut, which is its most insistent feature in both editorial and iconic terms, is deeply paradoxical. It stands both for a convergence of these interests in the representation through montage of historical crisis and for a principle of violent separation, a slaughterhouse vision, which eludes any effective dialectical recuperation. However powerful the close-up representation of the slaughter of the individual bull, it can embody the reality of the mass killing only as a graphic approximation, a kind of fetish.[86]

Like *Strike, Battleship Potemkin* is an epic celebration of a key staging-point in the revolutionary struggle; it too provides a bravura display of the formal possibilities of the montage aesthetic and incorporates a psycho-dramatic level of engagement. Whether in its seductive attention to the bodies of the sailors in the under-deck or in its powerfully emotive attachment to the individual fates of the victims on the Odessa Steps, the film charges its revolutionary documentation with desire and pathos. At the same time, it exploits it for an intensely orchestrated and syncopated visual spectacle. Eisenstein's account of the film suggests a work of finished Classical form, complete with a golden section, rather than a militant avant-garde happening. His prescriptions for a work following 'the laws of austere composition of tragedy' reveal an intensely formal preoccupation with pattern;[87] as Michael Minden has noted, they sound 'more like Aristotle than Marinetti'.[88] Not only does cinema imitate theatre here, but it does so in theatre's most canonical form. At the same time, the patterned form is a frame for powerful breaks, leaps and reversals, and these introduce a double potential into the shape of the film. The leaps into the opposite are seen by Eisenstein as at once following the 'formula of the ecstatic',[89] and so introducing an extreme psychic energy into the spectacle, and also emulating 'the *revolutions* which stimulate social development and social movement'.[90] That is, the film leaps in different directions under the cover of its tragic form. If it shows obedience to the conventions of the theatre in its overarching shape, making the city streets a site for a latter-day, mass version of Classical Tragedy, it also explodes that relationship. This is, after all, a film that culminates in the revolutionary act of bombing the city theatre.

One image or tableau from the Odessa Steps sequence has come to take on a special iconic status: the woman with the pince-nez having her eye put out (see plate 7); or rather, having had it put out, for Eisenstein strategically elides the before and after of the scene to make its enactment, its performative moment, rest in the direct editorial cut to the face disfigured by trauma. As in *Strike*, the cut of the montage work is concomitant with the impact of the physical cut or shot. Eisenstein describes it thus in his 1929 essay 'The Dramaturgy of Film Form': 'Representation of a spontaneous action, *Potemkin*. Woman with pince-nez. Followed immediately – without a transition – by the same woman with shattered pince-nez and bleeding eye. Sensation of a shot hitting the eye.'[91] In fact, there is footage between the two images, but its diegetic relationship to them is uncertain. Directly before the shot of the bleeding eye, a Cossack slashes viciously

Plate 7 The woman with the pince-nez on the Odessa Steps in *Battleship Potemkin* (1925). bfi Collections. © Contemporary Films Ltd., London.

to camera, and this shot acts as a hinge between that of the baby in the pram, which precedes it, and that of the injured woman. The bleeding eye can thus be read either as a wound inflicted by an act we do not directly see or as a kind of traumatic splash, a function of the old woman witnessing the bloody slaughter of the infant. The sensation that Eisenstein describes is reflexive in effect, impacting on the eye of the cinema-viewer as well as that of the old woman who beholds the horror at the scene. But there is more to this shot than the sensation of impact. While the representation of human trauma is more directly given here than in the cross-cut sequence in *Strike*, fetishism is once more at work. The famous pince-nez serves here as a fetish before the wound, a visual aid which, however, serves to efface the trauma behind it, representing its conversion into spectacle. The representation of the death of the ship's doctor earlier in the film by means of his trademark pince-nez caught in the rigging has established the eyepiece as a theatrical prop. It is worth recalling that 'gouged out' eyes are one of the elements of the theatricality of cruelty that Eisenstein notes in his discussion of Grand Guignol in 'The Montage of Attractions' (1923).[92] In this sense, this iconic tableau is not unlike the blind bull's-eye at the culmination of *Strike*, a visual image of extreme trauma that is none the less strategically marked by blinding, by an aversion of the gaze from the sight of the wound as such. When revenge is exacted for this violence, the *Potemkin*'s cannon-fire hitting the bull's-eye of the Odessa Theatre, it seems that the film recognizes something of its own, deeply ambivalent, fetishistic attachment to the spectacular pleasures of theatre.

When Barthes discusses Eisenstein's cultivation of the tableau as cut-out, he indulges in a cinephile fantasy: ('isn't it said that in some *cinémathèque* or other a piece of film is missing from the copy of *Battleship Potemkin* – the scene with the baby's pram of course – it having been cut off and stolen lovingly like a lock of hair, a glove or an item of women's underwear?').[93] The traumatic image, cut out and assembled in montage, also carries the allure of the fetish. *October*, too, is organized around the relationship between trauma and fetish. Its 'official' form is that of the revolutionary documentary, with set-piece scenes from the epic theatre of mass struggle.[94] But it also stages scenes from a different kind of theatre, where agit once more converts into Guignol or into a private theatre of fetishism, one that features all of the fetishes listed by Barthes: hair, costume accessories and items of underwear. In its exploration of palace apartments and galleries, the film finds spaces of aesthetic pleasure, of play

and display. When two female soldiers attend to their uniforms and make-up on the czar's billiard table, we are in a private counter-revolutionary theatre of masquerade behind the scenes of the Revolution. This wardrobe scene specifically displays a lacy bra hanging on some billiard cues and the women's uniforms on a marble sculpture, at once an iconoclastic abuse of the work of art as costume dummy and an indication that the cinematic fetish is also a thing of seductive aesthetic exhibitionism.

The fetishistic logic is also in evidence elsewhere. One such scene, set apart from and cross-cut with the revolutionary street scene, is the one where the bourgeois women set upon a young Bolshevik with their parasols. It is a savagely erotic assault, with the overdressed women stripping the revolutionary and spiking his naked torso. The brutal violence of the scene is theatricalized, with extravagant attention to costume – feathered hats, white gloves and frilled underwear. This theatricality is underlined by the applause of an onlooker, delighted at this savage attraction from the bourgeois street theatre. Eisenstein cuts from this Guignol stage to another scene of revolutionary trauma: the crowd rushing over a bridge encounter a hail of bullets, and the horse-drawn cart that leads them crashes out of control. The street is a stage for a dramatic accident that is under the direction of the regime. As the bridge is raised, so the horse is slung over the side, hanging in its harness, and presenting another image from the abattoir. The animal body hanging from the technical apparatus of the bridge represents the principle of biomechanical montage in its mortified form. This carcass is set in parallel with the body of a woman, whose hair is draped over the gap in the bridge and lifted in tantalizing animation as it opens. Again, the spectacle of the slaughterhouse is configured with an alluring cinematic fetish. Formalistic composition, revolutionary outrage and psychic cathexis are combined in this *tour de force* of Eisensteinian shooting and cutting.

Exemplary Readings – Counter-Exemplary Tendencies

In the closer discussion of three avant-garde films that follows, each will be taken as exemplary of one of the three trends that have been highlighted here: *Kuhle Wampe, Man with a Movie Camera* and *Un Chien andalou* will stand respectively as representative of the political, the formalistic and the psychic strains in avant-garde cinema. At the same time, the sorts of ambivalence that have emerged in the

discussion so far will be pursued further; each of these films, whilst highlighting one of the trends, will also be seen to give more or less explicit, and often contradictory, evidence of the others.

The three films have various motifs in common, amongst them the bicycle. As a basic machine, the bicycle can be appropriated for the propulsion of different interests. In *Kuhle Wampe*, the bicycle functions as a model vehicle for a political and economic apparatus that fails to work for the masses. In *Man with a Movie Camera*, the bicycle is primarily a vehicle for formal concerns of image: one of the shop-window dummies featured at the start of the film is on a bicycle that goes nowhere, and this framed form devoted to aesthetic display is recycled in the figure on an exercise bicycle later in the film. And in *Un Chien andalou*, the bicycle ridden along a street is a vehicle for the film's psychodrama rather than part of the routine social life of the city. If the bicycle is deployed in these different ways in the three films, it is also part of a network of traffic that is less regulated in its functions, susceptible to waylaying by other interests and collision with other vehicles. The visual matching that operates between the spinning wheels of the bicycle and the spinning cranks and reels of the cinematic machine also implies that this too is a vehicle for contradictory movements and for accidents.

Kuhle Wampe, *or,* How to read a film

As the subtitle of this section suggests, the reading of *Kuhle Wampe* that is proposed here is an exemplary one. It treats the film as a textbook enactment of the Marxist aesthetic as applied to the film medium, and hence as a model form of the political avant-garde. There is, however, a counter-exemplary twist in its tail. We shall see that even in this apparently model political film there are counter-movements at work.

Kuhle Wampe was produced by an artistic collective around director Slatan Dudov, in collaboration with various workers' groups. Posterity has often identified it as the film of its most celebrated participant, Bertolt Brecht, who had a major part in writing the screenplay and an unquantifiable input into its production. While the current reading will follow this tendency in focusing on Brecht and on the relationship of the film to his perhaps uniquely sophisticated formulation of a revolutionary performance ethic, this is inevitably a somewhat false move. The assumption that this project can be attributed to any single person should certainly not be taken for granted. As with so many of the key works of the avant-garde (including the

other two films to be discussed in this section) authorship is an inter-
active agency, never securely attributable to any presiding genius.
Where the argument refers to Brecht, the collective, both nameable
and unnameable, should always resonate along with the name of the
author. The key question here is the extent to which *Kuhle Wampe*
can be said to achieve a model form of revolutionary film-theatre,
and the implications this has for the more general relationship
between theatre and film in the avant-garde.

There is an abiding methodological contradiction in Brecht's
dramas around the relationship between text and performance. If,
on the one hand, Brechtian theatrical praxis subverts conventions of
the primacy of the text and upturns the hierarchical relationship of
literary creation to stage production, the principles of production
that are subsumed by the term *Gestus* can be said to retextualize the
behavioural shape of the play. That is, the spectacle of physical
performance is subjected to what Brecht calls 'literarization', and
hence provokes, in a special sense, acts of reading. When literary
critics turn to film studies, they tend to treat the cinematic medium
too textually. The metaphor of reading as applied to the viewing of
film needs to be scrutinized carefully if it is not to be a vehicle for the
sort of reductive misappropriation that elides the specificity of film as
audio-visual technology. But the sort of film-text that is proposed
here, as produced by Brecht and his collaborators in *Kuhle Wampe*,
can serve as a paradigm for critical film viewing, and by extension
for the critical reading of cultural products at large.

If the *Schaustück*, or show-piece, medium of film is to be converted
into a certain type of *Lehrstück*, less to be seen than to be read in a
critical act of learning, then its lexicon is derived from the repertoire
of *Gestus*. As *Gestus* is a word whose meaning cannot be assumed, it
might be worthwhile first to give a working gloss of it. *Gestus* always
has a dialectical character for Brecht. In its primary sense, *Gestus* is
social: it describes conventional or ritualized forms of behaviour,
conditioned by society but made to appear natural. By being natural-
ized, these ritual behaviours serve to sustain structures of social power.
To give a concrete example, the shrug of 'That's just the way it is'
could be seen as the archetypal *Gestus*; it is a gesture of social com-
munication, but one that signifies a fatalistic effacement or aversion
of active, political engagement.

Then there is the second-order form of *Gestus*, what might be
called 'performative *Gestus*'. As a technique of performance, this
form of *Gestus* is derived from the primary, social form, but turns it
into a reflexive, mediated act. This *Gestus* is performative in the

linguistic sense, a speech act that pronounces or enacts rather than simply describes; the act of *Gestus* in this form always also implies the performative framing of 'I pronounce' or 'I show'. The performative *Gestus* always combines styles of social behaviour with a gesture of demonstration. What it serves to show above all is that social *Gestus* is not natural, but constructed, and constructed to serve ideological interests. *Gestus* thus represents the performative in the sense developed by Judith Butler for her critique of the categories of gender and sexuality. In both cases, the performative at once embodies the repetitive power of the sorts of ritual behaviours that support dominant ideologies, yet also asserts opportunities for opening up critical distance by exposing the structural contradictions that those prescriptive performances would conceal.

The performative *Gestus*, as a way of showing that also shows the act and apparatus of showing, is perhaps pre-eminently desirable in that most compellingly showy, yet most self-effacing, of aesthetic apparatuses, the cinema: a medium that seduces so powerfully by hiding the complex machinery that mounts the seduction. It is fitting that Brecht should have derived an impulse for theatrical *Gestus* from the conventions of the silent cinema.[95] Silent film furnishes a model for *Gestus* because it is a medium in which bodily behaviour is always stylized by an extra need to show. Transferred to the stage or to sound film as a significant excess or supplement, this *Gestus* comes to show itself strategically, and thus to provoke the questioning of codes of behaviour. This accords with what Barthes described as the formalist element in Brecht's realist project, its recognition of the difference between signified and signifier. The human body and its language as signifying elements no longer simply embody their meaning, but demonstrate it through distance. Bodily behaviour as text in this sense elicits a defamiliarized act of reading. If the meaning of behaviour in theatre is not organically given, but constructed, then it is also susceptible to alteration; it is a textual construct that is open to critical acts of rewriting.

The elementary disjuncture between signifier and signified in the showing apparatus of the theatre is no less operative when Brecht turns, or returns, to cinema in the early Thirties and the collective project *Kuhle Wampe*. This is a film drama that is shot through with the showing both of its own apparatus and of the machinery of other forms of production, social, economic and political. In this most technologized of performance arts, Brecht recognizes the possibility for an aesthetic of montage in the material sense: a form of representation in which the components are mounted in a machinery, but

always mismatching and so subverting any emulation of the organic coherence associated by convention with the natural body. For Brecht is above all concerned to expose the contradictions in the apparatus, physical and ideological.

Kuhle Wampe is a work in three acts, with a prelude or overture. The first act shows the hunt for work as a form of work and the effects of unemployment on the Bönike family. It culminates in the suicide of the out-of-work son who raced after work in vain. The second act shows the daughter Anni rehearsing her brother's futile quest in her attempts to forestall the family's eviction and their sub-sequent removal to the colony on the Müggelsee named Kuhle Wampe. Anni becomes pregnant, and her shotgun engagement to Fritz is celebrated, only for her to leave him and join her friends in the Workers' Sports League. In the third act, a sports festival with agitprop elements is featured (see plate 8), sport functioning here as another form of revolutionary work; Fritz and Anni are reunited in the festival; the film ends with a discussion in the municipal railway about the injustices of the coffee industry and the final rallying cry in response to the question as to who will change the world: 'Those who don't like it.'

If *Kuhle Wampe* is subtitled 'Or Who Owns the World?', this indicates how Brecht's practical and theoretical engagement with the cinema asks fundamental questions about ownership, origination and theft. Who owns the rights to work, not least to the work of art? Who by rights owns film: the Hollywood or Babelsberg mogul and market forces, the regime through the offices of censorship, or the sort of collective that co-produces a work like *Kuhle Wampe*? For *Kuhle Wampe* is a film-work that sets out to redefine the idea of work away from the ethic of bourgeois capitalism, whereby anony-mous labour is converted into wares in a machinery controlled by the individual entrepreneur, and towards the idea of work as a collective process, made by the group for the group. Mainstream cinema is, by implication, like the coffee industry in the railway discussion, producing inflationary injustices in the name of laws of supply and demand. *Kuhle Wampe* looks instead for a type of film-work that is properly co-operative in its investment, production and consumption and that relates to a radical agenda for social change like the collectivity of the sports festival, where play – not least the playing of theatre before a mass public – is productive as political work.

Perhaps the most fundamental formal principle of production for Brecht and his collaborators is what he calls the radical separation of all the elements. This works on different levels. The elements, or acts,

Plate 8 Epic film-theatre: the agitprop group 'Das rote Sprachrohr' ('The red megaphone') performs in *Kuhle Wampe* (1932). bfi Collections. © Praesens-Film AG, Zürich.

of *Kuhle Wampe* are marked by strategic disruption in their relation-ships, both internally and between the acts. They incorporate, potentially, a range of genre set-pieces, from domestic melodrama in the first act, through pastoral romance in the second, to epic spec-tacle in the third. But not only are these mutually incompatible as components, opening up irremediable breaches in the montage struc-ture, they are also subject to internal breaks. These breaks serve to challenge the identificatory lure that is the common convention of all three generic systems. The epic spectacle of the final act is most evidently 'refunctioned' into epic in the Brechtian sense. The vehicle for heroic, racing individualism is converted into a more contradict-ory apparatus in which the collective narrative presents the only workable ground for identification. The potential psychological micro-dramas of the first two acts are thus sublated, taken up and overhauled, by the epic collectivism of the third.

Identification, on the Aristotelian model, is therefore disrupted. *Kuhle Wampe* refuses to be the cathartic tragedy, the representation of the 'shocking fate of an individual' that, as Brecht reports, the censor wanted of it,[96] indeed, to provide an individualized narrative at all. Rather, it works (and Brecht wrily praised the censor for per-ceiving this) as a generalized or typified experience that tests identi-fication at every turn. It employs what the censor in his critique of the suicide scene shrewdly identified as a demonstrative mechanics of human action. The suicide is motivated not by psychopathology but by the workings of the social apparatus. Rather than eliciting an empathetic urge to redeem the individual, this mechanization works to make the spectator understand the functional logic of the act and intervene to refunction the apparatus of reification that mass-produces such a typical object as this suicide.

The reification of the human subject as object-type is ironically framed when, in a typical materialist *Gestus*, the young Bönike inter-venes with a mechanical gesture to save an object of material produc-tion, the watch, before his suicide. Brecht argues before the censor, disingenuously no doubt, that this act helps to individualize the subject. In fact, the *Gestus* is above all a stamp of mass production. The epic scale of activity in the final act is intended to revitalize the social and political machinery that produces this sort of dead work. It demonstrates in heroic form the masses as empowered radically to refunction the political apparatus. This is a spectacle that, in its turn, is mounted as the proper product of film as mass medium.

This productive act of demonstration is continually working against what Brecht, akin here to Adorno, recognizes as the power of the film

medium to disable intervention by presenting a glossy *fait accompli*. Film can easily work not as an active production, but as an unalterable product of a system of reproduction; he records this critique in his American diary in 1942 after discussions with Adorno.[97] Against this he pits a more Benjaminian reading of the medium, with *reading* as the operative word. While Adorno is deeply suspicious of the slickness of film as prime production site of the culture industry, Benjamin is more prepared to valorize its resources of montage. Benjamin understands montage as a technical means of reformulating imagery into critical text. By means of the shocks produced by the breaks between elements, film is seen to provoke a form of active reading that in its turn provides a model for the effects of epic theatre.[98] And this is how Brecht incorporates montage into his epic revision of film drama.

The revising or refunctioning of individual drama into the narrative form of epic relies on the relationship that Brecht constructs between narrative conventions and the technological challenges of the film medium. In *Der Dreigroschenprozess: Ein soziologisches Experiment* ('The *Threepenny Opera* Trial: A Sociological Experiment' (1931)) Brecht argues that narrative in the film age must incorporate an instrumental aesthetic, exhibiting the mechanical functions of its construction to the reader.[99] Conversely, the cinematic apparatus should be subject to processes of 'literarization', made to gloss or footnote its slick projections with a sort of textual apparatus. That is, novels should be seen in the light of film, and film in its turn should be read rather than uncritically consumed.

The technological medium is not, in itself, more adept at exposing functions for change. Brecht famously cites the example of a photograph of a factory like the AEG or Krupp works, which, for all its capacity for authenticity, fails to expose the internal apparatus of work that sustains it.[100] In order for the photographic medium to, as it were, X-ray the apparatus, film needs to be constructed. Specifically, it requires the sort of construction that sustains a deconstructive edge – that is, the contradictory aesthetics of montage. Montage reveals the apparatus of aesthetic construction with all its contradictions, highlighting the discontinuities in form, the seams between the elements, which are as significant as the elements themselves. Thus, in line with Marx's Manifesto, form merges with content,[101] taking on a mimetic function, as montage imitates and so exposes sociopolitical constructions, complete with their grounding contradictions.

Aware as he is of the fetishistic power or aura of the film medium, montage is part of Brecht's strategy for a refunctioning of the

machinery, stripping it back so that it exposes itself. This is his intention in his cinematic end-game, the post-war project to film *Mutter Courage*, which was not to be realized before his death. He proposes in his Berlin diary of 1949 the strategic anachronism of daguerreotype-style photography to counter the sort of naturalistic reading that had always plagued the play.[102] This strategy represents a particular version of Brecht's axiomatic principle of historicization: here, the subjection of a medium that presents a surface of sheer contemporaneity to its technological prehistory.

This sort of anachronism, rolling back the technology, can be shown to be operating in the opening sequence of *Kuhle Wampe*. It will be seen to contribute to a more general demonstrative strategy of performance here, serving at every level to show that showing is taking place. It is a sequence that might seem on one level to serve a conventional establishing function by setting the scene for the drama to come. In fact, the establishing shots are 'refunctioned' here in proper Brechtian style. What is established above all is a certain *Einstellung*, a setting or disposition of the apparatus. It is a setting that always functions, as we shall see, through internal breaks and which, through its contradictions, activates the critical function on the part of the viewer. It serves, in other words, as a classic *Verfremdungseffekt*, showing the familiar in unfamiliar ways. The sequence is set to defamiliarize through contradiction on a series of different levels: contradictions between fixture and mobility; between individual and collective, part and whole; and between continuity and discontinuity, both within the visual language of the sequence and between that language and its sound-track.

The interplay of fixture and mobility creates a distinctive rhythm for the sequence. Brecht seems to go against the grain of cinematic technology when he defines film as working through framed shots. He sees film as following the laws of graphic art, constructing 'a series of tableaux',[103] rather than of motion pictures, following the dynamic perspective of the 'unchained camera' that was in vogue by the early Thirties.[104] This principle is demonstrated in the first shots of Berlin, from the Brandenburg Gate to tenement buildings, fixed as they are, postcard-style. The camera eventually begins to track across a building, inducing a sense of diegetic direction only to be arbitrarily stopped, stopped as it were from leading anywhere, as the film reverts to the still frame.

The tabular form of the fixed shot furnishes a frame for the showing of social *Gestus*, as the empty views become populated and come to expose behaviour. The insistence on the frame marks this *Gestus*

out as second order, a form of citation – that is, as performative. The social movement of the subsequent scenes is recurrently framed much like stage action, or indeed like the page of a book or a newspaper. The screen is indeed recurrently the frame here for the reading of newsprint. It sets up the reading of papers as a leitmotif in the film, with a focal function in each of the acts. The power of the print media in fashioning opinion establishes the act of newspaper reading as a privileged form of social *Gestus*, a ritual acquiescence in, and citation of, the gestures of the dominant ideology.

When, in a scene introduced by the textual image of the jobs paper, the young unemployed gather around the advertising column, a reading structure, in order to read that paper, so their drama may be said to be 'literarized' in Brecht's sense. It is refunctioned, that is, into a text eliciting critical reading; not a high-cultural text, but one that uses aesthetic structures to provoke socio-political analysis. It serves a function analogous to that of the *Schrifttafel*, the placard-style textual image famously employed as a demonstrative element in Brechtian theatre and reproduced in the film drama here, as we shall see, through the strategic use of the placard.

The gradual mounting of the human tableau, as figures assemble in the visual frame, imitates the slow-release photography that Brecht sees as a model means of the representation displaying the process of its own production.[105] The scene thus serves less to dramatize or individualize the newspaper headlines than to demonstrate them in the epic style. The fixture of the camera and the wandering of figures in and out of shot indicate an arbitrary character that belies the studied mounting of the shot: this is a scene that is demonstratively typical of everyday street scenes in Berlin. It is a scene that is interested less in following a story than in showing a social condition. It is characterized by a relay of *Gestus*, of marked social behaviour: the rubbing of hands, the grabbing of the short supply of papers, the acts of reading, the furtive pocketing of the paper. The model instance is what was proposed above as the archetypal *Gestus*, the shrug of 'That's just the way it is' – here the shrug of the supplier who has run out in a system where supply is designed to be outstripped by demand. This is the performance of *Gestus* as what, in order to emphasize the element of demonstrative setting, Benjamin called a sort of 'printing'.[106] The actors are, as it were, typesetting behavioural signs that are registered and framed by the camera in the role Brecht gives it as sociologist.[107] The apparatus thus literarizes the action, producing an aesthetically constructed sociological text meant to be read.

The textualization of the film is, so to speak, set in boldface by the musical accompaniment. The sequence is of course mute, helping to underline the *Gestus* by slipping anachronistically back into the mode of silent film. But the silent pictures are accompanied in productive tension by the co-text of Hanns Eisler's sound-track. The music is intended to orchestrate a dialectical reading of the sequence, one that looks for contradictions. Eisler sets out to make the music at once accompany the visual text and resist it, and thereby resist a totalizing of the film as an easy object for the spectator's consumption. This is music that is technical, constructed into an apparatus that runs along-side the visual track, but always in contrapuntal tension. The open-ing montage of dreary, static tenement images is set against the sharp and fast impetus of what Eisler calls a 'polyphonic prelude'. It is designed to provoke shock, to alert the spectator and evoke resist-ance rather than sentimental empathy. Eisler sees the 'technification of music' as an opportunity to activate in a dialectical fashion a medium that conventionally elicits dozing passivity.[108]

Film and sound are conceived, then, as contrastive forms of tech-nical apparatus, not straightforwardly disengaged, but rather moving in and out of synchronization, such as when the machinery of the train emerges out of the tableaux to engage motion pictures that for a short sequence catch up with the technical momentum of the music. When the race for work gets under way, the two systems engage rhythmically in a sort of parody of industrial machinery that turns manically but without producing anything. In this sense, they repro-duce the earlier imagery of the newspaper text that turns as if on the printing machine, too fast for the eye to see. The newspaper text is one moment so mobile as to be unreadable, the next merely giving snapshots of mounting unemployment statistics, and finally produc-ing adverts for jobs that will prove to be non-existent.

All that is produced here is a series of textual negations, or blocks. Thus, when the job-hunters arrive at the factory to seek work, they are turned away by a placard in the style of one of the earlier head-lines: 'Arbeiter werden nicht eingestellt' ('Workers are not being taken on'). This placard adopts the function of the *Schrifttafel* and does so in a particularly telling way. It acts as a form of *Verfremdungseffekt*, a prop in the action of the film which steps outside the plot to become a sort of inter-title, a part of the extra-diegetic text. It contributes to the generalizing effects of the Brechtian *Gestus*: the gatekeeper's gesture of denial is turned into a text that disclaims personal agency and proclaims an apparently universal significance. Specifically, the placard re-cites the subtitle of the job-hunting act:

'One Less Unemployed'. Both texts rely on a logic of double negation, headlining non-productivity. What is less in the subtitle is already less: the jobless. And the palpably negative text of the placard can also be read on a double level, *einstellen* being a verb that has both the productive meaning (negated here) of hiring and the meaning, which is effectively posited here, of closing production. It is thus perhaps not too fanciful to read in the function of this placard text a statement of the fundamental way in which the film is mounted, so to mobilize the third meaning of *einstellen*: the *Schrifttafel*, in montage with the other elements of the filmic text, as the signifier of its *Einstellung*, its aesthetic and political disposition or setting.

The final term in this series within the opening sequence is another placard-style prop at the entrance to a factory. As the cyclists enter the final factory, out rides another bicycle, with a man bearing a pane of glass, which is presumably what is produced there. The glass at first appears transparent, a virtual non-object, as though the man were miming an act of work, until it catches a reflection and hence acts as a sudden visual block. It is another emblematic statement of non-entry and non-productivity and a preview of the empty-handed exit of the job-hunters. Once more the camera fails to gain entry to the place of work, tracking instead up and down its exterior. When the trick of light turns the pane of glass into a blank window or mirror, or an empty version of the placard encountered earlier, it also seems to reflect on the film's relationship to realism. It is tempting to see the travelling invisible window or blank mirror as a strategically recycled version of the key figures of mimetic realism, the window on the world or, after Stendhal's description of the Realist novel, a mirror carried down a road. The conversion of the pane of glass from an object in, and lens upon, the real world into a form of *Verfremdungseffekt*, another link in the sequence of props that signify the constructed character of social reality, signals the radical *Einstellung* of *Kuhle Wampe* as film-text.

In the job-hunting sequence the visual episodes are 'montiert', constructed as an apparatus, not only in the structural sense of the mounted components of a montage aesthetic. Brecht argues that the shot and the sequence should reproduce each other structurally. Both are designed here to expose functional structures. Thus the shots develop from the external views, which mimic the factory photograph that Brecht says can never capture the factory's inner function, to images that do indeed expose function. As Roswitha Mueller persuasively argues in her reading of the sequence as syntagma,[109] the race for work is anything but a bicycle race, mounted for spectators

and relying on identification with individual competitors. It is a process with no real end, no teleological shape. Rather than being organically shaped towards a finishing point, it is disjunctive in both temporal and physical terms. The race is broken up both into stages and into the component parts of its physical apparatus. This is how shot and sequence imitate each other: the structural montage of the sequences is reproduced by the physical montage of body and bicycle parts, hands, wheels and so on in the individual frame. The one estranges expectations of narrative continuity, the other expectations of an organic coherence in identity. The film thus exposes the socio-political paradox of machinery in overdrive that cannot, however, find work, producing no proper object for those who have to drive it.

The initial intent had been rhythmically to inter-cut the cycles in this sequence with the rotations of a concrete mixer on a building site. In the event the physical apparatus and the sound apparatus are linked up instead with the workings of film itself. The reel of the travelling camera turns relentlessly as it films the relentless turning of the wheels. And the film apparatus, racing ahead of the racing cycles, is only apparently hidden from view. The visual insistence upon the shadows projected by the spinning wheels can be said to function as a self-reflexive emblem of the film machinery. For what is film other than a reeling apparatus projecting shadow-images of its own? The exposure of the false work produced by the capitalist system thus incorporates projections of other types of production. Film can be seen to project the means to refunction that system, turning the spinning wheels of the apparatus into revolutionary work. Hence the film's productive recycling of this dysfunctional machinery in the final act, where the race is rerun as a collective production, a spectacular *Lehrstück*.

What this film sequence shows, then, is a structure that might be transferred to Brechtian drama. It certainly follows the Brechtian dictum of the radical separation of elements, the successive scenes, the setting, the physical action, the textual language and the musical accompaniment. Above all it shifts the perspective from individual drama to collective conditions, from teleological suspense to a critical interest in how things work or are worked. To cite the terms Brecht develops in his manifesto for an epic theatre in the essay of 1930 on his opera in the epic style, *Mahagonny*, the suspense as to the 'Ausgang' (ending/exit) of Aristotelian drama is superseded by an exposure of 'Gang', of the gearing mechanisms of social processes.[110] And *Kuhle Wampe* achieves this by exploiting the particular capacity

of film to capture social behaviour in the form of demonstrative citation rather than glossy reproduction. As such, it typesets a working model of how to read a film in the Marxist mode.

There is, however, a troubling countermovement at work in the film. While it works, at face value, according to the orthodoxy of the Marxist dialectic, with the three 'acts' of the film conforming to the thesis–antithesis–synthesis model, the second act certainly contains elements that resist sublation into the heroic mass movement of the finale. When the film was shown in the Soviet Union, the response of the viewers trained in a Marxist understanding of proletarian politics was critical of the petty bourgeois mores that characterize much of the film's representation of working-class life in Berlin. Thus, the shotgun engagement party provides an opportunity for the film to provide the viewer with conventional, bourgeois cinematic pleasures of excess consumption and musical and slapstick entertainment, even as it ostensibly works to expose the petty bourgeois decadence that threatens working-class culture. The same is true of the scene in which Bönike and his wife sit at the table, which cross-cuts her mental images of the cost of meat as she tots up the shopping bill with his reading aloud of a newspaper account of the trial of Mata Hari (described as a 'choice dish'). The working-class couple are caught in the logic of the commodity, consuming both meat at exorbitant prices and media descriptions of exorbitant erotic and financial privilege. These are the sorts of acts of reading that pose a powerful counter-model to the Hegelian dialectics eagerly consumed by the young workers in the final section. And the entertainment industry provides only too many films in the style of the Lilian Harvey vehicle *Nie wieder Liebe* ('Never Again Love' (1931)), advertised at the cinema visited by Fritz and Kurt. The melodrama on the publicity poster functions as a sort of *mise-en-abyme* for *Kuhle Wampe*, a film within the film that shows up its more culinary ingredients.

In the *Dreigroschenprozess*, Brecht suggested that Eisenstein's representation of the revolutionary imperative through the image of rotting meat in *Potemkin* took a form that enabled the spectator to respond in a politically reactionary, philistine fashion, empathizing with the sailors as if the rotten meat had been served up at home.[111] The construction of much of the second act of *Kuhle Wampe* arguably enables a similar sort of 'human interest' consumption of the film. More particularly, the second act incorporates a sequence that apparently reverses the logic of the suicide in the first. If the mechanistic act of suicide was depicted as socially rather than psychopathologically driven, Anni's pregnancy is here represented in the form of

what the screenplay calls a 'Kinderpsychose', or children psychosis. Here the Expressionist style of psycho-dramatic representation emerges as the repressed of the film's political logic. In this 'psychotic' sequence montage operates not as a vehicle of considered political critique but as one of fantasmatic psychic disturbance in the Expressionist mode. It connects with the screenplay's description of the bicycles in the opening sequence and other machines as 'wahnsinnig', mad, in their operation, suggesting that there are aspects of disorder within the social apparatus that cannot be contained within the orthodox structure of Marxist political analysis.[112]

The artificial eye: Man with a Movie Camera

Just as *Kuhle Wampe* and the films of Eisenstein show evidence of a split focus, so too does Vertov's *Man with a Movie Camera*. The relationship between Vertov and Eisenstein, the two leading figures of the Russian cinematic avant-garde, can be said to follow what Freud calls 'the narcissism of small differences'. Vertov, leading light of the *kinoki* (cine- or kino-eyes) group of documentary film-makers, criticizes Eisenstein for sustaining the corrupt *ancien régime* form of narrative film making in revolutionary clothing. And Eisenstein attacks Vertov for indulging in a technical display of formalism, taking issue, for instance, with the use of slow motion in *Man with a Movie Camera*, which he sees as an exercise in 'formal trifles and pointless mischief with the camera'.[113] As is so often the case with internecine struggles between avant-gardists, the animus seems out of proportion to such differences as exist between their respective practices. It is telling that Eisenstein's most polemical attack on Vertov is prompted by an accusation of plagiaristic imitation, when Vertov suggested that the slaughterhouse imagery in *Strike* had been derived from that used in one of the *kinoki* films. Eisenstein insists that the coincidence of motif only serves to point up the fundamental difference in function between 'the abattoir that is *recorded* in *Cine-Eye* and *gorily effective* in *The Strike*',[114] and that what is needed is not an impassive, mechanical cine-eye so much as a 'cine-fist' with which to cut through to the skull.[115] The terms of the debate are performative of the combat between two avant-gardists for the cutting-edge position in the visual handling of the film medium.

Notwithstanding Eisenstein's appeal to the brutality of the fist, both he and Vertov are above all technical film-makers; their polemical statements may suggest a violent iconoclasm, but the style of their challenge to established cinematic practices is schooled in the

developed technological aesthetics of Cubo-Futurism and Construct-ivism. Their films are as precisely constructed as the montage placards of Mayakovsky's ROSTA windows, as Rodchenko's experiments in photomontage, or as Vladimir Tatlin's utopian design for a monument to the Third International.[116] For both Eisenstein and Vertov, manual intervention is in the service of a sophisticated aesthetic apparatus. While both resist the standard models of theatrical or narrative cinema, they also retain certain attachments to aesthetic conventions. While they seek, in proper avant-garde style, to integrate the cinema into the praxis of life, aspects of their respective cinemas are more attuned to autonomy. At its limit, this means that film serves as a supplementary display or distraction, a fetish object, rather than as an integral, material function in the everyday life of the Soviet metropolis. If, as we have seen, Eisenstein's version of the revolutionary cinematic project has an attachment to the aesthetic image as fetish, then he argues that the new documentary cinema in the style of the *kinoki* merely replaces forms of aesthetic fetishization by 'a fetish for raw material'.[117] In fact, the fetishism that can be found in the work of both directors is a feature of structure rather than substance, whether raw or cooked. It is not the opposition between the lingering shots of Rodin's *Spring* and other statuary in *October* and the shop-window mannequins in *Man with a Movie Camera* that is of the essence here. What counts is rather the way in which images are composed in each case, and in particular the fixation of a given image in the montage sequence for emblematic or fetishistic effect. Eisenstein's display of auratic objects of art corresponds to the cultivation of monumental aesthetic ordering in his revolutionary films, and, notwithstanding his apparent program of recording the raw material of the everyday, Vertov's film making is as carefully framed, posed and dressed as the window display.

While Eisenstein's films tend to operate in a historical dimension, *Man with a Movie Camera* is committed to the principle of presence. It is a film that records the process of its own production and con-sumption as co-present with its documentary footage of life in a city that is a simultaneous composite of Moscow and other Russian cities. Through the conceit of framing the film by its viewing in a film-theatre and organizing it through the live recording work of the man with the camera and shots of cutting and splicing at the editing table, it achieves the paradox of at once showing the whole apparatus of film mediation and making the process of production seem immediate. It combines the two paradigms of representation that Benjamin dis-cusses in the 'Work of Art' essay: the incisive instrumental intervention

of the photographer or film-maker as surgeon with that of the magician, which Benjamin aligns with painting and the achievement of aura. It is telling that sequences in *Man with a Movie Camera* place the cameraman on both sides of this divide, rushing to the scene of an accident in tandem with the ambulance in order to attend to the victim and set in parallel with a Chinese magician displaying his tricks. *Man with a Movie Camera* is committed to a form of viewing that transcends that of the human eye in its normal function, revealing what Benjamin calls 'the optical unconscious'. This function is, however, divided between two conceptions of the cine-eye: on the one hand, as a machine that simultaneously reveals what the eye would not otherwise see of the world and the machine's own workings, and, on the other, as a magical apparatus that causes delight and perplexity by acts of prestidigitation.

As we shall see, this bifocal view of the optical unconscious also involves a filmic unconscious in something closer to the psychoanalytic definition, a level of meaning that is subject to repression or to disavowal. Vertov's filming of Benjamin's 'optical unconscious' is at once the mechanical production of images by a Constructivist (the representations of the unconscious as aligned by Freud with telescopes and other technical apparatus) and the conjuring of images by a magician (the unconscious in the shape of images appearing and disappearing on Freud's mystic writing-pad). Following this double model, the film can be said to pursue an official or manifest programme of demystification of the film medium and an unofficial or latent programme of cinematic mystique, and thereby to place the viewer in a double position: as a technically knowing political subject and as a credulous child such as those shown watching the Chinese magician in the film. As the magician tricks the children with a sleight of hand, producing artificial structures and living things out of thin air, so the camera constructs and animates the images of the children from still frames: it shows its tricks in the making, but also has them work their magic on the viewer. And the film is also not free of the shadow side to this magic, the danger of lapse and accident that can introduce fatal disorder into the machinery of the spectacle.

While the finished version of *Man with a Movie Camera* has a beguilingly virtuoso shape, contending designs are at work within it. Vertov had originally conceived the project as a 'visual symphony', and the description he sets out early in 1928 is organized in three broad movements, according to a heroic dialectic. In the first 'movement' – the thesis – he conjures up the hermetic conditions of the studio-based film, the artificial world of the 'film factory' on the

Hollywood model, over which the director enjoys absolute but ulti-
mately fatuous control; its antithesis is presented in a vision of life as
it is, the life of the masses, seething and dynamic; and in the synthesis
the cameraman goes out into the world, at first faltering and then
confidently in stride with life. The false order evinced in the studio,
as microcosm of the pre-revolutionary order, is replaced here by a
new order where 'Nothing is accidental. Everything is explicable and
governed by law.'[118] The film is proposed here as a statement of 'faith
in socialist construction',[119] and its own workings are designed to
mimic the political and industrial construction of the 'Land of the
Soviets', resisting bourgeois capitalism in all its forms.

This is also the sort of shape – the conversion of disorder into
resolved form – that Vertov's brother, Mikhail Kaufman, the cinemato-
grapher and eponymous man with a camera, envisaged for the film.
In the event, however, the textbook dialectics fail to work smoothly:
Vertov insisted on maintaining a sense of energetic irresolution right
up to the end, and the brothers curtailed their collaboration. This put
an end to the 'Soviet of Three' that Vertov and Kaufman had formed
along with Vertov's wife Elizaveta Svilova, who was principally
responsible for editing the film and appears at the cutting-table within
it. The failure of the *kinoki* Soviet has implications for the wider
Soviet order which it had been established to promote. *Man with a
Movie Camera* is certainly not a film that serves the Revolution in
any straightforward, doctrinaire sense. The ostensible dialectical sym-
phony comes to show evidence of a more negative brand of dialec-
tics. While the film certainly has elements of patterning and rhythmic
organization, its relatively free form allows for twists and turns that
hardly conform to the model of a law-abiding film in which 'nothing
is accidental'.

In a way that is characteristic of much of the avant-garde, the
kinoki project is caught between the rhetoric of total renewal and
a more complicated practical disposition. Thus, the founding manifesto
of the movement, published in 1922 under the title 'We: Variant of
a Manifesto', indicates from the outset a principle of doctrinal vari-
ance. The manifesto excoriates conventional forms of film-theatre,
not least in the form of 'the psychological Russo-German film-drama
– weighed down with apparitions and childhood memories – an
absurdity'.[120] Caligarism is anathema to the *kinoki*. Yet there is
also an anxiety of influence in evidence here: the protestations of the
manifesto stress the 'leprous' character of the theatrical films: 'Keep
your eyes off them!', for they are powerfully contagious.[121] A keynote
of this and later theoretical statements is the transposition of

Einsteinian relativity to the screen, a radical reappraisal of the spatio-temporal dimensions of cinematic experience. But this filmic 'theory of relativity' is arguably no less active in ideological terms, subverting the absolutist discourse of the manifesto and opening up a dimension of relation to that which is held up to scorn. Like Eisenstein, who stages the bombing of the Odessa Theatre but remains attached to theatrical spectacle, Vertov uses a split-screen trick to collapse the Bolshoi Theatre; but the iconoclastic act is arguably just that, an anti-theatrical performance for theatrical effect.

Another key aesthetic statement, 'From Kino-Eye to Radio-Eye' (1929), starts with a number of exemplary scenarios for the new cinema. The first of these revisits what might be called the primal trauma of the film medium, the famous moment when the audience at a viewing of the 1895 Lumière film of the train entering the station at La Ciotat fled as the on-screen train came at them. Vertov tells of a showing of *Kinopravda* in a village near Moscow:

> On the screen a train speeds past. A young girl appears, walking straight toward the camera. Suddenly a scream is heard in the hall. A woman runs toward the girl on the screen. She's weeping, with her arms stretched out before her. She calls the girl by name. But the girl disappears. On the screen the train rushes by once more. The lights are turned on in the hall. The woman is carried out, unconscious. 'What's going on?' a worker-correspondent asks. One of the viewers answers: 'It's kino-eye. They filmed the girl while she was still alive. Not long ago she fell ill and died. The woman running toward the screen was her mother.'[122]

The description frames the image of the girl coming at the audience with a cinematic memory of the Lumière train, which transports the idea of traumatic accident into the scene, as though the girl might be about to feel the impact of the machine. The scene is recognized as a classic effect of the cine-eye project, in so far as the filming of 'life as it is' can capture a life immediately before death. It seems, however, that it also carries with it a different implication. The woman rushing at the screen is like the primal film-goers who rushed away from it in 1895. This is film working not as a medium of technical capture and demonstration, but as a powerful apparatus of identification. And what it produces, in spite of itself, is a scene in the style of the reviled melodrama.

The subsequent scenes are equally ambiguous: a kiss on a park bench captured from a position concealed in a bush; a fire with the cine-eye camera arriving in time to film the arrival of the firemen;

a cameraman at Lenin's bier watching 'lest he miss something important or interesting';[123] and a cameraman in a cement works, who, rather than attending to the heroic production of the plant, films his colleague who has been badly injured in an accident, this before going to his aid. The scenarios, concerned with erotic encounter, accident, trauma and death as spectacle, indicate the sort of more questionable attractions that can motivate the cine-eye project: the twisting of life 'caught unawares' into a form of voyeurism or sensationalism; the displacing of direct intervention in recovery efforts by the desire to recover the striking image. Socio-political engagement is thus superseded by an engagement with the image that supposes aesthetic treatment, the application of formal awareness to 'life caught unawares' but also, by a particular attachment to the stuff of psychodrama, to the undercover erotics of a lovers' tryst, to the theatre of mourning that is Lenin's lying in state, or to the perverse fascination with trauma. Versions of these scenes will recur in *Man with a Movie Camera*, and here too formal and psycho-dramatic interests will be seen to interfere with the doctrine of political intervention.

It is a suitable irony that the film begins with quite an elaborate series of titles, amounting to a manifesto statement. In the 'From Kino-Eye to Radio-Eye' essay, Vertov describes *kinoki* film making, as characterized by the practice of montage, as a form of writing: 'Montage means organizing film fragments (shots) into a film-object. It means "writing" something cinematic with the recorded shots. It does not mean selecting the fragments for "scenes" (the theatrical bias) or for titles (the literary bias).'[124] In spite of Vertov's fierce insistence that film should be its own medium, his description of its key technical process apparently needs to borrow the terms of another, more established medium. The forms of dramatic or fictional writing against which he positions himself here, as represented by the scene and the title, are in fact more or less inevitable concomitants of the writerly aesthetic. The scenes described at the start of the essay are also 'scenes' in the theatrical sense, and the profusion of titles at the start of the film indicates a need to give it a preface that tells the viewer how to read it. The titles are riddled with contradictions. Written in Russian, they celebrate the idea of film as a 'truly international absolute language'. The titles deny that the film will have, or have need of, a scenario or inter-titles, 'based on its total separation from the language of theatre and literature'. Whether by conscious ironic intention or not, under the title that explains that this will be a communication of visible events 'without the use of inter-titles', Vertov

writes a gloss in the form of a subtitle in parentheses, and this takes
the form of a reiteration of the line above: 'A film without inter-
titles'. There appears to be an excessive anxiety here in the need to
spell out the fact that the film will not need to spell things out. In
fact, it will use not inter-titles but other indexical forms to organize
and direct viewing, not least through the recurrent appearance of
'titles' on the banners, street signs, posters and advertisements that
figure amongst the less than random found objects of the film.

The title that denies that the film will have the aid of theatre takes
a different form from those on inter-titles and scenario that precede
it: here there is no direct repetition, but a gloss of the lack of 'theatre'
is indeed given: 'A film without sets, actors etc.' What the definition
exposes is the alternative definitions of theatre that might indeed
be applicable to the film, which can certainly be said to incorpor-
ate aspects of performance. The film's material is no more purely
'unplayed' than the behaviour of mourners 'caught in the act' at the
scene of Lenin's corpse. When Vertov signs off the introductory
titles, along with his collaborators, he gives himself a role, that of
'author-supervisor', which is evidently designed to challenge the con-
ventional function of the director. In fact, the authorial signature can
be seen to point to the combination of filmic writing and perform-
ative supervision that he undertakes in the production. No less than
Eisenstein, and notwithstanding his collaborative network, Vertov is
an *auteur* with a strong sense of film-theatre.

The first sequence of the film can serve to illustrate its ambivalent
relationship to the appeal of film-theatre. We see the man with the
camera in a trick shot on top of another monumental camera, with
an exalted view over the city at dawn. The film then transfers to a
theatre, and shows the cameraman slipping between the curtains and,
by implication, on to the screen that we glimpse through the gap. The
cameraman will be the 'star' of the film as well as the agent of its
production. Curtains serve the teasing theatrical purpose of creating
the expectation of display, and the film makes a theatrical scene out
of that expectation, with animated seats, the arrival of an audience,
and the playing of an orchestra. When what is apparently the film
proper starts, it does so through acts of awakening, the first of these
being approached by the camera travelling towards a window with
lace curtains. Expectation of display is thus transferred from the
film-theatre to a private space, and this is set in the classic mode of
cinematic voyeurism, the camera drawn to and through the scantily
covered window, and on to the scantily clad sleeping body of a young
woman. She sleeps under a film-poster, which will take on the function

of a leitmotif in the film, advertising one of the sorts of film-factory melodramas that the *kinoki* abhorred, and comparable to that showing at the cinema in *Kuhle Wampe*, *Das Erwachen des Weibes* ('The Awakening of Woman' (1927)). In association with the lightly clad figure on the bed, this image turns the idea of awakening towards the sexual.

The scene is then intercut with others that represent the mode of performance: there are shots of a series of dummies, mannequins in shop-windows and wax figures of *ancien régime* figures from museum show-cases. It seems that the intercutting is designed to suggest that the alluring figure we have left in bed is also a dummy, an unthinking doll given to the transparent pleasures of shopping, costume fantasies and melodrama. A shot of a city street under a banner carrying the name of Gorky, serves as an intra-diegetic title to suggest that the street too is a place under the sign of theatre.[125]

Meanwhile, the film opens up an alternative kind of theatre – that of dreams. In another scene reminiscent of the primal trauma of the Lumière train, replayed in so many train accident fantasies in early film, the cameraman is seen lying across railway tracks as a train speeds towards him. His foot is shown caught on the rail as the train passes. It seems that this sequence, the inaugural instance of the cameraman's filming of speeding vehicles, will also have been the last. As the train careers through the screen, shots of the sleeping woman are intercut, suggesting that the sequence on the rails is a dream on her mindscreen. She awakes and gets out of bed; meanwhile the cameraman leaves the scene of the apparent accident unharmed. The spectator has been drawn into a stock cinematic fantasy only to have it exposed as a trick, an exposé of the sort of trick that the standard film-theatre is always playing on spectators. Having thus cheated the viewer of a cinematic fantasy of violence, the focus reverts to the 'awakening' of the female figure, allowing the camera to expose her body to the voyeuristic gaze. The body parts slipping into lace and silk mimic the earlier shots of the display dummies and of the lace curtain, presenting the viewer with a classically fetishistic perspective, matching the underwear displayed by Eisenstein in *October*. A cut to more mundane figures awakening on the street then blocks the fetishistic pleasure.

The opening sequence thus takes the viewer through the repertory of dreams and fantasies of erotic allure and violent catastrophe served by popular cinema. The explicit intention of these is doubtless to debunk such shallow, hackneyed pleasures. But a film that works in the imitative mode of parody will always run the risk, or perhaps

enjoy the opportunity, of repeating and reinforcing the conditions it is intended to subvert. In the case of *Man with a Movie Camera*, the opening sequence certainly fails to contain the stock cinematic moves that it exposes. No sooner does the camera shoot the awakening of 'real life' in the street than it repeats on the open stage of the city the scene from the private theatre of the bedroom. Another sleeping female figure lying on a bench is awakened by the gaze of the camera, which settles on her stocking-clad legs in a reprise of the shot of the woman dressing on the bed. While the first woman performed her washing and dressing as though unaware of the eye of the camera, the second gets up hurriedly and escapes from its intrusive gaze. The scene of the kiss on the park bench noted in the 'Kino-Eye to Radio-Eye' essay is exposed for its voyeurism by this similar scene. At this point the camera looks back at itself, as it were, and sees the eye of the film-maker in its aperture (see plate 9). The biomechanical montage can serve to remind us that the cine-eye is still, at core, a human eye, caught in the act with its old peep-show tricks.

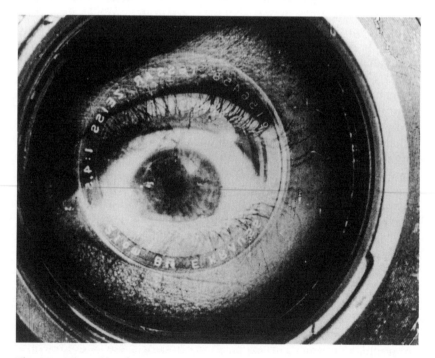

Plate 9 The self-reflexive cine-eye in *Man with a Movie Camera* (1929). bfi Collections.

The same sort of double bind applies to the accident that the film stages and then undoes at the start, suggesting that it can free itself from the cinema's psychic fixation on trauma. One of the film's favourite moves is to appropriate the established cinematic cliché of the chase; the cameraman races after horse-drawn and motorized vehicles in order to catch them in their acts. The chase is linked to the scene on the railway track early in the film; it represents the threat of machinery racing out of control towards catastrophic impact that emerges repeatedly in the film. The awakened city moves at a fast pace on a mass level, and there is always a potential for the intersections of its movements to become sites of collision. The camera seeks to keep pace with the other machineries of the city, but it too is susceptible to traumatic impact. When the camera-car races alongside the horse-drawn vehicles transporting passengers from the station, the horse is seen to gallop out of control before being fixed in a still. It is the first time that stills intervene in the film, and the effect is of a sudden mortification: a biomechanical seizure of the horse and the apparatus that is recording it.[126] While the film recovers from this paralytic fixture, resuscitating the stills that follow into animation on the editing table and eventually returning to the trap, to show it arriving at its destination, the traumatic dysfunction of the accident is linked into its system.

It is in the character of trauma to elude adequate apprehension, either as it strikes or in memory, and to repeat its impact compulsively. The multiple repetitions that feature in *Man with a Movie Camera*, and that were another source of disagreement between Vertov and Mikhail Kaufman, are suspended between alternative possibilities. They may be understood as devices of patterning, helping (as in the case of the recurrent film-posters) to organize our viewing. But they can equally be seen as figuring a form of repetition compulsion, whereby the film can only mimic the uncontrolled machinery – now hyperactive, now stalled – of life and death in the city.

Perhaps the most insistent point of return in the film is the traffic intersection, where pedestrians, trams and other vehicles converge. In its return to this spot, the film orchestrates a series of mobile configurations, including trick, split-screen shots that splice the passing trams into each other and through the bodies of passing pedestrians. A shot of this kind introduces the film's next return to the scene of the accident. This version of the accident is a fractured composite. The cameraman, who escaped from the train at the start of the film, is now run over by the tram, filming it from a perspective that seems bound to be fatal. There is a rapid, confused montage of skewed

street scenes, the cameraman's eye and a horse's head, which seem to suggest an actual version of the horse-drawn accident that remained virtual in the earlier sequence. The camera rushes across the square with people scattering on every side, suggesting that it is now the cinematic apparatus itself that is the vehicle out of control. In response to this repeated accident, the ambulance rushes to the scene, filmed by the camera-car which follows it. Having established the accident through a series of cinematic effects, the film now turns to human reality, a sequence from an actual accident, showing a severely injured young man.[127] At this point, there is a repeat of the trademark image of the eye seen through the camera lens. As with its earlier appearance at the bench scene, it seems to be designed to function as a demonstrative gesture, to say 'This is cine-eye' as in the captured scenes catalogued in the 'Kino-Eye to Radio-Eye' essay. It could be argued, however, that in both cases it shows the cine-eye to be caught in the voyeuristic act.

Seth Feldman has argued that the cine-eye, notwithstanding the claims of its proponents that it transcends human perspectives, is susceptible to forms of humanized experience. He reads this accident scene as the camera succumbing to anthropomorphic failure: 'The camera in *Chelovek s kinoapparatom* suffers from human vulnerability, as when an ambulance is called immediately after it has an attack of swish pans.'[128] It seems that the cine-eye is split here between a sort of traumatic inability to keep up with its material, and hence an identification with the victim of the accident, and its role as an apparatus of recovery, brought immediately back to full function in order to attend to the victim in tandem with the ambulance. It produces an extreme form of Brecht's exemplary scenario of the street accident, where the agency of representation is split between a sort of identificatory enactment and a third-person narrative account, between dramatic and epic modes. In Vertov's version, the second of these – the cinematic apparatus as epic, impersonal agent of narrative recuperation – also incorporates a troubling human aspect, less one of pathos than of voyeuristic intrusion on real-life human drama. What is clear is that the recovery is incomplete. No sooner is the young man rushed off in the ambulance than the fire brigade is mobilized, though with no fire in evidence. The shots of the ambulance rushing in one direction and the fire-engines in the other are intercut in such a way as to suggest a potentially catastrophic sense of misdirection in the machinery of recovery. The camera, which is following both emergency services at once, seems to be rushing into collision with itself. If the ambulance was indeed, as Sethman suggests, also called to attend

to a camera in collapse, the only fire in the film to which the fire-engine might be responding is the one in a later sequence where the cameraman is filming the raging flames of a steel foundry. The cine-eye encounters its limits here in the human vulnerability of the cameraman, who is forced to move back from the flames. The scene seems ready to confuse two of those scenarios described in the 'Kino-Eye to Radio-Eye' essay: the cameraman called to the scene of a fire and the cameraman filming the injuries of an over-eager colleague after a factory accident.

The recovery apparatus of the cine-eye remains susceptible to human interest and accident. The aesthetic regime of montage, incorporating arresting images, both mobile and immobile, new and recycled, in cut, cross-cut and intercut form, is divided between different forms of human interest. The first of these is the interest in the form itself, the pursuit of the perfected filmic structure. In his manifesto essay 'Kinoks: A Revolution' (1923), Vertov berates other cinematographers for keeping 'prerevolutionary "artistic" models hanging like ikons' within them;[129] but his own cinematic practice is not free of the iconic effect. This may be a new form of Constructivist icon, one that stresses facture over aura,[130] but something of the appeal to the formal magic of the image persists. The second is the political interest that drives the film's ideological agenda, leading it to expose the underworld of the mine-worker and the abjection of sleeping rough that sustains the decadent pleasures of the unreconstructed bourgeoisie. But there is something in the fetishistic attention to the awakening female body and in the sentimental view of the awakening street urchin, scratching his armpit and grinning mischievously at the camera, which still conforms to the cinematic habits and expectations of the bourgeois audience. As the fetishism suggests, the third level is a more unconsciously motivated interest in the film's human material. Its shadow side is the traumatic compulsion that is one of the film's defining rhythms.

The final sequence is a breath-taking medley of repeat shots, accelerated, reversed, syncopated and merged, including a recurrent subjection of the audience within the film-theatre to the primal trauma image of the train rushing at them. The repetition is ambivalently cast between exhilarating orchestration and traumatic compulsion. The closing shot of the trademark eye in the camera lens, designed to give the *kinoki* imprimatur to the film, is still laden with the ambiguous potential of the scenes of its earlier appearances. The cine-eye remains an ambivalent film-theatrical agency, one given at once to the iconic display of the formalist regime, to the epic demonstrations

of the political regime, and to the erotogenic thrills and traumatic shocks of the psychic regime.

Dream visions: Un Chien andalou

In the manifesto 'Kinoks: A Revolution', Vertov summons up a scene that anticipates the climactic moment in the sequence from the prologue to *Un Chien andalou* that has achieved the status of a cinematic icon. Vertov describes a punishment fantasy aimed at a film public in thrall to conventional satisfactions: a 'dreamy' audience awaiting 'the moon of some new six-act production' is confronted instead with the revolutionary evisceration of cinema's belly.[131] The passive pleasures of dreaming of the moon are to be violently replaced by the revolutionary reality of life as a slaughterhouse. The slitting of the eye, visually matched with the moon, that introduces *Un Chien andalou* is also understandable as a revolutionary act, one that opens up the revolution to other meanings than the purely political. As we saw in *Man with a Movie Camera* and Eisenstein's films, the cutting and shooting of revolutionary cinema is an aesthetic and a psychic enterprise as well as a political one. Like Eisenstein's woman with the pince-nez, the image of the woman with the cut eye in *Un Chien andalou* is a multivalent icon. Jean Vigo sees the film as combining aesthetic rigour with ideological critique and psychic depth, and the image captures this combination.[132] It serves a socio-political purpose, demonstrating the need to see things in a radically different way from the conventions of bourgeois culture; it is aesthetically framed and sequenced, and so ready to become a cinematographic fetish; and it is, above all, one of cinema's foundational acts of psychic fantasy, enacting the primal cinematic trauma of a cut to the eye. It achieves in archetypal form the sort of extreme psychic shock to the eye that Artaud envisaged as the filmic counterpart to the Theatre of Cruelty.

Un Chien andalou was directed by Luis Buñuel in 1928, based on a screenplay co-written with Salvador Dalí. The circumstances of its conception are surrounded by a contradictory mythology, but it seems clear that it was devised quite spontaneously or automatically on the basis of dreams and other shared psychic enthusiasms and obsessions, and then put together in a much more measured way. Buñuel insisted that the film was not simply the narration of the contents of a dream, but that it emulated the structural mechanisms of dreaming.[133] Like Artaud's theatrical and filmic projects, this involves, in particular, the performative deployment of the

dream-work principles of condensation and displacement, whereby figures and objects are merged and mixed, relocated and dislocated. In the course of the studio production, the primary 'psychic' material underwent substantial 'secondary revision', developing a sophisticated montage aesthetic in the management of the film's dream work. The model of dream montage allows the film to achieve what Freud calls 'compromise formations', hybrid combinations of figures and styles. It mobilizes something like the montage of attractions in Eisenstein's definition, a quick-changing sequence of acts or exhibitions, mixing the performative styles of Guignol, music-hall, melodrama and cinematic slapstick.[134] And it switches its sound-track between the 'Liebestod' from Wagner's *Tristan und Isolde* and tango, so that the characters enact their relationships in a mix of high operatic drama and more popular cultural choreography.[135]

While Buñuel was concealed behind the screen at the opening night, ready for another avant-garde counter-performance, the film enjoyed great success and gained the two artists, newly arrived in Paris, an immediate licence for incorporation in the Surrealist group. As a key aesthetic statement of Surrealism, albeit one made outside its official margins, the film bears the tensions between conflicting interests that, as we have seen, are characteristic of the movement. At a time when Surrealism was passing from its established revolutionary base, defined above all in psycho-aesthetic terms, into more expressly political service, *Un Chien andalou* points up the limitations of that accommodation. The film's formal experiment is above all in the service of psycho-dramatic performance.

Like *Kuhle Wampe* and *Man with a Movie Camera*, *Un Chien andalou* is, nominally at least, a city film, set in Paris. The three films under review here are all in fact organized through an analogous triangular spatial scheme: each features, albeit in varying functions and proportions, a configuration of the urban exterior, domestic interiors and extra-urban recreational space. In so far as *Un Chien andalou* is set in the city, it is charged with the potential for the enactment of contemporary politics on a mass scale. Where it draws a crowd, however, it is in the style of Artaud's *Butcher's Revolt*, as supernumeraries in a psychic Theatre of Cruelty. Whereas the films of Eisenstein used the imagery of the abattoir to represent the conditions for revolt against political butchery, Buñuel and Dalí follow Artaud in figuring the slaughterhouse as a predominantly private space, the privileged theatre of the psyche in revolt. The interior space, which is temporarily negotiated in the first 'act' of *Kuhle Wampe* and in the bedroom of the young woman in *Man with a*

Movie Camera, is the principal scene of *Un Chien andalou*. As in the other two films, the interior is marked as a kind of theatre, an enclosed site for drama and, in particular, for the generic formulas of melodrama; but in *Un Chien andalou* the film's take on that mode of theatre, merged here with farce, dominates. The street and the seaside are accessed by the communicating stage-doors of the domestic theatre and are sites for alternative scenarios; not for nothing is the street scene viewed from the window of the apartment, as though from a box in the theatre. In one scene the male protagonist is the actor in a street accident scenario, viewed from above by his female counterpart; in the next, both are spectators, witnessing more accidental drama on the street below.

If the film can be understood as film-theatre in this peculiar sense, then its prologue is, as it were, played out behind the scenes, in the theatre wardrobe or the film cutting-room, where the film-theatre is prepared. The female 'star' sits in costume, awaiting the 'director'. The male figure – a director-figure indeed, played by Buñuel himself – sharpens his razor; the implication is that this is another of Surrealism's bearded women for exhibition (it is her underarm hair that is 'shaved off' later in the film). What we take to be the same male figure is pictured behind the woman, and he too has dressed for the part, now with a striped tie and collar. The lack of the watch he was wearing before also suggests a subversive lack of continuity editing; we cannot take the narrative coherence of what we see for granted. As has often been remarked, the prologue is a self-reflexive 'act'; the manual cutting of the eye stands for the director's editorial intervention in the material of the film, and for the need for both actors and spectators to be made to see differently.

It is as though the director's preparatory work includes an interfilmic citation of the iconic image from *Battleship Potemkin*, one of Buñuel's favourite films, inflicted here in a controlled, interior space and in a hyberbolic, close-up form. While the physical cut in *Potemkin* is displaced on to the cutting of the montage, here it is actually experienced. Or rather, it is virtually actually experienced. As utterly unexpected as this most direct representation of violence was for a film audience of 1929, expectation is provided in its careful setting up: the sharpening of the razor, tested against the man's thumbnail, the visual anticipation in the slicing of the sliver of cloud across the moon, and the holding of the eye in readiness. It is clear that the director is not about to apply make-up here. All of this helps to make the actual act of slicing the eye unwatchable. The viewers are ready to avert their gaze from this unbearable vision, and so not to see

what actually happens: a film trick. The eye of a dead animal, surrounded by unshaven facial hair, is substituted for that of the living woman. The moon-as-eye or eye-as-moon metaphor is thus extended into a third element: another figure from the slaughterhouse of avant-garde film making, but here used as an instrumental production device rather than a metaphor for human violence. While the blinding of the eye seems to represent the end-point of cinematic possibility, it should in fact be seen as a model form of 'découpage', the key aesthetic trope of cinema for Buñuel. As he defines it, the cut of 'découpage' is also the hinge between images: 'Excising one thing to turn it into another'.[136] The cutting of the woman's eye is also a cut to the other, animal eye, not the terminal elision of the viewing process, but a creative act of segmentation. Thus it does not stop the film but leads into its segmented narrative.

What the prologue does above all is to mount a demonstration of the fact that this film will be concerned with a radical assault upon, and play with, acts of vision. The fact that the cut to the eye is mediated by a simultaneous cut to another eye indicates that the violence and the play will be inextricably linked. This most physically violent cinematic act is simultaneously exposed as an 'act' of representation. Adjacent to the scenario of the film published in *La Révolution surréaliste* is a contribution by Magritte, entitled 'Les Mots et les images' ('Words and Images'), which can usefully be read in conjunction with the eye-cutting sequence. Magritte's pictorial games extend to representations of comparable violence, in particular in *Portrait* (1935), where a knife lies beside a plate ready to cut into a slice of ham with an eye at its centre. But the picture text of 'Les Mots et les images' is an object lesson in the games that representations play. One of the line drawings shows a face in profile, with a wall, a tree and clouds, indicating the way in which solid and soluble objects intersect in space.[137] Both the cloud and the staring face are images, and in the dimension of the image a cloud can cut an eye or an eye a cloud. One of the lessons of the drastic cut in the prologue to *Un Chien andalou* is that the image can be made to exert extraordinary physical power, but that, notwithstanding, this is an image fabricated like any other.

The film will look at once directly and obliquely; it will both show and hide its material.[138] The cut eye is as much of a signature figure as the cine-eye for Vertov. But while the recording and cutting apparatus of the cine-eye is ostentatiously technological, linking industrial machinery to that of the cinema, the film eye of *Un Chien andalou* is configured with the more archaic technology of the cut-throat razor.

It is telling that Buñuel includes Vertov among the makers of abstract cinema in his critique of what he sees as impressionistic or formalist shadow-play without a relationship to the essence of experience.[139] However sophisticated the film's montage technique and other visual moves and tricks of substitution may be, they are grounded in a primal cruelty. The prologue can be understood, in an extension of the psychoanalytic sense, as a primal scene. The scene that we witness illicitly, behind the scenes of the film proper, a coming together of a male and a female figure that is traversed by a cut, a traumatic mark of separation, conforms to that model. Not for nothing does Linda Williams, in her 'rhetorico-psychoanalytic' analysis of the film, read the cut as a figure of castration.[140] And following the psychoanalytic model, it is a dramatic sight that is always still there at the base of future experience. Its introduction through the fairy-tale device of 'Once upon a time' indicates a mythical scene, at once occupying 'an other scene' at a remove from the subsequent time-frames of the film and remaining omnipresent as a formative structure. The film can be understood as a sort of fairytale-cum-case-history. It shares many features, in particular, with the classic primal scene text, one that is constructed around fairy-tale motifs, Freud's case history of the Wolfman. The case of the Andalusian Dogman also involves obsessions with striped clothing, with buttocks, and with a variety of animals and insects, not least the moth in place of the Wolfman's butterfly.

The cut of castration can certainly be said to mark the presence of what we are given to see with traumatic absence, as Williams suggests. In conjunction with the model of 'découpage' elaborated by Buñuel, it might be most appropriate to understand it as incorporated into a structure that psychoanalytic film theory would call 'suture'. That is, the Imaginary allure of self-sufficiency (imaged here in the iconic, gazing face of the female figure) is subjected to a cut, but the Symbolic order, the order of (film) language, intervenes to recover the cut, stitching it into the editorial fabric of cinematic narrative. In Buñuel's terms, the excision of the 'découpage' also turns the first thing into another. As Williams recognizes, the gaps or artificial orifices that are cut into the body are figures not just of absence but of the desire that is provoked by absence.[141] The hole or wound creates desire for an object to fill the gap, which, in turn, produces narrative development.

The film remains ambiguously cast between the potential for desire as a creative force arising out of the condition of absence and the darker, more perverse possibility that desire could in fact take

absence – the cut – as its object. The first of these is particularly present in the form of the fetish, the items of clothing and other part-objects that are subject to special cathectic investment by the characters. The second possibility – what we might term a 'traumatophilic attachment' – is present in the recurrent mutilations, the fixture upon absence rather than on frilly aprons or other covers for absence. The film's fetishism is profoundly ambivalent in its function, playing elaborate games with absence and presence. An example is the 'duelling' sequence between the man and the woman, where he first removes his mouth and then hides it with hair apparently taken from her armpit. The fetish of the pubic wig, in the style of Magritte's *Le Viol*, hides not the mouth as hole in the body, but its absence.[142] The lack of a gap becomes the gap that is shown to be hidden here. The fetish in its psychoanalytic sense always has an ambivalent character; it serves the desire of the fetishistic subject to disavow the traumatic separation inflicted by the cut of castration, yet also attaches the subject to the spectacle that it hides. This raises the potential for a gap rather than a cover to become invested with fetishism. In *Un Chien andalou*, the wound – for instance, the hole in the man's palm with the ants swarming out of it – becomes another form of fetish, a part-object that sustains the fascination of the gaze.

In *Beyond the Pleasure Principle*, Freud theorizes the dialectic between the drive for pleasure and the drive for death, which here we can understand respectively as the desire for the fetishistic cover and the desire for the cut. This model is enacted in the early part of the essay through the motions of the 'fort-da' game, where the child's game with a cotton-reel is seen at once as an attempt to master the traumatic absence of the mother by controlling the coming and going of a substitute object and as the binding of the child to the condition of absence – the 'da' of the cover-object called into presence is only meaningful in its exchange with the 'fort' of the cover's removal. Freud sees the rhythm of this game as primal, defining the variety of experience that is deployed in a life's narrative as always also marking out the rhythm of return to the gap or to death. As Kaja Silverman has argued, the 'fort-da' game can also be taken as a template for the operation of suture, for the stitching of the viewing subject into the to-and-fro of a film's image sequence.[143]

Un Chien andalou performs an intense version of the 'fort-da', as it brings objects into play and then removes them or turns them into their negative, exchanging the fascination with the cover for a fascination with the hole. The most binding of its objects are those that

fix the gaze upon visual absence. Thus the elaborate version of the 'fort-da' cotton-reel, the plaything constructed out of priests, pianos, dead donkeys and other paraphernalia that the man drags into the visual field of the woman,[144] is not least a spectacle of blindness. Her shocked gaze is intercut with the gouged-out eye of the donkey, a vision of a visual hole that cannot be seen from her point of view but that none the less fascinates the camera-eye. Similarly, the death's head moth holds the gaze of both figures. It first appears as a mere mark on the wall, before coming into close-up focus as an object of visual fascination. Like the skull in Lacan's reading of Holbein's *Ambassadors*, or indeed the mimetic shape of eyes and other markings on animals that he discusses elsewhere in his seminar on the gaze, the putative visual object is ready to become the subject of viewing.[145] The empty eye sockets control the gaze and cast the eye of the beholder into a mortal fixation with absence.

If the cutting of the eye in the prologue can be understood as an act of trauma, then the act is recursive. It sets the film off on a course of encounters with further forms of mutilation. Trauma is a form of experience that impacts violently upon the psyche, but cannot properly be apprehended either at the time of its happening or in memory. The body broken psychosomatically by the traumatic act cannot be adequately re-membered. In its psychoanalytic definition, trauma is the wound that always comes too soon, happening all at once to the subject as a personal catastrophe, but never properly in the subject's experience, always at another time and in another place. Trauma may be planned in its infliction, but for the subject it is always a function of accidence. It is also scheduled to return in further accidental forms. The objects that are in various ways prepared for viewing, the moth as a kind of staring portrait on the wall or the Dalíesque action-art assemblage dragged by the man,[146] also have a relationship to the staging of accidents in the film. They too are framed, prepared, but unexpected in their impact on the gaze. As the cutting of the eye is both elaborately controlled and unbearably shocking, so its traumatic return is a series of accidents waiting to happen.

Following the prologue, the narrative restarts with the male protagonist cycling down Parisian streets, wearing an assortment of maid's clothing over his suit and a striped box around his neck. Here the bicycle, ridden 'mechanically' as the scenario has it, serves as a kind of bachelor-machine,[147] the self-sufficient libidinal apparatus of the single male rather than the vehicle of collective movement as in *Kuhle Wampe*. The streets are practically deserted, but in one shot we see a crowd gathering at the end of a street, as though some potential for

collective action or spectacle exists. As he rides along, the cyclist's image is split into the rear view of the figure proceeding down the street and another, full-size, semi-dissolved rear view superimposed upon it. The protagonist, who will later be visited by his *Doppelgänger*, experiences his first splitting here. Another cyclist races across the street in the gap between these body images, suggesting an accident that has failed to happen – a collision that is only avoided by the cutting of the character in two. The accident thus pre-empted then duly happens, as the cyclist falls into the gutter in front of the female protagonist's apartment building.

As she jumps up in apparent anticipation of his accidental arrival, the woman casts aside a book that reopens at a reproduction of Vermeer's *The Lace-Maker*, a female figure who wears a collar not unlike the cyclist's. While *Man with a Movie Camera* aligned the spooling, cutting and splicing of the cine-eye machine with the spinning technology of the textile industry, this image indicates a different mode of production: a private act of visual concentration and manual fabrication. The figuration of the textile-worker as a latter-day icon, superimposed upon a circle of spinning spools at the culmination of *Man with a Movie Camera*, contrasts with the more conventional, pre-industrial iconic image of the lace-maker. The Vermeer picture suggests a production of accessories that will bear a particular investment of personal meaning, ultimately in forms of textile fetishism. The cyclist's costume accessories and the lace curtains at the window, through which these will be seen by the woman and later thrown out by the man's double, sustain that mode of production, one that focuses on the private, undercover pleasures of fetishism and voyeurism. It is through a private act of laying out the fetishistic clothing and of visual concentration that the woman as lace-maker achieves the recovery of her male counterpart in the following sequence. The elements of the costume come together, and the man appears in apparently recovered form behind her. Lace-making stands here for an act of suture, a stitching together of the traumatically broken narrative by a recuperation of what is lost in a new form. But the texture is always already torn; the new form typically carries the incompletion of the old, as here in the hole in the hand that attracts the gaze of both figures. The hand that cuts new forms and works new textures for the eye, in textile or in film, here follows the eye in being cut open.

The fascinating hole releases a montage of images apparently associated by shape: the armpit of a woman lying on a beach, a sea urchin that might be a metaphor for the armpit or a metonym

(replacing it because it could be found in contiguous space), and finally the head of a new figure seen from above. The round head of this figure, surrounded by a circle of onlookers and shot through a circular iris, takes the shape of an eye, representing the power of the gaze for the viewer who is drawn to the spectacle. As the scenario describes it, this 'eye' is violently captured by the iris of the camera; the camera-eye re-enacts the visual assault of the prologue. If we take this assault to re-enact a form of castration, then this perhaps helps to explain what must be assumed to be the textual parapraxis of the scenario in describing the androgynously styled figure in a mixture of genders as 'un autre jeune fille'.[148] It transpires that the figure is down in the street outside the window of the apartment. She uses a stick to toy with a severed hand lying on the street,[149] as though this were a vestige of the earlier accident, along with the striped box that is recovered from the scene. The crowd that now gathers around the scene of the accident, regrouping perhaps after having been seen in the distance in the earlier shot, is clearly not a revolutionary one. When the crowd assembles around the body of the young Bönike lying in the street after his suicide, there is immediately a sense of political energy and resistance. The suggestion is that the police who are controlling the crowd of onlookers have committed an 'accident' upon the young worker here. And the function of the police in *Man with a Movie Camera* is as formal regulators of the flows and rhythms of the film's traffic, aimed at the avoidance of accident. The policing of the crowd in *Un Chien andalou* is aimed at other sorts of energy. It is a crowd drawn to a spectacle of street theatre, fascinated by the psycho-dramatic scene, and bringing unconscious identification to it, as indicated by one of the onlookers anxiously rubbing his wrist. The orchestration of the circle around the central figure shows the film's attention to formal design, but this is above all in the service of the psychodrama. Vertov's cine-eye, capturing and orchestrating urban forms and rhythms and only occasionally slipping into a more psycho-dramatic mode, is here replaced by a gaze that is psychically focused on trauma and obsession.

The androgynous figure's obsessive concern with the hand, which is placed for her in the striped box by one of the policeman, and the mounting voyeuristic excitement of the cyclist watching the street attraction from the window above suggest a continuity in the psychic interests of the different figures at the same scene. And indeed, the recovery of the hand initiates the repetition of the street accident. The young woman, clutching her striped box, narrowly misses being run over by several cars, before finally being hit by one that drives

straight at the camera in a further reprise of the primal trauma of the Lumière train. Traumatic obsession with the dismembered body leads the figure to repeat rather than to re-member the event of trauma. Traumatic repetition is inevitably a form of continuity that is traversed by a cut, and this is marked in the representation of this second accident by a curious piece of discontinuity editing. As the car comes at her, the figure is shown to have dropped her object of obsession; but in the next shot, with impact imminent, she is once more shown clutching the striped box.

This sort of discontinuity is a persistent feature of this film, an adjunct to the more evident breaks marked by the sudden moves into new time-scales and spatial dimensions. There is a constant dialectical play between simultaneity and non-simultaneity. In the scene where the man pursues the woman around the apartment, for instance, a white cap is seen attached to the tennis racquet that the woman takes from the wall to defend herself. The cap, part of the film's relay of fetishistic accessories, appears and disappears in the course of both this scene and the encounter with the double that repeats it with variation. At one point it is tucked behind the frame of a picture on the wall. The film engages the viewer in games of 'spot-the-difference' that suggest forms of parapraxis, anachronic lapses in the continuity work of the film, but also teasingly put these on show (both the picture and the tennis racquet are framed objects of display). These acts of editorial sleight indicate a fundamental rhythm of repetition with difference: repetitions of scenes (the characters go from one room to another which is more or less identical with the first); of objects (props like the striped box, which reappear in different contexts); and of figures (not least in the classic embodiment of self-repetition, the *Doppelgänger*). The film follows a logic similar to the classic text of doubling, optical injury, strange playthings and uncanny substitutions, Hoffmann's *Der Sandmann*.[150] Each form of repetition is at once compulsive, an involuntary performance of the 'Now you see it, now you don't' logic of the 'fort-da' game, and marked by signs of difference, by slips and stigmata, which attest to the traumatic origins of the game.

We have seen, then, that montage is a more or less universal performative function of the cinema of the avant-garde, performative in the sense that the material of the film is only given its identity in the process of the act of montage. It is the performative dynamic of montage that gives to film a sense of live theatre in the avant-garde mode, of the attraction, rather than the sealed dramatic narratives of

conventional cinema. In its cutting from one image, figure or scene to another, montage creates a dialectical energy, at once making connections and breaking these. It is also the case that this energy works on different levels from film to film, from scene to scene within a given film, and even, on occasion, within the same scene. From a formalist point of view, montage is above all devoted to what Shklovsky calls *ostrannenia* – the defamiliarization of familiar structures and thereby of the process of viewing. This is what is performed by Vertov's cine-eye. From a political point of view, the defamiliarization is to be understood as *Verfremdung* in Brecht's sense, harnessed to the project of revolutionary social awareness and action. This is what is collectively performed in *Kuhle Wampe*. And from a psychic point of view, it is in the service of *Entstellung* in Freud's sense, exposing the condensations and displacements worked by the unconscious. This is what is performed by the dream work of *Un Chien andalou*. However, it is in the nature of montage, as an aesthetic of fragments and segments, to resist totalization of meaning. Whenever the meaning it is used to produce might seem to become all too familiar, montage is ready, whether by design or by accident, to enable it to be defamiliarized in a different direction. It is thus that the respective 'model' analyses of these exemplary films also revealed counter-exemplary elements, elements that properly belong to the other models, or indeed to the sorts of conventional film making from which all three seek to secede.

5

Case Histories: Narratives of the Avant-Garde

Of all forms across the various media, narrative is probably the one most at odds with the performative ethos of the avant-garde. If the avant-garde happening finds appropriate narrative expression, this is in shorter prose forms, where any substantial development can be resisted – that is, in narratives that are more properly anti-narratives. The manifesto texts discussed in the first chapter provide paradigmatic examples of such anti-narrative textual happenings. The sustained narrative development required of the novel, on the other hand, runs counter to the core model of the happening or manifestation. In general, the experimental novel writing of the early twentieth century is more associated with Modernism in its high form than with the actionist energy of the moment that characterizes the avant-garde. Even if such a high Modernist as T. S. Eliot claims that 'the novel is a form which will no longer serve',[1] it does provide a framework with which the Modernist can work in new modes. The early twentieth-century cityscape, in particular, provides an elaborate topography for new forms of narrative writing on an epic scale, in the Dublin of Joyce, the Berlin of Döblin, the Moscow and Petersburg of Bely, the Vienna of Musil, and the Paris of Wyndham Lewis and Proust. The narrative mapping of the city undergoes a paradigm change from nineteenth-century methods, however. A defining feature of the new versions of the epic is the transmutation of the extension of the Realist novel (its developed representation of the social environment) into elaborate forms of intension (in the in-depth, though often uncertain, representation of subjectivity).

This chapter, in its consideration of experimental versions of the novel and other longer prose forms, will therefore necessarily

encounter much that is not avant-garde in any pure sense, but it will seek to show avant-gardist elements at work in the more mixed economies of the texts in question. If, as Bakhtin suggested, the novel is an intrinsically dialogical genre, given to the interplay of different discursive voices, then this is certainly the case in the split and mixed generic modes and modalities of novel writing in this period, from the 'playpoem'[2] of Virginia Woolf's *The Waves* (1931) to the 'photo-roman', or the novel in collage in the style of Max Ernst's *Une Semaine de bonté* ('A Week of Goodness' (1934)). What these experimental revisions of the novel have in common is the sort of techniques of defamiliarization, the *Verfremdungseffekte*, that Brecht saw as the disruptive *Gestus* of the generic and discursive polyphony in *Ulysses*. When Woolf has each of the versions of soliloquy that make up *The Waves* terminated in the invariable form '*x* said', she is turning the first-person poetic and dramatic interiority of the monologue towards the third-person mode of the epic. She takes the most conventional of narrative formulas and turns it into a device of strategic defamiliarization. Just as Brecht made his actors frame their speeches in rehearsal with 'said *x*', so that the third person would always defamiliarize the speech acts of the first, so too does Woolf in some of her most intensive moments – albeit for different ideological purposes. While novelists like Woolf can hardly be categorized as avant-garde, any more than Eliot in his anti-poetical use of the 'said' technique, the high Modernist discourse of their works is certainly inflected by avant-garde vocal effects or accents of this kind. The defamilarizing discourse of the avant-garde will be heard, in different forms and to different extents, as a dissident voice in the polyphonic narratives to be discussed here.

As in the previous chapter, the discussion will be organized around a central triangular tension, that between formal experiment, political engagement and psychic exploration. The first of these has the potential to lift narrative out of its relationship to the experience of history, to subject it to abstraction; the second takes narrative back to history, but seeks new ways of configuring the relationship; and the third tends to convert the relation of history at large into that of the subject – what might be called, in a broad sense, the case history. While the mimetic logic of Realist narrative gave it a privileged relationship to history, that relationship could all too easily become hegemonic, suggesting that the novel can achieve its licence only if it conforms above all to the official narrative scheme of history and the ideology that underpins it. The orthodoxy of the Realist novel required formal transparency, an ordered, teleological model of

narration, and the binding of individual experience into the contextual framework of society. A characteristic tendency of the Modernist break with Realism is a rupture not so much with the idea of mimesis – an imitative form of representation – *per se*, but with the ideology that focuses it upon the external world and its conventions. Realism comes under increasing pressure to incorporate internal dimensions of human experience, introducing levels of meaning that subtend and complicate the official narratives of social history. This in turn leads the narrative voices of late Realism into more oblique, undercover techniques. The narrator as historian, authoritative and impersonal, enters into compromising levels of intimacy with characters and their inner worlds. What I have called the intension of the Modernist novel, its paradigm shift into the hidden depth-psychological dimension of subjective consciousness, is produced by the contradiction that inhered in, and put increasing internal pressure upon, the Realist project.

This new mode of intensive narrative demands new forms of expression. While social intercourse served as a mimetic model for the dominant novelistic discourse of Realism, Modernism listens to inner voices, voices whose speech is not fashioned for social interaction. This means that novelistic discourse is no longer a function of the author's social consciousness, relayed to a company of readers by the more or less impersonal, socially licensed persona of the narrator, but a function of subjective consciousness. Narrative discourse is thus not socially exchanged, but intimately overheard, the private voice of the subject. This voice is to an extent socially determined certainly, subject to laws of social engagement, but also that of an outlaw, giving voice to socially anarchic thoughts. The fragmented, unofficial histories that emerged in the forms of free indirect speech that entered into the socialized regime of Realism come to take more direct control of the story here. At its limit, this means that the narrative legislated by social consciousness is overtaken by the law-breaking flux of subjective streams of consciousness. Narrative form comes to follow the new modes of understanding the dynamics of consciousness that emerge in the theories of psychoanalysis, in the psycho-philosophical work of Bergson, not least his theorization of time as a psychological dimension, and in the new psychology of William James. It is James, in his *Principles of Psychology* (1890), who provides the term 'stream of consciousness' for borrowing into literary usage: 'Consciousness, then, does not appear to itself chopped up in bits. Such words as "chain" or "train" do not describe it fitly as it presents itself in the first instance. It is nothing jointed, it flows. A

river or a stream are the metaphors by which it is most naturally described. *In talking of it hereafter, let us call it the stream of thought, of consciousness, or of subjective life.*[3]

The question is what room is left in this shift of consciousness for the demands of socio-political intervention made by the avant-garde? James's abandonment of chains and trains for the stream also indicates a turn away from a socially constructed understanding of consciousness towards a more organic one (by which it is 'most naturally described'). Can the political agenda of the avant-garde be satisfied in forms given to the flow of subjective consciousness and regulated, or deregulated, by psychological time? And is there a way of rehabilitating the social for more experimental modes of narrative writing, emancipating it from the conventions of representation that enforced its predominance under the order of Realism? In order to answer these questions, two forms of writing will provide a particular focus here: the case history and the detective novel. Both genres have a particular affinity with the order of Realism. In their ideal form they apply a framework of disciplinary control to phenomena that threaten social order: they locate, identify, judge and treat subjective disorders, trace their histories, in order to make them amenable to the demands of social reality. By systematically testing the boundaries of what is knowable as real, they serve the ideological purpose of reinforcing these. But the controlled release of anti-social energy that this testing requires is a dangerous business, particularly where the framing discipline and its discursive authority lapses.

This already happens in some cases, to be sure, in the age of Realism, but in the writing of Modernism there is a more general questioning of the ability – or indeed the desirability – of disciplinary discourses as regulators of experience. From the recidivist criminal and psychopathological case of Franz Biberkopf in Döblin's *Berlin Alexanderplatz* (1929), to the psychoanalytic insecurities of Svevo's *La coscienza di Zeno* ('Zeno's Conscience' (1923)), and the Taylorist dystopia of Zamyatin's *We* (1924), Modernist narratives question the amenability of social and psychic disorders to ordering frameworks. The avant-garde element in Modernism, in particular, works, albeit often in highly disciplined ways, to cultivate forms of aesthetic and social indiscipline. In this, Modernist narratives are guided not least by the dissident models of psychopathology and criminality and by their respective generic forms. The versions of the case history and the detective story that are produced by the experimental writers of the early twentieth century serve as exemplary case narratives for

some of the key features of avant-garde cultural history. They give evidence of the energy, but also the anxiety of dislocation, that the challenge to existing disciplines brings with it. At the same time, they are marked by the tension between the expressive needs of subjectivity and the demands of collectivist ideology that is a constant issue in the culture of the avant-garde. And the forms of dissident activity that characterize the avant-gardist are always ready, notwithstanding the scandals they produce, to be recuperated by the elastic laws of culture. As Gertrude Stein has it, 'the creator of the new composition in the arts is an outlaw until he is a classic'.[4] What culture can declare as outlaw or as mad by its performative authority, it can also come to pronounce as a classic form of itself.

Modalities of narrative time and space

In his *The Modes of Modern Writing*, David Lodge argues that the narrative order of Realism relies especially on the regulated application of the trope of metonymy.[5] The Realist text is propelled by a logic of contiguous displacement, organizing meaning by moving, in series, from the thing in hand to another that is found with it. The ideology of Realism believes that identity and experience are defined by context, by what is found in the natural or cultural space around a given character. The tendency of these texts is thus to produce meaning by contextual movement, travelling around social groups, and through domestic interiors, urban topographies or landscapes, following the principle of extension. This mapping takes metonymy as its vehicle of choice. For Lodge, Modernist narrative tends to work either by turning the metonymic logic towards the metaphorical or by taking it to an extreme that exceeds the order of Realism. According to this model, Modernist narrative works in a way that had hitherto been the special preserve of poetry, constructing identity and experience by means of frames of reference not conventionally found around them. This metaphorical mode is associated with the release of consciousness from answerability to the real and into alternative worlds. As James's description of the stream of consciousness acknowledges, it is in itself a metaphorical construct, but the stream can work in both metaphorical and metonymic directions, through associations of both orders.

Lodge's bipolar model of narrative figuration certainly holds to some extent. Metaphor lends itself to what has been called here narrative intension, to an intensive thickening of representation through

the combined presence of the object represented and the figure that represents it, rather than the attenuation that tends to be produced by the mapping motion of metonymy. It is also clear, however, that the tropic tendencies of metaphor and metonymy are interdependent, that most acts of representation move in at once metaphorical and metonymic, intensive and extensive directions. The modes of modern writing are subject to more compromised modalities. If the intensive mode of metaphor does indeed become dominant in Modernist narrative, then this has much to do with the gravitation into the domain of subjective consciousness, where the contiguities of the social map hold only in a relative sense. In the space of consciousness things found next to each other may not in any conventional sense belong together: psychic topography is as likely to be arranged according to a metaphorical logic as a metonymic one. That is, in accordance with the principle of the chance encounter propounded by the Surrealists, the object that happens to be found as you move around that space may be charged with a meaning far exceeding that of straightforward metonymic contiguity.

If the interplay between metaphorical and metonymic poles establishes a spatial model for understanding the working of narrative, it also has temporal implications. Spatial contiguity correlates with temporal continuity. That is, to proceed to something found in an adjacent or associated place is also to maintain an approximately continuous temporal frame for story telling. Metonymic extension implies a social coherence in the diachronic experience of time (time as marked by clocks and calendars), while metaphorical intension implies the synchronic dilation and the anachronic breaking up and layering of temporal experience. The thing taken for figurative purposes from another spatial dimension is also taken from, and brings with it, another temporal one.

We can see this spatio-temporal logic at work in another form of diegesis by returning to *Un Chien andalou*. The film's narrative structure is at once one of spatial and temporal disjuncture and equally unconventional points of conjuncture. It works through displacements and condensations in both dimensions. When the shot of the hole in the man's hand is cut into that of the armpit of a sunbather, and this, in its turn, into a shot of a sea-urchin, the condensation of visual likenesses suggests a metaphorical logic. This logic makes the film travel to another scene, the seaside, which will, in due course, become the scene of the film proper. In an anachronic film narrative that switches back and forth in time apparently at will, this metaphorical insertion works proleptically, as an anticipation of the time

when the film will move to that other place. At the same time, the passage from the armpit to the sea-urchin indicates that metaphor can also be sustained metonymically, that to enter into a metaphorical other place is to open up a new site of potential extension to other objects that share the same space. Given that the narrative will move seamlessly from the urban apartment through an internal door on to the beach, there is no guarantee that the 'other' place of figurative development is not as real as the 'actual' present place of the narrative.

In her reading of *Un Chien andalou*, Linda Williams follows Lacan's rhetorical understanding of psychic processes in seeing the metonymic and metaphorical moves of the film's narrative as corresponding respectively to the functions of displacement and condensation. Metonymy displaces meaning by moving to associated objects, while metaphor condenses meaning by introducing other dimensions into the present time and place of the narrative. This is to view metonymy less as the solid agency of mimetic continuity than as a figure of disguise and disorientation. The replacement of one body part by another, such as a mouth by armpit hair, is characteristic of this form of discontinuous metonymy, following the imperative of unconscious desire rather than the pragmatic logic of Realism. And the hair from the armpit has already been metaphorically co-opted by the earlier sequence, importing condensed meanings into the figurative play of the new scene. The film narrative is thus seen to adopt a rhetoric that imitates the workings of the unconscious, and thereby to move according to spatial and temporal co-ordinates of 'an other scene'.

Similar processes can be seen at work in a short narrative text that enacts a comparable psychodrama to that of *Un Chien andalou* and adopts analogous figurative and spatio-temporal structures, Kafka's 'Ein Landarzt' ('A Country Doctor' (1917)). Like the film, Kafka's narrative passes without mediation from one scene to another, subjecting conventions of map and clock to the alternative time-scales and topographies of the psyche. The conventional linguistic form that is characteristically applied even to Kafka's most unconventional subjects is replaced here by an unorthodox grammatical arrangement, with a paratactic sequence of short clauses in the first half of the narrative and unmediated switches of tense. The narrative follows the montage structure of dream, assembling different scenes and figures, human and animal, into hybrid figures of *Entstellung*. It takes a scenario that might derive from a piece of nineteenth-century Realist fiction – a country doctor called out to attend to a patient on a winter's night – and makes a febrile dream version of it. As in *Un Chien andalou*, the narrative of sexual aggression and untimely death

is organized around the figure of a wound, appearing without mediation, and here too the wound is both intensively and extensively laden with figurative meaning. As I have argued in detail elsewhere, the wound in the side of the doctor's young patient is at once a construction of metaphor (as a condensation of open wound, open flower and open-cast mine) and one of metonymy (figuratively containing the displaced body parts of the maid Rosa and the doctor).[6] The psychodrama shows the country doctor, a figure of authority in the world of nineteenth-century Realist fiction, defrocked and turned out at the end of his narrative, lost in a wasteland and in the suspended experience of a continuous present. Rather than keeping to the proper time and place of Realist narrative, he has followed the 'false ringing of the night-bell' and ended up not at the appointed place and time, but in the 'other scene' of the unconscious.[7]

The strange case of Kafka's country doctor shows how a figure of social history can be waylaid into the dream or nightmare territory of the case history. The doctor who might be expected to solve and treat the case of the patient becomes the apparently irremediable subject of such a case. An agent of social order is turned into a disordered outlaw, implicated in malpractice and expelled from the community. This abduction of the doctor from both his place in history and the continuity of his personal narrative shows the extremity to which the intensive mode of Modernist fiction may go. The case would seem to be a cautionary one: this technically most avant-garde of Kafka's narratives also leads into an autistic space away from any possible social intervention. The isolation of the title figure and narrator in a geographical non-place and historical time warp, with no end in sight, is exceptional, but also repeated to varying degrees in a number of the other narratives to be considered here: Joyce's Molly alone in her bed at the end of *Ulysses*, Schnitzler's Fräulein Else alone in the bed of her hotel room at the end of her text, Woolf's Mrs Dalloway at once in society and alone with her consciousness at the end of hers, and Breton's Nadja, shut away in an asylum at the end of the text that carries her name. Intensive narratives in the style of 'Ein Landarzt', reading like the notation of a dream from Freud's case-book, require conditions of isolation akin to the psychoanalytic couch for their speaker. These case history narratives inevitably take their protagonists out of the historical sphere even as they lead them into more experimental reaches of narrative discourse. And the move out of the social can be experienced either as a liberation – a form of solipsistic free association with the self – or as an autistic abjection, as embodied in the outcast figure of Kafka's country doctor.

If the country doctor ends up in a wasteland outside of his rural community, it is more usual for the narratives of Modernism to explore the city, its spaces both of mass community and mass movement and of exile, voluntary or involuntary. The Modernist subject is drawn to the city as the privileged site for the experience of modernity, and yet all too often estranged from it. The home from home of the modern city has a tendency to become *unheimlich*, an uncanny un-home, as does Paris for one of the pioneering Modernist narrator-protagonists, Rilke's Malte in *Die Aufzeichnungen des Malte Laurids Brigge* ('The Notebook of Malte Laurids Brigge (1910)).[8] The modern city certainly yields a space for new versions of old genres, for picaresque adventures or confessional narratives. It suspends old categories of temporal and spatial organization, and casts conventions of social distinction (class, nationality, gender, sexuality) into a melting-pot. As a site of multiple encounters and relationships, it provides a fertile territory for story telling. Yet it also threatens the very basis of the act of story telling – interrupting the fundamental continuities of development from beginning to end that define narrative possibility and the communal structures that enable its transmission. The complex networks of relationship that the city yields for narration are also always subject to effects of dispersal and fragmentation. Like Rilke's Malte at the start of his narrative, isolated in a private space that is at the same time riven and alienated by the intrusion of the urban world outside, the Modernist narrator of city life all too easily takes refuge from the atomization of metropolitan experience in an attempted recuperation of inherited forms of experience and generic models (childhood memoir, family mythology, biblical parable, etc.).

If Malte, the aristocrat in exile, escapes from the flux of early twentieth-century Paris into the imaginative spaces of a feudal narrative system, Louis Aragon's *Paysan de Paris* ('Paris Peasant' (1925)) advocates a more direct engagement with urban modernity. The persona of the urban peasant allows him to adopt a working relationship to the territory of the city: the poet-peasant, with his intimate, organic knowledge of his 'land', its topography and its productivity, works the spaces of the city in his narrative. The authenticity of this persona and its claims must, however, be open to some question. As Malte's appropriation of the narrative territory of which he has been disinherited involves a type of aristocratic masquerade (as in the costume dramas played out in his childhood), Aragon's peasant is also arguably only a mask for the more leisured, bourgeois mode of urban *flânerie*. But Aragon's narrator certainly engages with the

urban environment with an exploratory enthusiasm that Rilke's cannot muster.

Aragon was a founding member, with Breton and Soupault, of the Surrealist movement. He was to become estranged from the group by 1930, not least because his eager *rapprochement* with Soviet Socialism was viewed with suspicion by Breton. *Le Paysan de Paris* documents the ideology of Surrealism in its pre-revolutionary phase, before Aragon had embraced the sort of more politicized realism that would be amenable to Socialist doctrine. *Le Paysan de Paris* is above all interested in seeking out the marvellous in the mundane, the seams of surreality that can be traced in the real, and not least in the everyday world of the city. In the encounter of the Surrealist adventurer with the spaces and objects of the urban landscape, the routine metonymies of Realist fiction are transformed by the charge of metaphor. This is the basis of the 'modern mythology', constructed through a cult of the image, which Aragon catalogues in the text. The metaphorical potential of the figures and objects he encounters in his passage through Paris sublimates them into carriers of mythical agency. Aragon sets out to write what he would later call this 'novel-that-was-not-a-novel', one that would 'infringe all the traditional laws of the genre',[9] in order to defamiliarize the act of novel reading in parallel with the defamiliarization of the familiar sites and activities of the city. While the traditional novel form relies on a teleological model, the movement towards a determined end, Aragon organizes his 'anti-novel' according to the principle of passage for its own sake, focusing upon a form of transient presence that is not bound for its meaning to an origin or an end-point. The principle of mobility is enshrined not least in the unconventional form of the 'novel'. This Surrealist travelogue is a collage of different generic forms, discourses and dialogues, signs and advertisements, labels and tickets, imitating the mixed modes of reading that are required of the urban wayfarer.

The special site of Aragon's explorations is, in every sense, one of passage. In the 'Passage de l'Opéra', the narrator finds a place that is defined by passing in both spatial and temporal senses: a place where people pass through and take passing advantage of various services as they do so. It is a space that, at the time of writing, has also passed into urban history; the Passage has been demolished and is available only through acts of narrative memorization. It is thus under the sign of one of the key deities in Aragon's modern mythology, the polymorphous figure of 'l'éphémère',[10] which, like the other iconic presences of the ambulant 'mythologie en marche',[11] is encountered by means of the mobility of perception. The Passage, like the park that

Aragon, Breton and Marcel Noll visit later in the narrative, is a liminal site of the city's unconscious, a place of access to subjectivist fantasies. In the performative spaces of the special interest shops, the erotic Théâtre Moderne, which the narrator claims to be the seat of the true avant-garde, the bar that was the meeting-place of the DADAists, and the brothel or 'maison de passe' (incorporating sexual encounter into the system of passage), the text explores the spatial site of temporal transgressions, of the 'dérèglement passager'.[12] As a place of deregulated pleasures, where the unconscious is temporarily released from the tyranny of rational order, it also represents a threat to the 'société policiée',[13] which is seen to balk at the narrator's transgressive naming of what comes to pass in this undercover world.

As with Artaud's theatre, the political challenge of *Le Paysan de Paris* is one of psychosexual anarchy, rather than revolutionary organization. Aragon's peasant records the transgressive forms of 'symptomatic act' from a past world,[14] rather than taking political action for a new order. It is perhaps indicative that the impact of the new mass politics is registered in the novel only by a cipher, the letter 'W' that is found amongst the obscene graffiti on mirrors and walls,[15] implicitly representing Mussolini in the sign language of the Italian Fascists. Aragon treats this sign as just one more of the monstrosities and enchantments of everyday life that fail to be registered as such by his contemporaries. That is, he submits to a selective blindness of his own, failing to achieve an adequate attribution of the sign to the political conflicts of the historical process.

As Susan Buck-Morss has argued, this failure to historicize is the ground for Benjamin's critique of Surrealism, and not least of *Le Paysan de Paris*, one of his favourite Surrealist texts.[16] While Benjamin is powerfully drawn to the Surrealist programme of revealing the enchantments of modern technological and commodity culture, he is also critical of its tendency to seek to keep those enchantments intact. His *Passagen-Werk* is not least a critical revisiting and reworking of the Surrealist cult of the passage, in which he seeks to subject the enchanting objects to the disenchanting strategies of historically grounded dialectics. Benjamin's ambivalent relationship to Surrealism aligns him with Freud, whose project he extends into the cultural political domain. The Surrealists were drawn to Freud in so far as he revealed the occult territory of the unconscious, but were resistant to the enlightenment aspirations of his programme. When Benjamin reviews the Surrealist cult of the urban unconscious, he figures his work, that of the critical historian, by analogy with Freud's. While Aragon is seen as maintaining a somnolent enjoyment of dream and

mythology, Benjamin advocates the activation of the 'dialectics of awakening', and he takes as his model for this Freud's 'Nature-dream' from the *The Interpretation of Dreams*.[17] Freud's interpretation of the dream in question works by rehabilitating the 'paralytic' sense of time that obtains in it, and placing the images and text of the dream out of their *Entstellung* and into a coherent personal narrative.[18] It thus provides a model for Benjamin's programme of treating dream as a 'historical phenomenon'. Benjamin undertakes, as it were, a secondary revision and interpretation of the Surrealists' attachment to the primal processes of the psyche, individual and collective. At the moment when humanity awakes and takes passing cognizance of the dream image, Benjamin's 'historian takes up the task of applying dream interpretation [*Traumdeutung*] to it'.[19]

If the psychoanalyst is one model for Benjamin's dialectical work on the passages of the city, transposing the individual case-historical model into a dialectically organized accounting of collective history, then the detective is another. Benjamin sees the *flâneur* as an avatar of the detective as urban observer, concealing his active surveillance of the transgressor behind a show of indolent vagrancy.[20] Part of the attraction of Aragon's narrative is his enactment of the *flâneur* figure in the guise of a private detective, investigating the undercover transgressions of the 'société policiée' in the modern city. Aragon conducts a combined mode of detection and dream work on the city. As Breton has it, 'Nobody could have been a more skilful detector of the unwonted in all its forms; nobody else would have been transported to such intoxicating reveries about a sort of secret life of the city.'[21] This double agency is clearly a problematic one. Like Kafka's doctor, called to diagnose and treat a mysterious case of illness, but drinking on the case and drawn into a dreamlike pathology of his own (projecting his own psychic interests into the wound in the boy's side), the Surrealist detective is prone to getting drunk on dreams. The true significance of the letter 'W', a clue to the monumental historical threat of Fascism, is thus effaced by the narrator's uncritical oneiric intoxication with the manifold secret signs of the Passage. The dialectical attentions of the forensic oneirocritic Benjamin are certainly needed here. Both Kafka's doctor and the Surrealist detective are called upon to make objective case studies, but what emerges from these ostensible figures of enlightenment in their Modernist incarnations is a sort of case history whose authority is compromised by subjective fantasy. These two types of case study will recur in the discussions of other Modernist narratives that follow, and provide ambiguous models for the ascertainment of the facts about both case history and history at large.

Metamorphoses of Gender and Sexuality

Part of the conundrum constructed by the wound in Kafka's 'Ein Landarzt' is the ambiguous shaping of gender and sexual identity. The doctor gets into bed with his young male patient, and the wound in the youth's side takes a female genital shape. As has often been noted, Rosa, the doctor's maid, who is envisioned by him as the victim of rape by the bestial groom while his master is making his nocturnal visit to the patient, is introduced into the wound by means of the colour pink, 'rosa' in German. The boy's wound takes her shape, and if the doctor were not dreaming, he might be able to recognize the clues to his own fantasies that are displayed in this configuration. The wound, as a figure of *Entstellung*, stands not least for the displacement and disfigurement of conventional gender and sexual roles.

For the dreaming detective, Aragon, on the other hand, the representation of the objects of the urban unconscious seems to be securely, even hyperbolically gendered female. The heterosexual encounter with the *flâneuse* Libido and her handmaidens is characteristic of the sexual ideology that rules the Surrealist movement. Notwithstanding some dissident voices, the 'Recherches sur la sexualité' ('Inquest into Sexuality') in *La Révolution surréaliste* presents a decidedly heterosexist picture of the interests of this homosocially organized group.[22] But in *Le Paysan de Paris*, too, there are indications that sexuality may not conform to the official model, but that – following the theories of Freud, described as the little dog following at her feet – Libido may also be subject to other, potentially queer forms of gendering. The barbers of the Passage are distinguished by their lack of sensuality, in opposition to the feminized eroticism on offer all around them, but this leads the narrator into an extravagant celebration of the sensual pleasures purveyed by certain barbers' shops in the suburbs, where 'capillary artists' work their delicate surprises on their clients with an 'unprofessional passion'.[23]

As these two examples indicate, the shaping or reshaping of gender and sexuality is one of the defining characteristics of Modernist narratives. The exposure of sexuality, so often hidden or compromised in Realist fiction, is fundamental to the project of exploring the intensive aspects of human experience. The form that this takes is, however, distinctly variable. There is certainly a move towards breaking down the binary, hierarchical model of gender difference and its hetero-normative logic, but there is also a more blatant appropriation of that model. As we saw in the discussion of Surrealist

exhibitions and exhibitionism, the exposure can all too easily take the form of an objectified, genital femininity, openly displayed for the male gaze. While the avant-garde defines itself through perform-ative novelty, the performance of gender and sexuality often relies on an essentialist view of these categories. To use the terms developed by Judith Butler, it tends to operate in the mode of the appropriation rather than the resignification of hetero-normative models. Where reshapings are indeed achieved, where agency is given to feminine sexuality or heterosexist norms are queered, this is often in less than emancipatory ways. Thus, Marinetti's programmatic novel *Mafarka le futuriste* ('Mafarka the Futurist' (1909)) deploys in the form of a conventional adventure epic a vision of Futurism that is profoundly atavistic, not least in its appeal to fantasies of sexual violence. It endows female figures with a rapacious sexuality, but only in order to service the needs of the title-figure and his co-warriors. Indeed, the novel develops a preposterous fantasy of male self-propagation to rid the Futurist hero of those needs. Not only does Marinetti's vision of Futurism involve an even more homosocial community than that of the Surrealists, but the bonds of homosociality are ripe with lurid, muscular homoerotics in the relations between Mafarka and his brother and son.

As with Marinetti and Aragon, the shaping of gender and sexuality in Joyce's *Ulysses* (1922) is organized around what Eliot defined in his discussion of the work as 'the mythical method', superseding the narrative models of social realism.[24] The latter-day *Odyssey* con-structs another version of the modern mythology, and the character given the final word in the novel, Molly Bloom, takes on the propor-tions of an Earth Goddess. As the adjectivally over-laden muscu-lature of Marinetti's prose structure gives performative shape to the body image of exorbitant masculinity that it celebrates, the final sec-tion of Joyce's *Ulysses* is notoriously a performance of the female protagonist's consciousness as a function of her sexual body. Joyce describes this gynomorphic modelling of her narration thus: the mono-logue turns slowly, 'like the huge earth ball', its four cardinal points being 'the female breasts, arse, womb and . . . expressed by the words *because, bottom* (in all senses bottom button, bottom of the class, bottom of the sea, bottom of his heart) *woman, yes*'.[25]

The narrative mode of stream of consciousness is established here, in perhaps its definitive performance, as a bodily function (Molly wants to have speech 'the way a body can understand'),[26] and one that is gendered female. The multifarious voices and generic styles of this polyphonic epic achieve a sort of confluence in the streaming

consciousness of Molly Bloom, which pours out of her 'like the sea'.[27] She figures herself here as a 'flower' and thereby embodies a leitmotif of the novel, as Bloom's bloom. And the 'flower' is also, according to one of the novel's key word-play devices, a 'flow-er', streaming forth in body and language. She speaks what Bloom had thought of as the 'Language of flowers',[28] the same language of flowing and flowering that Stephen heard on the beach: 'It flows purling, widely flowing, floating foampool, flower unfurling.'[29] As the reference to the language of flowers suggests, the flower is the most commonplace of objects for figurative appropriation. Joyce, however, like Kafka with his flower-wound, makes an overdetermined metaphorical–metonymic complex of the flower/flow-er. The final embodiment of this complex in the shape of Molly, the metaphorical flower, is also metonymically sustained: Molly becomes the flower she wears and the flow-er of her bodily and mental fluids. The 'lett and flow',[30] to which the letter and flower had been reduced earlier in the narrative, is here converted into a flowing and flow-ering without let. It is a playful stream of free association, as creative as it is incontinent, without the encumbrance of syntactic blocks and channels, and barely impinged upon by the conventional spatio-temporal demands of narrative ('I never know the time').[31]

The mythologizing of Molly certainly subjects her to an essentialized view of femininity: the 'flower' who has to be 'planted' by her husband,[32] and the 'flow-er' whose stream of consciousness is constructed as such by the male author. At the same time, her apparently masturbatory free association, climaxing with the sex-word 'yes', achieves an extraordinarily frank autonomy for feminine sexuality. And, as essentialized as she may be, she is also a consummate performer – not for nothing is her stream of consciousness text generally known as a monologue or soliloquy. Her performance extends to the queering of gender; in her excitement at her own body and imagining of the male position in sexual intercourse for herself, she resignifies sexual gender performance even as she appropriates it. Unlike the Surrealist exhibitionism of the female body, or indeed the scene with Gerty MacDowell on the beach, appealing to Bloom's taste for 'exhibitionististicicity',[33] Molly's exhibition is a performance of and for herself. She free-associates alone in her bed, in conspicuously good mental and physical health, free from the intervention of the doctor/analyst and ventriloquizing in mock forms the discourse of other patriarchal agencies. In her 'talking of dreams', as with the rest of her psychical life, she is always ready to overflow, to 'let out too much'.[34] And she is thus liberated at once from the conditioning structure of the case

history and from what Stephen calls the nightmare of history.[35] This autonomous performance is apparently what is needed to end the novel in an unconditional affirmative.

The case of Schnitzler's *Fräulein Else* (1924) serves as the counter-model to 'Molly's soliloquy', enacting a version of the case-historical paradigm. As we will see, Schnitzler co-opts that model from psychoanalysis, whilst also questioning its viability.[36] While readers habitually make intimate with the free agent Molly and her soliloquy, adopting first-name terms, the title of Schnitzler's novella indicates that the narrator-protagonist is constitutionally subject to socialization. Fräulein Else is closer in this to Gerty MacDowell, talking to her mirror image, adopting the fantasies and discursive formulas of popular fiction, and becoming subject to the voyeuristic attentions of an older man. While Molly's stream of consciousness achieves a high degree of autonomy from the social order and its spatial and temporal co-ordinates, Fräulein Else's interior monologue is framed throughout by social appointments of one kind or another (the proposed tryst with von Dorsday being the undercover version of these). The text derives its pathos from the disjuncture between the 'Fräulein' role demanded by social decorum and the associations and fantasies that run through the character's consciousness. The form of Fräulein Else's narrative is less radical than that of Molly's, the stream of her thought processes punctuated in more or less conventional form, and interrupted at points by dialogue; but this linguistic control seems only apposite for a figure whose subjectivity is so conditioned by her social objectification. Fräulein Else enacts a version of Butlerian gender performance, where the social role of the 'Fräulein' is intensely regulated by performative requirements, and her inner life is a theatre both of performances of that role and of counter-performances. Else's transformation of von Dorsday's demand for a personal act of sexual display into a theatrical social performance of exhibitionism at once follows the performative logic of the gender and sexual role required of her and exposes it by giving von Dorsday the kind of performance he would not want. In Butlerian terms, it is at once an appropriation of the social role of sexual commodification and a theatrical resignification of that role. The price of the frustrated actress's dissident enactment is her fall into terminal isolation; it seems that Fräulein Else's performance can be achieved only as sacrifice, over her dead body.[37]

Schnitzler hardly fits into the avant-garde mould, and his adoption of this Modernist mode of experimental narrative here and in his earlier novella *Leutnant Gustl* (1900) is motivated by a more

conventional form of social critique, exposing the double standards that twist and vitiate the identities behind the social titles of young bourgeois protagonists. What the use of the, albeit regulated, stream of consciousness does do, however, is to operate subversively on the two forms of case study that Modernism might adapt from nineteenth-century culture as frames for the control of relationships between the disordered subject and society: the psychiatric and the criminological. On the one hand, Else is figured as a hysteric, akin to the young women whose psychosexual narratives were recorded by Freud and Breuer. Her narrative is thus organized around key scenes and words that follow a logic of *Entstellung*, producing condensed and displaced levels of meaning. When, in her final delirium, she sees the 'Filou' figure following 'einen so schwindligen Weg' ('such a dizzying path'),[38] and imagines he will meet her father on it, a slippage between the two senses of *Schwindel* (dizziness and swindling) is activated. In its representation of an escape from the social world, the mountain path is both a metonymic track, a dizzying part of the local landscape, and a metaphorical one, a place for swindlers to encounter each other.

Through such figures the psychopathological case history inter-sects with the criminal case. Else's is the story of a victim of crime, subject both to the criminal status of her father and to the blackmail of von Dorsday, who offers her money for the sexual favour of see-ing her naked. What is distinctive about Schnitzler's handling of these two paradigms, however, is the failure to introduce into the text the agencies that might regulate them. While the nineteenth-century novellas of crime and madness were typically framed (albeit not always securely) by enlightened structures of control, *Fräulein Else* has no such framing. There is no sign of judicial control of von Dorsday's activities, and the country doctor called to tend Else fails to appear. Else's father is a lawyer threatened with imprisonment, and her cousin Paul a hapless gynaecologist who is exposed by his secret lover Cissy as playing the doctor at Else's deathbed, and ironically makes her feel 'sick with laughter'.[39] All potential agencies of law or medicine are compromised, part of the 'Schwindelbande' ('band of swindlers').[40] There is neither a detective nor a suitable doctor to provide a meta-narrative framework for Else's interior monologue, to provide the sort of explanatory or therapeutic agency that might be expected from these narrative models. Unlike the film narrative of crazed criminality in *The Cabinet of Dr Caligari*, with its recuperating frame, *Fräulein Else*'s story retains real subversive political potential, even over the dead body of the protagonist.

While Schnitzler's narrative is an individualistic one, focused upon, and focalized by, the title-character, the implication of the different types of transgression that, on a social level, go undiscovered in the story, is that the individual narrative has more general, cultural historical implications. Fräulein Else, and Leutnant Gustl before her, are, as it were, figures in the social round-dance of Schnitzler's drama *Reigen* ('Round-Dance' (1900)), individual but also exchangeable elements in a collective social structure of exploitation and duplicity. In these terms, there is more of a political challenge at work in these texts of personal melodrama than might at first meet the eye. Schnitzler subverts the bourgeois moral order from within, exploiting its interest in the intimacies of personal narratives in order to expose the endemic bankruptcy and derangement of the social system.

Virginia Woolf's *Mrs Dalloway* (1925), too, is a revision from within of the model of the bourgeois novel, rather than a properly avant-garde intervention. As with *Fräulein Else*, the prime concern is the effect of social construction upon the psychical household of the title-character. Both women compose themselves before mirrors, making up their persona before entering the social theatre. Mrs Dalloway is as constrained by, and in tension with, the performative requirements of her social title as is Fräulein Else. Here, though, the sacrifice of the individual to social demands is made over the dead body of her male counterpart, Septimus Smith, rather than that of Mrs Dalloway herself. Fräulein Else's hysteria finds its corollary in the male hysteria of the shell-shock suffered by Septimus, who, like Else, commits suicide, and Mrs Dalloway is thus enabled to continue her social performance without succumbing to her own case history.

Like *Fräulein Else*, *Mrs Dalloway* is organized around an eminently bourgeois social framework: the preparation of a party. It retains the vestigial structure of what Woolf would come to describe as the 'waste' mode of social mimesis: 'this appalling narrative business of the realist: getting on from lunch to dinner: it is false, unreal, merely conventional'.[41] Against this conventional diachronic schema she sets the intensive poetic mode of writing the moment, revealing the saturated significance that is contained at each synchronic point. The third-person narrative of Mrs Dalloway's day is hybridized with monological interior voices, not least her own, which go beyond the time and place of society to open up the dimension of psychological time and the subjacent domain of what she describes in the essay 'Modern Fiction' as the 'dark places of psychology'.[42] *Mrs Dalloway* is thus a staging-post on Woolf's journey towards an abstraction of the novel genre from the social world, a project that was most nearly

realized in *The Waves* and its assembly of voices in the mode of what she calls in the essay 'The Narrow Bridge of Art' the 'soliloquy in solitude'.[43]

Woolf's reaction to Joyce's *Ulysses* was deeply ambivalent. She was both excited by the release it offered from the conventional modes of narrative and into 'life itself' and repelled by the fleshy Rabelaisian corporeality of his writing: 'When one can have the cooked flesh, why have the raw?'[44] For Woolf, the complex of the flower and flowing is worked out in a way that is characteristic in its attention to the 'cooked' form. In *The Waves* she has Rhoda give an at once more poeticized and socialized version of Molly's soliloquy, where the erotic energy of what Rhoda calls 'the flow of my being' is sublimated into the poetic and social language of flowers: 'To whom shall I give all that now flows through me, from my warm, my porous body? I will gather my flowers and present them.'[45] Rhoda's porosity is contained within the social figuration of sexuality as gathering and presentation. And the flux is thus figured in a far less free-flowing, grammatically impeccable, version of the stream of consciousness.

The language of flowers in *Mrs Dalloway* is introduced in the social mode, as decoration for the party, but it also gives access to the darker places of the novel's psychology. When Mrs Dalloway is choosing the flowers for her party at the florist's, she feels buoyed up by the scent and sight of them, as they 'flow over her' like a wave and overcome her feeling of hatred.[46] However, the therapeutic motion from flowers to flowing is interrupted by the backfiring of a car that is taken to be a gunshot. Whereas William James, in his conception of the stream of consciousness, sees such explosive shocks as still amenable to the continuous flow of thought,[47] in *Mrs Dalloway* the shock has a more traumatic character, introducing a break in apprehension. The shocks in question are both a disruptive part of the fabric of urban life, in a Benjaminian sense, and more domestic in character, both external and introspective. The language of flowing, associated with the flowing of the text's language, is recurrently subject to intrusion from without and breaking from within. When Mrs Dalloway is caught in one of her characteristic frames in the liminal moment before 'plunging' into the drawing-room like a diver into the sea, she sees before her the waves 'which threaten to break'.[48] The thrilling moment of plunging into the flow is dialectically bound up with breaking and mortification. Throughout the novel, the parallel figurations of flowers and fluidity are marked by this ambivalent structure, sustaining continuity but also associated with the shocks and disjunctures of the darker places of psychology. There is the

flower that marks out a kiss with another woman as her most 'exquis-
ite moment',[49] now lost in her heterosexual routine. And the flower
becomes a figure for Septimus's hysteria; as with the patient in Kafka's
story, flowers wound him: the metonymic order that keeps the red
flowers of his wallpaper in their place is broken, as they become
traumatically displaced to grow 'through his flesh' as a misshaping
figure of *Entstellung*.[50] As the flowers grow into him, so he is borne
by the imagery of the sea, the constellation of plunging, floating and
drowning that he shares as a leitmotif with Mrs Dalloway. Flowers
and flowing are configured and confused, as with the sirens 'dashed
in his face like bunches of roses',[51] or his wife's image of the two of
them as caressed by the sea and herself strewn 'like flying flowers
over some tomb'.[52] The language of flow(er)ing is marked by mortal-
ity, and its pathology is as it were contracted performatively by the
narrative style of the work. While Joyce's textual flow through the
mind and body of Molly is put under the sign of fertile vitality,
Woolf's 'fluid' style is ready to become pathological, as she would
diagnose it in her later texts.[53]

At the same time, the language of flowing is incorporated into
the representation of the historical world that surrounds the case-
historical core of the narrative. While time, and with it history, barely
impinges on the consciousness of Joyce's Molly in the distant striking
of a clock, clock-time marks a repeated intrusion of social time into
the psyches of the characters assembled in *Mrs Dalloway*. In the
leitmotif of Big Ben, striking the time, flow is configured here with
shock and concussion: the bell strikes vertically into the temporal
flow and releases metaphorical time-waves, spatialized as concentric
circles spreading horizontally from the point of the strike. This figure
of striking time is worked and reworked throughout the narrative, in
particular as a corollary of Septimus Smith's suicidal plunge. Big Ben
marks time as the striking heart of the body politic, organizing social
life and spreading through the consciousnesses of the characters dis-
persed across the city, but it also strikes at them, marking the poten-
tial for a terminal breaking of the social for the individual. The
pounding heart of the body politic, and the bells that follow it through
the city, chime with the stricken heart of Mrs Dalloway. Thus Peter
Walsh hears the striking of St Margaret's, remembers Mrs Dalloway's
heart condition, and imagines her having a cardiac arrest: 'and the
sudden loudness of the final stroke tolled for death that surprised in
the midst of life'.[54]

Big Ben is the iconic embodiment of the establishment discourses
that frame the narrative: the discourses of Imperial politics, law and

medicine. The case history that Woolf projects from Mrs Dalloway on to her 'double' Septimus Smith is designed to expose the historical conditions that first produce and then fail to provide a remedy for it. The shell-shocked Smith is a victim of the European war, a war fought over Imperial politics, and in the doctors called upon to treat him he becomes a victim once more of patriarchal brutality. The psychiatric case is converted into a criminal one. Smith comes to see himself as the perpetrator of crimes, chief amongst them his failure to apprehend the trauma of Evans's death. And first Dr Holmes (a parodic conflation of Sherlock Holmes and Dr Watson, who is incapable of diagnosing the truth of the case) and then Sir William Bradshaw treat the case as a potentially criminal one, making of psychiatric medicine 'a question of law'.[55] Bradshaw's project for introducing 'proportion' into the mental lives of his patients is aligned with the violence of the Imperialist project of conversion and backed up by the 'police and the good of society'.[56] As Mrs Dalloway thinks, following the suicide, Bradshaw the lawgiver is also 'capable of some indescribable outrage – forcing your soul, that was it'.[57] The doctor is given responsibility for the death of his patient, indictable for psychical rape. Like the police force, evidence of whose 'malpractices' is being collected by Richard Dalloway,[58] the institution of medicine breaks ethical laws in its enforcement of the law of the land.

Notwithstanding its apparent preoccupation with the inner world of the society hostess, *Mrs Dalloway* exposes the workings of the social. It is no revolutionary text, but it certainly turns the case history form towards a political intervention in history and the discourses that dominate it. If the disorder of the case history is recovered at the end of the narrative, Mrs Dalloway released back into social assembly after the sacrifice of her *alter ego*, the traumatic impact of the case is still felt, and its closure remains questionable. The interior monologues of the narrative have given unusual access to the psyches of the principal characters, apparently opening up their darkest places – not least the ambiguous shapes of their gender and sexual identities. The reader might none the less still be troubled by the figure that is given the final word in the novel. We have followed Peter Walsh in his *flânerie* through the internal and external spaces of the city, with seemingly intimate access to what he is thinking. But there remains something profoundly troubling about this character who is constantly playing with his pocket-knife, not least when he sets off in pursuit of a strange woman on the street: 'Straightening himself and stealthily fingering his pocket-knife he started after her to follow this woman.'[59] His excitement here, along with the 'sort of lust' he feels

at thinking of death in the scene following the suicide,[60] might still resonate in the excitement that fills him as Mrs Dalloway enters at the end. The reader is always susceptible to what, to use Bradshaw's parlance, would be disproportionate and therefore 'mad' readings, following what the psychiatrist diagnoses as Septimus's 'serious symptom', in attributing meanings 'of a symbolical kind' to words.[61] Such a reading would see the possibility of another case and case history that is closed without being explicitly opened in the novel. In her reading of the novel, Rachel Bowlby sees Peter Walsh as a *flâneur* figure in pursuit of a 'passante',[62] which would align him with the detective according to Benjamin's model. But the new-found promiscuity of the urban street can also lead in the direction of another, diametrically opposed urban myth, that of the Ripper, the sex criminal undetected by the forces of law. Benjamin reminds us that the *flâneur* can also be viewed, on the model of Poe's *The Man of the Crowd*, as embodying criminality,[63] a sort of urban werewolf, and that his appearance incorporates a dialectical sense of being at once inconspicuous and fundamentally suspect.[64] It might not be too disproportionate – or too paranoid – a reading to see Peter Walsh as such a master of criminal disguise, a version perhaps of the cult figure Fantômas, stalking the streets of London under an outwardly respectable social guise.[65] As David Trotter has argued, the condition of paranoia is a distinctive feature of Modernism,[66] and the persecutory anxieties of Septimus Smith, the systematic violations of psychiatry, and the potential hidden violence of Peter Walsh can be seen as a symptomatic construction of that disorder in *Mrs Dalloway*.

A common feature of *Mrs Dalloway* and *Fräulein Else*, then, like 'Ein Landarzt' before them, is a release of disorder, psychical and criminal, actual and potential, which resists recuperation by the case history model. The experimental modes of narrative intimacy at once give the reader access to new possibilities for coming to know characters, yet highlight the limitations of any such knowledge in so far as it is mediated by the sanctioned models of diagnostic and detective case studies. In this way, these narratives given to modes of isolation and introspection find unlikely ways of exposing the dysfunctional workings of historical processes, not least the failure of those processes to allow an adequate incorporation of gender and sexual identity. Only the somnolent and isolated Molly seems able to achieve the conditions that allow for such an incorporation outside the 'nightmare' of history. History, through its disciplinary institutions and discourses, requires a normative performance of identity, and law and medicine are designed to correct by their performative

authority any performances that fail through perceived indiscipline. The narratives considered here enact counter-performances that highlight the violence and the limitations of the performative authority of the social order. The formal experimentation of these narratives allows for oblique rather than demonstrative versions of the sorts of critical intervention in social reality that the avant-garde demands.

In the readings that follow, this model will be extended in detail to two paradigmatic examples of the case-based narrative: Gertrude Stein's avant-garde revision of the detective story: *Blood on the Dining-Room Floor* (1933) and André Breton's Surrealist case history, *Nadja* (1928). The first, a radical rewriting of the country house murder genre, retreats from the city into an at once countrified and intensively abstract narrative space. The second, written from the writer's retreat in a country house, gives the opportunity to consider further the function of the case narrative through its extension into the urban environment. Like the other narratives considered in this chapter, they show both the instrumental potential and the limitations of more developed narrative forms for avant-garde interests. Both represent exemplary cases of the sorts of ambivalence that operate in narratives of the avant-garde.

Stein's *Blood on the Dining-Room Floor*: Background and Case

Gertrude Stein is often cited primarily for her connections, as a close friend and proponent of Picasso, in particular, and for keeping her Parisian salon for an assortment of avant-garde painters and writers. Her writing, apart from the more accessible biographical pieces, is often seen as idiosyncratic and somewhat marginal to the mainstream of Modernism. She was, however, perhaps the most rigorous of the avant-garde narrative experimenters, and she made a major contribution to the theorization of narrative form for Modernist usage. She was particularly drawn to the genre of detective fiction, which she read voraciously in its more popular forms. She saw it as a form proper to the early twentieth century, not least because it is fundamentally abstract in its focus, freed from the sort of event-based human interest that drives traditional plot models: 'the detective story which is you might say the only really modern novel form that has come in to existence gets rid of human nature by having the man dead to begin with the hero is dead to begin with and so you have so

to speak got rid of the event before the book begins.'[67] Like Brecht in his epic revision of the theatre, Stein is interested above all in the process of construction or reconstruction of things, rather than the climactic human event of traditional teleological forms. It is the analytic procedure of detection rather than the thrill of the crime as event that draws her to the detective fiction genre. The statement immediately introduces the key feature of Stein's writing, the self-referential logic in which the theory and practice of writing connect. Her 'sentence' on the detective novel is performative of what it describes. The removal of the conventional end-point of the human interest plot also involves a suspension of the sequential order of narration, whether in fictional or theoretical discourse. Time as a function of narrative is rescaled: diachrony is superseded by forms of synchrony and anachrony: the simultaneity of the conventionally non-simultaneous. Syntax as the performance of linear logic is suspended, while the two rhetorical inserts 'you might say' and 'so to speak' indicate that this type of writing is attuned to speaking. The quotation derives from the text of a lecture, but its form is transferable to Stein's writing as a whole. It is perhaps best described as a sort of 'speech act': a performance of language that is at once closely attuned to ordinary forms of speaking and yet self-consciously transforms these into an ongoing performative act.

If the detective story appeals to Stein because its hero is dead from the start, this is not to say that it frees narrative from all teleological demands. She acknowledges that the dead hero may simply be replaced by the detective as hero, a more conducive, less humanist model for her analytic concerns. And detective fiction can of course become a particularly formulaic version of the teleological model, leading, classically, from the mystery of the corpse at the beginning to the solution and resolution at the end. This formula is at once a fascination for Stein, attractive as an abstract model of analytic felicity and prompting her to experiment with its reproduction on a more sophisticated level, and also an epistemological impossibility. Her experimental writing constantly takes her away from the possibility of resolved form; the narrative is never adequately closed. As we will see, *Blood on the Dining-Room Floor*, her performance of the detective fiction model, is above all about the resistance of her material to the 'closure in disclosure' formula of the genre. And it resists that model not least because there is no detective-hero to work on the case. As she ruefully, though perhaps also disingenuously, recognized, the title is the only element of the narrative that conforms to generic requirements: 'on the whole a detective story has to have if it has not

a detective it has to have an ending and my detective story did not have any. . . . I was sorry about it because it came so near to being a detective story and it did have a good title.'[68]

Stein's interest is above all in an abstracted idea of detection as analytic process, the possibility of an intellectual agency that would work with the objective certainty of a total machine. Her philosophical training, as a student of William James, alerted her to the relativity of things, the realization that the dimensions of the phenomenal world cannot be understood in any absolute scientific sense, but are always complicated by the ambiguous imbrication of psychology in the world. The implication is a fundamental dualism of perspective: a focus on the world that is always also introspective. Stein's writing project is driven by an attempt to define a mode of psychology that would understand the make-up of the world, the order that might be detected even in the disorder of crime, and to replicate that order in the performance of narrative. Her Jamesian training dictates that the performance has to be a fluid-dynamic work of streaming rather than a machine of 'chains' and 'trains', but that the stream has to be precisely constructed for performance. Above all, the narrative stream has to be dialectically complicated by the principle of fracture and interruption, thereby to perform the experience of fragmentation that is the defining feature of modernity.

She finds a corollary for this project in the pictorial work of Cubism, as recorded in her 1938 essay *Picasso*. The Cubist aesthetic is seen as a paradigm for the representation of the fragmented structure of modernity, the twentieth century as a time 'when everything cracks, where everything is destroyed, everything isolates itself'.[69] Cubism takes this fragmentation and makes compositions of it, but compositions that resist the logic of sequence. Conventional metonymic connections, which put things into a hierarchical order in order to frame the central aesthetic focus, are replaced by a more inclusive model of representation. Rather than replicating the framed isolation of the aesthetic object, Cubism extends artistic composition to embrace the extended 'composition of living' in modernity,[70] incorporating the found objects of urban modernity into its representational space. As conventional frameworks of perception are undermined, Cubism takes the objects of its representations out of the frame: 'A picture remaining in its frame was a thing that always had existed and now pictures commenced to want to leave their frames.'[71] It challenges conventional modes of seeing by at once breaking up and multiplying temporal and spatial perspectives and forming these into a different kind of unframed compositional order.

Cubism serves as a pictorial correlative for Gertrude Stein's writerly composition in its relation to the modern 'composition of living'. She seeks to achieve an anti-hierarchical mode of writing, one that retrieves ready-made objects that are conventionally overlooked and that forgoes the conventional framing mechanisms of syntax. Composition is a key term in Stein's aesthetic lexicon, referring at once to the way in which things are found together in the world and the way in which they are placed together in the work of art. As she defines it in her lecture 'Composition as Explanation' (1926), it is above all a performative concept, attached to the principle of present action: 'Composition is the thing seen by every one living in the living they are doing, they are that composing of the composition that at the time they are living is the composition of the time in which they are living. It is that that makes living a thing they are doing.'[72] The reiteration of the present participle, in its verbal and nominal forms, is of the essence here: composition has to take the active form of happening: the living of living. Stein's favoured verbal form is the continuous present, as deployed in particular in *The Making of Americans* and in her exercises in portrait writing. Like the simple present (in such speech acts as 'I pronounce you . . .'), this tense is particularly attuned to the performative, and so apposite for the recording of processes of making. As a speech act in the performative mode, the continuous present is peculiarly self-reflexive, defined by its own action: 'A continuous present is a continuous present.'[73]

These forms of the active present indicate Stein's abiding concern for contemporaneity. Composition, as the make-up, or the continuous making up, of things in the present moment involves above all a spatialization of time as contemporary experience. In the Cubist canvas, the happening of life may be frozen in a spatial layout, but it is composed out of what is found to be happening at any given time, as represented emblematically by the fragments torn out of the newspaper of the day. By adopting a multiplicity of perspectives 'at the same time', it shows the contemporary moment to be complex and differential. The freeze-framing of time in the Cubist picture is not tantamount to a removal of temporality, for this is seen to be sustained in the assemblage of perspectives: 'even if there is no time at all in the composition there must be time in the composition which is in its quality of distribution and equilibration'.[74] This form of composition gives a new likeness of things, but always also by exposing the elements of difference that are intrinsic to them: 'if it is all so alike it must be simply different'.[75] The apparent sameness of so many Cubist pictures serves, like the apparently unremitting alikeness of

Stein's writing, to reveal the differential aspects that give definition to likeness.

Stein's compositional method is thus a dialectical one, working and reworking the relation between difference and similarity, equilibration and distribution. While it is certainly an abstract method, it is also a concrete one. The difficulty of reading her texts lies in their structural modulations rather than in arcane semantic flights. They are as simple as they are difficult. The performative principle, with its insistence upon contemporaneity, is also – albeit in abstracted form – a measure of commitment to the real of lived experience. The revision through distribution and equilibration of old ways of organizing writing is conceived as an agenda of reform with political implications. To distribute and equilibrate narrative perspective is to embrace what Stein sees as a democratic principle, to engage with the conditions of living even as you appear to be most abstracted from them. This principle makes her write with simplicity but also with an attention to equilibration that is profoundly testing for readers used to ready textual consumption.

It is also a source of trouble for the writer. In the 'Composition as Explanation' lecture, she schematizes her writing history in relation to cultural history more generally, and in particular the pivotal experience of the First World War. The early experimental writing is categorized as in the 'confused' mode of the continuous present, the writing under the shadow of the war as marked by a 'romantic' extrication from the brutality of history, and the writing of the present moment in the mode of distribution and equilibration: 'now there is either succeeding or failing there must be distribution and equilibration there must be time that is distributed and equilibrated. This is the thing that is at present most troubling'.[76] In particular, the ongoing performance of distributing and equilibrating, the attempt to keep the composition simultaneous with the present, involves a threat to its vitality as it proceeds: 'This is what is always a fear a doubt and a judgment and a conviction. The quality in the creation of expression the quality in a composition that makes it go dead just after it has been made is very troublesome.'[77] The writer attached to the idea of contemporaneity is troubled by a morbid fear of the present becoming irretrievably past. It is the constitutional, melancholic problem of the avant-gardist who detects in him- or herself the killer of the work.

In her narrative 'Subject-Cases: The Background of a Detective Story' (1923), Stein essays the analytic ground of detective fiction. It is defined as background in so far as it is both the necessary preparatory

grounding for a detective story to work, yet separate from the fore-ground actions and relations of the potential story. By looking into the background of an object case, the forensic narrator exposes a plurality of subject-cases: the range of potential associated subjects that the given case brings with it. The narrative seems to proceed by the loosest of associative schemes, moving from one word to the next by virtue of homophonic or other apparently incidental links. If its outward appearance is one of arbitrary word-play, however, the piece in fact works and reworks in a scrupulously dialectical fashion the conditions of possibility of detective fiction writing. Its opening lines introduce this principle:

> In case of this.
> A story.
> Subjects and places.
> In place of this.
> A story.
> Subjects and traces.
> In face of this.
> A story.[78]

The rhyming words – case, place, trace and face – can be understood as the keywords of an abstracted detective story, but their composition is also a de-composition. The case is not established but a conditional eventuality (in case of). The place that might be the scene of the crime is multiplied along with the subjects that meet around the crime, and it too is transferred by an idiomatic figure into a subversive double meaning (in place of). The case has become conditional, and its place one of substitution. This prepares for the move from places to traces, from an apparently secure sense of where something happens to a fragile remnant of what has occurred. This impacts, in turn, upon the face, the place in which the perceived identity of criminal or victim (subjects in the personal sense) is found, here echoing also the uncertainty of the trace. And the face is turned by a third version of the pattern of idiomatic construction into a figure of opposition, of encounter with a case that in the differential repetitions of these beguilingly simple opening statements has already been rendered impossibly difficult. Following the move from object to objection on the next page of the narrative, the subject-cases are cases where both the human subjects and the thematic subjects are in subjection to an intense epistemological scrutiny, to every kind of possible objection.

'Subject-Cases' is fraught with Steinian distributions and equi-librations, where the term just is suspended between doing justice, adjustment and (only) just being just: 'just to state and adjust it, just to state it in justice'.[79] The narrative is distributed through time and space, incorporating the need to investigate 'a history of habita-tions'.[80] And each new extension to another time or place requires a new equilibration: 'To have a history and not to deny extracts as extraordinarily and houses as seen to be scattered and in many cases not clearly separated.'[81] The place that the story should inhabit, the potential scene of its potential crime, is thus scattered across insepar-able but non-identical habitations and points of history. The recurs-ive reference to 'ante-dating' and its cognates suggests that the story can never settle in a simple present, but always has to be bound to previous times. And it is also always inhabited by another, com-pounded place, a confederated state: 'Is it to a confederate state that it is antedated. To confederate to state that it is antedated. Too confederate to state that it is antedated.'[82] State here is a form of grammatical and philosophical interstate, at once verbal and nominal, the act of speech and the legally bounded place.

The account constantly reverts to the parlor as its special scene, but with the suggestion that this is the place for speaking a prepar-atory discourse for telling the story ('so much for the use of the parlor')[83] rather than the actual scene of the putative crime. As the scene is protracted outwards to other habitations, so it is also intensi-fied inwards, creating an effect of *mise-en-abyme*, of parlors upon and within parlors. The parlor as place of domestic conversation becomes a place of lack of knowledge, where 'none' and 'known' are made to sound homonymic: 'Parlors are none none are in parlors, parlors are known and unknown and peculiar.'[84] The parlor is a site of the uncanny, a place for the enactment of strange cases, where familiarity and unfamiliarity are peculiarly confused. And within the (un)known internal space of the parlor ('parlors are private'[85]), there is also the cryptic, doubly private and doubly uncanny place of the closet. As the parlor is a private or disconnected place that is supposed to be used for 'connectedly speaking',[86] the closet and the act of closeting are dialectically divided between connection and dis-connection: 'not as if to be closeted, closeted connects again. Closet to connect again and to closet or a closet.'[87]

The closet as the classic space of hidden crime or transgression can be viewed as emblematic of Stein's project of preparing for a piece of detective fiction. It is at once a project of opening up the background spaces that are conventionally left closed by the genre, yet one that

recurrently encounters blocks or foreclosures in its investigation. To get close to the distribution and equilibration of the just spatio-temporal preparation for the story is also to get 'closed inclosed, closed in';[88] there is a slippage between closure, both in its positive and negative senses, and approximation, 'to close and to be close'.[89] The narrative gets close to closing the preparatory work necessary to open the case, but its possession of the facts, imperative for opening the crime narrative proper, could only be guaranteed by its constant re-performance. The narrator has to have the matter in hand and say it again and again: 'Have to have and to be considered to have. This is the best yet and matters in hand and the matter in hand and to the matter in hand is to be added intensity and reiteration. Reiteration is said to have been said for them. Parlors and parlors.'[90] And at the end of this reiterative performance of the background to the case, there can only be an approximate closure, a concessive termination that leaves the subject-cases only close to being closed:

> And more as soon.
> Or in as wanted.
> Can it be or ordered ahead.
> Not fairly sorry not so much nearly as that.
> For nearly as that.
> That is the end of it.[91]

The closet as the emblematic innermost space in the narrative has a particular resonance for a writer like Stein, living in an open secret of a lesbian relationship with her long-term companion Alice B. Toklas. Following Eve Kosofsky Sedgwick, the closet is inhabited by a particular epistemology; it is a structure at once of hiding and of showing, of unknowing and of certain forms of knowledge.[92] If lesbian detective fiction has become a cult genre, it is doubtless in part due to the fact that it allows for a transgendered performance of a stock male agency, but also because it plays with the teasing exposure of closeted knowledge. In Stein's narratives, such personal knowledge is largely kept out of the subject-case. The line 'Linger longer Lucy' might seem to register a desire for the sustained presence of a female object in 'Subject-Cases',[93] but like the other personal identities that are registered in the course of the narrative, she does not linger. When the narrative proposes 'to say it with flowers',[94] there is no sense of the flow of passion that informs the flower language of *Ulysses*, *The Waves* or *Mrs Dalloway*. If there is a possibility of investigating passion behind the crime in this case, then it remains well concealed.

As the frontispiece for the mock autobiography that Stein writes in her lover's name (*The Autobiography of Alice B. Toklas* (1933)), stands a photograph by Man Ray of Stein the writer at her desk, with Alice B. Toklas attendant in the doorway of the study.[95] As the autobiography is really that of Stein rather than Toklas, so the photograph of 'Alice B. Toklas at the door' is in the first instance that of the writer in the act of writing in the foreground. And yet the figure at the door, balanced in a liminal position before or behind the scene of writing is also illuminated for viewing; following the favourite technique of Stein's writing, the background of the composition is foregrounded. With its careful chiaroscuro lighting and the attention to Alice B. Toklas's old-fashioned bibbed dress, it is a nice photographic pastiche of an old master domestic genre picture. It resonates, in particular, with the pictorial logic of Vermeer, in such pictures as *Lady Writing a Letter with her Maid* (1670), implying at once a hierarchical relationship between the writing figure and the attendant and one of potential complicity in undercover erotic scenarios. Getrude Stein is writing herself through the narrative voice of her lover, at once using her as a vehicle and revealing their intimacy as the secret of the writing. The photograph opens up the writer's closet for viewing, and while the bodily erotics of the relationship remain under cover, the epistemological meaning of this closeted intimacy as the background knowledge to Stein's writing is there for all to see.

While the abstraction of Stein's writing project is grounded in the concrete world of objects, this rarely takes the form of the body in its erotic potential. The prose poem 'Lifting Belly' (1917), where the compositional development highlights the physical poetry of the erotic appetite, movement and showing of the female body ('Lifting belly seeks pleasure. And she finds it altogether.'),[96] achieving a playful linguistic performance of feminine sexuality, is striking by its difference from most of the other work. By contrast with Joyce's uninhibited exhibition of the female form in particular, and the bodily in general, Stein's writing remains largely bodiless. And this issue extends to the role of corporeality in crime writing, where the presence or absence of the body is all-important for the workings of the genre. When Stein returns to detective fiction ten years after 'Subject-Cases', to reopen the case of crime writing and to reiterate its difficulties, the absence of the body as *corpus delictus* is one of the key ways in which the generic conventions are strategically rewritten. Notwithstanding its promising title, *Blood on the Dining-Room Floor*, which might be considered to be the founding text of the lesbian crime fiction genre, is a murder mystery that is lacking a body in the proper sense.

In its classic form, the murder mystery is perhaps the model form of metonymic narrative. It relies on the sort of association by contiguity that is the stuff of metonymy, and the body is the genetic core of the metonymic system. The act of murder is reconstructed by following clues that are left on or around the body by another body or other bodies. The detective works to put the clues in their proper, metonymically organized order, and thereby to complete a recognizable picture of the crime, of whodunit and how. However, the clued and closed plotting model that makes a recognizable 'body' of the narrative for the reader is always susceptible to disordering when the detective is not willing to stop the metonymic lines of enquiry at the 'appropriate' point. David Lodge sees Stein's prose as gravitating between extreme forms of the metonymic and the metaphorical modes of Modernist writing,[97] and in *Blood on the Dining-Room Floor* she certainly hyperbolizes the metonymic regime of the detective story. In Stein's deconstructive version of the genre, detection goes too far; the hyper-metonymic logic disrupts the instrumental treatment of crime for readerly consumption.

Blood on the Dining-Room Floor was written in the aftermath of the immensely successful publication of the *Autobiography of Alice B. Toklas*. In the wake of a success that seemed too easy, Stein was suffering from writer's block, and she chose her favourite generic format of the detective story as a way of releasing herself from the blocking. The mysterious events of 1933 in and around the country house in Bilignin that Stein and Toklas shared provided the material for the narrative. Cars and a telephone were apparently tampered with at the house, and two women died in separate, mysterious incidents in the vicinity. The blood on the dining-room floor in the title imitates a classic form of the genre – suggesting a physical clue to domestic violence – but it is never encountered as such in the narrative itself. It may be the blood of the second of the two women, who was found with two shotgun wounds, but this is the body that the narrative fails to show. While there is obsessive interest in the death of the hotel-keeper's wife, who was found with terminal injuries in the courtyard of the hotel, having supposedly fallen from the window, the second body, and the crime that might be associated with it, has only a shadowy presence. The title thus strategically misdirects the text, laying a clue that will not be taken up. If the text seems to ask to be read as a *roman à clef*, it also resists that sort of recuperative treatment.

Whereas Benjamin correlates the detective with the *flâneur*, trained to see the incidental clue in the urban scene, to detect the criminal

personality concealed in the impersonality of the crowd, the other stock scene of the detective fiction genre is of course the country house. As in Conan-Doyle's *Hound of the Baskervilles*, the urban master-detective takes his skills in criminological and anthropological surveillance to the country and its more isolated communities, but the reduction of the crowd of possible suspects does not necessarily render the task of detection easier. The rural community, where there is an assumed total local knowledge of social roles and relations, can also conceal the unknowable: the country house dining-room is as likely to incorporate closets as the urban parlor. Inhabitants like Stein and Toklas, visiting from the city, are in the position of amateur detectives when it comes to understanding what goes on in the country. When the community is disrupted by a sequence of mystery 'crimes', personal knowledge of identities and relations, rather than the impersonal acuity of the *flâneur*, seems to be the prerequisite for the detection of the truth behind them, but such knowledge is blocked by the anonymity that in fact resides in the community. Not for nothing does one character in the novel leave the city for the country because 'she had an absolute need for a private life'.[98] As Kafka's country doctor fails in his perception of the pathology in the estranged community that he treats, so here the detective *faute de mieux* that is the city-dweller transposed to the country, seems bound to fail to define the terms and detect the truth of her subject-case or -cases.

Just as the 'Subject-Cases' narrative establishes a signature of slippage between case, place and face, so *Blood on the Dining-Room Floor* does the same with try, cry and die. There is the idea of possible suicide as trying to die in a way that is deemed 'not right to try',[99] and the crying around this act, as well as the writer's trying to write about this dying and being reduced to crying. As she records in the essay 'Why I like Detective Stories' (1937), 'I tried to write one well not exactly write one because to try is to cry but I did try to write one.'[100] The death of the hotel-keeper's wife five days after her 'fall' indicates a trying to die that is a failure even if it succeeds in the end, and the text's trial of the detective story is haunted by the same sort of traumatic failure in the act. Trying also resonates with the attempt at making a judgement upon the case that is a constant concern of the text. It is thus a specific version of the performative act of pronouncement. It places the text in a continuous present of its own performance, as indicated by the interjection 'Read while I write'.[101]

The opening of the text establishes the performative mode by defining the scene with precise pronouncements: 'A house in the country is not the same as a country house', and then going on in the

description of the servants to enact a version of the classic performative of pronouncing a couple married: 'a man and a woman that is to say husband and wife'.[102] The definitive judgements of the opening statement provide a template for trying and adjudging throughout the narrative, but the initial scheme is set to be subverted. The couple become part of a series of servants substituted for other servants, and the social imprimatur of 'husband and wife' is, as it were, queered by the ensuing description: 'They had a queer way of walking.'[103] If the wife in the next pair of servants also has a queer way of walking, this suggests that all is not right in the series of backgrounds provided for the case. The implication is that the case will be a serial one, that each element in the series will be different but also have queer similarities, that trying immediately becomes an impossible trial for the writer of crime fiction. Much of the ensuing narrative is an impossibly complex accounting of the family histories associated with the mysterious events of the case: the married couple with a queer way of walking becomes extrapolated into complicated genealogical structures, made up of individuals, named or unnamed, remaining blank or given queer features. The hotel-keeper's wife, in particular, has a queer way of walking in the sense that she is said to be a sleep-walker, an assumption that may or may not account for her death.

The descriptions of the servants in the opening pages, where the impersonal sequence of substitution is complemented by isolated, queer intimacies of detail that may or may not be germane to the investigation, provide a model for what might be called the 'extimacy', the paradoxically intimate anonymity, of this crime narrative. The double character of personal impersonality that characterizes the *flâneur*-detective is thus transposed to the scene of the country house mystery as described from outside and inside by the second-home owner as outsider inside the community. If we take Stein, the writer and owner of the country house, to be the personal identity behind the detective-narrator of the text, then she as the writing agent is cast in the most impersonal terms: 'The next morning on coming to the desk to write a letter it was noticed that. . . .'[104] The identities and relationships of the victims, potential perpetrators and investigators of the crimes are all kept in this extimate mode. In particular, in this narrative so preoccupied with questions of marriage, forms of relationship without social sanction, 'queer' relationships, are blanked out. Not only are Stein and Toklas impersonalized, as 'they' or 'some one' or 'some one else', but the second death of the summer, which haunts the text as a story that cannot be told, indicates that

unconventional identities and life-styles have to be protected. The death of Mme Pernollet, the model for the hotel-keeper's wife, becomes the basis for the protracted genealogical investigation of the family structures around her, whereas the death of Mme Caesar, a friend of Stein's, dying or killed in the context of apparent jealousies between women living together, is written out of the plot. The sporadic appeals by name to female listeners or readers (Lizzie and Edith) to listen or understand or give answers in the course of the narrative only serve to point up the extimate character of the treatment of relations between women in the recounting of the subject-cases.

If the cases to be investigated involve relationships that are not 'felicitous' performances of the conventional models of gender and sexuality, this, in its turn, implies a lack of felicity in the writerly performance of the detective novel genre. Stein's detective story conceals the body that queers the norms of the community whilst returning again and again to one that appears to be securely meshed in normative relationships. The over-elaborate performance of the relationships around the corpse of Mme Pernollet and the closeting off of those around that of Mme Caesar both highlight, in their different ways, the impossible character – ethically and epistemologically – of what the text is trying to do in treating real events in the author's life in the detective fiction format. The failure of the law to deal with the real events is matched by Stein's inability to achieve a felicitous performance of the rules of the genre. The narrative shows no evidence of the forensic agencies that might shed light on the case (a mechanic substitutes for the police, the son who wants to become a lawyer is prevented from this by his mother's death, and a doctor is said to have been responsible for the death of the aunt of one of the characters).[105] Within this context, the amateur detective-narrator is caught in a predicament like that of Kafka's country doctor. Stein's writerly trying that becomes crying also becomes displaced from its case and ends in an anxious questioning of understanding ('Do you understand anything'[106]). In the cases of both Kafka and Stein, the confused and potentially criminal relationships between the owners of the respective houses and their servants at the start of the narrative come back to haunt the investigation of the case proper. The false security of the opening of *Blood on the Dining-Room Floor* echoes at its end:

> Thank you for anxiously.
> No one is amiss after servants are changed.
> Are they.[107]

The possibility of being amiss remains the anxiety of the text in its closing question without a question mark. It is the question that hangs over the performance of this detective story with its missing body, and in its formulation it inevitably opens up a second level of meaning, another kind of anxiety closeted within the first, in classic Steinian fashion. Gertrude Stein is a miss and amiss after servants are changed, a misfit in her adopted community, and bound to miss the truth of its crimes. She is a miss living with another miss, in a patriarchal social order that pronounces such arrangements queer. She is thus amiss as a miss in a different way to the suicidal Fräulein Else, but both of them are identified as disordered in relation to the performative demands of their social titles. Equally, they share a condition of being amiss with women, real and fictional, who appear to have conformed to those demands but who are in fact, at least potentially, suicidal misfits: Woolf's Mrs Dalloway or Stein's Mme Pernollet and Mme Caesar.

Stein is also amiss in a further sense: an uncomfortable fit in the ostensibly anti-patriarchal but often all-too patriarchal order of the avant-garde, where it is easier for a woman to provide a stage for male talent than to perform her own. Miss Stein is also amiss in the class politics of the avant-garde. As with many of her male counterparts, her background and life-style are deeply bourgeois, sitting uncomfortably with the practical political demands of avant-garde ideology. In *Blood on the Dining-Room Floor* she turns to the anachronistic, feudal structure of the country house crime novel (presumably ex-servants at least are amiss when servants are changed). She reworks the genre in deconstructive fashion, but thereby produces a style of text that, notwithstanding her project for democratizing literary language, seems reserved for the appreciation of an elite readership, for bourgeois collectors only. The recurrent references in the text to poverty and to the war are never developed into political analysis or activation. Judged by the imperative of artistic interventionism, Stein is at once not avant-garde enough in a practical political sense and too avant-garde in a formal sense: in short, amiss in the avant-garde.

Who Am I? The Strange Case of Breton's *Nadja*

In Stein's writing, narrative detection tends to skirt around the possibility of psychopathology: in *Blood on the Dining-Room Floor* sleep-walking, uncanny dreams and the time when 'the servants went mad'[108] are registered amongst the other features surrounding the

core mysteries without being deemed worthy in themselves of special investigation. Breton's *Nadja*, on the other hand, the final text to be considered here, combines aspects of the psychopathological case history with the detective story, providing deeply ambivalent and intermeshed versions of both models. At the same time, Stein's, albeit ironic, instrumentalization of Alice B. Toklas's autobiography for the purposes of writing her own life is repeated by Breton in his appropriation of the story of the eponymous Nadja for his own purposes. The question 'Who am I?', which opens the narrative, wants at first sight to be read in the voice of the title-figure, but it is soon clear that it is the author-narrator speaking, and that Nadja is a vessel for his discourse of self-exhibition and self-exploration. As much as *Le Paysan de Paris*, as described by Aragon, *Nadja* is 'the novel of what I was at that time'.[109]

What, then, does Breton make of the genre that he describes in the first Surrealist manifesto as 'inferior' and in need of fertilization by the marvellous?[110] *Nadja* is a curiously hybrid text. Like *Blood on the Dining-Room Floor*, it is to some extent a *roman à clef*,[111] though one that appears to be open with the historical identities and locations of its story. It is part personal memoir, part case history. Written between the two Surrealist manifestos, it turns the programmatic zeal of those texts into a more retrogressive and potentially melancholy mode, that of the confessional memoir. Nadja is constructed allegorically as the spirit of Surrealism, but one that is struck with the transience of the allegorical method, already lost at the time of writing, and replaced by what Navarri calls the 'anti-Nadja' to whom the last pages of the text are dedicated.[112] Encountered as a 'passante' by Breton the latter-day *flâneur*,[113] and so the human figuration of the cult of the passage as established by Aragon, Nadja encompasses the ambivalent range of the different versions of the verb *passer* that recur throughout the text. She is a passing figure, a figure of happening, and an elusive one, ultimately bound to be forfeited.[114] As the embodiment of Surrealism's cult of chance and deregulation, she follows a course that the practising director of the movement is unable to follow. It is telling that she leaves the first manifesto, which Breton lends her, unread: the theory of the movement appears to have no purchase on the living performance of its ultimate practitioner. Whether voluntarily or involuntarily, this text recounts the history of Surrealism as case history, revealing its delusions and symptomatic lapses.

As we saw in the first chapter, Surrealism is fundamentally constructed as an exhibitionistic fantasy. Both Freud and Benjamin make

this diagnosis of the Surrealist project, though in different ways. When Breton accuses Freud of not pursuing the analysis of his own dreams in the way that he does those of his patients, Freud suggests that he is seeking to avoid the exhibitionistic exposure of his relationship to his dead father, in implicit contrast to the uninhibited exhibitionism of Breton and his group.[115] Benjamin describes Breton's programme in *Nadja*, to write a book with its door wide open and represent himself as if in a 'house of glass', as a positive kind of 'moral exhibitionism', the prerequisite for a truly revolutionary text replete with the kind of 'profane illuminations' that Benjamin values in Surrealism.[116] What these two different forms of diagnosis have in common, however, is a fundamental sense of uncanniness. While Freud registers a reluctance to expose the uncanny character of his relationship to his father, Benjamin compares Breton's idea of the text with a wide-open door with his 'uncanny' experience of staying in a hotel where the delegates for a Buddhist convention did not shut their doors.[117] Breton's critique of Freud might in fact be uncannily turned back upon his own practice and the unacknowledged revelations that his ostensibly open and transparent text makes. When Benjamin tempers his praise of *Nadja* by registering symptomatic lapses ('Ausfallserscheinungen') in the narrative,[118] it is arguably its uncanny lack of knowledge of its own repressions that he recognizes. Benjamin's example shows the text's inclination to veer from political considerations to parapsychological ones, in the apparently unwitting repetition of the name 'Sacco', but the lapsing extends to other areas.

It is fitting that Breton introduces the text with the uncanny idea of a phantom identity, haunted and haunting.[119] This self-styling as phantom might lead us to align Breton, like that other *flâneur*-cum-stalker figure, Woolf's Peter Walsh, with the masked figure of the master criminal Fantômas. By recounting a narrative that leads from the transgressive freedom to the psychiatric sequestration of its title-figure, *Nadja* follows the form of both criminal and psychopathological case. Nadja thus takes a prime position in the gallery of criminal and/or deranged women – from the parricide Violette Nozières to the Papin sisters, who murdered their employers, and the anarchist assassin Germaine Berton – whose transgressions attract the at once political and erotic fascination of the Surrealists. Nadja is pursued both by the law and by psychiatric medicine. The role of Breton as narrator of the dual-focus case is compromised. He is at once complicit with the transgressor, forced to ask himself whether he was responsible for her madness, and aligned with the role of detective-psychiatrist in relation to her, in pursuit of and seeking to control her mystery, and

thus also implicated as an accessory to the 'crime' of her internment. Peter Nicholls argues that *Nadja* can be read as 'a sort of parody of the detective thriller in which an excess of "clues" leaves the central mystery intact';[120] but some of the clues, at least, uncannily implicate the detective-narrator in the crime.

The idea of psychopathological crime is staged in the narrative's description of the production of the play *Les Détraquées* ('Disordered Women'). Not only does Breton fail, apparently because of a 'lack of adequate clues',[121] to comprehend the mystery behind the staged crime, but, as Susan Suleiman has shown, the account of the play is marked by massive disavowal. While the central figure, the lesbian murderess Solange, who so fascinates Breton, was in fact subject to the full forensic force of psychiatry and the law in the play's dénouement, he prefers to fantasize the possibility that she might have escaped diagnosis and detection, subject only to the limited judgement of a country doctor. On the one hand, this is a product of his voyeuristic fixation; as Suleiman describes it, what 'Breton sees, in his recounting, and what excites and mesmerizes him, is the spectacle of female "otherness": madness, murderousness, lesbianism'.[122] What it also represents is an exorbitant example of the narrator's selective blindness to himself, his inability to provide a satisfactory answer to the question 'Who am I?' that opens the narrative. When Solange's crime is discovered, it is in the Grand Guignol form of a spectacular opening of the closet, as the concealed body of her young victim is exposed to view. Breton's fantasy, however, wants at once to have the spectacle of the open closet and to disavow it, to act as though the rapacious lesbian might in fact have been interested in performing for his eyes only.

As he recognizes, though without pursuing this in his analysis, the dream he has following the recounting of *Les Détraquées*, or of his viewing of it, is informed by the experience of the play. As he only tells part of the story of the play, so his exhibitionism encounters its limits when it comes to recounting the 'infamous' dream. Breton would criticize Freud for not telling the whole story with his dreams and their analysis, but here he does the same. What he does describe is the final sequence of the dream: an insect, which has taken the place of an old man, slips one coin instead of two into a slot machine; outraged at this act of fraud, he hits the insect with his cane; it falls on his head and, with two of its velvety paws down his throat, he almost suffocates and feels the utmost disgust. Breton recognizes that a dream such as this must be, in Freud's sense, overdetermined in its meanings, but the work of the detective-analyst

in exposing those meanings is neglected. For the analysis of the slot-machine, we have to have recourse to *Les Vases communicants* ('Communicating Vases' (1933)), where Breton is less coy in the Freudian analysis of his dreams: 'I am unable to conceal from myself the fact that [. . .] slot machines [. . .] symbolize sexually – the disappearance of the tokens into the slot – and metonymically – the part for the whole – woman.'[123] That is, the slot-machine incident performs, in an abject shape, the genital penetration that Solange seems to offer Breton as viewer. That she is described by him as proceeding across the stage 'like an automaton',[124] prepares for her appropriation as a bachelor-machine,[125] but the construction is undermined by the facts of the case. The fantasy is marked by fraud – readable as a failure of sexual performance adequate to the needs or interests of the co-opted object. At the same time, the outraged intervention in the dream exposes the outrageous failure of Breton to perceive his own fraudulence in the reception and description of the play. Thus the punishment rebounds upon him: the super-ego figure is counter-attacked, penetrated in his turn, by the monstrous id, and 'inexpressible' self-disgust is the result. Breton's self-exhibition in his response to the extravagant exhibitionism of *Les Détraquées* is blocked by a severe case of self-closeting.

The discussion in the second chapter of Surrealist paintings and exhibition practices showed that the movement's performance cult of exhibitionism was based upon a contradictory agency. Not for nothing does the circle of Surrealists in its 'Recherches sur la sexualité' produce such ambivalent views on the question of exhibitionism. Images like *Le Viol* at once make phallic objects of the female form exhibited by and for the male gaze, yet invest the object with an uncanny gaze of its own. Surrealist exhibitionism provides an exemplary case of the performative in Judith Butler's sense. Its performance is governed by patriarchal rules of enactment, subjecting the female object to acts of male fantasy, but it also creates a certain space for the subversive resignification of the acts in question. The female object, as performed by the male artist, can slip into the function of the subject of Surrealist experience and a performance of her own. This applies in particular to the visionary faculty that is prized above all by Surrealism. The male gaze is recurrently challenged in its attempts to appropriate the viewpoint of female visionaries and clairvoyants. As the generically male viewer of *Le Viol* sees breasts in place of eyes and the genital in place of the mouth, so the visions that this oracular sphinx-like figure might speak for him are blocked by more voyeuristic pleasures. Similarly, when the Surrealists adopt the

figure of Gradiva from Jensen's story, as analysed and popularized by Freud, what they see is not her perspicuous eye or wise mouth but her sex or the fetishistic representation of it. In André Masson's *Métamorphose de Gradiva* ('Metamorphosis of Gradiva' (1939)), a characteristic example of Surrealism's Freudian workings of Classical metamorphoses in the style of Ovid, the sleeping figure's eyes and mouth are closed or effaced, and her distorted vagina gapes mouth-like in the centre of the canvas. She is at once opened up for male exploration and poses the ultimate, most uncanny threat to it with her vagina dentata. Breton's own pursuit of the figure follows a more indirect, fetishistic logic, in line with his view in the 'Recherches sur la sexualité' that 'semi-exhibitionism' can be attractive.[126] Both in the essay 'Gradiva' and in the motto for *Les Vases communicants*, he focuses on a particularly suggestive movement of this adopted figure of Surrealist revelation, the lifting of her robe. As the motto reveals, Gradiva is appropriated as a 'passante', giving sexual promise to the dreaming man on the street as, enveloped in his gaze, she lifted the hem of her robe and 'passed to the other side of the street'.[127] Not for nothing does Gradiva give her name to one of the key Surrealist sites of exhibition, the 'Galerie Gradiva' in Paris, as a representative of the female objects that the men of Surrealism use as a basis for their exhibitionism.[128] She elicits the sort of exhibitionist attention that, as we saw earlier, Breton prescribes for men seeking to have themselves noticed by a woman on the street: the text of *Les Vases communicants*, with its revelations of Breton's dream-life, performs that act of counter-exhibition. While Masson is transfixed by the total, gynaecological exposure of Gradiva's eroticism, Breton is fixated upon the promissory foot. In either case, Gradiva, the embodiment of feminine agency and erotic power, as metamorphosed for Surrealist usage, reveals only the limitations of the objectifying desires of the male viewer.

In Gradiva the Surrealists adopt a figure from a case history who acts as proto-analyst of the male protagonist's dreams and delusion; but if their appropriation of her serves to expose their own delusions, this seems to remain on an involuntary level. Gradiva is not allowed to become the counter-force she might have been to the Surrealist fantasies around the psychopathologized woman. In particular, by turning her exposure of male delusion into an exposure of herself as sexual object to their view, they as it were make a hysterical conversion of her, turning her into their preferred fantasy object: the female hysteric. As Susan Suleiman has argued, the scenario of the hystericized female body, displayed for the scientific and voyeuristic interest of a

group of men, is a dominant structure in Surrealist fantasy life, and the *Iconographie de la Salpêtrière* a subtext for the textual and iconographic organization of *Nadja*: 'The madwoman observed, theatricalized, photographed, eroticized – this was clearly the aspect of Charcot's legacy to which Breton most deeply responded.'[129] In the celebration by Breton and Aragon of the 'fiftieth anniversary' of hysteria, published in the same number of *La Révolution surréaliste* as an excerpt from *Nadja* and featuring images of the 'attitudes passionnelles' of their favourite patient of Charcot's, hysteria is figured as a suggestive condition of 'reciprocal seduction' between patient and doctor.[130] Much like Fräulein Else's cousin Paul, and perhaps, indirectly, the doctor-author Schnitzler, Breton, the psychiatrically trained writer, is implicated in a fantasy of fascination with the hysterical exhibitionist under the cover of medical licence, wanting, as Suleiman puts it, 'to "play doctor" with the madwoman',[131] much as he plays detective.

This logic of exhibitionism can certainly be seen to be at work in *Nadja*, not only in the 'passante' who gives her name to the text, but also in the other female figures that pass through or are passed by it. First there are the women who prepare for the entrance of Nadja. There is the woman passing along the side galleries of the 'Électric-Palace' who, in the style of Fräulein Else, is described as being naked apart from a coat.[132] There is Solange, who lifts her skirt to reveal 'a marvelous thigh, there, just above the dark garter'.[133] And, following the loss of Nadja from the text, there is a return to this object of exhibition in the description of the wax model from the Musée Grevin. The 'adorable lure' of 'this woman pretending to hide in the shadows in order to attach her garter' seems to be designed to provide a fetishistic substitute for the text's lost object.[134] It confirms Breton's pronouncement in the 'Recherches sur la sexualité' that he has a fetishistic conception of love.[135] While the narrative turns from this sexual exposure to the eyes of the dummy, it does so only in order to register how extraordinary it is that a statue should have the eyes of provocation. That is, the model is given eyes only in order to provoke the male viewer: they serve to relay the gaze back to the promise revealed beneath the skirt. The photograph added to the version of the text revised by Breton in 1962, indicates that the viewer's gaze remains fixed on the naked flesh above the garter, which is nicely framed by the gloved hands of the figure (hands and gloves having attained a fetishistic investment in the course of the text).[136] This displacement of viewing also leads into a displaced re-entry of Nadja into the text, in the form of a footnote that appears to have nothing

to do with the statue and its provocation. The footnote describes a car journey with Nadja, and her attempt at 'total subversion', as she presses Breton's foot on the accelerator and tries to cover his eyes.[137] It seems that the pleasure derived from the exhibitionistic model, revealing the leg beneath the line of the skirt, provokes only a half-hidden recognition beneath the level of the text proper of the narrator's inability to succumb to Nadja's provocative subversion, his refusal to be blinded to normality in order to see things as she sees them.

The text is constantly preoccupied with activities of viewing, and with the failure of the narrator to see things according to Nadja's privileged but deeply dangerous point of view. The discussion of effects of *trompe-l'oeil* and anamorphism indicates that things can, indeed should, be seen simultaneously from different perspectives, but there is also a resistance to this bifocal view at work in the text. In her role as clairvoyant, Nadja sees above all that Breton cannot see as she can: 'You will never be able to see this star as I saw it.'[138] This also has implications for the style of the text, for its incorporation of alternative voices and, in particular, the possibility of speaking as Nadja speaks. If Breton seeks to adopt the style of medical, specifically of neuro-psychiatric, discourse,[139] then this not only removes the text from the descriptive language of the Realist novel, which he reviles, but also from any possibility, or danger, of it becoming a stream-of-consciousness. While Molly's stream-of-consciousness, albeit in the service of a male fantasy of female sexual exhibitionism, is given the role of the consummating voice of *Ulysses*, the stream of consciousness that would have been Nadja's own narrative is never allowed to flow in Breton's textual treatment of her. Her 'soliloquy' is characterized as 'untranslatable',[140] for which we have to read 'untranslatable into the chosen terms of the text'. To see as Nadja sees would also be to speak or write as she does, and this presents the same sort of mortal danger to the text as does Nadja's attempted interference with Breton's driving skills. Breton the driver is also the pilot at the helm of a vessel,[141] and Nadja, as a key figure in Surrealism's 'modern mythology', also embodies a more traditional mythology of the feminine: the waters that have to be traversed and that threaten the navigator with their allure. Nadja presents and represents herself as a water-spirit, as a siren or fountain, identified above all with the mythical figure of Melusine, the archetypal figure of lethally seductive feminine fluidity. If Nadja is constructed as the text's hysterical analysand, her case history is that of a Fish- or Water-woman.

The resistance of the text to her seduction is perhaps best illus-
trated by its description of the encounter of Breton and Nadja with
one of her self-figurations, the fountain. For Nadja, in one of the
more extended citations of her voice in the text, the circulating flux
of the fountain, rising and falling, breaking and rejoining, repres-
ents the confluence of her consciousness with his. But the narrator
channels the visionary originality of her stream-of-consciousness image
into a more measured, received form, suggesting that it derives from
a scene in Berkeley's *Dialogues between Hylas and Philonous*. The
transmission of her image into the patriarchal discourse of Classicism
is supported by two images inserted into the text: the first, one of the
many photographs that are designed to save the narrative from the
descriptive business of mimesis, and the second, an allegorical image
in Baroque style from the French edition of Berkeley's text. The
photograph (see plate 10) shows the fountain in question, and carries
the caption: 'We are before a fountain, whose curve she appears to be
following',[142] following the flow, that is, visually, linguistically and
almost physically, rather than the constraint that Breton puts upon
her to follow him.[143] The curve that Nadja follows here, as repres-
ented in the frozen arching stream of water in the photograph, can
be viewed as a counterpart to Charcot's photographic iconography
of the hysteric, in the archetypal 'attitude passionelle' of the arch. She
follows this flowing shape, but Breton is unwilling to be hystericized
into following her in his turn. His interest is rather in the fixing of the
image for the gaze.

The photograph points up the inadequacy of the photographic
prostheses to their function: not only does the fountain have an
adequate description in the excerpt from Nadja's 'soliloquy', but its
photographic record seems designed to expose its own failings.
The photographs, taken after the event and ostensibly adopting the
angle from which Breton had viewed their subjects,[144] tend to have a
deadening effect on the narrative flow, arguably because they fail
even to attempt to incorporate the perspective of the other. Benjamin
is clearly inclined to see them as functioning in line with his anti-
auratic theory of the photographic medium, suggesting that they are
at once banal images, as if taken from a piece of pulp fiction, and yet
able to captivate the viewer as they turn the Parisian architectures
upon the action of the text with 'the most original intensity'.[145]
Whether this second element in fact operates in the photographs and
dialectically complicates their banality is questionable. This, in turn,
questions Benjamin's assertion that the images of things past or
passing in the text carry with them a potential for conversion into

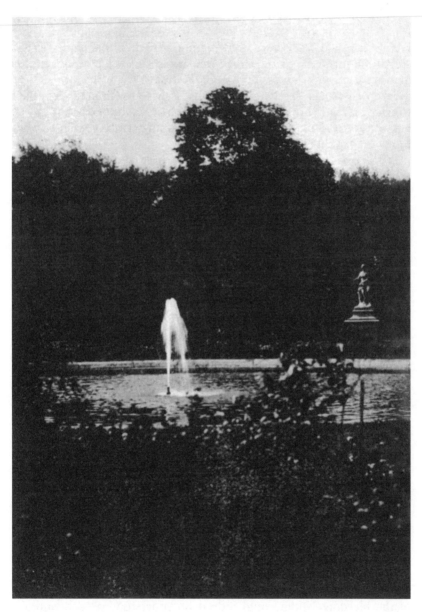

Plate 10 The fountain in the Tuileries gardens. André Breton, *Nadja* (1928).

'revolutionary experience, if not action'.[146] They seem, on the contrary, designed to freeze any idea of historical changeability. There seems to be no trace here of Benjamin's spark of coincidence that singes the image,[147] of the shock that he sees as the prerequisite for new forms of viewing in the Age of Technical Reproducibility,[148] or indeed of Barthes' arresting 'punctum'.[149] It seems more appropriate to view them, with Rosalind Krauss, as 'absolutely banal',[150] as entirely given to the more generalized, framing effect of what Barthes terms the 'studium'.

In the photograph under consideration here, the fountain appears at a distance and as iconographically related to a sculptural figure of a woman, gesturing towards it from behind the pool. The absorption into the object, which is the basis of Nadja's image making, is lost. The dynamics of the fountain are arbitrarily fixed by the image, and Nadja is replaced by a frozen, Classical figure that only emphasizes the evacuation of human presence. The photograph previews the substitution that Breton is about to make, fixing the flow of Nadja's soliloquy into the Classical image of a dialogue that is put under the control of the male speaker. On the emblematic picture reproduced from Berkeley's text, it is the male figure who gestures towards the fountain and figures it, following the Latin caption that Breton has quoted to Nadja, as the flow of Idealist discourse. She, meanwhile, is no longer listening.[151]

This section of the narrative, in its manipulation of text and emblematic imagery, may be viewed as emblematic of the *Nadja* project as a whole. The vision and voice of the eponymous character are displaced from their place of origin by the secondary revisions and re-voicings of the male narrator. While Benjamin suggests that Breton writes in the tradition of the esoteric love narrative, where the lover-narrator is closer to the things associated with his lady than to herself (the 'most inessential' element of such narratives),[152] this segment shows that the metonymic association with the things around her is in fact at a double remove, always relayed into things around himself. This shows the narrative's processes of resistance to contamination (Suleiman) or absorption (Adamowicz) by the voice of the other.[153] Suleiman argues that Breton's fear of contamination is focused, in particular, on female blood, and it seems that his abjection of the bleeding Nadja could indeed be understood as concomitant with the staunching and eventual exclusion of her flow from the text. As we saw in the discussion of the city poetry, menstruation takes on a focal symbolic function in the negotiation of the hitherto repressed by avant-garde writing: the free flow of Molly, the more oblique

references to Fräulein Else's period, the poeticized internal flow of Woolf's Rhoda, the spectacle of the genital wound in Kafka's 'Ein Landarzt', the blood of the unidentified female victim on Stein's dining-room floor, and the twin scenarios in *Nadja* of the bloodied corpse of the young girl in the closet of *Les Détraquées* and of Nadja bleeding on to her male assailant, show the range of forms that that symbolic function can take. The performances of flowing and stopping that go on in and around these texts between men and women, women and women, men and men, give a measure of the potential and the limitations of the avant-garde in its psycho- and socio-sexual forms.

In the case of Nadja, feminine flow is at once put on show for, and held away from, the narrator and the implied homosocial readership of the Surrealist text. In spite of his declared desire to infuse more 'adequacy' and 'fluidity' into the text in his later revision of it,[154] Breton is unable to find an adequate dialogical flow with Nadja. In its refusal to follow the flow, the narrative exhibits the sad case of its narrator, his delusions and fixations, as much as that of its nominal subject. Disconnected from the flow of consciousness that would give them their meaning, the text's uninhabited pictures perform a melancholic function: a morbid fixing of loss. In keeping with Benjamin's analysis of Atget's evacuated urban photographs (which he sees as anticipating Surrealist photography), the photographic evidence of *Nadja* suggests a series of crime scenes fixed on file.[155] The sense of guilt that Benjamin sees as occupying such scenes is here that of the failure to achieve a true flow of communication and, by extension, that of complicity in Nadja's fate. The case-book style of the text only serves to highlight the sense of fixture. It performs the rationalization of the performative energy of Nadja's 'untranslatable' soliloquy, one that might otherwise have produced a text in the avant-garde, 'happening' style of Molly's soliloquy or of Stein's perpetually mobile subject-cases. Stein should perhaps have the last word here: 'Technique is not so much a thing of form or style as the way that form or style came and how it can come again. Freeze your fountain and you will always have the frozen water shooting into the air and falling and it will be there to see – oh, no doubt about that – but there will be no more coming.'[156]

6

Conclusion: Allegories of the Avant-Garde

It seems suitable in the conclusion to this study to look once more to Klee's *Angelus Novus*, as read by Benjamin. This classic version of the avant-garde allegory, seen as looking back over the accumulated fragments of history, can serve nicely as a device through which to view the assemblage of case material presented here in pursuit of a cultural-historical picture of the European avant-garde. The allegory, we recall, is a form of representative image, characteristically a body image, that serves to represent above all in so far as it incorporates its own sense of incompletion. It is resistant to attempts to totalize the picture, to derive complete mythologies of experience. It sustains the disruptive energy of the negative dialectic, working against the synthesizing projects of orthodox ideologies, political, psychoanalytic, formalist or otherwise. The intention in this study has been to follow that principle by showing up the internal breaks and contradictions as well as the potential of these different ideologies and their modes of reading. By putting the principal focus of the discussion upon representative examples, rather than historical survey, the book has applied an allegorical method to the structural analysis of the avant-garde. The purpose has not been to give a comprehensive account, but to demonstrate the, often contradictory, workings of these exemplary cases. What has emerged is thus in the style of a montage, where the internal relations and contradictions of the individual case studies are set into critical relief by their configuration, through relation and contradiction, with others.

The allegorical image has arisen in various forms in the course of the study: from *Angelus Novus*, to the manifestation art of the Futurists, Magritte's *Le Viol*, Lorca's self-portrait of the poet in the city,

Eisenstein's cinematic attractions, the tableaux of Brechtian *Gestus*, and the images and self-images of Nadja. In each case, the image is at once charged with the avant-garde's principle of manifestation, performing an immediate and active bodily demand upon the viewer, and yet, in various ways, elusive, fragmentary, contradictory in the viewing it requires. The allegory has thus made common cause with the fetish in the way that Benjamin recognizes.[1] It fixes upon a partial or accessory object that is related metonymically to the 'true', ultimate object of interest, but represents that object's absence as well as a striking or seductive substitute for it. Psychoanalysis and Marxism have alternative ways of construing the fetish, as invested with psychosexual or commodity value, but what they have in common is the recognition of its ambivalence, its way of at once concealing and exposing the structures of the prevailing economies and their defining contradictions and lacunae. Similarly, the formalist project at once relies upon, and gives fetishistic significance to, the special instance of aesthetic formulation, yet wants that instance to stand for a total commitment to pure form, one that is necessarily compromised in practice. Each of these totalizing aspirations has been seen here to fail, not least by invoking contamination from the others. The various fetish images that have been the object of scrutiny have manifested this reliance upon, or appeal to, other than their apparent perspectives.

Between the single image of the allegory and the total picture of the ideological system, montage is interposed: the dialectical principle of assemblage that shows the breaks between, as much as it enables, the configurations of individual elements. In its classic, emblematic form, the allegory has the structure of montage. It is a construction of elements in different media, of image and text. Superficially, the elements are designed to cohere in the emblem's representative meaning. In fact, their meaning is always disrupted by the act of fixture, which sets a framework of loss around the emblematic figure. The allegory is always also an allegory of loss. Thus, the construction of Nadja's fountain as emblem, with its caption as *subscriptio* drawn from the text, is exposed as the concealment of a loss of relation that obtains both within the respective orders of language and image and between them.

In his account of the history of photography, Benjamin argues that new modes of photographic reproduction effect a shock that brings the 'mechanism of association' in the beholder to a standstill. At this point, he suggests, 'inscription' (*Beschriftung*) has to intervene in order to subject the photographic medium to the 'literarization of all

the conditions of life'.[2] On a literal level, this inscription is the cap-
tion or *subscriptio*, but on a transposed level it refers to the internal
textualization of the order of the image and the necessity for the
viewer to achieve literacy in the language of the photographic 'text'.
Benjamin follows Brecht in suggesting that the straightforward
image of a factory tells the viewer nothing about the factory as socio-
political institution, and that the photographic image should be
constructed in order to be made amenable to critical reading. For
Benjamin, the Surrealists are the pioneers of the new constructed
form of photographic representation.[3] Against this utopian reading
of the modern medium, however, we have to set the evidence of
Breton's instrumentalization of it in the fountain photograph. Here,
the standstill in the mechanism of association operates on the level of
Nadja's stream-of-consciousness, and the fixture of her associative
flow is reinscribed rather than released by the textual construction
of the image. It provides an image, therefore, of the sort of impediment
that afflicts the performative constructions of the avant-garde, whether
in the orders of text or image, or indeed between them. In this it
concurs with another emblematic text-image of the avant-garde,
Apollinaire's calligrammatic poem 'La Colombe poignardée et le jet
d'eau' ('The Stabbed Dove and the Fountain' (1914)) (see plate 11).[4]
Here, the poet's mournful elegy to friends lost in the war is inscribed
in the shape of a stylized fountain springing from a basin in the shape
of an eye. The act of reading is divided between a readerly dynamic
that is, however, also disjunctive (the reader's eye has to find its way
and to stop and restart at the end of each line of tears) and the pictorial
fixture of the fountain as emblematic figure of the language of melan-
choly, of the mortified gaze, that recurs in the text. Breton's appro-
priated form of Nadja's fountain can be viewed through the mediation
of Apollinaire's calligramme as a text-image that fixates loss.

As an emblem of the avant-garde, Breton's fountain partakes of the
same fundamental ambivalence as the *Angelus Novus*. The backward-
looking Benjaminian allegory of history that opened this study rejoins
the backward-looking allegorical figuration of the Surrealist move-
ment that closes it. These two framing emblems of the avant-garde
both stand nicely as disjunctive representations of its cultural history.
On the one hand, they represent, the one in abstracted, the other in
photo-realist form, the relationship of the avant-garde to history,
both in a conceptual sense (in Benjamin's reading of the Klee image)
and in a more empirical sense (in Breton's indicative attachment of
his memoir of Surrealism to the historical reality of Paris in the 1920s).
Both the metaphysical body of the angel, co-opted for a new age, and

La Colombe poignardée
et le jet 'd'eau

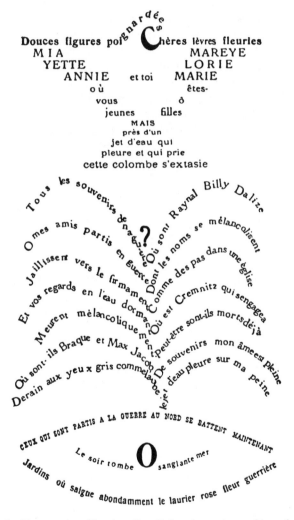

Plate 11 Guillaume Apollinaire, 'La Colombe poignardée et le jet d'eau' (1914).

that of the Classical sculpture in the fountain photograph also indicate the reliance of the avant-garde upon the recycling of old images for its construction of new mythologies. These mythologies are, however, unreliable. Klee's painting, *pace* Benjamin, also piles up the old as detritus. The photograph seems to preserve it more organically in compositional balance with the fountain, until we see how broken up this composition must be by the power of the flow in the text behind it, the rising and breaking of the water as embodied allegory of the pulsations of consciousness. As different as they are in appearance, the two images are thus also the same in a key feature: theirs is a negatively dialectical relationship. The angel is propelled forward but looks back, and the water of the fountain is propelled onward but its performative flow, its happening, is also fixed as past experience. The two images envision possibilities for the future, yet also mark that future out as already past, cast in a melancholic form of the future perfect, of that which will have been. In this, they do indeed join up, through difference, as emblematic of the disjunctive continuities of the cultural history of the avant-garde.

Epilogue: After the Avant-Garde?

Discussions of the avant-garde are, it seems, like the phenomenon itself, preoccupied with questions of historical origin and duration. There is the moment of birth in 'the first avant-garde', which some locate in the 1890s, some around 1910. And there are the obituaries for 'the last avant-garde', from the vantage-point of a postmodern culture that is judged to come more or less categorically 'after the avant-garde'.[1] The contention of this study has been that the so-called historical avant-garde looks both ways: forwards to the future that it is programmatically creating and backwards in its previewing of the inevitable conversion of that future into the past. This begs the question of what happens next to the avant-garde. The study draws a line at 1940, partly for compelling historical reasons: in the 1930s the rise of new forms of totalitarianism and the Second World War that developed out of them intervened to fragment and disperse those movements of the European avant-garde that were still active. The War represents a rupture in cultural history effected by the *force majeure* of political history. In the cases of Germany, Italy, Spain and the Soviet Union, in particular, the dominant ideologies of Fascism and Stalinism had by 1940 largely suppressed the 'degenerate' or 'decadent' activities of the avant-gardists. Those from the ranks of the Futurists, the Expressionists or the Constructivists who had made common cause with these ideologies in their earlier phases were made to see that they demanded conformism rather than avant-gardism from their official artists. Such avant-garde work as survives from those years is largely done in isolation and underground; the 'unpainted pictures' of Emil Nolde, paintings that he found ways of making but which officially did not exist, stand emblematically for

all that either remained hidden or was actually unmade under those regimes.

While much of the creative synergy of the historical avant-garde arose out of the migrations of individuals, groups and ideas across Europe, and from other parts of the world into Europe, the new totalitarianism and the war it brought with it caused less voluntary forms of migration for the exponents and proponents of the avant-garde. The lead figure of this study, Walter Benjamin, who committed suicide on the run from the south of France to Spain, provides one of the most poignant examples. The 'inner emigration' of the likes of Nolde was matched by outer emigration, from continental Europe to Britain and, especially, to the United States, which became the principal location of avant-garde activity in the decades after the War. The avant-garde thus also survived in new locations on varying scales, from the public designs of émigré architects like Mendelssohn, Gropius and Mies van der Rohe to the more reclusive space of Kurt Schwitters's final installation of Merz artwork in a farm shed in the English Lake District. And it survived on a latent level into the post-war period in continental Europe too. While the aftermath of the War largely engendered cultural sobriety and conservatism rather than avant-garde exuberance, continuities with the pre-war avant-garde were maintained by figures like Raymond Queneau, who – in collaboration with Duchamp, Perec, Calvino and others – came to reconfigure the narrative experimentation he had conducted under Surrealism in the Oulipo (Ouvroir de Littérature Potentielle) project, devoted to working out new literary potential in systems such as computer language.

Genealogies can certainly be traced back from the leading edge of experimental writing, film, and visual and performance art in the second half of the twentieth century to the heyday of the historical avant-garde. There have been fierce debates about the relationship between the two, between the avant-garde 'proper', which developed in an ambivalent clinch with Modernism, and the putative forms of avant-garde that have emerged under the postmodern condition. There is a line of argument that sees the avant-garde as a unique product of the historical conditions of the first four decades of the twentieth century, and what comes after as experiment in a different ideological mode. Thus, Peter Bürger disparages the 'neo-avant-garde' as a form of mimicry of the historical avant-garde, coming after the event and without the political intervention that for him is the defining feature of an avant-garde now definitively past. In *After the Great Divide*, Andreas Huyssen makes a similar judgement of what he calls a

'depoliticized cultural avantgarde' in the United States, which he sees as having produced 'largely affirmative culture, most visibly in pop art where the commodity fetish often reigns supreme'.[2] For Huyssen, Warhol's serial black-and-white photographic portraits of the *Mona Lisa* lack the iconoclastic political challenge of Duchamp's *LHOOQ*,[3] as it were the 'original' work of avant-garde reproduction. These judgements seem to participate in a form of Left melancholia produced by the apparently irremediable disjuncture between aesthetic and political cultures. After its flirtation with revolutionary political agendas, experimental art is seen to be lured into the ever more industrialized factories, galleries and theatres of culture.

Such judgements are countered, however, not least by Hal Foster, who, in his *Return of the Real*, undertakes a vigorous rehabilitation of the American avant-garde of the second half of the century, arguing that it is still imbued with iconoclastic energy and political relevance. Equally, a series of critics have argued for a special genealogical relationship between particular movements of the historical avant-garde and their counterparts in postmodernism.[4] Perhaps Susan Suleiman's and Peter Wollen's differential assessments are most adequate to the contradictions of the general picture. Suleiman, in her *Subversive Intent*, sees the post-war literary avant-garde in France as divided between the politicized challenge of the group around the journal *Tel Quel* and the more aesthetically and psychologically preoccupied exponents of the *nouveau roman*. And Wollen argues that the two filmic avant-gardes of the Twenties – abstraction as an extension of painting and the deployment of montage techniques in the service of the revolution – are replicated respectively in the experimental film making of the Co-op movement and that of such European new wave *auteurs* as Godard or Straub and Huillet.[5] Wollen would not wish to deny that either of these is an avant-garde, but only to insist that their differences are respected, and that any avant-garde requires critical definition in order to make the term meaningful.

While the post-war avant-garde needs to be scrutinized for its political commitment and its innovative effect, and can certainly often be found to be in thrall to the culture industry, this should not be used to promote a myth of origin for the historical avant-garde. Rosalind Krauss has deconstructed the 'Modernist myth' of the originality of the avant-garde, showing it to partake in a repetitive sequence of cultural-historical renovations from the eighteenth to the late twentieth century. The allure of the avant-garde mythology is powerful – indeed, Krauss herself appears to succumb to it when she takes the rhetoric of new birth in Marinetti's foundational manifesto of Futurism

at face value. As we saw in the second chapter of this book, even such ostensibly heroic moments of self-origination, as Marinetti emerges, to cite Krauss, 'as if from amniotic fluid to be born – without ancestors – a futurist',[6] are always already derivative, bound to ancestry and repetition in spite of themselves. And while Marinetti's rhetoric of origin may not understand its own contradictions, much of the work of the historical avant-garde certainly does. Krauss argues that in 'deconstructing the sister notions of origin and originality, postmodernism establishes a schism between itself and the conceptual domain of the avant-garde, looking back at it from across a gulf that in turn establishes a historical divide'.[7] This divide, I would argue, is not as great as she or Huyssen might seem to suggest, and should be seen as relative to the substantial internal divisions that characterize both the historical avant-garde and the postmodern project. The 'discourse of the copy' is already at work, whether acknowledged or unacknowledged, manifest or latent, in all branches of the historical avant-garde. The differences between a Duchamp and a Warhol canvas, a phonographic or pictographic poem by Stramm, Apollinaire or Schwitters and the concrete poetry of the Fifties and Sixties, Stein's narrative experimentations and those of the L=A=N=G=U=A=G=E group, should not be exaggerated. In its at least partial knowledge and display of its own lack of originality, whether critical, playful or melancholic, the historical avant-garde already comes after itself. What Krauss calls its 'forward march',[8] is always also turned backwards upon its historical tracks after the manner of Benjamin's angel. It seems only reasonable, therefore, that the versions of the avant-garde that follow it should indeed in their turn come 'after the avant-garde'.

Notes

Chapter 1 Introduction: The Historical Avant-Garde and Cultural History

1 For an account of the technologization of the body in Modernism and the avant-garde, see: Tim Armstrong, *Modernism, Technology, and the Body: A Cultural Study* (Cambridge: Cambridge University Press, 1998).

2 In the wake of Deleuze's reading of Bergsonian duration as a differentially organized dimension, scholars have readdressed the apparent antagonism between Bergson and the proponents of relativity. See Timothy S. Murphy, 'Beneath Relativity: Bergson and Bohm on Absolute Time', in *The New Bergson*, ed. John Mullarkey (Manchester and New York: Manchester University Press, 1999), pp. 66–81.

3 In his 1868 policy statement for the League of Peace and Freedom, 'Federalism, Socialism and Anti-Theologism', Bakunin prepares for his critique of Marx by insisting that Communist strivings for unity should be tempered by liberty: 'The League recognizes only one unity, that which is freely constituted by the federation of autonomous parts within the whole' (quoted in Anthony Masters, *Bakunin: The Father of Anarchism* (London: Sidgwick and Jackson, 1974), p. 175).

4 Sigmund Freud, *Die Traumdeutung* [The Interpretation of Dreams], in *Gesammelte Werke*, ed. Anna Freud et al., 18 vols (Frankfurt am Main: Fischer, 1999), vol. 2/3, p. 335.

5 Renato Poggioli, *The Theory of the Avant-Garde*, tr. Gerald Fitzgerald (Cambridge, Mass.: Harvard University Press, 1968), p. 9.

6 Walter Benjamin, 'Über den Begriff der Geschichte', in *Gesammelte Schriften*, ed. Rolf Tiedemann and Hermann Schweppenhäuser, 7 vols (Frankfurt am Main: Suhrkamp, 1991), vol. 1.2, pp. 691–704 (pp. 697–8).

7 Peter Bürger, *Theorie der Avantgarde* (Frankfurt am Main: Suhrkamp, 1974), pp. 101–4.

8 Walter Benjamin, *Ursprung des deutschen Trauerspiels*, in *Gesammelte Schriften*, vol. 1.1, pp. 203–430.

9 Hal Foster, *The Return of the Real: The Avant-Garde at the End of the Century* (Cambridge, Mass., and London: MIT Press, 1996). For a theoretical discussion of relations between the 'historical' avant-garde and its postmodern successors, see *New German Critique*, 22 (Winter 1981).

10 I would thus see more use in the angel figure than does Peter Osborne, who views Benjamin's appropriation of the figure as conventionally historicist and inured to the innovatory energy of the avant-garde. Peter Osborne, *The Politics of Time: Modernity and Avant-Garde* (London and New York: Verso, 1995), p. 150.

11 Raymond Williams, *The Politics of Modernism: Against the New Conformists* (London and New York: Verso, 1989), p. 92.

12 Walter Benjamin, 'Das Kunstwerk im Zeitalter seiner technischen Reproduzierbarkeit', 3rd edn, in *Gesammelte Schriften*, vol. 1.2, pp. 471–508 (p. 500).

13 Benjamin, 'Der destruktive Charakter', in *Gesammelte Schriften*, vol. 4.1, pp. 396–8.

14 Ibid., p. 398.

15 Susan Buck-Morss, *The Dialectics of Seeing: Walter Benjamin and the Arcades Project* (Cambridge, Mass., and London: MIT Press, 1991), p. 95.

16 Benjamin, 'Das Kunstwerk', p. 507.

17 Benjamin, 'Über den Begriff der Geschichte', p. 703.

CHAPTER 2 MANIFESTATIONS: THE PUBLIC SPHERE

1 Bürger, *Theorie der Avantgarde*, p. 50.

2 Renato Poggioli, in his *Theory of the Avant-Garde* (pp. 68f), talks of the 'futurist moment' that belongs to all avant-gardes.

3 Filippo Tommaso Marinetti, 'The Founding and Manifesto of Futurism in 1909', in *Futurist Manifestos*, ed. Umbro Apollonio (London: Thames and Hudson, 1973), pp. 19–24 (p. 19).

4 John J. White, *Literary Futurism: Aspects of the first avant garde* (Oxford: Clarendon Press, 1990), p. 8.

5 Apollonio, *Futurist Manifestos*, p. 21.

6 Ibid., p. 20.

7 Ibid.

8 Ibid., p. 97.

9 Ibid., p. 21.

10 Ibid., p. 22.

11 Ibid., p. 24.

12 Ibid., pp. 24–7 (p. 25).

13 Ibid., p. 27.
14 Ibid., p. 47.
15 Ibid., p. 48.
16 White, *Literary Futurism*, pp. 26–7.
17 Apollonio, *Futurist Manifestos*, pp. 118–25 (p. 121).
18 White, *Literary Futurism*, pp. 76–99.
19 Apollonio, *Futurist Manifestos*, pp. 95–106 (p. 96).
20 Ibid., p. 99.
21 Vladimir Markov, *Russian Futurism: A History* (London: Macgibbon and Kee, 1969), p. 158.
22 Anna Lawton (ed.), *Russian Futurism through its Manifestoes, 1912–1928* (Ithaca, NY, and London: Cornell University Press, 1988), p. 56.
23 In her Preface to *Some Imagist Poets 1915*, quoted in Peter Jones (ed.), *Imagist Poetry* (Harmondsworth: Penguin, 1972), p. 135.
24 Ibid., p. 129. As Poggioli argues, the open flow implied by the avant-garde movement is counteracted by other types of less future-oriented groups, who choose for themselves emblems of spatial focus and containment (Imagism is a case in point) or of an exclusive, fixed configuration like the elitist 'circle' around Stefan George (*Theory of the Avant-Garde*, p. 20).
25 Ezra Pound, *Selected Poems* (London: Faber & Faber, 1977), p. 53.
26 Jones (ed.), *Imagist Poetry*, p. 130.
27 *BLAST: Review of the Great English Vortex*, 1 (20 June 1914), p. 153.
28 Ibid., p. 143.
29 *BLAST*, 2 (July 1915), p. 26.
30 This structure follows the model of Apollinaire's 'L'anti-tradition futuriste', which lists its loves and hates under 'rose à' and 'merde à' respectively.
31 *BLAST*, 1, p. 30.
32 Ibid., p. 11.
33 Ibid., pp. 17, 26.
34 Ibid., p. 147.
35 Ibid., p. 154.
36 Ibid., p. 26.
37 Ibid., p. 154.
38 Ibid., p. 60.
39 Ibid., p. 8.
40 For a discussion of Lewis's 'proto-Fascism', see Fredric Jameson, *Fables of Aggression: Wyndham Lewis, the Modernist as Fascist* (Berkeley: University of California Press, 1979).
41 André Breton, 'Géographie Dada', *Littérature*, 13 (May 1920), 17–18 (p. 17).
42 Tristan Tzara, *sept manifestes DADA, lampisteries* (Paris: Pauvert, 1978), pp. 15–17.
43 Ibid., p. 15.

44 Ibid., p. 15.
45 Ibid., pp. 19–39 (p. 21).
46 Ibid., p. 26.
47 Ibid., p. 21.
48 Ibid., p. 23.
49 Ibid., p. 24.
50 Ibid., p. 27.
51 Ibid., p. 28.
52 Alongside references to Hegel and Engels, they cite Freud's argument that every thought in the unconscious is bound to its contrary. André Breton, *Oeuvres complètes*, ed. Marguerite Bonnet et al., 2 vols (Paris: Gallimard, 1992), vol. 2, p. 805.
53 Tzara, *sept manifestes*, p. 32.
54 Ibid., p. 21.
55 Ibid., p. 20.
56 As Naomi Sawelson-Gorse notes in her introduction to *Women in Dada: Essays on Sex, Gender, and Identity* (Cambridge, Mass., and London: MIT Press, 1998).
57 Tzara, *sept manifestes*, p. 15.
58 In the first manifesto of Surrealism, Breton enacts something like this scenario: in dialogue with a doctor, a patient with echolalia or Ganser syndrome (giving inconsequential answers) is claimed to be freer and stronger than the interlocutor who constrains him. André Breton, *Manifestes du surréalisme* (Paris: Gallimard, 1977), p. 48. DADA, whether construed as meaning father or mother, is a primal instance of speech as echo, both internally repetitive and designed to be repeated by the child as the parent repeatedly utters it. The normative regime of echoing may easily take on the appearance of the pathological condition of echolalia.
59 André Breton, *La Clé des champs* (Paris: Sagittaire, 1953), p. 19.
60 Breton, *Manifestes du surréalisme*, pp. 23–4.
61 Ibid., p. 37.
62 Breton's choice of Dostoevsky as model case of this vice is curious, given that his version of bourgeois realism is shot through with elements of the fantastic.
63 Breton, *Manifestes du surréalisme*, p. 127.
64 Ibid., p. 69.
65 Ibid., p. 17.
66 Ibid., p. 139.
67 Ibid., p. 33.
68 Breton calls spiritualism 'one of the most extraordinary *meeting grounds*', and seeks to locate that ground for encounter with the para-psychological away from both the crude sensationalism of the side-show and the demystification of the doctor's office (ibid., p. 140n.).
69 Ibid., p. 90.
70 Ibid., pp. 96, 92.

71 Ibid., p. 52.
72 It is comparable in this to the less overtly political position of early
 DADA, standing, according to the 'manifeste de monsieur antipyrine',
 on its balcony from where all the military marches can be heard,
 before 'landing in a public baths to piss and understand the parable'
 (Tzara, *sept manifestes*, p. 16). Tzara hears the march of history, but
 produces a form of response to it that is strategically useless except as
 a provocation.
73 Breton, *Manifestes du surréalisme*, p. 106.
74 Ibid., p. 118.
75 Ibid., p. 98.
76 Ibid.
77 Ibid., p. 86.
78 Ibid., p. 67.
79 Ibid., p. 69.
80 Ibid., p. 44.
81 For a full account of the three exhibitions, see: Bruce Altshuler, *The
 Avant-Garde in Exhibition: New Art in the Twentieth Century* (Berkeley
 and London: University of California Press, 1994), pp. 60–115.
82 From the memoir of Sprovieri, the gallery owner, as quoted in Günter
 Berghaus, *Italian Futurist Theatre 1909–1944* (Oxford: Clarendon
 Press, 1998), p. 235.
83 As Sprovieri notes, the *serate* were often violently interactive: 'The
 performances were unpredictable and entertaining, and were created
 to a large extent by the spectators themselves, who made a dogs' noise
 when echoing our declamations or dismantling and reassembling the
 components of Boccioni's polymaterial sculptures' (ibid., p. 236).
84 Tom Gunning, 'The Cinema of Attractions: Early Film, its Spectator
 and the Avant-Garde', in *Early Cinema: Space – Frame – Narrative*,
 ed. Thomas Elsaesser (London: BFI, 1990), pp. 56–62 (p. 59).
85 Apollonio, *Futurist Manifestos*, pp. 126–31 (p. 126).
86 Ibid., p. 127.
87 Ibid., p. 129.
88 In Michael Kirby, *Futurist Performances* (New York: Dutton, 1971),
 pp. 248–9.
89 Ibid., pp. 234–5.
90 Ibid., pp. 236–7.
91 Apollonio, *Futurist Manifestos*, p. 131.
92 Robert Short, *Dada and Surrealism* (London: Octopus Books, 1980),
 p. 57.
93 This is thus a version of the experimentation with transgendering that
 Duchamp undertook under the identity of his female *alter ego* Rrose
 Sélavy.
94 Benjamin, 'Das Kunstwerk', p. 476. A photograph of it hangs, for
 instance, in one of the bohemian interiors of early avant-garde Paris
 in Wyndham Lewis's *Tarr*, much to the disgust of the title figure. He

rails against the commodity value of the 'Gioconda smile' on canvas and as reproduced on the living faces of 'spiritual' women. Wyndham Lewis, *Tarr: The 1918 Version*, ed. Paul O'Keeffe (Santa Rosa, Calif.: Black Sparrow Press, 1990), pp. 52, 40.

95 In addition to Duchamp's *LHOOQ*, the *Gioconda* image is 'rectified' in the collage *Kompositsiia s Monoi Lizoi* ('Composition with Mona Lisa' (1914)) by Malevich. The torn postcard image of the *Mona Lisa* has its features crossed out, and a cigarette is said to have been attached to its lips.

96 Walter Benjamin, 'Kleine Geschichte der Photographie', in *Gesammelte Schriften*, vol. 2.1, pp. 368–85 (p. 379).

97 As propounded, in particular, in her *Gender Trouble: Feminism and the Subversion of Identity* (New York and London: Routledge, 1990) and *Bodies that Matter: On the Discursive Limits of "Sex"* (New York and London: Routledge, 1993).

98 Maurice Nadeau, *The History of Surrealism*, tr. Richard Howard (Harmondsworth: Penguin, 1973), p. 71.

99 Breton argued that the wide-open doors of the 1918 DADA manifesto in fact led on to circular corridors. See J. H. Matthews, *An Anthology of French Surrealist Poetry* (London: University of London Press, 1966), p. 10.

100 Breton, *Manifestes du surréalisme*, p. 45.

101 Ibid., p. 27.

102 Ibid., p. 53.

103 Ibid., p. 141.

104 Elza Adamowicz, *Surrealist Collage in Text and Image: Dissecting the Exquisite Corpse* (Cambridge: Cambridge University Press, 1998).

105 Dawn Ades, *Dada and Surrealism Reviewed* (London: Arts Council of Great Britain, 1978), p. 313.

106 Michel Foucault, *This Is Not a Pipe*, tr. James Harkness (Berkeley and London: University of California Press, 1983).

107 Freud, *Die Traumdeutung*, p. 284.

108 Jack J. Spector, *The Aesthetics of Freud: A Study in Psychoanalysis and Art* (London: Allen Lane, 1972), pp. 172–6. Breton, in his prose poem 'Violette Nozières', suggests that the first part of the name chosen for her indicates 'psychoanalytically' the father's incestuous project. See, Breton, *Oeuvres complètes*, vol. 2, pp. 217–21 (p. 220).

109 Freud, *Die Traumdeutung*, p. 364.

110 As Sarah Whitfield points out, *Le Viol* has a particular iconographic relationship to the highly styled publicity images for cigarettes that the artist was producing around that time (*Magritte* (London: The South Bank Centre, 1992), no. 63). Avant-garde 'exhibitionism' thus imitates and exposes the public exhibition of body images by the advertising industry.

111 Freud in his 1922 essay on the head of Medusa , 'Das Medusenhaupt', in *Gesammelte Werke*, vol. 17, p. 48.

112 Elizabeth Wright, *Psychoanalytic Criticism: A Reappraisal*, 2nd edn (Cambridge: Polity, 1998), pp. 108–9.

113 Foucault, *This Is Not a Pipe*, p. 51.

114 The special exhibitionism of the Galerie Gradiva will be discussed further below.

115 Agamben has discussed the relationship between Benjamin/Klee's angel of history and what he reads as the 'angel of art' in Dürer's image (Giorgio Agamben, *The Man without Content*, tr. Georgia Albert (Stanford, Calif.: Stanford University Press, 1999), pp. 104–15).

116 For a detailed discussion of *The Ambassadors*, see my *The Doppelgänger: Double Visions in German Literature* (Oxford: Clarendon Press, 1996), pp. 69–72, 82–5.

117 *Bulletin international du surréalisme*, 3 (August 1935).

118 Jacques Lacan, *The Four Fundamental Concepts of Psycho-analysis*, ed. Jacques-Alain Miller, tr. Alan Sheridan (London: Vintage, 1998), pp. 88–9.

CHAPTER 3 WRITING THE CITY: URBAN TECHNOLOGY AND
POETIC TECHNIQUE

1 Martin Heidegger, *Unterwegs zur Sprache* (Pfullingen: Neske, 1959), p. 78.

2 Maud Ellmann, 'Eliot's Abjection', in *Abjection, Melancholia, and Love: The Work of Julia Kristeva*, ed. J. Fletcher and A. Benjamin (London and New York: Routledge, 1990), pp. 178–200 (p. 193).

3 From 'L'Esprit nouveau et les poètes', in Guillaume Apollinaire, *Oeuvres complètes*, ed. Michel Décaudin, 4 vols (Paris: André Balland and Jacques Lecat, 1966), vol. 3, pp. 900–10 (p. 910).

4 References to *Zone* are by line number to Apollinaire, *Oeuvres complètes*, vol. 3, pp. 55–60.

5 In Georg Trakl, *Sämtliche Werke und Briefwechsel: Innsbrucker Ausgabe*, ed. Eberhard Sauermann and Hermann Zwerschina, 6 vols (Basel: Stroemfeld/Roter Stern, 1995–), vol. 3, p. 351.

6 Heidegger, *Unterwegs zur Sprache*, p. 80.

7 Oswald Spengler, *Der Untergang des Abendlandes: Umrisse einer Morphologie der Weltgeschichte* (Munich: Beck, 1969), p. 673.

8 T. S. Eliot, *The Waste Land*, in *The Complete Poems and Plays of T. S. Eliot* (London: Faber & Faber, 1969), pp. 59–80; references are by line number in brackets.

9 Trakl, *Sämtliche Werke*, vol. 2, p. 24.

10 See, e.g., the opening lines of Trakl's 'Psalm', which create a positive poetic entity through a recurrent performative 'Es ist' ('There/it is'), even where the images are of extinction or nonentity (*Sämtliche Werke*, vol. 2, p. 24).

11 In Edschmid's terms, 'Sie sahen nicht. Sie schauten' ('They did not see. They were seers') (Kasimir Edschmid, *Über den Expressionismus in der Literatur und die neue Dichtung*, 7th edn (Berlin: Erich Reiß, 1920), p. 52).

12 Else Lasker-Schüler, *Sämtliche Gedichte*, ed. Friedhelm Kemp (Munich: Kösel, 1966), p. 152.

13 References are by line number to the third version of 'Abendland', in *Sämtliche Werke*, vol. 4.1, pp. 254–5.

14 Elis is taken to be based on a young man whose corpse was preserved lifelike in a mine, a story recounted in E. T. A. Hoffmann's *Die Bergwerke zu Falun* ('The Mines of Falun' (1818)).

15 In 'An den Knaben Elis' the youth's body is figured as a hyacinth (*Sämtliche Werke*, vol. 2, p. 433).

16 Trakl, *Sämtliche Werke*, vol. 4.1, p. 207.

17 Another key example would be Gottfried Benn's 'Untergrundbahn' ('Underground Railway' (1913)), a poem that uses the most modern technology of urban transportation as a vehicle for regressive fantasy.

18 This was the judgement of Georges Duhamel, who claimed that the eclectic mix of objects put on show in Apollinaire's bric-à-brac shop showed a lack of creative productivity. See Guillaume Apollinaire, *Alcools: choix de poèmes*, ed. Roger Lefèvre (Paris: Larousse, 1971), p. 18.

19 Eliot attended Bergson's lectures in Paris in 1910–11.

20 Frank Kermode (ed.), *Selected Prose of T. S. Eliot* (London: Faber & Faber, 1975), pp. 37–44 (p. 38).

21 Ibid., p. 38.

22 Eliot, *Complete Poems and Plays*, pp. 18–21 (p. 21).

23 The 'London Letter' of October, *The Dial*, 71 (1921), 452–3.

24 Eliot did indeed contribute to the Vorticist journal *Blast*.

25 Eliot, *Complete Poems and Plays*, p. 20.

26 '*Ulysses*, Order, and Myth' (1923), in Kermode (ed.), *Selected Prose of T. S. Eliot*, pp. 175–8 (p. 177).

27 John Bowen, 'The Politics of Redemption: Eliot and Benjamin', in *The Waste Land*, ed. Tony Davies and Nigel Wood (Buckingham and Philadelphia: Open University Press, 1994), pp. 29–54.

28 Eliot, *Complete Poems and Plays*, p. 147.

29 Brooker and Bentley have argued that this is a portrait in the Cubist style, a compilation of partial perspectives (Jewel Spears Brooker and Joseph Bentley, *Reading 'The Waste Land': Modernism and the Limits of Interpretation* (Amherst: University of Massachusetts Press, 1990), p. 11).

30 It is generally agreed that the authoritative voice of the notes must be treated with no less care than the motley voices of the poem. They carry the possibility of being redundant red herrings or entrapments for the 'hypocritical reader'.

31 See Bertolt Brecht, 'Short Description of a New Technique of Acting which Produces an Alienation Effect', in *Brecht on Theatre: The Development*

of an Aesthetic, ed. and tr. John Willett (London: Methuen, 2001), pp. 136–47 (p. 138).

32 The note on Tiresias suggests that this is his role. As a transsexual visionary, who has always already experienced all couplings everywhere and at every time, he embodies a dialectical principle of sameness through difference.

33 The typist acts as a metamorphic machine woman, much like the hybrid 'fishmen' in the next scene.

34 Coote's reading of this line as 'the nadir of sterility' needs some qualification (Stephen Coote, *The Waste Land* (Harmondsworth: Penguin, 1985), p. 39).

35 See Ariel's song from *The Tempest*, which is cited here.

36 These images are strikingly similar to those deployed in the apocalyptic visions of Trakl's late war poetry (notably the maternal lamentations of 'Das Gewitter' ('The Storm')).

37 As argued above, DADA can be understood in terms of the phatic 'da' of Freud's 'fort-da' game. Here the invariable invocation of presence stands against the varied absences of the sequence of quotations at the end of the poem.

38 Eliot, *Complete Poems and Plays*, p. 80.

39 As Alison Sinclair notes, Lorca had certain affinities with the *ultraístas* and their cult of urban excitement, and was a signatory to the *Catalan Anti-Artistic Manifesto* (Alison Sinclair, 'Lorca: Poet in New York', in *Unreal City: Urban Experience in Modern European Literature and Art*, ed. Edward Timms and David Kelley (New York: St Martin's Press, 1985), pp. 230–46).

40 The lecture functions in much the same way as the notes to *The Waste Land*, as a supplement that helps to explicate some of the poetry's obscurities, but also as a model for reading that may be reductive or misleading.

41 From the lecture 'A Poet in New York', in Federico García Lorca, *Poet in New York*, ed. Christopher Maurer, tr. Greg Simon and Steven F. White (Harmondsworth: Penguin, 1990), p. 190; all references to the poems are to this edition.

42 Ibid., p. 254.

43 The nightingale, e.g., is no less ambivalently charged than in *The Waste Land*; it remains wounded in 'Vals en las ramas' ('Waltz in the Branches') and estranged in 'Tu infancia en Menton' ('Your Childhood in Menton').

44 Lorca, *Poet in New York*, p. 67.

45 Though the 'ojos de cristal definitivo' ('final crystal eyes') in 'Grito hacia Roma' ('Cry to Rome'), are hardened to the sort of redemptive resonance that is applied to the eyes in *Zone* (ibid., p. 150).

46 Ibid., p. 6.

47 Ibid. In one of the internal memories of the collection, the mobility of the coiled serpent is fixed in crystal in 'Nocturno del hueco' ('Nocturne of Emptied Space'): 'y eran duro cristal definitivo / las formas que

buscaban el giro de la sierpe' ('and shapes that looked for the serpent's coiling / crystallized completely') (ibid., p. 106).

48 Ibid., p. 6.
49 The 'unspeakable' natural function of menstruation is a key object for the breaking of taboos of abjection in the avant-garde period, as we will see in the narrative texts discussed in the final chapter.
50 Federico García Lorca, *Obras completas*, 22nd edn, 3 vols (Madrid: Aguilar, 1986), vol. 3, p. 502.
51 Lorca, *Poet in New York*, p. 46.
52 As the 'maricas' are vilified as a corrupt counterpart to Apollonian homosexuality, so the Jews are represented here as embodying an urban corruption that is a foil to the essential naturalness of the Blacks. The cult of the natural and the same allows for the celebration of the self-identity of certain forms of sexual and racial otherness, but it also creates a license for homophobia and anti-Semitism.
53 Lorca, *Poet in New York*, p. 32.
54 Ibid., p. 36.
55 Ibid., p. 132.
56 Ibid., p. 134.
57 Helen Oppenheimer, *Lorca, The Drawings: Their Relation to the Poet's Life and Work* (London: Herbert Press, 1986), p. 89.

CHAPTER 4 MODES OF PERFORMANCE: FILM-THEATRE

1 Kurt Schwitters, 'Die Merzbühne', in *Das literarische Werk*, ed. Friedhelm Lach, 5 vols (Cologne: DuMont, 1981), vol. 5, p. 42.
2 Benjamin, 'Das Kunstwerk', p. 478.
3 Ibid., pp. 489–90.
4 Ibid., p. 478.
5 For a reading of the play as a precursor of the Theatre of Cruelty, see Christopher Innes, *Avant garde Theatre: 1892–1992* (London and New York: Routledge, 1993), pp. 52–8.
6 A key example of this dialectic would be *Marat/Sade* by Peter Weiss, where the political imperative of Brechtian theatre is set in dialogue with the psychic cruelty of Artaudian drama.
7 Williams, *The Politics of Modernism*, pp. 49–50.
8 Benjamin, 'Das Kunstwerk', p. 500.
9 As famously set out by Siegfried Kracauer in his *From Caligari to Hitler: A Psychological Study of the German Film* (Princeton: Princeton University Press, 1947).
10 Serge Eisenstein, *Film Form: Essays in Film Theory*, ed. and tr. J. Leyda (New York: Harcourt/Brace, 1949), p. 203.
11 See my argument on *Caligari* and other films in 'Canning the Uncanny: The Construction of Visual Desire in *Metropolis*', in *Fritz Lang's*

Metropolis: *Cinematic Visions of Technology and Fear*, ed. Michael Minden and Holger Bachmann (Rochester: Camden House, 2000), pp. 249–69.

12 Gunning, 'Cinema of Attractions', p. 59.
13 Benjamin, 'Das Kunstwerk', p. 502.
14 Ibid., p. 492.
15 Erwin Piscator, *Theater Film Politik: Ausgewählte Schriften*, ed. Ludwig Hoffmann (Berlin: Henschelverlag, 1980), p. 109.
16 Ibid., p. 87.
17 Ibid., p. 14.
18 Ibid., p. 15.
19 Ibid., p. 13.
20 Gropius's conception of the 'Totaltheater' used multiple screens and projectors to turn the spectatorial space (*zuschauerraum*) into a space of filmic projection (*projektionsraum*), breaking down the notional fourth wall dividing the stage from the auditorium. For his account of the project, see Erwin Piscator, *Das Politische Theater* (Berlin: Henschelverlag, 1968 [1929]), pp. 125–7.
21 Ibid., pp. 171–74.
22 Piscator, *Theater Film Politik*, p. 30.
23 Ibid., p. 47.
24 Examples would be the Berlin Volksbühne productions of Paquet's *Sturmflut* and Welk's *Gewitter über Gottland* in 1926 and 1927 respectively.
25 Piscator, *Theater Film Politik*, p. 48.
26 Brecht, 'The Piscator Experiment', in *Brecht on Art and Politics*, ed. Tom Kuhn and Steve Giles (London: Methuen, 2003), pp. 64–5.
27 Brecht, 'Piscator Theatre', in *Brecht on Art and Politics*, ed. Kuhn and Giles, pp. 65–6 (p. 66).
28 Brecht, 'Piscator Experiment', p. 64.
29 Brecht, 'The Expressionism Debate', in *Brecht on Art and Politics*, ed. Kuhn and Giles, pp. 213–14 (p. 214).
30 Brecht, 'Notes to *Die Rundköpfe und die Spitzköpfe*, in *Brecht on Theatre*, ed. Willett, pp. 100–3 (p. 102).
31 Benjamin, *Gesammelte Schriften*, vol. 2.2, p. 537.
32 In Marc Silberman (ed. and tr.), *Brecht on Film and Radio* (London: Methuen, 2001), p. 10.
33 Brecht, 'From the ABCs of the Epic Theatre', in *Brecht on Film and Radio*, ed. and tr. Silberman, p. 7.
34 Ibid.
35 Ibid.
36 Roland Barthes, *Critical Essays* (Evanston, Ill.: Northwestern University Press, 1972), pp. 74–5.
37 Silberman (ed. and tr.), *Brecht on Film and Radio*, pp. 142–3.
38 In Willett (ed.), *Brecht on Theatre*, p. 41.

39 For a psychoanalytically disposed reading of Brecht, against the grain, see Elizabeth Wright, *Postmodern Brecht: A Re-Presentation* (London and New York: Routledge, 1989).

40 Antonin Artaud, *Oeuvres complètes*, 20 vols (Paris: Gallimard, 1964), vol. 4, p. 150.

41 'In the theatre only what is theatrical interests me, to use the theatre to launch any revolutionary idea [. . .] appears to me the most base and repulsive opportunism' (quoted in Innes, *Avant garde Theatre*, p. 70).

42 Artaud, *Oeuvres complètes*, vol. 1, p. 287.

43 Ibid., vol. 4, p. 34.

44 Ibid.

45 Ibid., p. 13.

46 Ibid., p. 109.

47 Ibid., p. 34.

48 Ibid., p. 86.

49 Ibid., p. 99.

50 Freud, *Gesammelte Werke*, vol. 2/3, p. 51.

51 Ibid., vol. 16, p. 144.

52 Artaud, *Oeuvres complètes*, vol. 4, p. 146.

53 Ibid., p. 52.

54 Ibid., p. 38.

55 Ibid., p. 66.

56 Ibid., p. 65.

57 Freud, *Gesammelte Werke*, vol. 2/3, pp. 283–4, 326, 358.

58 Artaud, *Oeuvres complètes*, vol. 4, p. 86.

59 Ibid., p. 135.

60 Ibid., p. 137.

61 Innes, *Avant garde Theatre*, p. 64.

62 Ibid., p. 79.

63 Artaud, *Oeuvres complètes*, vol. 4, p. 167.

64 Ibid., p. 101.

65 Ibid., vol. 3, p. 95.

66 Ibid., vol. 3, p. 73.

67 Ibid., p. 77.

68 Ibid., pp. 83–4.

69 Ibid., p. 23.

70 Ibid., p. 21.

71 Ibid., p. 22.

72 Ibid., p. 98.

73 A crystal ball has a similar function in *La Coquille et le clergyman*.

74 He proposes a theatre in which the violent physical images will at once 'pulverise and hypnotise' the spectators' sensibility (Artaud, *Oeuvres complètes*, vol. 4, p. 99).

75 Ibid., vol. 3, p. 52.

76 'The epic theatre wants to establish its basic model at the street corner, i.e. to return to the very simplest "natural" theatre, a social

enterprise whose origins, means and ends are practical and earthly' ('The Street Scene', in Willett (ed.), *Brecht on Theatre*, pp. 121–9 (p. 126)).

77 The 'Factory of the Eccentric Actor' (FEKS), led by Kozintsev and Trauberg, aspired to theatre as trick- and poster-art; it derived its ethos of performative eccentrism from the circus, sporting events, the music-hall and comic cinema.

78 Sergei Eisenstein, *The Film Sense*, ed. and tr. Jay Leyda (London: Faber & Faber, 1968), p. 16.

79 Ibid., p. 21.

80 Ibid., pp. 20, 27.

81 Roland Barthes, *Image – Music – Text*, tr. Stephen Heath (London: Fontana, 1977), p. 71.

82 Jacques Aumont, *Montage Eisenstein*, tr. Lee Hildreth et al. (London: BFI, 1987), pp. 75–107. Aumont argues that despite the scepticism of his pronouncements on psychoanalysis, Eisenstein was fundamentally influenced by his reading of *The Interpretation of Dreams* and other texts of Freud's.

83 Sergei Eisenstein, *The Battleship Potemkin*, tr. Gillon R. Aitken (London: Faber & Faber, 1984), p. 21.

84 Leon Trotsky, *Literature and Revolution* (Ann Arbor: University of Michigan Press, 1960), p. 149.

85 Richard Taylor (ed.), *The Eisenstein Reader* (London: BFI, 1998), p. 56.

86 In his discussion of the sequence in his essay 'The Montage of Film Attractions', Eisenstein says that he uses the slaughter of the bull both to provide a strong image of bloody horror and to avoid shooting the death of the masses in close-up and the inevitable 'falseness' that such footage would create (ibid., p. 38).

87 Eisenstein, *The Battleship Potemkin*, p. 8.

88 Michael Minden, 'Politics and the Silent Cinema: *The Cabinet of Dr Caligari* and *Battleship Potemkin*', in *Visions and Blueprints: Avant-garde Culture and Radical Politics in Early Twentieth-Century Europe*, ed. Edward Timms and Peter Collier (Manchester: Manchester University Press, 1988), pp. 287–306 (p. 302).

89 Eisenstein, *The Battleship Potemkin*, p. 15.

90 Ibid., p. 16.

91 Taylor (ed.), *Eisenstein Reader*, p. 103.

92 Ibid., p. 30.

93 Barthes, *Image – Music – Text*, p. 72.

94 As Wollen notes, 'the scenes of the storming of the Winter Palace were evidently echoes of the enormous pageants that had taken place in Petrograd, when tens of thousands had swarmed through the street and squares, re-enacting the events of the October Revolution' (Peter Wollen, *Signs and Meaning in the Cinema: Expanded Edition* (London: BFI, 1998), p. 29).

95 In his essay 'On Film Music', Brecht testifies to how the experimental theatre of the pre-Hitler era 'made use of epic, gestic and montage elements that appeared in films' (in Silberman (ed.), *Brecht on Film and Radio*, p. 11).

96 Bertolt Brecht, 'Short Contribution on the Theme of Realism', in Silberman (ed.), *Brecht on Film and Radio*, p. 208.

97 Bertolt Brecht, *Werke: Große kommentierte Berliner und Frankfurter Ausgabe*, 30 vols (Berlin and Frankfurt am Main: Suhrkamp/Aufbau, 1988–), vol. 27, p. 76.

98 Benjamin, *Gesammelte Schriften*, vol. 2.2, p. 537.

99 Brecht, *Werke*, vol. 21, pp. 464–5.

100 Ibid., p. 469.

101 Ibid., p. 480.

102 Ibid., vol. 27, p. 307.

103 Brecht, 'From the ABCs of the Epic Theatre', in Silberman (ed.), *Brecht on Film and Radio*, p. 6.

104 As Silberman notes, the film's 'punctuation' is influenced by the innovations of Soviet cinema (Marc Silberman, *German Cinema: Texts in Context* (Detroit: Wayne State University Press, 1995), p. 41).

105 Bertolt Brecht, *Der Dreigroschenprozess*, in *Werke*, vol. 21, p. 480.

106 Benjamin, *Gesammelte Schriften*, vol. 2.2, p. 529.

107 Silberman (ed.), *Brecht on Film and Radio*, p. 135.

108 Hanns Eisler, 'Funktion und Dramaturgie der Filmmusik', cited in *Kuhle Wampe oder Wem gehört die Welt?: Protokoll*, ed. W. Gersch and W. Hecht (Frankfurt am Main: Suhrkamp, 1969), p. 99.

109 Roswitha Mueller, *Bertolt Brecht and the Theory of Media* (Lincoln, Nebr., and London: University of Nebraska Press, 1989), pp. 79–87.

110 Brecht, *Werke*, vol. 24, p. 79.

111 Silberman (ed.), *Brecht on Film and Radio*, p. 171.

112 The core of psychic trauma here corresponds to that in Walter Ruttmann's *Berlin: Die Sinfonie der Grosstadt* (Berlin: Symphony of the City, 1927). While Ruttmann's film follows the objectified aesthetic ethos of *Neue Sachlichkeit* in its representation of the dynamics of urban technology, it incorporates the suicidal scene of a woman jumping into the river, where the turning motion of the city as machine is converted into a spiralling compulsion that hysterically afflicts the objective camera.

113 Taylor (ed.), *Eisenstein Reader*, p. 92.

114 Ibid., p. 57.

115 Ibid., p. 59.

116 Annette Michelson draws a detailed analogy between the 'multiple, polyvalent, contrapuntal' design of Tatlin's monument and Vertov's work (Annette Michelson (ed.), *Kino-Eye: The Writings of Dziga Vertov* (Berkeley: University of California Press, 1984), p. xxxiii).

117 Taylor (ed.), *Eisenstein Reader*, p. 76.

118 Michelson (ed.), *Kino-Eye*, p. 287.

119 Ibid., p. 288.
120 Ibid., p. 5.
121 Ibid., p. 7.
122 Ibid., p. 85.
123 Ibid., p. 86.
124 Ibid., p. 88.
125 Gorky, who, in spite of his Marxist politics, had resisted the Bolshevik Revolution, returned to Russia from exile in 1928 to great festivities. The banner can be understood to represent the idea of the mass theatrical celebration of this man of the theatre.
126 Slavoj Žižek discusses film stills in these terms in his *The Plague of Fantasies* (London and New York: Verso, 1997), p. 88.
127 Yuri Tsivian, in his commentary for the BFI video of the film, suggests that the accident material was shot for *Kinoglaz*.
128 Seth R. Feldman, *Dziga Vertov: A Guide to References and Resources* (Boston: G. K. Hall, 1979), p. 39.
129 In Michelson (ed.), *Kino-Eye*, p. 13.
130 Michelson cites Vladimir Markov on the Constructivist reworking of the icon, as a configuration of the unreal and 'the assemblage of *faktura*' (ibid., p. xlviii).
131 Ibid., pp. 11–12.
132 Vigo praises 'its perfect amalgam of visual and ideological associations, its sustained dreamlike logic' (cited in Philip Drummond (ed.), Luis Buñuel and Salvador Dalí, *Un Chien Andalou* (London: Faber & Faber, 1994), p. xxv).
133 'Although I availed myself of oneiric elements the film is not the description of a dream' (*An Unspeakable Betrayal: Selected Writings of Luis Buñuel*, tr. Garrett White (Berkeley and London: University of California Press, 1995), p. 250).
134 The scenario refers to the male protagonist's performance of the 'gesture of a villain from a melodrama'. In the duel, he is described as forcing his double into a 'Hands up!', as derived from early Hollywood crime thrillers (*La Révolution surréaliste*, 12 (15 December 1929), pp. 35, 37).
135 In the final scene, when the male and female figures move off in a clinch along the seashore, the performance of the tango is rendered most explicitly; the female figure even gives a little kick.
136 Buñuel, *Unspeakable Betrayal*, pp. 131–2.
137 *La Révolution surréaliste*, 12, p. 33.
138 As Drummond has it, there is here a 'continual play with vision in relation to the maintenance or disturbance of filmic space through eyeline-matches and mis-matches and looks directed on-screen and off-screen' (Drummond (ed.), *Un Chien Andalou*, p. xxi).
139 See ibid., p. x.
140 Linda Williams, *Figures of Desire: A Theory and Analysis of Surrealist Film* (Berkeley and Oxford: University of California Press, 1992).

If the alignment of the moon with the eye and the phallus as sus-
ceptible to castration seems questionable, it is worth noting that in
Lorca's film-script *A Trip to the Moon*, a similar psychoanalytic logic
is followed. A figure gazing at the moon sees it fade into a male sex
organ and then into a screaming mouth. See Oppenheimer, *Lorca,
The Drawings*, p. 138.

141 Williams, *Figures of Desire*, p. 212.
142 The scenario describes the move of hand to mouth as like that of
 somebody losing their teeth. At another point, the description of the
 man's mouth as though 'squeezed by a sphincter' indicates the
 psychoanalytic metonymies at work in the play with orifices here (*La
 Révolution surréaliste*, 12, pp. 35, 37).
143 Kaja Silverman, *The Structure of Semiotics* (New York: Oxford Uni-
 versity Press, 1983), p. 200.
144 The dead donkeys harnessed into the apparatus here are reminiscent
 of other images from the slaughterhouse of avant-garde performance,
 not least the horse hanging from the bridge in *October*.
145 Lacan, 'Of the Gaze as *Objet Petit a*', in *The Four Fundamental Con-
 cepts of Psycho-analysis*, pp. 67–119. The seminar aligns the skull in
 Holbein's picture with features of Dalí's paintings.
146 Drummond points out that in 1928 Dalí was constructing canvases
 with a variety of heavy objects suspended from them (Drummond
 (ed.), *Un Chien Andalou*, p. xiii). The artist performs part of his own
 installation in the film version, in the person of one of the priests.
147 The term 'bachelor-machine' has a particularly avant-garde provenance,
 coined as it was by Marcel Duchamp in his description of the lower
 part of his assemblage *La Mariée mise à nu par ses célibataires, même*
 ('The Bride Stripped Bare by her Bachelors, Even' (1923)). For a dis-
 cussion of the bachelor-machine in the context of the avant-garde, see
 Constance Penley, *The Future of an Illusion: Film, Feminism, and
 Psychoanalysis* (London and New York: Routledge, 1989), pp. 57–
 80.
148 *La Révolution surréaliste*, 12, p. 35.
149 The severed hand recalls the wax hand on show in a display-case
 in the early scene from *Man with a Movie Camera*. There the dis-
 membered hand as fetish object is set against the virtuoso manual
 dexterity on show in other parts of both films, not least the hand as
 controlling the editorial organization of the film medium.
150 See my reading of *Der Sandmann* according to the model of the
 'fort-da' game in *The Doppelgänger*, pp. 121–48.

CHAPTER 5 CASE HISTORIES: NARRATIVES OF THE AVANT-GARDE

1 Eliot, '*Ulysses*, Order, and Myth', in Kermode (ed.), *Selected Prose of
 T. S. Eliot*, p. 177.

2 Virginia Woolf, *A Writer's Diary*, ed. Leonard Woolf (London: The Hogarth Press, 1953), p. 137.

3 William James, *Principles of Psychology*, 2 vols (repr. New York: Dover Publications, 1950), vol. 1, p. 239.

4 Gertrude Stein, *Composition as Explanation* (1926), repr. in *Writings 1903–1932* (New York: Literary Classics of the United States, 1998), pp. 520–9 (p. 521).

5 David Lodge, *The Modes of Modern Writing: Metaphor, Metonymy and the Typology of Modern Literature* (London: Edward Arnold, 1977).

6 Webber, *The Doppelgänger*, pp. 328–35.

7 Franz Kafka, 'Ein Landarzt', in *Die Erzählungen und andere ausgewählte Prosa*, ed. Roger Hermes (Frankfurt am Main: Fischer, 1996), pp. 253–60 (p. 260). The 'false ringing' (*Fehlläuten*) of the bell might be construed by analogy with *Fehlleistung* ('parapraxis') in the Freudian lexicon.

8 Rainer Maria Rilke, *Die Aufzeichnungen des Malte Laurids Brigge* (Frankfurt am Main: Suhrkamp, 1979). The 'Unheimliche' that characterizes Malte's childhood (p. 28) is repeated in the uncanniness that inhabits his encounters in the metropolis.

9 Louis Aragon, *Je n'ai jamais appris à écrire, ou les incipit* (Geneva: Skira, 1969), p. 54.

10 Louis Aragon, *Le Paysan de Paris* (Paris: Gallimard, 1953), p. 111.

11 Ibid., p. 143.

12 Ibid., p. 66.

13 Ibid., p. 105.

14 Ibid., p. 67.

15 Ibid., p. 216.

16 Buck-Morss, *Dialectics of Seeing*, pp. 253–86.

17 Benjamin, *Gesammelte Schriften*, vol. 5.2, p. 1214.

18 Freud, *Die Traumdeutung*, pp. 440–3.

19 Benjamin, *Gesammelte Schriften*, vol. 5.1, p. 580.

20 Ibid., p. 554.

21 André Breton, *Entretiens 1913–1952* (Paris: Gallimard, 1952), p. 39.

22 'Recherches sur la sexualité', in *La Révolution surréaliste*, 4, 11 (15 March 1928), pp. 32–40.

23 Aragon, *Le Paysan de Paris*, pp. 55–6.

24 Kermode (ed.), *Selected Prose of T. S. Eliot*, p. 178.

25 In a letter of 16 August 1921 to Frank Budgen, in Stuart Gilbert (ed.), *Letters of James Joyce*, 2nd edn, 3 vols (New York: Viking Press, 1966), vol. 1, p. 170.

26 James Joyce, *Ulysses* (Harmondsworth: Penguin, 1971), p. 675.

27 Ibid., p. 690.

28 Ibid., p. 79.

29 Ibid., p. 55.

30 Ibid., p. 278.

31 Ibid., p. 668.
32 Ibid., p. 673.
33 Ibid., p. 476.
34 Ibid., p. 664.
35 Ibid., p. 40.
36 For further discussion of *Fräulein Else* as evidence of the ambivalent relationship between Schnitzler and Freud, see my argument in *The Doppelgänger*, pp. 335–9.
37 See, for a discussion of the ambivalent character of Else's self-authorship, Elizabeth Bronfen, *Over Her Dead Body: Death, Femininity, and the Aesthetic* (Manchester: Manchester University Press, 1992), pp. 281–90.
38 Arthur Schnitzler, *Fräulein Else*, in *Fräulein Else und andere Erzählungen* (Frankfurt am Main: Fischer, 1987), p. 158.
39 Ibid., p. 150.
40 Ibid.
41 Virginia Woolf, *Writer's Diary*, p. 139.
42 Virginia Woolf, 'Modern Fiction', in *Collected Essays*, vol. 2 (London: The Hogarth Press), p. 108.
43 Ibid., p. 225.
44 Woolf, *Writer's Diary*, p. 47.
45 Virginia Woolf, *The Waves* (London: The Hogarth Press, 1990), p. 35.
46 Virginia Woolf, *Mrs Dalloway*, ed. G. Patton Wright (London: The Hogarth Press, 1990), p. 10. There is an intertextual link here to Wyndham Lewis's *Tarr*, where Tarr, the Parisian *flâneur*, is figured as a street-swimmer as he moves on from the window of a florist's (Lewis, *Tarr*, p. 48).
47 James, *Principles of Psychology*, vol. 1, p. 240.
48 Woolf, *Mrs Dalloway*, p. 25.
49 Ibid., p. 30.
50 Ibid., p. 59.
51 Ibid., pp. 49–50.
52 Ibid., p. 133.
53 In a diary note of 1928, Woolf cites the critique of a reviewer 'that I have come to a crisis in the matter of style: it is now so fluent and fluid that it runs through the mind like water'. Writing in this stream-of-consciousness mode is, she says, a 'disease' (Woolf, *Writer's Diary*, p. 137).
54 Woolf, *Mrs Dalloway*, p. 43.
55 Ibid., p. 85.
56 Ibid., p. 89.
57 Ibid., p. 163.
58 Ibid., p. 102.
59 Ibid., p. 45.
60 Ibid., p. 134.

61 Ibid., p. 84.

62 Bowlby's reading makes a strong case for understanding the novel as a whole as a *flâneur* text, dallying its way through the streets and public spaces of London (Rachel Bowlby, *Feminist Destinations and Further Essays on Virginia Woolf* (Edinburgh: Edinburgh University Press, 1997), pp. 191–219).

63 Benjamin, *Gesammelte Schriften*, vol. 1.2, p. 551.

64 Ibid., vol. 5.1, pp. 526, 529.

65 The fictional masked criminal Fantômas, who specializes in violating and knifing society ladies, fascinated many avant-garde writers and artists, from Robert Desnos to Juan Gris.

66 David Trotter, *Paranoid Modernism: Literary Experiment, Psychosis, and the Professionalization of English Society* (Oxford: Oxford University Press, 2001).

67 Gertrude Stein, 'What are Master-pieces and Why Are There So Few of Them' (1935), in *Gertrude Stein: Look at Me Now and Here I Am: Writings and Lectures 1911–1945*, ed. Patricia Meyerowitz (London: Peter Owen, 1967), p. 149.

68 Gertrude Stein, 'Why I Like Detective Stories' (1937), in *The Previously Uncollected Writings of Gertrude Stein*, ed. Robert Bartlett Haas, 2 vols (Santa Barbara, Calif.: Black Sparrow Press, 1977), vol. 2: *How Writing is Written*, p. 149.

69 Gertrude Stein, *Picasso* (repr. New York: Dover, 1984), p. 49.

70 Ibid., p. 12.

71 Ibid.

72 Gertrude Stein, 'Composition as Explanation', in *Writings 1903–1932* (New York: Literary Classics of the United States, 1998), pp. 520–9 (p. 523).

73 Ibid., p. 524.

74 Ibid., p. 529.

75 Ibid., p. 525.

76 Ibid., p. 529.

77 Ibid., pp. 528–9.

78 Gertrude Stein, 'Subject-Cases: The Background of a Detective Story', in *The Yale Gertrude Stein* (New Haven and London: Yale University Press, 1980), pp. 200–29 (p. 200).

79 Ibid. p. 202.

80 Ibid., p. 204.

81 Ibid., p. 209.

82 Ibid., p. 203.

83 Ibid., p. 218.

84 Ibid., p. 208.

85 Ibid., p. 210.

86 Ibid., p. 218.

87 Ibid., pp. 210–11.

88 Ibid., p. 211.

89 Ibid., p. 215.
90 Ibid., p. 214.
91 Ibid., p. 229.
92 Eve Kosofsky Sedgwick, *The Epistemology of the Closet* (Harmondsworth: Penguin, 1994).
93 Stein, 'Subject-Cases', p. 210.
94 Ibid., p. 205.
95 Gertrude Stein, *The Autobiography of Alice B. Toklas*, in *Writings 1903–1932*, pp. 653–913 (p. 654).
96 Gertrude Stein, 'Lifting Belly', in *Writings 1903–1932*, pp. 410–58 (p. 453).
97 Lodge, *Modes of Modern Writing*, pp. 144–55.
98 Gertrude Stein, *Blood on the Dining-Room Floor* (London: Virago, 1985), p. 23.
99 Ibid., p. 6.
100 Stein, 'Why I Like Detective Stories', p. 148.
101 Stein, *Blood on the Dining-Room Floor*, p. 69.
102 Ibid., p. 1.
103 Ibid., p. 2.
104 Ibid., p. 3.
105 With no reliable doctor to call to the case, the narrator appeals to the her listeners/readers for medical advice on symptomatic signs: 'Do any of you know of a disease that makes complete black rings all around the eyes' (ibid., pp. 14–15).
106 Ibid., p. 73.
107 Ibid.
108 Ibid., p. 26.
109 Aragon, *Je n'ai jamais appris à écrire*, p. 58.
110 Breton, *Manifestes du surréalisme*, p. 24.
111 Benjamin suggests that it achieves a synthesis between the *Schlüsselroman* (*roman à clef*) and the *Kunstroman* (artistic novel) (Walter Benjamin, 'Der Sürrealismus', in *Gesammelte Schriften*, vol. 2.1, pp. 295–310 (p. 298)).
112 Roger Navarri, *André Breton: Nadja* (Paris: Presses Universitaires de France, 1986), p. 15.
113 André Breton, *Nadja* (Paris: Gallimard, 1964), pp. 87–8. The 1928 edition has 'personnes' for 'passantes'.
114 *Passer* is 'to pass', *se passer* 'to happen', and *se passer de* 'to do without'.
115 In a letter to Breton, Freud suggests that he was right in limiting the 'inevitable exhibition' of his relationship with his father. Breton thinks the 'fear of exhibitionism' is not a satisfactory excuse for this deficiency, and that Freud's over-anxiety to answer his criticism is symptomatic of unacknowledged repressions. Freud's desire not to make an exhibition of himself goes hand in hand with his inability to see the point of Surrealist exhibitions or exhibitionism. As if in answer

to the question of Breton's *Qu'est-ce que le surréalisme?*, he declares that he is unable to determine 'what Surrealism is or wants' (Freud, in *Le Surréalisme au service de la Révolution*, 5 (May 1933), p. 11.

116 Benjamin, 'Der Sürrealismus', p. 298.
117 Ibid.
118 Ibid., p. 297.
119 Breton, *Nadja*, p. 9.
120 Peter Nicholls, *Modernism: A Literary Guide* (Basingstoke: Macmillan, 1995), p. 292.
121 Breton, *Nadja*, p. 55.
122 Susan Rubin Suleiman, 'Breton, Charcot, and the Spectacle of Female Otherness', in *Subversive Intent: Gender, Politics, and the Avant-Garde* (Cambridge, Mass., and London: Harvard University Press, 1990), pp. 99–110 (p. 103).
123 André Breton, *Les Vases communicants* (Paris: Gallimard, 1955), p. 53.
124 Breton, *Nadja*, p. 53.
125 The reading of the play as Breton's bachelor-machine, serving his psychosexual desires, seems more appropriate than Benjamin's view that it is a 'machine infernale' designed to explode the moral idealism of the bourgeois Left (Benjamin, 'Der Sürrealismus', pp. 304–5).
126 Breton, in 'Recherches sur la sexualité', p. 35.
127 Breton, *Les Vases communicants*, p. 7.
128 Marking the entrance to the site of exhibition, the name Gradiva over the gallery's façade was also made to stand for other Surrealist heroines or anti-heroines: D for (Freud's) Dora and V for Violette (Nozières).
129 Suleiman, *Subversive Intent*, p. 106.
130 André Breton and Louis Aragon, 'Le Cinquantenaire de l'hystérie (1878–1928)', *La Révolution surréaliste*, 4, 11, pp. 20–2 (p. 22).
131 Suleiman, *Subversive Intent*, p. 107.
132 Breton, *Nadja*, p. 45.
133 Ibid., p. 49.
134 Ibid., p. 179.
135 Breton, in 'Recherches sur la sexualité', p. 35.
136 Susan Buck-Morss (*Dialectics of Seeing*, p. 369), provides a more inclusive image of the waxwork and its provocative eyes.
137 Breton, *Nadja*, p. 179.
138 Ibid., p. 81.
139 Ibid., p. 6.
140 Ibid., p. 125.
141 Ibid., p. 20.
142 Ibid., p. 99.
143 'I end up constraining her to follow me' (ibid., p. 98).
144 Ibid., p. 177.
145 Benjamin, 'Der Sürrealismus', p. 301.
146 Ibid., p. 300.

147 Benjamin, 'Kleine Geschichte der Photographie', p. 371.
148 Ibid., p. 385.
149 The punctum is the pointed detail in the photograph that takes hold of the viewer. See Roland Barthes, *La Chambre Claire: Note sur la photographie* (Paris: Gallimard Seuil, 1980), p. 49.
150 Rosalind E. Krauss, *The Originality of the Avant-Garde and Other Modernist Myths* (Cambridge, Mass., and London: MIT Press, 1985), p. 101.
151 The fountain encounter is part of the sequence from *Nadja* included in *La Révolution surréaliste*, 4, 11, pp. 9–11. Here the images are replaced by a reproduction of de Chirico's *Le delizie del poeta* ('The Poet's Delights' (1913)), where a small female figure in white is isolated in a public square that also contains a pool with a fountain. This early version of a series of variations on themes of enigma and melancholy performs an analogous act of melancholic fixture to the images in the book. The clock, the frozen fountain and the train caught on the horizon all suggest fixture of the figure in a condition of absence, of a missed appointment. In several of the later versions of the scene, the fountain is replaced with a sculpture, and the enigmatic female figure by a male couple.
152 Benjamin, 'Der Sürrealismus', p. 299.
153 Suleiman, *Subversive Intent*, p. 108; Adamowicz, *Surrealist Collage*, pp. 139–41.
154 Breton, *Nadja*, p. 6.
155 'Is not every spot in our cities the scene of a crime? Every one of their passers-by a perpetrator?' (Benjamin, 'Kleine Geschichte der Photographie', p. 385).
156 Gertrude Stein in conversation with John Hyde Preston, in *Atlantic Monthly*, 156 (August), pp. 187–94 (p. 188).

CHAPTER 6 CONCLUSION: ALLEGORIES OF THE AVANT-GARDE

1 In the *Passagen-Werk* he notes that there is a consonance between allegory and commodity in their fetishistic character (Benjamin, *Gesammelte Schriften*, vol. 5.1, p. 274).
2 Benjamin, 'Kleine Geschichte der Photographie', p. 385.
3 Ibid., p. 384.
4 In Apollinaire, *Oeuvres complètes*, vol. 3, p. 201.

EPILOGUE: AFTER THE AVANT-GARDE?

1 See Robert Boyers, *After the Avant-garde: Essays on Art and Culture* (University Park: Pennsylvania State University Press, 1988).

2 Andreas Huyssen, *After the Great Divide: Modernism, Mass Culture, Postmodernism* (Bloomington: Indiana University Press, 1986), p. 6.
3 Ibid., p. 147.
4 Examples are Marjorie Perloff, *The Futurist Moment: Avant-Garde, Avant Guerre, and the Language of Rupture* (Chicago and London: University of Chicago Press, 1986); Richard Murphy, *Theorizing the Avant-Garde: Modernism, Expressionism, and the Problem of Postmodernity* (Cambridge: Cambridge University Press, 1999).
5 Peter Wollen, 'The Two Avant-Gardes', in *Readings and Writings: Semiotic Counter-Strategies* (London: Verso, 1982), pp. 92–104.
6 Krauss, *Originality of the Avant-Garde*, p. 157.
7 Ibid., p. 170.
8 Ibid.

Index

Illustration page references are italicized.

Adamowicz, Elza, 55, 212
Ades, Dawn, 55
Adorno, T. W., 136–7
Agamben, Giorgio, 229 n.115
allegory, 7–8, 10, 15, 23, 60, 68,
 71, 85, 210, 214–15, 216,
 244 n.1
Apollinaire, Guillaume, 83, 84,
 85, 89, 222, 225 n.30,
 230 n.18
 Alcools, 67
 Calligrammes, 67
 'La Colombe poignardée et le
 jet d'eau', 216, *217*
 'Lundi Rue Christine', 88
 Les Mamelles de Tirésias, 19
 Zone, 65, 66–72, 73, 74, 85,
 92, 94, 96, 98, 231 n.45
Aragon, Louis, 32, 54
 Le Paysan de Paris, 175–8,
 179, 203, 208
Armstrong, Tim, 223 n.1
Arp, Hans, 31
Artaud, Antonin, 37, 109,
 115–22, 123, 156, 177,
 234 n.74

Les dix-huit Secondes, 120–1
La Révolte du boucher, 121–2,
 157
Aumont, Jacques, 124, 235 n.82

Bakhtin, Mikhail, 168
Bakunin, Mikhail, 1, 2, 223 n.3
Balla, Giacomo, 43–4
Barthes, Roland, 114, 123–4,
 129, 133, 212, 244 n.149
Bauhaus, 17, 108–9
Bayer, Herbert,
 Zeitungskiosk, 17–18
Bely, Andrei, 167
Benjamin, Walter, 3, 5–8, 10,
 11–13, 14, 15, 21, 48, 50,
 60, 64, 85, 101, 104–5,
 106, 107–8, 112, 137, 139,
 145–6, 177–8, 185, 188,
 198–9, 203–4, 210–12,
 213, 214, 215–16, 218, 220,
 222, 224 n.10, 229 n.115,
 242 n.111, 243 n.125,
 244 n.155, n.1
Benn, Gottfried,
 'Untergrundbahn', 230 n.17

Bentley, Joseph, 230 n.29
Bergson, Henri, 1, 2, 64, 169,
 230 n.19
Berkeley, George,
 *Three Dialogues between Hylas
 and Philonous*, 210, 212
Boccioni, Umberto, 44, 227 n.83
 Il corpo che sale, 45
 La Garçonnière, 45
 Materia, 23
Bowen, John, 85
Bowlby, Rachel, 188, 241 n.62
Brecht, Bertolt, 64, 89, 106, 109,
 111–15, 118, 119, 122, 123,
 131–44, 154, 166, 168,
 190, 215, 216, 234–5 n.76,
 236 n.95
 Baal, 115, 122
 *Der Dreigroschenprozess: Ein
 soziologisches Experiment*,
 137, 143
 Die Beule, 114–15
 Die Mutter, 113
 Lebenslauf des Mannes Baal,
 115
 Mahagonny, 115, 142
 Mann ist Mann, 113
 Mutter Courage, 113, 138
Breton, André, 32, 35, 37–41,
 53–4, 55, 121, 176, 178,
 226 n.58, n.68, 228 n.108,
 242–3 n.115, 243 n.125
 Nadja, 11, 14–15, 38, 54, 174,
 189, 202–10, *211*, 212–13,
 215, 216, 218, 244 n.151
 Les Vases communicants, 206,
 207
Bronfen, Elizabeth, 240 n.37
Brooker, Jewel Spears, 230 n.29
Buck-Morss, Susan, 13, 177,
 243 n.136
Buñuel, Luis, 93
 Un Chien andalou, 109, 130–1,
 156–66, 172–3, 237 n.133

Bürger, Peter, 8, 9, 10, 19, 220
Butler, Judith, 52, 104, 133, 182,
 206

Calvino, Italo, 220
Cangiullo, Francesco,
 Il donnaiuolo e le 4 stagioni,
 45, 46
 Milano-Dimostrazione, 43
 Piedigrotta, 43–4
Carrà, Carlo, 44
 Manifestazione Interventista,
 24, *25*, 26
Charcot, Jean-Martin, 54, 208,
 210
Conan-Doyle, Arthur,
 The Hound of the Baskervilles,
 199
Constructivism, 17, 122, 125,
 145, 146, 155, 219,
 237 n.130
Coote, Stephen, 231 n.34
Cubism, 27, 30, 31, 34, 43, 62,
 66, 67, 191–3, 230 n.29
Cubo-Futurism, 17, 26, 42, 125,
 145

DADA, 30–4, 35, 37, 42, 46–53,
 66, 92, 103, 108, 110, 113,
 177, 226 n.58, 227 n.72,
 231 n.37
Dalí, Salvador, 34, 59–60, 93,
 156, 157, 162, 238 n.145,
 n.146
 Le Grand Masturbateur, 55, 57
Darwin, Charles, 1, 2
da Vinci, Leonardo, 47
 La Gioconda, 21, 23, 36, 46,
 47, 48, 57, 221, 227–8 n.94,
 228 n.95
de Chirico, Giorgio,
 Le delizie del poeta, 244 n.151
Deleuze, Gilles, 223 n.2
Derrida, Jacques, 104

Desnos, Robert, 121, 241 n.65
De Stijl, 17
Döblin, Alfred, 167
　Berlin Alexanderplatz, 170
Dostoevsky, Fyodor, 38, 226 n.62
Drummond, Philip, 237 n.138,
　238 n.146
Duchamp, Marcel, 34, 220, 222,
　227 n.93
　Fontaine, 48–50
　LHOOQ, 36, 46–8, 49, 50,
　52, 53, 54, 55, 221
　La Mariée mise à nu par ses
　célibataires, même, 238
　n.147
　Nu descendant un escalier, 43,
　62, 64
Dudov, Slatan,
　Kuhle Wampe oder Wem
　gehört die Welt?, 109, 115,
　130, 131–4, *135*, 136–44,
　151, 157–8, 162, 164, 166
Duhamel, Georges, 230 n.18
Dulac, Germaine,
　La Coquille et le clergyman,
　121, 234 n.73
Dürer, Albrecht,
　Melancholie, 60, 229 n.115

Edschmid, Kasimir, 230 n.11
Einstein, Albert, 1, 2, 41, 148
Eisenstein, Sergei, 44, 107, 108,
　109, 122–30, 144–5, 148,
　150, 156, 157, 215
　Bronenosets Potyomkin, 111,
　125, 127, *128*, 129, 143,
　156, 158
　Oktyabr, 113, 123, 124, 126,
　129, 145, 151, 235 n.94,
　238 n.144
　Stachka, 125–7, 129, 235 n.86
　Staroye I Novoye, 124–5
Eisler, Hanns, 140

Eliot, T. S., 97, 167, 168
　'East Coker', 67
　'Portrait of a Lady', 84–5
　The Waste Land, 21, 65, 66,
　74–5, 83–93, 94, 96, 97, 99,
　231 n.40, n.43
Ellmann, Maud, 66, 96
Ernst, Max,
　Une Semaine de bonté, 168
exhibitionism, 16, 42–60, 107,
　130, 158, 180, 181, 182,
　197, 203–4, 205, 206,
　207–9, 228 n.110, 242–3
　n.115
Expressionism, 8, 27, 72, 75–6,
　82, 105, 106, 110, 112, 114,
　125, 144, 219

Fantômas, 188, 204, 241 n.65
Fascism, 13, 29, 177, 178, 219
Feldman, Seth, 154
fetishism, 12, 28, 45, 59, 124,
　126, 129–30, 137, 145, 151,
　155, 156, 161, 163, 165,
　208, 215, 244 n.1
Fischinger, Oskar, 109
flâneur, 52, 69, 94–5, 175, 178,
　179, 187–8, 198–9, 200,
　203, 204, 240 n.46,
　241 n.62
Flint, F. S., 27
Foster, Hal, 9, 221
Foucault, Michel, 55, 59
Freud, Sigmund, 1, 2, 3, 11, 12,
　19, 22, 23, 33, 34, 35, 37,
　39, 40, 41, 47, 48, 53, 54,
　57–8, 59, 105, 111, 115,
　116–18, 121, 123, 144, 146,
　157, 160, 161, 166, 174,
　177–8, 179, 183, 203–4,
　205–6, 226 n.52, 231 n.37,
　235 n.82, 239 n.7, 240 n.36,
　242–3 n.115, 243 n.128

Futurism, 8, 13, 20–6, 27, 29,
30, 31, 34, 36, 37, 43–6, 61,
62, 66, 112, 180, 214, 219,
221–2

Gaudier-Brzeska, Henri, 28, 29
Godard, Jean-Luc, 221
Goll, Yvan,
Methusalem, 119
Gorky, Maksim, 151, 237 n.125
Gris, Juan, 241 n.65
Gropius, Walter, 110, 220,
233 n.20
Grosz, Georg, 50
Gunning, Tom, 44, 107

Heartfield, John, 8
Preussischer Erzengel, 42–3
Heidegger, Martin, 65, 73
Heym, Georg, 72, 76
Höch, Hannah,
Da-Dandy, 50, 51, 52, 54,
104
Hoffmann, E. T. A.,
Der Sandmann, 165, 238 n.150
Die Bergwerke zu Falun,
230 n.14
Holbein, Hans,
The Ambassadors, 60, 162,
229 n.116, 238 n.145
Huelsenbeck, Richard, 31
Huillet, Danièle, 221
Huyssen Andreas, 220–1, 222
hysteria, 28–9, 54, 183, 184,
186, 207–8, 209, 210,
236 n.112

Imagism, 27, 30
Innes, Christopher, 119, 232 n.5

James, William, 169–70, 171,
185, 191
Jameson, Fredric, 11, 225 n.40

Jarry, Alfred,
Ubu roi, 32, 103, 104
Jensen, Wilhelm,
Gradiva, 22, 206–7, 243 n.128
Joyce, James, 167
Ulysses, 85, 112, 168, 174,
180–2, 185, 186, 196, 197,
209, 212, 213

Kafka, Franz,
'Ein Landarzt', 173–5, 178,
179, 181, 186, 188, 199,
201, 213, 239 n.7
Kaufman, Mikhail, 147, 153
Khlebnikov, Velimir, 26
Klee, Paul,
Angelus Novus, 5, 6, 7–8, 10,
11, 12, 15, 21, 23, 41, 42,
60, 101, 214, 216, 218, 222,
229 n.115
Kokoschka, Oskar,
Mörder Hoffnung der Frauen,
105
Kozintsev, Grigori, 235 n.77
Krauss, Rosalind, 212, 221–2
Kruchenykh, Alexei, 26

Lacan, Jacques, 58, 60, 162, 173,
238 n.145
Lasker-Schüler, Else, 76–7, 80
'Georg Trakl', 77
Lautréamont, Comte de, 36, 37,
38
Laverdant, Gabriel-Désiré, 4–5
Lenin, Vladimir Ilyich, 110, 112,
124, 149, 150
Lewis, Matthew,
The Monk, 36
Lewis, Percy Wyndham, 27–9,
167, 225 n.40
Enemy of the Stars, 29
Tarr, 227–8 n.94, 240 n.46
Lichtenstein, Alfred, 72

Lodge, David, 171, 198
Lorca, Federico García, 109,
 231 n.39, 237–8 n.140
 Canciones Gitanas, 93
 Poeta en Nueva York, 64–5,
 89, 93–102
 *Self-Portrait of the Poet in
 New York*, 99, 100, 101–2,
 214
Lowell, Amy, 27
Lumière, Auguste and Louis,
 *L'Arrivée d'un train en gare
 de La Ciotat*, 148, 151, 165

Magritte, René, 4, 55–64
 La Clé des songes, 55–7
 La Durée poignardée, 61, 62,
 63, 64
 Les Liaisons dangereuses, 59
 'Les Mots et les images', 159
 La Représentation, 59
 Portrait, 159
 The Spoiler, 60
 Le Trahison des images, 4, 55,
 57
 Le Viol, 55, 56, 57–9, 161,
 206, 214, 228 n.110
Malevich, Kasimir,
 Chetyreugolnik, 42
 Dama u afishnogo stolba,
 17–18
 Kompositsiia s Monoi Lizoi,
 228 n.95
manifesto, 9, 10, 16, 18–43,
 53–4, 55, 64, 103, 104, 110,
 117, 118–19, 137, 147, 149,
 203, 221–2
Marinetti, Filippo Tommaso, 13,
 20–2, 26, 28, 29, 33, 43,
 44–5, 46, 64, 66, 127,
 221–2
 Mafarka le futuriste, 180
Markov, Vladimir, 237 n.130

Marx, Karl, 1, 2, 3, 11, 41,
 105–6, 137, 223 n.3
Marxism, 2, 3, 10–11, 13–14,
 32, 40–1, 106, 110, 111,
 114, 118, 123, 125–6, 131,
 143, 215
Masson, André,
 Métamorphose de Gradiva,
 207
Mayakovsky, Vladimir, 109, 125,
 145
melancholy, 7, 8, 16, 23, 24,
 29, 60, 83, 102, 108, 193,
 213, 216, 218, 221, 222,
 244 n.151
Mendelssohn, Erich, 220
Meyerhold, Vsevolod, 109–10, 122
Michelson, Annette, 236 n.116
Mies van der Rohe, Ludwig, 220
Minden, Michael, 127
Moholy-Nagy, László, 109
montage, 8, 15, 17, 44, 68, 83–4,
 94, 107, 112, 122, 123, 125,
 126, 129, 130, 133–4, 136,
 141–2, 145, 149, 152,
 153–4, 155, 157, 158,
 163–4, 165–6, 167, 214,
 215, 236 n.95
Morise, Max, 54
Mueller, Roswitha, 141–2
Munch, Edvard,
 The Scream, 75, 82
Murphy, Timothy S., 223 n.2
Musil, Robert, 167
Muybridge, Eadweard, 62

Nadeau, Maurice, 53
Navarri, Roger, 203
Nicholls, Peter, 205
Nietzsche, Friedrich, 1, 2
Nolde, Emil, 219, 220
Nozières, Violette, 57, 204,
 228 n.108, 243 n.128

Oppenheim, Meret,
 Déjeuner en fourrure, 34
Oppenheimer, Helen, 101
Osborne, Peter, 224 n.10

Palau, Pierre,
 Les Détraquées, 205–6, 213,
 243 n.125
Penley, Constance, 238 n.147
Perec, Benjamin, 220
performativity, 16, 18–19, 29,
 30, 31, 35, 52, 104, 106,
 110, 132–3, 139, 156–7,
 165–6, 167, 177, 180,
 181–2, 184, 188–9, 190,
 199–200, 201, 202, 203,
 206, 213, 218, 235 n.77
photography, 12, 17, 50, 61, 62,
 76, 137–8, 139, 141, 145,
 146, 210–12, 213, 215–16,
 217–18, 244 n.149
Picabia, Francis, 47, 55
Picasso, Pablo, 189, 191
 Les Demoiselles d'Avignon, 20,
 66
Piscator, Erwin, 105, 109–11,
 112, 123
Poe, Edgar Allan, 37
 The Man of the Crowd, 188
Poggioli, Renato, 4, 224 n.2,
 225 n.24
Pound, Ezra, 27, 29
 'In a Station of the Metro', 27
Proust, Marcel, 167
 *A la Recherche du temps
 perdu*, 64
psychoanalysis, 10–11, 13–14,
 20, 22, 24, 32–4, 35, 37–8,
 40–1, 106, 115, 116, 123,
 124, 126, 144, 146, 160,
 161, 162, 178, 207, 214,
 215, 228 n.108, 234 n.39,
 237–8 n.140, 238 n.142

Pudovkin, Vsevolod,
 Konyets Sankt-Peterburga, 113

Queneau, Raymond, 220

Ray, Man, 197
Reiniger, Lotte, 109
Richter, Hans, 109
Rilke, Rainer Maria,
 *Die Aufzeichnungen des Malte
 Laurids Brigge*, 175–6,
 239 n.8
Rimbaud, Arthur, 38, 76
Rodchenko, Alexander, 145
Ruttmann, Walther, 109
 *Berlin: Die Sinfonie der
 Grosstadt*, 236 n.112

Sawelson-Gorse, Naomi,
 226 n.56
Schlichter, Rudolf,
 Preussischer Erzengel, 42–3
Schnitzler, Arthur,
 Fräulein Eise, 174, 182–4, 188,
 202, 208, 240 n.36, n.37
 Leutnant Gustl, 182–3, 184
 Reigen, 184
Schwitters, Kurt, 103–4, 220,
 222
Sedgwick, Eve Kosofsky, 196
Severini, Gino, 24, 44
Shklovsky, Viktor, 112, 166
Short, Robert, 46
Silberman, Marc, 236 n.104
Silverman, Kaja, 23, 161
Sinclair, Alison, 231 n.39
Soupault, Philippe, 176
Spector, Jack, 57
Spengler, Oswald, 73–4
Sprovieri, Giuseppe, 227 n.82,
 n.83
Stein, Gertrude, 171, 189–202,
 213, 222

Stein, Gertrude (*cont'd*)
 The Autobiography of Alice B. Toklas, 197, 198
 Blood on the Dining-Room Floor, 189, 190–1, 197–203, 213, 242 n.105
 'Lifting Belly', 197
 The Making of Americans, 192
 Picasso, 191
 'Subject-Cases: The Background of a Detective Story', 193–6, 199
Stramm, August, 82, 222
Straub, Jean-Marie, 221
Stravinsky, Igor,
 Le Sacré du printemps, 84, 97
Strindberg, August, 105, 106, 121
Suleiman, Susan, 205, 207–8, 212, 221
Surrealism, 11, 14–15, 30, 34–42, 52, 53–60, 61, 64, 93, 113, 115–16, 157, 172, 176–8, 179, 180, 181, 203–4, 206–8, 209, 213, 216, 220, 242–3 n.115
Svevo, Italo,
 La coscienza di Zeno, 170
Svilova, Elizaveta, 147

Tatlin, Vladimir, 145, 236 n.116
Toklas, Alice B., 196, 197, 199, 200, 203
Tolstoy, Alexei,
 Rasputin, 110, 112
Trakl, Georg, 83, 96
 'Abendland', 65, 72–83, 85, 86, 90, 91, 92, 94
 'An die Verstummten', 72–3
 'Das Gewitter', 231 n.36
 'Psalm', 74, 89, 97, 229 n.10
Trauberg, Leonid, 235 n.77
trauma, 63, 64, 95, 125, 126, 127, 129, 149, 151, 153, 154, 155–6, 160, 161, 162, 163, 164–5, 236 n.112

Trotsky, Leon, 125
Trotter, David, 188
Tsivian, Yuri, 237 n.127
Tzara, Tristan, 30–4, 35, 47, 53, 227 n.72

Valentin, Karl,
 Mysterien eines Frisiersalons, 114
Vermeer, Jan,
 The Lace-Maker, 163
 Lady Writing a Letter with her Maid, 197
Vertov, Dziga, 160, 166
 Chelovek s Kinoapparatom, 109, 130–1, 144–51, *152*, 153–6, 157–8, 159–60, 164, 238 n.149
Vigo, Jean, 156, 237 n.132
Vorticism, 27–30, 84, 230 n.24

Wagner, Richard,
 Tristan und Isolde, 86, 157
Warhol, Andy, 221, 222
Weiss, Peter,
 Marat/Sade, 232 n.6
White, John J., 20, 23, 24
Whitfield, Sarah, 228 n.110
Whitman, Walt, 95–6
Wiene, Robert,
 Das Cabinet des Dr. Caligari, 105, 106–8, 147, 183
Williams, Linda, 160, 173
Williams, Raymond, 11, 106
Wollen, Peter, 221, 235 n.94
Woolf, Virginia, 184–9, 240 n.53
 Mrs Dalloway, 174, 184–9, 196, 202, 204
 The Waves, 168, 185, 196, 213
Wright, Elizabeth, 58, 234 n.39

Zamyatin, Yevgeny,
 We, 170
Žižek, Slavoj, 11, 237 n.126

POKÉMON™

Legends of Alola

By Simcha Whitehill

Legends of Alola

Written by Simcha Whitehill

The Prima Games logo and Primagames.com are registered trademarks of Penguin Random House LLC, registered in the United States. Prima Games is an imprint of DK, a division of Penguin Random House LLC, New York.

DK/Prima Games, a division of Penguin Random House LLC
6081 East 82nd Street, Suite #400
Indianapolis, IN 46250

ISBN: 978-0-7440-1945-2 (Paperback)
ISBN: 978-0-7440-1949-0 (Hardback)

Printing Code: The rightmost double-digit number is the year of the book's printing; the rightmost single-digit number is the number of the book's printing. For example, 18-1 shows that the first printing of the book occurred in 2018.
21 20 19 18 4 3 2 1

01-311217-Aug/2018
Printed and bound by Lake Book.

Credits

Publishing Manager
Tim Cox

Book Designer
Tim Amrhein

Production Designer
Tim Amrhein

Production
Beth Guzman

Prima Games Staff

VP
Mike Degler

Publisher
Mark Hughes

Licensing
Paul Giacomotto

Marketing Manager
Jeff Barton

Digital Publisher
Julie Asbury